BERLIN CALLING

BERLIN CALLING

A Story of Anarchy,
Music, the Wall,
and the Birth of
the New Berlin

Paul Hockenos

THE NEW PRESS

25 YEARS

NEW YORK
LONDON

Requests for permission to reproduce selections from this book should be mailed to:
Permissions Department, The New Press, 120 Wall Street, 31st floor, New York,
NY 10005.

Published in the United States by The New Press, New York, 2017
Distributed by Perseus Distribution

LIBRARY OF CONGRESS CATALOGING-IN-PUBLICATION DATA
Names: Hockenos, Paul, 1963- author.
Title: Berlin calling : a story of anarchy, music, the Wall, and the birth of
the new Berlin / Paul Hockenos.
Description: New York : The New Press, 2017. | Includes bibliographical
references and index.
Identifiers: LCCN 2016052402 (print) | LCCN 2016055590 (ebook) | ISBN
9781620971956 (hardcover : alkaline paper) | ISBN 9781620971963 (e-book)
Subjects: LCSH: Berlin (Germany)—History—1990- | Berlin (Germany)—Social
life and customs—20th century. | Berlin (Germany)—Social
conditions—20th century. | City and town
life—Germany—Berlin—History—20th century. | Berlin Wall, Berlin,
Germany, 1961-1989. | Social change—Germany—Berlin—History—20th
century. | Post-communism—Germany—Berlin—History—20th century. |
Political culture—Germany—Berlin—History—20th century. | Popular
music—Germany—Berlin—History—20th century. | Popular
culture—Germany—Berlin—History—20th century. | BISAC: HISTORY / Europe
/ Eastern. | ART / Art & Politics. | MUSIC / Genres & Styles / Punk. |
POLITICAL SCIENCE / Political Ideologies / Communism & Socialism.
Classification: LCC DD881.3 .H63 2017 (print) | LCC DD881.3 (ebook) | DDC
943/.1550881—dc23
LC record available at https://lccn.loc.gov/2016052402

The New Press publishes books that promote and enrich public discussion and under-
standing of the issues vital to our democracy and to a more equitable world. These books
are made possible by the enthusiasm of our readers; the support of a committed group
of donors, large and small; the collaboration of our many partners in the independent
media and the not-for-profit sector; booksellers, who often hand-sell New Press books;
librarians; and above all by our authors.

www.thenewpress.com

Book design and composition by Lovedog Studio
This book was set in Walbaum MT

Printed in the United States of America

10 9 8 7 6 5 4 3 2 1

To Johan

Contents

Acknowledgments *xiii*

Introduction 1

Part I: WEST BERLIN

1. Learning to Love the Wall *11*

2. Bowie's Berlin *39*

3. Wall City Rock *66*

4. Free Republic of Kreuzberg *95*

Part II: EAST BERLIN

5. Flowers in the Red Zone *125*

6. Glasnost from Below *167*

Part III: THE NEW BERLIN

7. The Miracle Year *201*

8. One Nation, One State, One City *236*

9. Peace, Joy, Pancakes *258*

Conclusion: Berlin Now *280*

Epilogue *306*

Select Bibliography *311*

Notes *315*

Photo Credits *321*

Index of Names *323*

The Berlin experience is how to make
a lot out of nothing.

—DIMITRI HEGEMANN, BERLIN CLUB OWNER

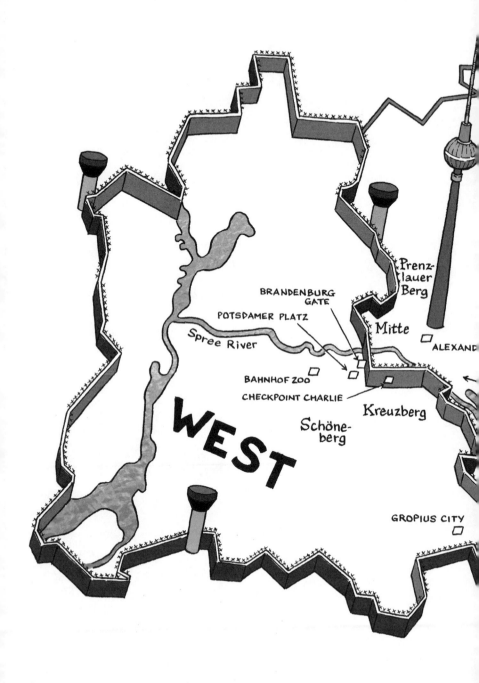

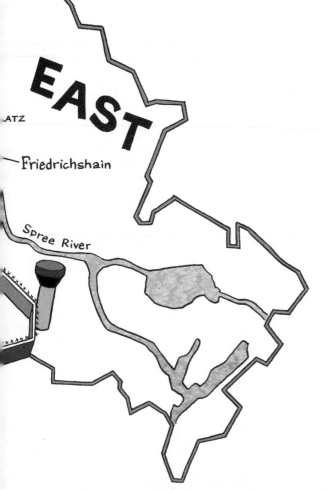

Acknowledgments

I wrote the bulk of this book in 2015 and 2016 from my office in Prenzlauer Berg on Berlin's east side, the site of many of the stories I narrate. This chronicle parallels my own journey since the 1980s, but is not limited to it. I write about the episodes that took place in Berlin when I lived there in part through my own experiences; for events or time periods that I didn't witness firsthand, I've relied on interview partners, some of whom I've known for years, such as Claudia Diedenhoven and Richard Wagner, and then others such as Danielle de Picciotto, Harald Hauswald, Swanhild Maass, and Wolfgang Müller, whom I met in the process of my research. I conducted all of the interviews myself, unless otherwise indicated and sourced, traveling by bicycle to cafés, pubs, and studios to meet my interlocutors—even in the dead of winter, as many Berliners do. Most of the book's protagonists still live in the neighborhoods that I write about, amid the many newcomers, a testament to the fact that as much as Berlin changes, some things remain the same.

Thematically, I'm indebted to music critic Greil Marcus, whose *Lipstick Traces: A Secret History of the 20th Century* called our attention to the many subaltern currents that flow through our

cultures and subcultures. Also, while writing, I thought often of my former professor at the University of Sussex, the late Gillian Rose, whose teachings remain with me despite her early departure from this world. And over my other shoulder, as always, was the encouraging spirit of my father Warren, who was always deeply committed to all of his sons' endeavors.

I thank all of the more than one hundred people I interviewed, including those not named in the book. I also thank Bill Martin, Karen Margolis, Gwen Jones, Jasper Tilbury, Hayyan Al-Yousouf, Colin Shepherd, Joshua Hammer, Rüdiger Rossig, Deborah Chasman of the *Boston Review*, Erhard Stölting, Randy Kaufman, Mark Swatek-Evenstein, Heinz Havemeister, Matthew Hockenos, Rachel Tausendfreund, Bernd-Rainer Barth, Robert Van Meter, Jim Ogier, Dirk Moldt, Café Anita Wronski, Lothar Schmid of worldwidefotos, and Felix Denk for their suggestions and support. Anne Crookall Hockenos read every page, still a meticulous copy editor twenty years after leaving the profession. My deep gratitude goes to my old friend Joe Sacco for the Berlin map. My agent Cecelia A. Cancellaro of Word Literary is a magnificent anomaly in the world of commercial publishing: always encouraging and motivated by her love of books. I also want to say thank you and good-bye to Christian Semler, one of my favorite *Gesprächspartner*, who died in 2015. And, not least, I thank my wife Jenni Winterhagen for her unstinting support and love. One day, our son Johan will read this book, I hope, and learn a little more about his father and much more about the city he was born and raised in. Lastly, I'm grateful to my editor, Marc Favreau of The New Press, for his hard work and commitment to the project.

BERLIN CALLING

Introduction

At the height of the Cold War, West Berlin was as far as one could travel east without leaving the Western world. The stranded city lay like an island in the middle of communist East Germany, detached from West Germany and circumscribed by the Berlin Wall. This enforced seclusion made West Berlin a sanctuary for contrarians looking to lose themselves, to search and reinvent. By the 1980s, stories of its all-night clubs, loose morals, and occupied tenements, known as squats, had leaked out through the militarized borders. On U.S. television news, I had seen the riotous street fighting between squatters and police in a haze of tear gas. *Rolling Stone* effused about the industrial sounds of the Berlin band Einstürzende Neubauten. And David Bowie and Iggy Pop attributed their most inspired work to the crucible of West Berlin, their home in the late 1970s.

Berlin's staggering contradictions only made the divided city all the more beguiling. West Berlin was reputed to be the West's showcase of capitalism, a glittering ornament to dangle in the face of the poor East bloc. Behind the Cold War's front lines, West Berlin lay like a sore in the heart of Soviet-run Eastern

Europe, a far-flung outpost occupied by World War II's Western allies. Thus, simply by living in West Berlin one was manning the barricades of the Atlantic alliance. And yet, by the 1960s West Berlin had become a hotbed of radical critique whose partisans mocked West Germany's subservience to Washington. An antidote to tradition-girded Germany, the walled-off half city buzzed with subversive energy. Gay people, covetous of its thick cloak of anonymity, flocked to West Berlin, as did free thinkers of many stripes. Hundreds of squats and collectives functioned as open-ended experiments in direct democracy and alternative lifestyles.

In autumn 1985, I disembarked at West Berlin's main train station, Bahnhof Zoo, with a thousand dollars in my duffel and not a clue as to where I'd sleep that night. I was fleeing upstate New York, Reagan-era America, and the pressure to choose a career. I had no premonition that I'd find myself here thirty years later, living in the unified city's east side, nor that every year U.S. college kids and millions of other visitors would gravitate to the city known as Europe's hippest capital.

There are many fine studies of the city. But I couldn't find in them the Berlin that makes the city so appealing to me—and, I think, to many others, too. "Berlin's the only city in the world," an aide to Berlin's mayor told me some years ago, "where people come as tourists and stay to live." The mayor in the aughts, Klaus Wowereit, famously quipped that Berlin was "poor but sexy." Berlin has come a long way since then, but it's still, for the moment, sexy. Which doesn't mean it'll stay that way forever.

Most narratives pay short shrift to Berlin's rich countercultural past: the figures and venues, episodes and movements that stamped their imprint on Berlin. Yet the city's rough-around-the-edges reputation, its distinct cool today, lives from its off-grid experiments—and those that inspired them. The ravers queuing

for hours to pass into the techno citadel of Berghain (touted "the world's best night club") may not be aware of it, but Berghain is inconceivable without the lipstick traces of Kommune I, the nest of 1968's lifestyle rebels, or the East German punks who rocked the dictatorship in the 1980s, or the "miracle years" of post-Wall innovations. There are subterranean tides and eddies beneath Berlin that reach all the way back to the post-World War I avant-gardes of the Dada movement and the sexual anarchy of Weimar-era Berlin. This heritage has enabled the city to posit itself anew many times over and will continue to, if the conditions are right. This is the story I want to tell.

In contrast to the new Berlin, Cold War West Berlin wasn't a magnet for tourists, and living there wasn't for everyone. At first I suffered from its darkness. The two-hour journey from mainland West Germany to West Berlin tied my stomach tight in a knot. The monotonous 106-mile stretch through East Germany felt like a timeless tunnel. You were suspended in the matrix of the East bloc, forbidden to stray from the straightaway of the *Transitautobahn*, a special transit highway. At the border, East German authorities could ruin your day by making you wait for hours for no apparent reason. A U.S. passport guaranteed you a hassle of some sort. At worst, they'd say *nein* and not let you pass, no explanation given. But with time, this passage became nothing more than an annoying ritual—the price for living apart from the rest of civilization.

West Berlin's attraction was, in part, the exhilaration of existing on the brink. Its gray, forlorn districts along the Wall, like the neighborhood I lived in, stared the bleak reality of the Cold War in the eye. Behind the graffiti-sprayed Wall lay the so-called death strip with its barricades, guard towers, flood lights, and East German patrols armed with automatic weapons. A friend of mine lived so close to the Wall that at night you could hear the

border guards' chit-chat. Beyond the Wall, in every direction, spread the communist bloc.

Packed in my bag with two sets of clothing were Christopher Isherwood's Berlin novellas, an English translation of Hegel's *Phenomenology of Spirit*, and *Christiane F: Wir Kinder vom Bahnhof Zoo*.* I enrolled at the Free University, West Berlin's postwar academy, with vague plans to read Marx and Hegel in the upcoming semester.

I wasn't alone in seeking refuge in West Berlin—or reading Hegel, either. Almost everyone there was fleeing something: sexual prejudice, provincial West German hometowns, the East bloc's secret police. Young West German men flooded into the city that, on account of its postwar status, spared them military service. Most of my male acquaintances in West Berlin were dodging the draft. Moreover, the West's proclaimed beacon of free-market prosperity was in fact an economic basket case, kept afloat through subsidies doled out by the well-heeled Federal Republic of Germany, or West Germany. The generous supports and dirt-cheap rents translated into oodles of free time to do your own thing.

In far-away West Berlin "nobody gives a shit" about you, something David Bowie noted appreciatively. "There was this incredible feeling of freedom!" my old friend Claudia, a 1980s Berlin transplant from the Ruhr Valley, told me recently in a trendy tapas bar along Görlitzer Park. She admitted this sounds a bit hokey today. "But," she emphasized, "Berlin was so liberating compared to stuffy, old West Germany." The morbid charm of Berlin's decrepit cityscape held a fascination for those fed up with pretty little German towns and their stale traditions. The individualists who had trickled into the city infused it with a

* *Wir Kinder vom Bahnhof Zoo* was published in English translation in 1982 as *Christiane F.: Autobiography of a Girl of the Streets and Heroin Addict*. An inferior translation came out in 2013 entitled *Zoo Station: The Story of Christiane F.*

unique libertine flavor and an aesthetic—one could even say its own particular brand of cool—that would outlive West Berlin and its wall.

West Berlin, of course, was only half of the story. Across the Wall lay East Berlin, capital of the German Democratic Republic (GDR), a city run according to the logic of Soviet communism. In the mid-1980s, I crossed over to East Berlin many times hoping to scratch its polished veneer. But it didn't scratch easily.

Unknown to most West Berliners, East Berlin's inner-city neighborhoods sheltered a bohème every bit as raw and inventive as their own, perhaps even more so—certainly the stakes were higher. I couldn't initially locate it because it was underground in the truest sense: illegal and clandestine. Iconoclastic behavior, from sporting punk coiffeurs to communal living, was deemed subterfuge by the one-party regime and subject to reprisal as grave as prison. Among regime opponents, culture was a potent political weapon. In a state that insisted that it control everything, subculture pried open space that the state didn't regulate, and it communicated ideas beyond its own tight circles. In crumbling tenements, the underground hosted wild all-night parties and over-the-top, costumed performances. This revelry was more than just a party; it was one plank in a strategy to show up the dictatorship and, eventually, overthrow it.

Only much later did I come to realize how East and West Berlin were linked in ways invisible to the eye. And in both Berlins, subculture, everyday life, and against-the-grain politics were tightly intertwined. The political context of the Cold War lent painting, fashion, and experimental music urgency and relevance. In Berlin, squats were art, and art was part of a larger political project.

Berlin's denizens excavated the city's past, searching for traditions of utopian politics and libertine practices that the

dictatorships had strived to erase. Anarchist passions, for example, coursed through Berlin's rebel projects. Some of them explicitly called upon historical forefathers, such as the Dadaists or the Situationist International. Others simply pursued self-determined lives and do-it-yourself enterprise as they saw fit. Anarchy wasn't a doctrine as much as a mode of operation. In the form of punk, and techno in its early days too, it imbued the creative sets with fierce contempt for the establishment and the world of money.

I left West Berlin in the late 1980s for stints in Washington, D.C., New York City, and then Brighton, England, the latter for a year of graduate school. (Recalibrating my ambitions, I read German philosophy in English.) It was happenstance that I found myself in West Berlin in September 1989 when the East bloc was dissolving, with one Soviet ally after another rising to cast off the shackles. I met a friend of a friend from Brighton in one of West Berlin's legendary nightspots, Kumpelnest 3000. On a lark, she convinced me to hitchhike down south to Hungary, where East Germany's discontents were pouring through the opened border to Austria. We stayed in Budapest for two years, our courtyard apartment the perfect perch from which to watch communism implode.

In a Danube beer bar, I by chance befriended a few of the youngest of East Germany's dissident opposition, who were visiting friends in Hungary. These twentysomething punk rockers from East Berlin were pushing the wobbly East German regime from below—as hard as they could. I was struck by them, as they weren't joining the exodus to the West. On the contrary, they told me, they intended to transform East Germany, to remake it into a state more egalitarian and more democratic than either of the existing Germanies. In fact, their group, Church from Below, would play a decisive role in the "peaceful revolution" a

few months later that brought the regime to its knees, a story that has thus far eluded history books. And though they failed to inspire a new Germany, they helped fashion a new Berlin.

When the Wall crashed on November 9, 1989, the subcultures of East and West collided in the ruins of eastern Berlin. The east side morphed into a carnivalesque happening: the site of squats, hole-in-the-wall galleries and cafés, and all-night partying. The city was open to anyone with a crowbar and a good idea, among them the progenitors of the trippy techno clubs where kids from East and West bonded in the druggy bliss of the moment. The boundless untended spaces invited improvisation. Squatters reconfigured the relics of industrialism into collective living quarters and art houses, just as they upcycled other remnants of Germany's past.

Berlin's early 1990s were aptly dubbed "the wonderful years of anarchy." For me, though, the magic ended abruptly on the night of November 21, 1992, when one of the Church from Below was murdered by neo-Nazis. The new Germany had a sinister underside, too. Berlin was an open, international city for the first time since the Nazis' takeover in 1933. Yet right-wing thugs prowled its streets again. The far right's presence in eastern Germany and other former communist societies cast a dark shadow over the democratic transitions. At the time, I was writing my first book, *Free to Hate*, which examined how authoritarian mindsets persisted in the fresh democracies of Central Europe.

Nevertheless, the sprawling innovation set in motion in 1989 reverberated powerfully in Berlin, as it still does today. This was the zero hour of the new Berlin. The 1980s counter-cultures weren't negated with unification, but were, in good dialectical form, subsumed and transformed into something entirely original. The rocky process of coming together commenced in Berlin's squats and clubs, providing a taste of what

was to come in the years ahead as, on a much larger scale, the unified Germany struggled to unite its people. But in contrast to the country as a whole, Berlin took something of the years of anarchy with it as it embarked on a new chapter in its turbulent existence.

Part 1

WEST BERLIN

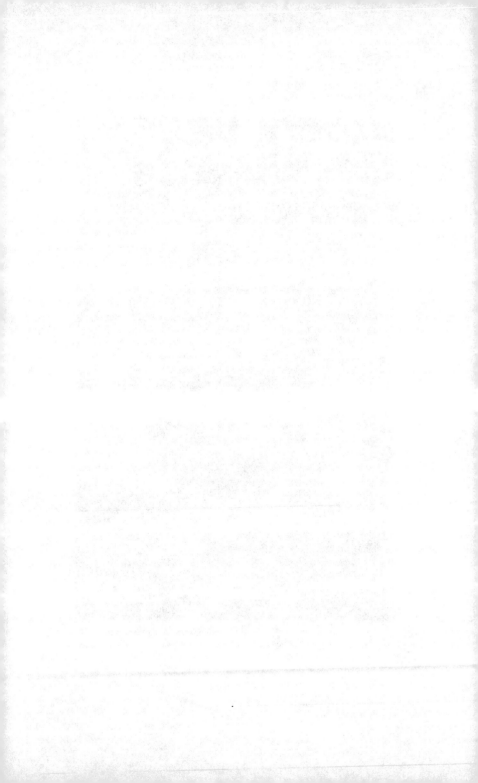

1

Learning to Love the Wall

WEST BERLIN'S UNDERGROUND METRO, CALLED THE U-Bahn, was a rare place in the Cold War city where all of its disparate populations intersected. By the mid-1980s, a broad society of new wavers and punks, the whole queer community, house squatters, student rebels, and artists had, in terms of quantity, reached a critical mass. They'd inscribed their signature on whole city districts where they flaunted an alternative economy of clubs and collectives in vast city blocks dominated by squatted housing. Tongue-in-cheek, some referred to the domains as their self-made "free republic."

In contrast to the 1970s, when freaks with spiked hair and studded leather jackets or outré drag queens stood out, by the '80s the fringe had become a strand of the larger tapestry. The denizens of "the scene," as it was called, joined the likes of the city's gray-bunned war widows and Allied soldiers as constituents of the bizarre microcosm that was West Berlin. Above the U-Bahn tunnels, on the city's surface, these communities had precious little truck with one another, even though they hunkered down together in the West's geostrategic outpost. But their

convergence in the U-Bahn, as passengers, was anomalous. In its unearthly neon light, deep beneath the cityscape, you'd rub elbows with fellow Berliners.

The first trains of the day, around 4:30 a.m., were particularly surreal. Because West Berlin was the only metropolis in all of Europe with no closing hour for bars and clubs, partying started late and began to taper off when the U-Bahn restarted. Energies spent, we gawked innocuously across the aisle at the West Berlin natives and migrant *Gastarbeiter,* or guest workers, who were off to early shifts. The working class stared back, just as uncomprehendingly, as if we hailed from a faraway planet.

Many of the nightlife's regulars couldn't name to their circle a single indigenous Berliner or regularly employed burgher. And they were proud of it. The suit-and-tie class barely existed in West Berlin, which is exactly why so many individualists had chosen self-imposed exile in West Berlin in the first place. "If you wanted to pursue an above-board, paying career, then you'd go to another city, but not to West Berlin," explains Michael Sontheimer, a journalist who grew up in the city. "This was a great thing about West Berlin. All the assholes left for West Germany."

Berlin's proletariat was another story: alien but tolerable. It was unthinkable that any of its workaday types would show up at the dives of the scene dwellers, bars such as Risiko, the punk club SO36, or one of the squats' makeshift cafés. Likewise, no one from the cool crowd would dream of drinking a beer with a salty Berlin worker in an old-fashioned corner *Eckkneipe.* "We had our own geography," says Fetisch, a former West Berlin DJ. "We navigated [West] Berlin like it was a jungle. This was our own parallel Berlin. We didn't even acknowledge the presence of most of the things or the people around us. We blended them out."

On late-night U-Bahn lines you might cross paths with off-duty French, British, or American soldiers, the occupation forces that supposedly guaranteed West Berlin's security. Despite the staunchly anti-American politics of the counterculture—and West Berlin's rich culture of street demonstrations—there was surprisingly little friction between the troops and the nighttime demimonde. The soldiers went out on the town too, negotiating their own universe of discos, pool halls, and brothels. On two routes, the West Berlin U-Bahn burrowed beneath East Berlin, a creepy, foreboding stretch of track that passed dimly lighted, cinder-block-and-cement sealed stations called the ghost stations, which East German authorities had closed down after the Wall was erected in 1961. This six- or seven-minute foray into the East bloc visibly unnerved some of the American soldiers, prompting a few I traveled alongside to duck down so that the border guards on the desolate platforms wouldn't see them. Not all of them, though. Once I saw a GI jerk the U-Bahn's doors open a crack and over the train's roar yell at the top of his lungs: "Fuuucking cooommunists!" He did it every time he passed through the ghost stations, he told me. The East Germans were the enemy, not West Berlin's freaks.

Older West Berliners, such as the widows cloistered in the prettier neighborhoods of West Berlin, were the ones most likely to give you an earful—if you let them. A floor beneath one of my West Berlin abodes lived a Frau Jones, a German woman who had married an American serviceman after the war. She'd grumble without prompting about the thankless students, the endless demonstrations, the GDR and communism, all of which vexed Frau Jones to her core. But being from the United States, I think I got off lightly. Though Captain Jones had died by then, the frau's pro-American sympathies hadn't perished with him. If it weren't for the Americans, West Berlin wouldn't exist today,

she'd tell me with gratitude when I passed her doorstep, as if I had had something to do with it.

Island City

In its favor, the Wall had perks that helped one learn to resent it less—an attachment that deepened the longer you lived in West Berlin. Take, for example, the GDR border posts at the Wall, initially a source of anxiety. All car travel out of West Berlin had to pass through the East German checkpoints along the Wall's perimeter in order to get onto the GDR highways that led from Berlin to West Germany. This made hitchhiking a cinch. You just queued up alongside the crawling lanes of traffic at the Drewitz-Dreilinden checkpoint with a cardboard sign that read "Hannover," "Vienna," "Munich," "Paris," or any other point west, and you were soon on your way to Mom's or off to the Spanish coast for the summer. The favorable conditions for hitchhiking were, in the long run, the equivalent of a free Eurail train pass, once you got the drill down. But this was just one—and actually one of the more minor—West Berlin bonuses that endeared the Wall to us.

The Wall was the foremost global symbol of communist dictatorship in the Prussian city that had served as capital of the Third Reich. For most young West Germans these counted as high negatives. But the city's unique historical baggage and heavy symbolism didn't dissuade the transplants who, to their credit, labored to make Berlin their own, in defiance of history. Some of them, such as the band Einstürzende Neubauten, even considered their art a means of exorcising the past, of purging the sinister spirits of the Nazis with fiery onstage sorcery against the background of megaloud untuned guitars and thunderous drumming.

One German journalist speculated that errant young Germans set up camp in "the ruins of German history" because Berlin's bombed-out spaces and bullet-pocked facades functioned as an ever-present warning to future generations not to lapse into forgetfulness, the way they claimed their parents had. Perhaps Berlin's mise-en-scène would render them impervious to forgetting, they reasoned. At the time, there were few monuments to mark the years of Nazi rule; you had to get tips from insiders to locate the key sites. To peek at the remains of the headquarters of the Nazi secret police, the Gestapo, and elite shock troops, the SS, one had to sneak along the Wall before scrambling through overgrowth to find the concrete corners of the Nazis' infamous buildings protruding from the earth. Today there's a proper exhibition at the site called "Topography of Terror," which a million tourists a year line up to view.

Like most of the *Wahlberliner,* or Berliners-by-choice, in the 1980s, I too took for granted that this exclave of worry-free counterculture would remain intact for many years or even decades to come. But West Berlin was contingent upon the Cold War, and it would vanish the moment this context changed. At the time—just five years before everything did change—it couldn't have been further from our minds, even though a thoughtful reformer by the name of Mikhail Gorbachev had just come to power in the Soviet Union.

When the Wall did come crashing down, many of the artists and hipsters reacted much differently than did indigenous Berliners, the natives living on both sides of the city. The habitués of Kreuzberg—a West Berlin district abutting the Wall, bastion of radicalism and do-it-yourself lifestyles—weren't popping bottles of warm champagne and hugging giddy East Germans. November 9, 1989, was the day their little bubble burst and, once they comprehended the implications of the Wall's breach, they

wept tears of sorrow—not joy. When the East German check-points at the Wall were abandoned, our free travel passes expired, as did the social benefits, wage supports, duty-free alcohol, low rents, and array of other freebies that made our lives comfortable and, more critically, provided the artistically minded with the free time, the space, and the means to pursue the ventures that defined 1980s West Berlin.

The West Berlin disc jockey named Motte (or Moth, known to his mother as Matthias Roeingh) cried on the telephone to his American girlfriend, Danielle de Picciotto, when the Wall's border crossings opened on November 9, 1989. West Berlin was, and always had been, the twenty-nine-year-old's home—and in that moment he lost it. The first reaction of my friend Astrid, an English graduate student, was to bemoan the disappearance of "all that wonderful art" that wrecking cranes would demolish when the Wall went. (In fact, it was tourists with chisels who laid waste to much of the world's biggest open-air art gallery, a foretoken of what visiting hordes would do to Berlin in decades ahead.) Astrid and I had taken afternoon-long weekend walks along the magnificent Wall, gazing at the murals and politically charged graffiti art, stopping periodically for *Milchkaffee* at the little cafés in its lee. I'd miss this, too.

For another friend, Claudia, Ruhr Valley émigré and proud Kreuzberger, it meant that swarms of badly dressed East Germans would muddy the cutting-edge chic of her funky neighborhood, pressed as it was up against the Wall. She and her clique had run away from the hidebound West Germans only now to be confronted with a deluge of their eastern counterparts (who were, as it turned out, in many ways squarer and certainly less politically correct than their western cousins). Soon, the days would be gone when she could prop up a chair against the Wall

and sunbathe nude on a grassy patch along the Landwehrkanal. Her boyfriend Richard had greater cause for concern. The West German authorities were coming after him and thousands of other men who had holed up in West Berlin to duck military service.

At the time, none of these melancholic West Berliners could know that the Wall's breach and German unification would provide them with opportunities, cultural as well as professional, that were unthinkable in old West Berlin.

Graveyard of Ideology

One of Berlin's striking continuities has been its intensely political demeanor, as a city that wears the headline ideologies of the era on its sleeve—and discards them just as quickly. When I arrived, Berlin was the epicenter of the Cold War, a divided city in a divided Germany in a divided Europe, as the British historian Timothy Garton Ash put it. Just decades before that, it hosted the headquarters of Adolf Hitler's murderous Reich from 1933 to 1945, the command center from which Europe would be broken and its Jewry exterminated. Yet the city on the Spree River exited the twentieth century as a global symbol of freedom and democratic renewal, as well as the capital of a liberal-minded, unified Europe.

Germany started off the twentieth century as a Prussian-style monarchy with Berlin as its capital. Called to life in 1871 in the name of a single German nation, the German Empire ranged from the Alps to the Danish border, and incorporated under its wing historical Prussia all the way to today's Lithuania. The Great Powers—imperial Germany, Austria-Hungary, the

Russian Empire, the United Kingdom, and France—waged World War I against one another, leaving the continent shell-shocked and impoverished. The victorious Entente alliance concluded that Germany was the guiltiest party, and would therefore pay even more, much more, for having begun and lost the war. The forfeit of territory, population, and sovereignty, followed by the Great Depression and mass employment, sowed the seeds for fascism and another world war just twenty years later.

No phenomenon better reflected the anguish and the disillusionment of World War I's bitter end and chaotic aftermath than the antiart Dada movement. Though Zurich was its birthplace, Berlin was one of Dada's centers, where radical painters, sculptors, and poets, figures such as John Heartfield and Max Ernst, fused art and politics in a way unthinkable before the war. The Dadaists' nihilistic weltanschauung, often expressed in playful, absurdist creations, reflected the devastation, intellectual as well as physical, of the four-year atrocity. Although other European metropolises hosted Dada too, the Berliners distinguished themselves as the most expressly political of the avant-gardes, taking on the complex politics and combustible social tensions of postwar Berlin. Leading Berlin Dadaists participated in the 1918–19 November Revolution, when socialist- and communist-led factions forced the emperor's abdication. Dada proclaimed an abrupt, total break with the past: the advent of a Europe—and new art forms—that shared little with the long nineteenth century and its conventions. Dada came and went quickly, but it opened the way for surrealism, New Objectivity, Bauhaus, readymade art, and other modernist currents that looked at the world with new eyes. (When Dada celebrated its hundredth anniversary in 2016, Europe's media and museums fell over themselves in praise of its genius, which was probably the last thing its progenitors had ever thought possible or, for that matter, would have wanted.)

The Great War snuffed out monarchy once and for all in Germany and, in time, when Berlin crawled out from beneath the wreckage, the city experienced a concentrated blast of republican rule and libertine effervescence known as the Golden Twenties. Berlin became the capital of the Weimar Republic, named for the site of the 1919 constitutional assembly that breathed life into the democratic state. Weimar-era Berlin would become synonymous with the eccentricity and sexual tumult that flourished in the unique historical moment bookended by the world wars.

The image of Berlin's '20s that most readily springs to mind is that of the Berlin-born actress Marlene Dietrich playing the trashy Lola Lola in the 1930 classic *The Blue Angel*. Her charm on the stage of a tawdry transvestite cabaret mesmerizes and then destroys old Professor Rath, who had come to the club to hunt for boys, not girls. As madness overtakes him, Rath, disgraced and ousted from his school, ends up playing the cabaret's house clown, just as the weak, decadent, overly intellectual Weimar Republic served as Hitler's clown in the Nazis' rise to power.

Even though this heyday burned brightly for just six or seven years in the latter half of the decade, the city's vampish cabaret, sexual freedom, and culture of intemperance has fired imaginations ever since. Weimar Berlin lingered on long after its death, not least in the stories and larger-than-life characters of Christopher Isherwood's Berlin novellas and Bob Fosse's 1972 film *Cabaret*, the Academy Award–winning screen version of the stories. Fifty years after the Nazis shut down (or Nazified) interwar Berlin's entertainment industry and banned its decadent artists, one of West Berlin's famous exiles, David Bowie, came looking for the Berlin of Lola Lola and Isherwood's protagonist Sally Bowles.

The Nazis' swift, brutal ascent and imposition of dictatorship wiped out just about everything that exuded a whiff of the

golden era. By 1935, the Weimar Republic was ancient history. Democracy had been suspended, and almost all of the bawdy cabarets, burlesque shows, and gay salons that the Gestapo hadn't already shuttered for good would close soon after the 1936 Olympics. Those who had operated them—and weren't by then Nazi party members—were chased out of town, if they were lucky. In Nazifying Berlin, Hitler systematically severed and then sought to obliterate all threads leading back to that era, so that it could never raise its head again, no matter the ultimate fate of the Third Reich. He obviously underestimated the resilience of Berlin's urban culture.

When Nazi Germany finally capitulated, on May 8, 1945, the city of Berlin was prostrate, nearly half of its buildings—apartment houses, churches, museums, department stores, schools—flattened or badly damaged. A million and a half of its 4.3 million prewar inhabitants had either perished or fled. Its houses of culture, too, had been wiped out. Only twenty out of the city's four hundred cinemas survived the sustained Allied bombing and fierce house-to-house combat waged between the remnants of the Wehrmacht and the Red Army in the final battle of the European theater.

Italian director Roberto Rossellini's postwar film *Berlin Year Zero* includes stark, breathtaking footage of the mountains of rubble around Alexanderplatz that the protagonist, the boy Edmund, deftly navigates to fend for his kin (see film stills on facing page). Any family fortunate enough to occupy an inhabitable flat was obliged to share it with at least one other family. As food was tightly rationed, the black market flourished in the U-Bahn tunnels and around the former Reich Chancellery in the central district of Mitte, literally translated as "middle."

In the war's wake, during the summer of 1945, the victorious Allies—the Soviet Union, the United States, Great Britain, and

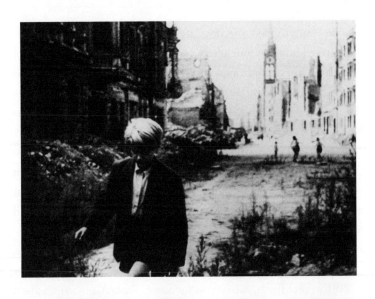

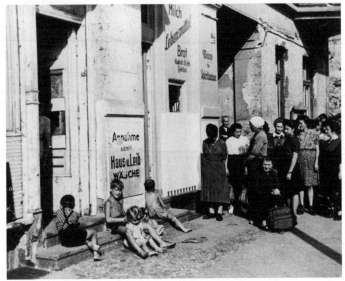

TOP The twelve-year-old Edmund in postwar Berlin in
Roberto Rossellini's 1948 film *Germany Year Zero*.

BOTTOM Postwar Berlin in *Germany Year Zero*.

France—subdivided the desolate capital of Hitler's Reich into first three and then four sectors, with each power responsible for one sector, but all four jointly responsible for a unified Berlin. As per the 1944 London Protocol, the capital city on the Spree—the potent symbol of German power—belonged neither to the Soviet Union nor the Western nations, but to all of the Allies. (On paper, this remained the case until German unification in 1990.) From day one, this cohabitation pleased no one. The Soviet leader Josef Stalin believed that the Soviets alone had the right to occupy and run Berlin. After all, Red Army ground forces had conquered the final Nazi stronghold, taking heavy losses. Moreover, Berlin was smack in the middle of the Soviet occupation zone in eastern Germany.

Berlin rapidly became the locus of East-West animosities, soon to be known as the Cold War, as the Western allies and the Soviet Union drifted apart and geostrategic jockeying heated up. In both eastern and western Germany, embryonic polities began to emerge with laws, de-Nazification processes, economic policies, and then in 1948 currencies that reflected the affinities of their occupiers. In 1949, two German states came to life, one a communist single-party state, the other a Western-style democracy. In the east, the German Democratic Republic emerged from the Soviet zone with its capital in the Soviet sector in East Berlin.

In western Germany, the French, U.S., and British zones fused to create the Federal Republic of Germany. Its provisional capital was the little city of Bonn along the Rhine River, deep in the new state's western regions, far away from Berlin but close to the new chancellor's garden villa. Nevertheless, the Federal Republic's provisional constitution declared that Berlin was Germany's rightful and legal capital. This, though, could only come to pass in a united Germany, one brokered by all of the Allies

and the Germans, too. In fact, so unlikely did this seem, over the decades many Germans forgot about the clause.

In June 1948, before the two Germanys had officially declared themselves as such, the Soviets made a desperate lunge to dislodge the West from Berlin. Known as the Berlin Blockade, the Soviets cut off all of the western sectors' land supply routes in an attempt to force the Allies to buckle and vacate the city. The West responded with an airlift called the *Luftbrücke*, literally "air bridge," that supplied the isolated sectors. For nearly a year, British and American aircraft landed around the clock delivering everything from coal and heating oil to powdered milk and toothpaste to the West Berliners. In May 1949, the Soviets quit the blockade, opening the roads to western Germany. The ordeal went down as epic legend: a testament to the native West Berliners' fortitude and unflagging will to live under democracy. In the eyes of the West Berliners like my neighbor Frau Jones, the airlift turned the former occupiers, the Western powers, into the city's protectors.

But the crisis's resolution didn't settle the confounding questions around the ultimate fate of Berlin. If shared four-power control was now a fiction, should Berlin's western sectors become part of the Federal Republic? With the Cold War escalating by the day, would Moscow and the East German authorities tolerate the western sectors forever, an "open wound" as they called it in the communist bloc? After all, ever more of their educated professionals and skilled workers were escaping by the day via the western zones. And, how could the western sectors, now referred to as "West Berlin," survive—much less prosper—when cut off, boycotted, and contested by a formidable hostile power surrounding them on all sides? Given Berlin's exorbitant cost to the West, big-name politicos among the Western Allies and West German officialdom posed the existential question "Why West Berlin at all?" More than once, thoughts were voiced about abandoning the

white elephant that it would become. West Berlin was a thorn in the side of the Soviet bloc—and of its custodians, too.

During the 1950s, the flow of eastern Germans to the West through West Berlin picked up briskly as the two societies' contrasts became ever starker. West Germany's economy boomed through the 1950s, earning it the title *Wirtschaftswunder*, or economic miracle, a feat that the East Germans couldn't hope to match (partly because the Soviets had stripped their factories clean of machinery and shipped it to the motherland). Moreover, the repressive character of the GDR became increasingly pronounced: forced collectivization, political repression, sham elections. It became quickly apparent to those not already convinced that these atrocities were integral to the system, not the short-term phenomena of postwar transition.

The first incarnation of the Wall was thrown up in utmost haste on the night of August 12 and the morning of the 13th, 1961 (see photos, page 25–26), taking almost everybody by surprise—with the notable exception of the Western powers, ironically, whom the Soviets had sounded out on the plan. (U.S. president John F. Kennedy privately welcomed the Wall's construction as West Berlin was struggling to manage the deluge of refugees. Also, Berlin's division, staked out in cement, finally provided clarity to the muddle of the city's postwar administration.) At first, the barrier was mostly barbed wire and security fencing patrolled by East German troops; masons and prison brigades, with automatic rifles trained on their backs, sealed the border tight by cementing cinder blocks on top of one another around the entire, nearly one-hundred-mile perimeter of West Berlin. For its part, the East German leadership proclaimed the Wall an "antifascist protection rampart," designed to stop Nazism from creeping over from the West, a red herring not swallowed by even the GDR's truest apologists.

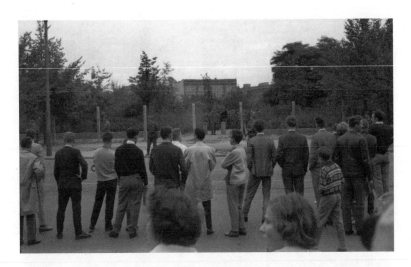

West Berliners awake to the first manifestation of the Wall on
Ebertstrasse in Mitte on August 13, 1961. The group pictured could
be a local, impromptu demonstration against the Wall or an attempt
to aid fleeing East Berliners. East German soldiers are visible
in front of and behind the fencing.

Since the Wall was exclusively on East German territory,
property of the GDR, West Berlin mayor Willy Brandt was help-
less to do more than stage angry protests and plead for the North
Atlantic allies to intervene. Incredulous West Berliners shouted,
"The Wall must come down!" as they strode together through
the city. There was international outcry, but the West had no
intention of risking a world war, this time between nuclear-
armed adversaries, over a symbol. As it happened, the Wall
turned Berlin into the quintessential icon of the Cold War and
Soviet oppression, a one-sided propaganda coup for the West. In
June 1963, President Kennedy, on a visit to West Berlin, scored
gigantic propaganda points by famously declaring that he'd be
proud to say, "Ich bin ein Berliner!" ("I am a Berliner!"), words that
rang out around the world. This, however, was poor consolation for

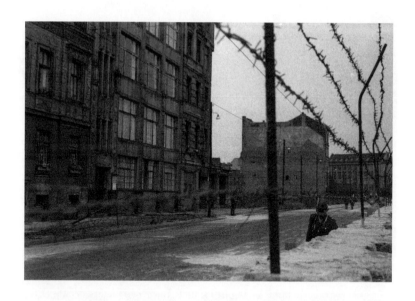

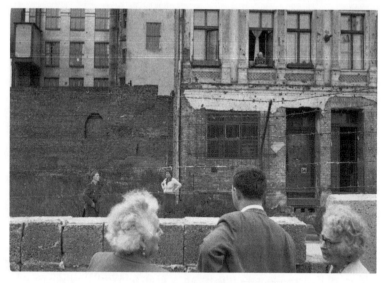

TOP The first winter of the Wall in 1962.

BOTTOM The Wall from West Berlin, probably
Zimmerstrasse, looking into Mitte, 1962.

the thousands of families cut off from one another and the workers employed across the border who found themselves jobless from one day to the next. The sealed city was now more isolated than at any point since the blockade. So grave was the crisis, many observers doubted that West Berlin would survive it.

But the city did survive, and the Wall, the standoff, and the angst became the city's quotidian reality. As the cities on opposite sides of the Wall evolved, so did the Wall itself: from a makeshift barrier to a complex security system fabricated out of thousands of twelve-foot-high, four-foot-wide slabs of reinforced concrete and three hundred watchtowers. Along its crest, a smooth pipe lip made scaling it virtually impossible. Less than a year after the construction of the initial barrier, GDR authorities bulldozed much of the east side housing near the Wall in order to add a militarized buffer zone, which varied between 35 and 165 yards in width. A second interior wall, the one that East Berliners saw, closed off the buffer area, known in the West as the death strip. Attempting to cross the militarized swath, complete with automatic weaponry, antivehicle trenches, and guard dogs, meant not only evading the lethal machinery, but eluding elite soldiers with shoot-to-kill orders. These troops wouldn't forswear their pledge to fire on "republic defectors." During the Wall's twenty-eight-year life, ninety-seven people were shot dead in the process of escape, and another forty were killed in other ways.

One Commune

In its early phase, in fact all the way to the 1960s, the young Federal Republic sidestepped a rigorous *Aufarbeitung der Geschichte*, or coming to terms with the Nazi past. Observers often relativize this shortcoming as a strategic trade-off made

by West Germany, implying that facing up in full to the Nazis' crimes was somehow incompatible with reviving the economy, which it did with finesse. But the two projects were by no means mutually exclusive. And it was this deficit, foremost among others, that propelled the West German student movement into motion in the mid-1960s—from which the first shoots of postwar subculture in Berlin sprung and took hold, and which would reverberate in Berlin for decades thereafter. Born mostly in the sweep of the 1940s, the young people had had their eyes opened to the Third Reich's crimes as well as their perpetrators' identity: among them their parents, neighbors, teachers, and politicians. Prominent former Nazis sat at desks in the judiciary and even in the cabinet of West Germany's long-reigning first chancellor, Konrad Adenauer. The new chancellor as of 1966, Kurt Georg Kiesinger, had been a Nazi party member for the entirety of Hitler's rule. By the mid-1960s, young Germans believed they saw a proto-fascist state rising from the ashes of the old one. Add to this that French and American students were protesting the war in Vietnam and rebelling against their establishment, and the upshot was upheaval on the campuses that spilled out into the streets.

In one of our many chats about the time, my former neighbor Christian Semler told me, "We were off the mark, we know that now!" referring to the students' conviction that the Federal Republic was sliding down the slope of authoritarianism. Semler had been one of the movement's orthodox Marxists, known for hardline positions on class struggle that he had since, long before I met him, discarded as wrongheaded. By the time we crossed paths, he was an editor at the left-liberal newspaper *Die Tageszeitung*,* respected by his younger colleagues for his

* The Daily Newspaper, known in Germany simply as *taz*.

prodigious knowledge of history and theory. "But that someone like Kiesinger could be chancellor, a full two decades after the war's end!" he said, explaining the students' reaction. "And then there was everything we were learning then through new studies, films, and the trials of former Nazis. There were real problems with the Federal Republic, which we rightly zeroed in on," he said. When I'd visit Semler, or he'd come over to our place, my wife would often wrinkle her forehead. Her parents, too, had been principals in the Socialist German Student Union or SDS, the main student organization, but in the southern university town of Tübingen. They weren't ideological Marxists, as Semler had been, and the peaceful, easygoing character of the Tübingen students exemplified the highly decentralized nature of the movement. Indeed, the uprising had a unique profile in every university city. West Berlin's was as the most radical of them all.

June 2, 1967, was a fateful day for West Berlin. Students had been demonstrating against the visit of the shah of Iran, a dictator too chummy with the Federal Republic for their taste. Police had already broken up the rally when a plainclothes West Berlin officer shot and killed a novice protestor point blank. The theology student, Benno Ohnesorg, had been standing alone, apparently on his way home. The murder of one of their own at the hands of the state sent shock waves across the campuses. The spark from West Berlin blew over into West Germany, where demonstrations, nonviolent until then, rocked the universities and swelled the movement with recruits, ever more of whom believed that militancy was the only answer to the police state.

Ohnesorg's killing and the students' radicalization turned West Berlin into the hotbed of the student movement. Moreover, West Berlin was the home turf of the charismatic and erudite Rudi Dutschke (see photo, page 30). A stocky five foot five with a shock of brown hair and multicolored striped sweater, Dutschke's

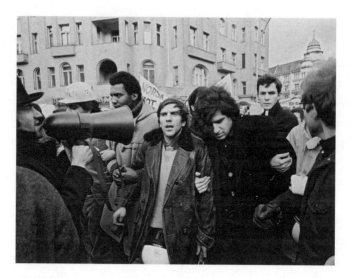

**Rudi Dutschke at the front of an anti-Vietnam-War demonstration
in West Berlin, February 19, 1968.**

stirring oratories clicked with college-age idealists who were fed
up with the Federal Republic's mimicry of American capital-
ism. In America-friendly West Berlin, the searing critique of the
U.S.-led war in Vietnam—and the Federal Republic's abetting
of it—set an entirely new tone, as did the students' embrace of
"socialism." Even though there was no confusing Dutschke's dem-
ocratic vision of socialism with the top-down version next door in
the GDR (the state that Dutschke, an East German citizen, quit
on the day the Wall went up in August 1961), West Berliners took
it personally. But for the campus activists, when the words glided
off Dutschke's silver tongue, an egalitarian and liberal society of
self-realizing citizens sounded possible, even inevitable.

Dutschke saw the world's urban centers in revolt, West Ber-
lin one of the fronts. His vision was to transform all of Berlin
into an open metropolis, independent of both East and West
Germany. All of the city's walls would come down, not just the

concrete monstrosity cutting across the city. The Free and the Technical Universities (in the west), the Humboldt (in the east), and all of the city's other academies would be dissolved in favor of a sprawling, unstructured "learning city." Berlin would be governed by local councils and communes; workers would take over the factories while police and bureaucracy would be abolished. Self-organization would prevail from schools to hospitals. If it worked, it could be a model for a unified Germany, argued Dutschke, who, as a former GDR citizen, was one of the few student rebels who cared a fig about uniting Germany. Even though Dutschke's plans never left the drawing room, they illustrate how Berlin's possibilities could stoke the imagination—and that long before 1989 a unified Berlin was conceivable to someone thinking outside the box.

Less than a year after Ohnesorg's death, blood flowed again on West Berlin's pavement. This time it was Dutschke's, the student leader gunned down in broad daylight by a right-wing extremist. The shooter, a young man from Munich, had been egged on by media that painted Dutschke as an East-bloc-paid rabble-rouser. He fired three bullets into Dutschke's head and shoulder, bringing him within a hair's breadth of death. In West Berlin, rage and anger boiled over. Furious protesters targeted the Springer publishing house, home of the mass-circulation newspapers that had vilified Dutschke and the students in general. The protests triggered the most acute crisis of the young republic's existence. In West Berlin, just yards from the Wall itself, cars burned and police water cannons blasted protestors to the ground. Although Dutschke survived the assassination attempt,* he departed West Berlin and the movement to convalesce abroad, leaving shoes that no one else could fill.

* Dutschke died eleven years later in Denmark from an epileptic seizure, a complication of the head injuries he sustained in Berlin.

West Berlin's '60s burnished another side too—one less sober, more flippant—that was lived out in freewheeling lifestyle experiments. In hindsight, historians argue it was through such cultural innovations that the student revolt made its mark on Germany; the '60s were a cultural, not an overtly political, revolution as the likes of Dutschke and Semler had intended. The countering of mainstream culture started a ball rolling that transformed the way Germans lived, learned, dressed, and even loved.

The most celebrated of the day's forays into the cultural unknown was Kommune I (Commune 1). Also a West Berlin phenomenon, the politically imbued venture would become the great-grandfather of all of Berlin's collective housing projects. In fact, it's not overstatement to claim that Kommune I marked the advent of modern subculture in Berlin. Kommune I's seven men and two women (and a nine-year-old girl) made music, dropped acid, smoked water pipes, practiced free love, shunned private property, and went to other extreme lengths to pose a foil to the prototypical German *Kleinfamilie*, in their eyes the nucleus of both capitalism and fascism. The Nazis' rise to power could never have happened were it not for the skewed microculture of the German nuclear family, which they diagnosed as subservient, rule-bound, and consumerist.

The guiding principle of Germany's most famous commune, and an assumption that would shoot through all of Berlin's countercultural projects, was that the personal is inherently political. According to the communards, our political cultures—be they authoritarian or liberal, militaristic or peaceful—reflect our interactions with one another: in the family, sexual relationships, leisure, work, and elsewhere. Logically, as they saw it, Germany had to distance itself not just from Nazism as such, but from the conditions that enabled it to germinate and thrive. Their goal was to invent a way to live and work that would nurture a new, genuinely

humane society. Yet there was no book on how to do it. Trial and error was their only method, and there'd be plenty of errors along the way.

Among the commune's illustrious bohemians was Dieter Kunzelmann, in his late twenties one of the elders, who had earned his spurs in Munich in the early 1960s with a branch of the Situationist International. The Situationists, whose ideas would go on to affect urban culture from punk to postmodernism—and are experiencing another revival in the twenty-first century in discourses on "smart cities"—surfaced first in Paris in the late 1950s and would accrue notoriety not least through the French and German student movements' select application of their philosophy. As avant-garde agitators, Kunzelmann and his Munich cohorts followed in the Dadaists' footsteps by declaring art and satire as political weapons, and their purpose as cultural sabotage. Yet the Situationists, steeped in Hegel and Marx, pressed beyond Dada's pervasive negativity by endorsing a social revolution that, they argued, was possible, even if initially in bits and pieces of daily life. Individuals and groups could break out of everyday capitalist routines when they recognized them as such. New architecture and living experiments could undermine convention and expand the sense of what is possible. The Situationists strove to transform both urban space and society at large, linking the two in a single process of radical change.

For the Situationists, the establishment had defined meaning so completely that it made everyday social constructs, the status quo, appear given and even natural—and thus immutable. So, armed with (counter)culture, such as symbols, "situations," manifestos, and performance art, the Situationists set out to crack that edifice—to smash the elite's hall of mirrors—and reveal it for what it was: leader-fixated, corrupt, and self-legitimizing. The Situationists reinvented the political by

giving it substance beyond politicians and parliaments, and thus injected rebellion with new forms too. By yanking the imperative of meaning production away from the power elite, they argued they could overthrow the system.

In contrast to the deadly earnest student radicals, Kommune I brandished irony and humor. "Revolution should be fun!" they cried, trying to loosen up West Berlin a bit. They dug out Situationist proverbs, such as "Never Work!" and "All Power to the Imagination." Wearing outrageous costumes or cross-dressing, the hell-raisers broke rules just to show how ridiculous the rules were. They fired off typewritten manifestos and communiqués that mixed nonsense, political critique, and scathing digs at hierarchical power in all of its manifestations.

In the Kommune, money was collected in one pot and divided equally. Bathroom doors were torn off their hinges. All of the mattresses were laid out on the floor of the biggest room. The novelist Peter Schneider, then a student in West Berlin, remembers the Kommune upon his first visit as "a manifesto made of furniture." The "antithesis of a bourgeois living room" in practice was "boxes of books, kitchen and dining utensils, chairs, desks, and beds all scattered around indiscriminately. The only thing missing from the commune was a toilet seat," he remembers. They not only espoused the equality of men and women, and the fallacy of "owning" partners through marriage or children through families, but attempted to practice it. An inkling of just how radical a rupture the commune was at the time, many German landlords flinched at unwed men and women living together. Until the mid-1960s, most students in West Berlin still rented rooms in apartments in which the landlord or landlady also lived.

But just two years after it came to life, the Kommune disintegrated, not least under the superhuman expectations that it had set for itself. Free love and the flat-out renunciation of private

property proved easier said than done. Moreover, generations of discrimination against women had conditioned mindsets and behavior that couldn't be nullified with good intentions, a state of affairs that led the first female communards to depart. Drugs, mostly hashish, but also quaaludes and LSD, entered the Kommune over the course of 1968, casting the experiment as more inward-looking and hedonistic. There's hardly a snapshot from this latter period in which the communards are not passing around a ludicrously oversized, cone-shaped joint. Kunzelmann's discovery of heroin estranged him from the commune's other members, who showed him the door.

Yet more damning, the pioneers of a life beyond materialism found themselves tempted by the filthy lucre. They even took to charging for interviews. Communards Rainer Langhans and the model Uschi Obermaier posed half naked for the glossy *Stern* for $12,000, setting off a storm of incredulity among the serious-minded activists who'd already had it with the antics of the commune's unpredictable pop stars. Later, in the early 1970s, Kunzelmann and Fritz Teufel, and fellow travelers close to the commune, went the way of left-wing terrorism. Lastly, although Kommune I was never linked to pedophilia, other left-wing communal living communities were, and the specter of children and sex still hangs over the German commune movement today.

Kommune I dissolved in unsightly spectacle as the student revolt unraveled too in late 1969. Nevertheless, despite its gaffes and failings, the project's actionist ethic, communal ideals, and eagerness to invent spawned many more such experiments, many hundreds in West Berlin alone, as well as other kinds of collective-living arrangements over the decades. A subset of the full-blown commune was the *Wohngemeinschaft* (literally "living community" but perhaps better translated as "apartment collective"), a smaller grouping of anywhere from two to about

eight people who'd share an apartment and aspects of daily life, such as buying groceries, cooking meals, socializing, or throwing parties. Through the 1970s and '80s, the apartment collective was the preferred model for younger people, especially students, to live together in West Berlin and in other university towns across West Germany. In the West Berlin of the 1980s, I didn't know a single person not living in some construction of collective flat.

When the cerebral, male-dominated student movement faltered and dissolved, its protagonists and their younger siblings scattered across the left side of West Germany's political spectrum. Unwilling to give up on class struggle, doctrinaire Marxists, such as Christian Semler, set up splinter parties, and anarchists organized their own communities. The legacy of Kommune I was particularly central for the anarchists calling themselves "Spontis." The Spontis, which had strong concentrations in West Berlin and Frankfurt, were unideological, anti-party anarchists who extolled spontaneous action and individual development. Their name riffed off Vladimir Lenin's critique of spontaneity, which he argued ran counter to the well-planned strategies of the Communist Party. Others from the student movement went on to launch the powerful mass movements of the '70s and '80s such as the women's movement, the peace movement, the environmental movement, and the anti-nuclear-energy campaign, which mobilized many millions of Germans. The student movement also set into motion a "long march through the institutions" in which one-time student radicals entered the system as teachers, social workers, psychologists, journalists, and even lawyers in order to transform Germany from within. (My mother-in-law became a high school teacher, my father-in-law an editor at a publishing house.)

The conclusion of the smallest handful was that only armed

struggle, not demonstrations or collaboration with the establishment, would upend the system. The urban guerillas of the Red Army Faction (RAF), which was born in West Berlin, launched a terror spree across West Germany targeting U.S. Army bases and prominent public figures. The left-wing violence of the RAF, the state's iron-fisted crackdown, and the polarization of West German society over the issue, culminated in the so-called German Autumn of 1977. The bloodbaths that claimed the lives of police officers, businessmen, RAF militants, U.S. soldiers, and many innocents horrified Germany. The grisly period cast a grim pall over West Berlin and all of the Federal Republic. Most leftists were repulsed by the bloody, ruthless tactics of the terrorists who claimed to act in the name of their ideals. On the other hand, the police dragnets and crackdowns pushed the younger generation of Germans even further away from the republic. The German Autumn was a moment of profound disillusionment and confusion for the many postwar-born Germans who had hoped to change Germany for the better, but could only conclude that, after so many years, they'd failed.

Yet from the shards of the German Autumn arose something new, which was its reverse: nonviolent, pragmatic, undoctrinaire responses to the state and ideological excess. West Berlin was one of the bastions of Germany's "alternative movement": a loose, unstructured array of grassroots citizen's initiatives, NGOs, communal housing models, co-ops, and self-administered projects that posited themselves beyond the commercial mainstream. "We are the spring of the German Autumn," announced the Regenbogenfabrik, or Rainbow Factory, one of West Berlin's alternative redoubts that was a housing collective, kindergarten, bicycle shop, canteen, and cinema all in one. The trickles of do-it-yourself initiative across the country, from cities to rural settings, swelled into a tsunami when channeled together, a

culture unto itself and yet part of the greater whole, too. The only criteria were a healthy distrust of authority and a fresh approach to fusing work and life. They did their own thing on shoestring budgets or no budget at all, their projects encompassing organic farmers' markets, alternative nurseries, cafés, lesbian bookshops, off-theater, self-made media, nontraditional health care practices, and much more. Another Germany existed beyond grainy gray mainstream Deutschland, one colorful, sundry, socially responsible, and not-for-profit.

The various strains among the amorphous Alternativen included Spontis and other anarchists, who concentrated their energies on self-organized neighborhood groups that worked with migrants and fought gentrification. There were full-fledged communes of multifarious views across the city, but also untold thousands of smaller self-organized collectives, each one fitting democracy to its needs and conditions. The newspaper *taz*, for which Semler worked, emerged out of the confluence of the new social movements and the lifestyle projects in West Berlin in 1979, and provided all of West Germany with against-the-grain news laced with tongue-in-cheek humor. Nearly forty years later it still does, as an entrenched part of Germany's media landscape that is taken seriously far beyond the circles of its subscribers. Likewise, a new environmental party called the Greens came to life as the parliamentary arm of the mass social movements, co-founded by Rudi Dutschke, artist Joseph Beuys, and writer Heinrich Böll, among many others. West Berlin was home to one of its most tenacious branches. The thought that the journey of the little party would three decades later land it in the highest offices of government in a united Germany, based in Berlin, was surely not something that even the most delirious among them would have suggested at the time.

2

Bowie's Berlin

ALMOST A DECADE BEFORE I STEPPED FOOT IN BAHN-hof Zoo, a teenage girl named Christiane Felscherinow cata-pulted the city's central train station, and 1970s West Berlin with it, into the all-time annals of decadence and excess. Teen drug addicts roamed train stations in other European cities too, but Christiane F.'s lurid tale became synonymous with West Berlin.

Felscherinow was a junkie and part-time hooker who sniffed her first line of heroin at the age of thirteen. She later told her bleak but engrossing story to the world in a 1978-published memoir *Wir Kinder vom Bahnhof Zoo*, which became an in-ternational bestseller and, in 1981, a cult biopic—released as *Christiane F.* in the English-speaking world (see film still, page 40). The book, still in print today, was translated into fifteen languages and has sold five million copies. In West Germany, an entire generation of high school students had the book as-signed in class.

Bahnhof Zoo is the chronicle of a bright, by all accounts beau-tiful young girl who winds up a skin-and-bones addict trading sex for smack behind the station abutting West Berlin's zoo.

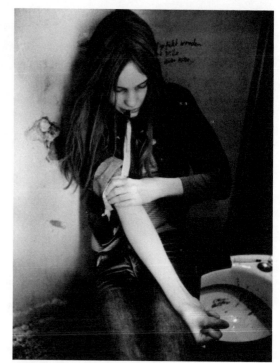

Actress Natja Brunckhorst as Christiane Felscherinow in the 1981 feature film *Christiane F.*, an instant classic of German postwar cinema.

Felscherinow's disturbing story, which she told to two German journalists who ghostwrote the first-person narrative, begins in the social housing project of Gropius City, an outlying suburb of West Berlin built in the 1960s along the Wall's westernmost perimeter.

Her family of four, having moved from the country in northern Germany, inhabit a drab two-and-a-half-room apartment on the eleventh floor of a building in the satellite suburb. The thirty-one-story cement *Neubau* (a newly built high-rise), the tallest in Germany at the time, was intended for lower-income families like the Felscherinows. In the early 1960s, this well-intentioned endeavor, ultimately an experiment in social engineering, was initially supervised by the prestigious Bauhaus

architect Walter Gropius, a Hitler-era exile and in-the-meantime U.S. citizen. Today Gropius is celebrated as one of the founders of modern architecture. But the monstrosity that emerged from Gropius's blueprints was the product of an experiment gone terribly awry.

Across West Germany, and at about the same time in East Germany too, such chockablock public housing was being thrown up furiously. Contrary to their purpose, however, the compartmentalized living spaces concentrated the fallout of a troubled society still grappling with its own physical and moral reconstruction. With extraordinary insight for a teenager, Felscherinow describes the grim underside of *Wirtschaftswunder* Germany, the miasma from which angry punk rock would emerge a few years later (and, soon after that, violent neo-Nazi cliques). Indeed, her critique of postwar German architecture reads like a script for the West Berlin band Einstürzende Neubauten, literally "collapsing new buildings."

In order to escape it all, twelve-year-old Christiane starts smoking hash, and then dropping acid and popping pills with kids a bit older. The girls doll themselves up and head off to the downtown West Berlin disco Sound, which billed itself as "the most modern discothèque in Europe." Sound was a dark, gymnasium-like hall filled with bored and unkempt young adults on the prowl for sex or drugs or both, anything to kill the tedium. Christiane gets hooked on H and winds up with fellow child addicts along the underpasses and alleyways of the Bahnhof Zoo station. Their hangout is the *Babystrich*, the child prostitution scene, where johns cruise in search of underage flesh. Two tricks buy a fix. "Man," says Christiane's best pal, Babsi, "I gave seven blow jobs this morning and made 200 marks! That's a lot of dough!" A few weeks later Babsi overdoses, making her the city's youngest drug casualty ever.

Christiane and her sixteen-year-old boyfriend, Detlef, also a junkie, share a hovel of an apartment with another addict, Armin. A black-and-white picture of RAF member Ulrike Meinhof is taped up over the dingy mattress, a reminder that everything in late 1970s West Berlin happened against the backdrop of the German Autumn. When they find Armin dead, needle dangling from his arm, Christiane and Detlef run for it, leaving behind the garbage-littered room and bloodstained bedding. One after another, Christiane's peers overdose as she and Detlef float among johns' apartments, shooting galleries, police lockups, addict programs, and then back to the dealers and the sleaze of the *Babystrich*.

David Bowie is close to Christiane's heart and never far from her thoughts. In the film, she cherishes the "Changesonebowie" album like a security blanket and takes a drag on her first joint listening to Bowie. It's after a Bowie concert that she does her first line of heroin. The cool boys from her clique "look like David Bowie." David Bowie and his music are everything that Gropius City and her life aren't.

The memoir understandably staggered West Germany. (East Germany, on the other hand, felt vindicated by the sordid portrayal of life in capitalism's showcase.) What had West Germany's astounding economic recovery, the breakneck urban reconstruction, and halfhearted confrontation with the past made of its youngest generation? West Berlin was a cesspit, awash in narcotics, in which anything goes and no one cares, not even parents. The city's own statistics confirmed it: in 1977 alone, eighty-four people died of drug overdoses, more than in any other city in Europe. Even before the book's publication, Bowie seemed to know this, calling West Berlin "the heroin capital of Europe."

While the book and film were adopted in high school curricula as a cautionary tale, in the United States the film was

aggressively edited and rated R, meaning one had to be seventeen just to watch it. But perhaps the American censors intuited something that the Germans missed. Contrary to the intentions of educators in Germany, the tale became a cult favorite of teenagers champing at the bit to cut loose from their homesteads. The kids saw Christiane F. as an antihero who put everything on the line, including her life, to go her own way and to escape the doldrums of everyday life in postwar Germany. Young girls sick of their dull existences in little towns devoured the book and took off straight to Bahnhof Zoo.

In terms of indulgence and living to tell about it, Christiane F. was the undisputed champ at just sixteen years of age. She pushed vice to the outermost extremes, and survived to tell the tale. The story ends with Christiane clean and happy, a state that wouldn't last long with her newfound wealth and fame. *Bahnhof Zoo* painted a morbid picture of West Berlin, one almost too ghastly to be true. But for many readers, including me, the takeaway was West Berlin as a city beyond the pale, where anything could happen.

Heroes

The West Berlin of the mid-1970s, in which the London-born David Robert Jones, alias David Bowie, arrived in 1976, was the city of *Bahnhof Zoo*. It wasn't a pulsating, Weimar-era-inspired sanctum of transsexual decadence and artistic ferment, as Bowie seems to have believed—or hoped. The Weimar Republic's offbeat revues and the dazzling pre-Nazi Berlin of Isherwood's novellas were, for the most part, buried deep beneath the war rubble. An expansive gay scene, the most feral in Germany, had reestablished itself soon after Nazi Germany's defeat, a graphic

demonstration of the way subculture in Berlin can bounce back despite ferocious repression. But the scene, even by the early 1970s, was closeted behind doors with buzzers and peepholes. The queer and punk rebellions of the near future were delicate buds just beginning to blossom in obscure niches. Bowie, though, looking to stumble onto fresh sources of inspiration, stepped into West Berlin at an auspicious moment, when a full-blown subcultural renaissance was in the offing. The West Berlin he'd leave would have more of the Golden Twenties about it than the one he entered. On the cusp of a new era, his person as well as his persona gave it a vigorous push.

Bowie's infatuation with Weimar-era culture and German expressionism in particular drew him to West Berlin in the first place. German films from the interwar years such as *Metropolis*, *M*, and *The Cabinet of Dr. Caligari* had captured his imagination years earlier. "Since my teenage years I had obsessed on the angst-ridden, emotional work of the expressionists, both artists and film makers, and Berlin had been their spiritual home," said Bowie in 1977. Bowie had seen the film *Cabaret* several times. In 1975, on the Diamond Dogs world tour, he'd met Christopher Isherwood backstage in Los Angeles, and he peppered the writer, who was on a Buddhist retreat nearby, with questions about Berlin. In the photo of Bowie most associated with Berlin, he's dandied up in a 1920s black-and-white tux, bow tie, and short, slicked-back hair: a modern-day John Heartfield.

The thirty-year-old Bowie lived in the city from summer 1976 to autumn 1978, renting a spacious but otherwise prosaic fin-de-siècle apartment above a car-parts shop at 155 Hauptstrasse in Schöneberg, a district of avenues and parks a bike-ride south of Bahnhof Zoo. Schöneberg was the heart of West Berlin's gay world, just as it had been in the interwar years. Isherwood had lived a twenty-minute walk from Bowie's address.

Bowie's name and his West Berlin labors are so closely linked to the city that forty years later a tourist bus schleps visitors around to the sites where the musican and his good friend Iggy Pop caroused back in the day. It makes stops at his former apartment on Hauptstrasse, the Hansa Studio, and the former location of Chez Romy Haag and the site of the now-long-defunct bar Dschungel. In West Berlin, in cooperation with the English musician and record producer Brian Eno, Bowie produced the so-called Berlin trilogy of albums: *Low*, *Heroes*, and *Lodger*, arguably his best work in a lifetime of making music. (In West Berlin, Bowie also co-wrote and produced Iggy Pop's albums *The Idiot* and *Lust for Life*, some of Iggy's finest work.) Bowie's single "Heroes" stands as an anthem of sorts for Berlin, a song purportedly inspired by a stealthy kiss along the Wall.

So hyped is Bowie's Berlin hiatus that some of the stories have become larger than life, at the expense of the facts. More than anything, though, Bowie's art of bending gender and fabricating identities—from Ziggy Stardust to the Thin White Duke, Major Tom to glam rock star—imbued West Berlin's subculture with fantasia that it riffed off of with verve. This is the case despite the fact that Bowie, while in West Berlin, dropped all of his alter egos and exotic costumes, and uncharacteristically played himself: painting, walking and cycling, writing songs. He dressed casually in jeans rolled up at the ankles, button-down shirts, and a 1950s-style golfer's cap.

One of the independent films from the day, the New German Cinema director Helke Sander's *The All-Around Reduced Personality*,* includes slow, silent panning shots of West Berlin streetfronts filmed at the time Bowie lived there. It depicts forsaken neighborhoods along the Wall passed over by the economic

* The German title is *Die allseitig reduzierte Persönlichkeit—Redupers* (1977).

miracle. There's no trace of the recovery that propelled the Federal Republic to the front of the industrial world. The film's Wall itself is largely unpainted, though randomly punctuated with sprayed slogans addressing the RAF or the Marxist splinter parties. Overgrown, trash-strewn lots and dead ends mark streets with buildings blackened by ash and soot. The handful of open shops have prewar-painted signs above their grimy windows such as "Laundry," "Coal Supplies," and "Groceries." Sander's sweeping shots of the neighborhoods bespeak squalor and emptiness.

In terms of avant-garde brio, West Berlin was largely barren. The alternative movement had sown its seeds here and there, but you would have to search long and hard to find an art gallery. The seclusion and the slow pace, however, provided Bowie with the anonymity and peace of mind that eluded him in the United States and the United Kingdom. Even his neighbors didn't seem to give a damn who he was. So unimpressed were they about living next to one of the world's greatest rock stars, they called him "Mr. Boffie."

"Nobody was coming to West Berlin for any other reason than just to get away from somewhere else," explains Wolfgang Müller, an art school student in the 1970s and the impresario behind the band Die Tödliche Doris (Deadly Doris). I talked to Müller several times for this book in his Kreuzberg walkup, a well-worn apartment he's been living in since the 1980s. It was Müller who suggested that I take a look at Sander's film, to get an idea of what 1970s West Berlin was like before the Wall was brightly painted. Müller decamped to West Berlin in the 1970s to get away from his industrial hometown of Wolfsburg. Wolfsburg was a city built by the Nazis for the purpose of manufacturing Hitler's automobile for the *Volk*, namely the Volkswagen. It was at the VW factory that Müller's father labored his life long, a fate Wolfgang Müller had no intention of replicating.

West Berlin's nightlife may not have been flashy, but it boasted gay bars aplenty and lesbian hangouts, too—more than any other German city. What made West Berlin attractive for gay men such as Müller, as well as lesbians and transsexuals, was its remoteness, far away and sealed off as it was from the Federal Republic. And the Berlin natives, though known for cranky demeanors, were less ruffled by nonconformist lifestyles than most western Germans. But until the end of the 1970s, says Müller, gay culture in West Berlin happened largely behind closed doors. The seventy or so establishments for gay men had buzzers and peepholes. A doorperson would admit select customers into closet-sized bars and backroom discos that looked straight out of Rainer Werner Fassbinder's film *Fox and His Friends*,* which portrays this milieu in seedy detail.

Their patrons kept pretty much to their own kind. "Men weren't allowed in lesbian clubs, for example, or leather gays in trans bars," says Müller. Yet many decades before their equivalent arose in other European metropolises, there were same-sex bars, dance halls, transvestite balls, and much more. Darkrooms were routine in clubs such as Mister X and Hoppla Sir, which attracted gay tourists like metal filings to a magnet for exactly that purpose. And the fact that West Berlin had no closing hour was icing on the cake.

It's often impossible to pinpoint the threads that lead from present-day Berlin back to the interwar era, so thoroughly did the Nazis blot them out. But the city's gay culture has a strong link to the past. Despite the Third Reich's brutal suppression of homosexuality, it rebounded remarkably quickly in the city, where, according to historian Robert Beachy in *Gay Berlin: Birthplace of a Modern Identity*, homosexual identity was born in

* The German title is *Faustrecht der Freiheit*, 1975.

the late nineteenth century and flourished until the 1930s. Berlin was known for its more liberal treatment of same-sex erotic love long before the era of Weimar. Beachy claims that the concept of *Schwul*, or "gay," didn't even exist in London or New York before it was parlance in Berlin.

A red-light district, sleazy even by the standards of connoisseurs, flourished along Potsdamer Strasse, Kürfürstenstrasse, and around Nollendorfplatz. Prostitutes, pimps, gamblers, thugs, and drunks mixed in the rough quarter where stabbings and shootings were commonplace. At the time, West Berlin's red-light scene had the reputation of offering absolutely *alles*, one explorer from the era told me. And you didn't have to look far to find it. "It was wild," says Michael Sontheimer, who lived on Potsdamer Strasse and one morning nearly collided with a man naked but for a cowboy hat and boots striding out from one of the brothels.

In the early 1970s, a love interest brought twenty-three-year-old Romy Haag to West Berlin, a city that the transsexual performer had long been linked to—even though she'd never been there. In Paris, at clubs like the legendary Alcazar de Paris, she was introduced as "the sensational Romy Haag, straight from Berlin!" Apparently, it was thought to sound more risqué than Amsterdam. After the thrilling nocturnal splendor of the nightclubs of Paris and New York, Haag was as appalled as Wolfgang Müller at the quality of Berlin's nightlife. West Berlin's red-light district, notes Haag scornfully in her autobiography, was the only place where—and context in which—you could find transsexuals in West Berlin. She'd change that.

Born as Edouard Frans Verbaarsschott in 1951 in the Netherlands, the chubby-faced child, a boy who felt like a girl, broke loose of his parents' grip at the age of twelve to join the circus. By sixteen, Eva Maria Verba, her new name, had worked as a

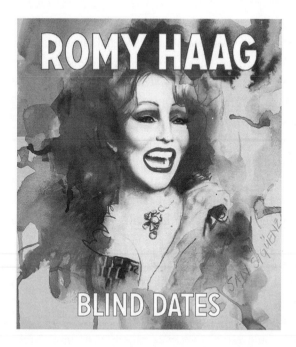

West Berlin's
transsexual
sensation,
Romy Haag.

bellydancer on Hamburg's notorious Reeperbahn, stripped in nightclubs from Antwerp to Monte Carlo, and headlined at the Alcazar de Paris, known for its exuberant shows full of glam and glitter. Her stage name from then on was Romy Haag (see above). "As a transsexual back then, one had only two options," she writes in her autobiography, "to hustle or go into show business. I decided to do both. There wasn't anything else I could do." Haag was such a sensation—a rare beauty with talent—that an American show-biz agent booked her for a tour in the United States, where she performed for weeks on end in Atlantic City and on Fire Island. Photos from the day show a ravishing redhead with full lips and seductive smile posing in audacious outfits with plunging necklines and an array of see-through lingerie.

Friends tried to talk Haag out of setting up her own shop in West Berlin, convinced it would flop. Haag's vision was an

extroverted, sexuality-celebrating burlesque show that fell somewhere between 1920s travesty and Andy Warhol's performance art. With $2,800 in startup capital, she rented a former disco in Schöneberg, which she did up in Art Deco style with black lacquer counters and plush red velvet curtains, crisply ironed white tablecloths spread on the tables. She recruited her international troupe from the bordellos and strip clubs across the city. Finally, she fastened onto the building's facade a high, eye-catching neon sign announcing, "Chez Romy Haag."

As it happened, West Berlin was ready for Romy, and much more. The very first night, all three shows—10 p.m., 1 a.m., 5 a.m.—sold out, and would remain sold out every night for months to come. The short acts, performed one after another in rapid-fire sequence, ranged from classic revue à la Mae West to star parodies, chorus lines, playbacks, and drag acts—all drenched in kitsch and camp. The last show, fueled by the evening's adrenaline and intoxicants, was usually the night's high point. Romy wore a slinky, glittering, full-length corset that in the spotlight lit her up like a disco ball. In the debut's encore, she dumbfounded everyone in the audience with an act that would become the club's signature. As she belted out the Welsh singer Shirley Bassey's "This Is My Life," she threw her earrings one at a time into the audience, ripped off her wig, and smeared lipstick all over her face. The crowd was speechless when the gig ended. *What had just happened?* they asked themselves. There was a hushed pause, and then thunderous applause.

Unwittingly, Haag ushered in a momentous transgender swerve that would play out in the city for decades to come. And, at the same time, she set off a veritable revolution in nightclub culture that doomed the likes of Christiane F.'s disco Sound. Haag's innovation, almost second nature today, was that she dismissed the pedestrian categories of "gay," "lesbian," and

"straight" in exchange for a much broader, more nuanced category of "queer," even if she didn't employ the term that theorists such as Eve Sedwick and Judith Butler would popularize decades later. According to queer theory—or likewise Haag's understanding of sexual and gender diversity—there are countless variations of sexuality beyond the dominant categories that society respects; sexual and gender identities are fluid, not fixed. It's not an exaggeration to say that this shift to "queerness," which Bowie had made years before, would transform the city like no other in Europe.

Chez Romy Haag was one of West Berlin's few late-night attractions that displayed some of the sparkle of the Golden Twenties. And, not coincidentally, by the time he arrived in Berlin, David Bowie was already a very close friend of Haag's. The two had met one night in West Berlin in April 1976, when Bowie was in town for a gig. Haag's club that evening was abuzz with the prospect of Bowie playing in the nearby Deutschlandhalle. Romy Haag wasn't a big Bowie fan, even though one of the club's skits riffed off "Space Oddity" with the lines "Ground control to Major Tom / Take your hormone pills / And put your wig right on!" But Romy tagged along to the gig with twenty or so others from the club, populating the groupie-thick front row with dressed-to-the-nines transsexuals of every shape and size. The Deutschlandhalle was sold out, with Christiane Felscherinow and her stoner clique among the audience.

"Everything was dazzlingly androgynous, and whoever knew how to use kohl eyeliner and lipstick did so with abandon," remembers Haag. Thus the Haag coterie was a bit taken aback when Bowie stepped out of a wall of smoke in a bomber jacket, lit up by walls of fluorescent white light on either side of him. This traditional rock star getup wasn't what they'd expected. Nevertheless, the hall roared with approval.

Halfway through "Station to Station" Bowie approached the edge of the stage, and leaned over toward the Chez Romy Haag crew. Romy flashed him a sensuous smile. "Suddenly our gazes met and fixed on each other—an intense experience that completely bowled me over, a kind of telepathic connection, and it was like I knew everything about this person," she claims to remember. "For a split second I forgot completely where I was and I had the feeling that we fell into each other's arms." She recollects: "It was clear to me then that something was going to come of it."

During the intermission, Bowie's staff approached Haag and said they'd like to come by the club after the show. Before the Chez Romy Haag troupe had even returned, the news of Bowie's pending visit had leaked out and the club was packed, journalists and camera crews thick on the doorstep. At the club, Bowie watched transfixed as Romy performed "My Life" and "Alabama Song" ("Show me the way to the next whisky bar"). The way Haag played with the ambiguities of sexuality and gender, as well as costumes and identity, was right up Bowie's alley.

After the show there was a little party back at Haag's penthouse for select guests. At dawn they began to depart until Bowie and Haag were alone. They kissed on the balcony and then fell into bed. But Bowie jumped up immediately and surveyed her enormous record collection. "Which David Bowie albums do you have?" he asked. "None," she replied, laughing. Bowie immediately phoned his people to have his complete discography sent over at once. The two spent the entire day together in bed, Bowie managing to get up and out the door to appear at his scheduled next gig in Hamburg three hours late.

Shortly thereafter, Bowie moved to Berlin. Days he spent at the studio, nights in her dressing room. At her place they'd turn off the phone and the doorbell, pull the curtains shut, and

enjoy long afternoons together. Haag says that Bowie saw her as a mirror in which he saw his own androgynous self after the destructive period of Ziggy Stardust—the decadent rock-and-roll messiah—which he wanted desperately to shed. He and Iggy were regulars at the club, as was the filmmaker Fassbinder, among the many other celebs who passed through, including Grace Jones, Tina Turner, and Freddy Mercury. Bowie and Iggy were drinking copiously and, according to Haag, doing lots of cocaine, too. "You had to step over the two of them on the floor," she remembers. Still, it was like a rehab clinic compared to Los Angeles, Bowie's previous home.

Haag and Bowie accompanied West Berlin as a new era broke over the city. One further manifestation of this was the café Andere Ufer (The Other Shore), conveniently located at 157 Hauptstrasse, two houses from Bowie's apartment. The café was the first of its type in all of Germany: an all-in-one coffee shop, gallery, restaurant, and night spot that beckoned to all homosexuals, transgender types, funky heteros, and anyone else who wanted to jettison the blinkered categories of the straight world. It marked the birth of uncloseted queer in West Berlin and signaled a new stage in the gay rights movement in Germany. Germany's first Christopher Street Day parade, now an annual international LGBT celebration and demonstration, would take place in West Berlin two years later in 1979.

While the lesbian and gay scenes had been cloistered in the past, Andere Ufer boasted an unobstructed plate-glass window facing the street that let the light of day shine in. It declared, as if printed on the front page, that there was nothing that it or its patrons had to hide. In the summer you could enjoy your cheesecake and bowls of *Milchkaffee* at sidewalk tables. Andere Ufer was like a shared living room for the Schöneberg crowd,

including the regulars Bowie and Iggy, as well as rock star Nina Hagen, the publishers Heidi Paris and Peter Gente of Merve Press, photographer Nan Goldin, and designer and cult film star Tabea Blumenschein, among many others.

Soon after opening, the café's owners, a male couple from Munich, found themselves in the line of fire, though not from straitlaced Schöneberg neighbors or right-wing thugs. A militant Marxist gay group griped that the café was "too commercial." The radicals smashed Andere Ufer's windows late one night when Bowie was home in his apartment. He heard the commotion and hurried down to help out. The world-famous rock star kept watch over the shop for the rest of the night until the window could be repaired the next morning.

Wolfgang Müller's first job in Berlin was at the café. "It was the only place where I could work where I didn't have to explain my sexuality," he says. "It was a place where many different types of people could meet. Take Blixa Bargeld, with his bizarre outfits. He didn't fit the classic male image. Or a woman like Gudrun Gut, who wanted to go out alone and not constantly be hit on." In fact, Blixa Bargeld and Gudrun Gut—the nucleus of the first constellation of Einstürzende Neubauten—met each other at Andere Ufer. Not long before the encounter, their names had been Christian Emmerich and Gudrun Bredemann. The two weren't alone in taking on a *nom de guerre*, a deliberate act of wiping clean the slate, starting anew. "I thought for a dude with long hair, he has pretty good taste in music," Gut remembers the encounter with Bargeld.

Bowie departed a West Berlin in flux, and he left traces on it, as had Kommune I, the student movement, Christiane F., and Chez Romy Haag—all crucial impulses to the city's emerging underground pastiche. They contributed to a mystique of the western side of the divided city that seeped out to the rest of

Europe and across its seas, too: Berlin, a place of extremes, a city in which to lose and then find yourself anew. A city with space to live and breathe and think.

By the time Bowie packed his last bag in 155 Hauptstrasse in spring 1979, he'd already forwarded the rest of his things to a loft apartment in Manhattan, his next port of call. Although nearly three years in one city was a comparatively long time for Bowie to stay put, it seems there was no one reason behind his leave-taking just then. The love affair with Romy Haag had cooled off during his absences: on world tour, vacation in Africa, acting stints. In the meantime, Haag had become Germany's most illustrious and beloved transsexual, appearing regularly on West German TV. The two soul mates kept in touch for years—a postcard, periodically a phone call. Bowie told her he wanted to come back to Berlin. Though he visited for concerts, such as the storied 1987 gig alongside the Wall that sparked riots in East Berlin, he wouldn't stay for long. "Never again would I feel so free as I did in Berlin," he said many years later. One of the last songs that Bowie wrote before his death in January 2016 was "Where Are We Now?," a wistful look back at West Berlin.

Ghetto Deluxe*

Even though West Berlin wasn't legally part of the Federal Republic, it became subject to most of West Germany's laws and functioned, for the most part, as an appendage to it. The West German capital of Bonn shelled out $6 billion a year in budget support, subsidies, and grants, in addition to plentiful tax benefits. Businessmen intrepid enough to set up shop in the

* "Ghetto de luxe" was graffiti painted on the Berlin Wall in 1984.

Frontstadt were plied with generous loans and other subventions. Their remit was to build a modern city that outshone the East in every way. West Berlin had to live up to its boast of being the West's glamorous window dressing. Not surprisingly, the quantity of largesse led to prolific corruption, mostly in the form of dirty deals between local politicians and construction magnates. Moreover, the buildings they threw up, cousins to Gropius City, were every bit as hideous as those in the East and just as poorly constructed. Also, for the privilege of West Berlin's occupation, West Germany paid about $490 million a year for the roughly twenty-five thousand American, British, and French soldiers and civilians, plus their dependents, in the city.

This financial lifeline was designed to keep West Berlin afloat. But a functional economy presupposes a population of active consumers and producers, and the city's administrators struggled just to keep the city populated. West Berlin's two million residents were considerably less than the pre-1945 population in the city's western districts, and Berliners steadily trickled out of the contested bastille in favor of the secure mainland. After all, the Federal Republic was a world-class industrial power with better jobs and higher living standards, as well as landscapes made for coffee-table books. The infusions of money were an attractive proposition for young Germans—and foreigners like me, too. West Berlin was on the drip, and it was a breeze to tap into it. To begin with, a good portion of the city was on welfare, which native Berliners considered tantamount to a birthright. And for the gainfully employed, all wages in West Berlin were topped off with an 11 percent subsidy, automatically paid by the city straight into employees' bank accounts: no forms to fill out, nothing. This was nicknamed the *Zitterprämie*, or "tremble premium," the payoff for the angst endured by living in West Berlin. There were tax concessions, too, which meant

that many West Berliners paid next to no social tithe. Christiane Felscherinow's parents, for example, were lured to the freshly walled-in city by West Berlin's subsidies and steady employment. But the subsidies had the wholly unintended impact of making West Berlin a haven for artists, as well as for alternative projects and other offbeat endeavors. The left-wing *taz* newspaper, for example, opted to set up shop in West Berlin rather than in Frankfurt for this very reason.

Yet another quirk of Berlin's occupied status, one with enormous implications for the counterculture, was that military conscription was off limits in the western sectors. As part of postwar rules, the West German army, the Bundeswehr, had no remit in the formally "demilitarized" city. One upshot of this was that the federal government couldn't require young men in West Berlin to serve in the Bundeswehr. Thus, pacifists and nonconformists in West Germany had only to obtain residency in West Berlin and they were scot-free. Of course, this changed when the Wall fell and Germany unified; the unluckier of the younger draft dodgers were unceremoniously packed off to boot camp.

As of 1957, conscription-age males started coming in droves, and didn't stop until 1990. The draft evaders were an unpredictable element that would season West Berlin's demeanor over the years. The young men weren't of one stripe, yet they tended to be critically minded and antiestablishment, a disproportionate swath of them gay. "They brought with them the sense that they were escaping the system, on the run from it. In a way, they were in exile in West Berlin," explains Tom Lamberty, who came to Berlin as a student in the 1970s. There's no aggregate figure for the German males in West Berlin bucking conscription, but it must have been staggering, judging just by the proportion of German men I knew who had chosen the city for this reason.

Nevertheless, the cake and all the icing wasn't enough to

counterbalance the negatives for some transplants. There were those who just couldn't hack West Berlin: too somber and gloomy, in-your-face unfriendly, and far away from the loved ones who, it turned out, were dearer to many exiles than they'd thought. One friend of mine, an old anarchist who had lived in West Berlin for years, took off in the 1980s for Munich for one reason: he needed more sunlight than Berlin, at the same latitude line as Hudson Bay, had to offer. A young American woman I knew told me that on winter evenings she'd open the door of her cold courtyard apartment and burst into tears. She couldn't bear the thought of stoking up the coal oven all alone and waiting three hours for the place to warm up. Alas, she didn't last long.

I nearly threw in the towel too, my first winter, the horrible, record-breaking arctic winter of 1985–86, when it snowed and snowed and snowed, temperatures crashing for weeks on end. In December, darkness begins to set in well before 4 p.m. I remember waking up mornings in the pitch black to the sound of glass bottles breaking like bombs as my neighbors dropped their empties in the courtyard's recycling bins about a yard and a half from my pillow. There were no pooper-scooper laws in the city, nor much in the way of snow removal, which meant that layers of dog shit and piss were preserved in the ice and snow. When it melted in spring, the neighborhood was covered in a reeking, slippery film.

I lived in Wedding, an old working-class district that was so stocked with proletarians in the interwar years that it earned itself the label "Red Wedding." The only reason anyone in my circles lived in Wedding was to bide time before, hopefully, landing digs in Kreuzberg or Schöneberg. By the time I arrived, Wedding was populated in roughly equal numbers with Berlin proles and foreign guest workers, the latter primarily from Turkey. Neither group had much interest in us students, and vice

versa, although the Turks at my local kebab shop took a liking to me when they discovered I wasn't German. I eventually met some decent, very bright people in Berlin—but it took a while, as it did for spring to come.

In order to keep the city up and running, from early on West Berlin's authorities went to extraordinary lengths. In 1949, long before the city's walled division, Heinz Zellermayer of the Guild of Berlin Hoteliers and Restaurateurs was miffed about the western sectors' 9 p.m. closing hour for bars. The Soviets had pushed their closing hour to ten o'clock to draw more bar business, which was hurting the West's establishments.

Zellermayer marched over to the command of the Western Allies—or so the story goes—to talk with no less than the U.S. commander in charge of the American sector, General Frank Howley. The Berliner proposed that licensing hours be annulled completely, which would endow West Berlin with the comparative advantage of 24/7 pubs. Howley brought the proposal before the Allied Control Council, where the French and the Americans outvoted the British, making West Berlin the only city in Europe with no closing hour. The city was a party Mecca long before the legendary techno club Tresor and the Circus Hostel opened their doors in the 1990s.

For many exiles, especially for draft evaders, student status was the easiest route to residency, which by no means meant that they actually had to read a book to get it, or keep it. It was widely known that the Free University's geology department had open-ended enrollment. If you had an up-to-snuff high school degree, all you had to do was go to the campus and register. The thirty-dollar-a-semester tuition fee got you full health insurance and discounts on already subsidized transportation and cultural events, as well as the opportunity to work tax free. Once on the gravy train, staying on it wasn't tough. You didn't have to

show up for a single class to remain on the books for years, even decades, as there was no cap on the semesters one could study.

The Free University (or the "FU," as everyone called it) had put West Berlin on the map as a place for doing it differently years before I arrived. The city had attracted the disenchanted and idealistic since the Wall's construction in 1961, some of them with names that would become forever linked to the city such as Benno Ohnesorg, Rudi Dutschke, and Rainer Langhans. Remarkably, the lateral thinkers that followed in their footsteps saw the city not foremost as the former nerve center of the Holocaust—in other words, as an inherently reactionary, evil place—but rather as the crucible of the 1960s student rebellion and laboratory for third-way models between the two Germanys. "West Berlin was sacred ground for us," explains Martina Siebert, an artist who made her way to the FU in the early 1970s, referring to the legacy of the 1967–69 student uprising and its martyrs. As an aspiring artist, it was logical to her that she enroll at the Free University's Otto Suhr Institute, the political science department, renowned for the 1968 pedigree of its faculty, whose long march never left the campus.

The FU flaunted a worldwide reputation as a hub of progressive political and social theory. This is what attracted me to it too. The FU was "progressive" in origin, having come to life in the postwar years as a free-thinking alternative to the "un-free" universities in the Soviet zone—and as a foil to West Germany's stodgy, tradition-steeped universities. The postwar academy embodied Germany's break with its past and, by being in West Berlin, was in a unique position to evolve in novel ways. The experiment in democracy was strongly U.S.-supported from the start, which President Kennedy underscored when he visited the campus in summer 1963. The Ford Foundation reached deep in

its pockets to fund it, earning the voluminous lecture hall on Garystrasse the name Henry Ford Building.

A delicious irony, the German students and the FU's young faculty took the American democrats at their word—and turned the university into something that Henry Ford would surely have gasped at. At first, the FU struck out on its own by enabling student participation in university bodies as well as holding seminars on contentious topics such as the developing world and the Holocaust. In the course of the 1960s, it earned itself the reputation as one of Western Europe's most critically minded universities, a bastion of New Left thinking that functioned like a siren song to rebellious-minded young Germans.

When I made my way down to its leafy campus in suburban Dahlem in 1985, in the heart of the American sector and just a football field away from U.S. Army barracks, the freestanding, four-story building of the politics department announced itself from afar with used-book stands along the sidewalk and posters tacked up on tree trunks advertising demonstrations and political meetings. The foyer of the Otto Suhr Institute, named after one of western Berlin's social democratic mayors, was wallpapered with handbills. At tabletop stands, students with their checkered keffiyehs and other revolutionary, dress-down apparel collected signatures for petitions and distributed Marxist literature. Bombastic political graffiti covered every inch of the men's restrooms, which in time I would learn accurately reflected the convictions of the very serious, very self-important student politicos of the institute. I also learned quickly that in their eyes Americans—all U.S. Americans—were indelibly tainted by Wild West capitalism and Disneyland, which made my integration into student circles all the more arduous.

The FU's winter semester course catalogue, as thick as a

telephone book, was an embarrassment of riches for an aspiring theorist. It listed many dozens of classes addressing Hegel and the philosophic tradition of German idealism, the Frankfurt School and critical theory, and more Marx than I imagined possible. Surely singular in the Western world, there was not just one but many sections of four-semester courses devoted singly to reading all three volumes of Marx's *Das Kapital*—offered in the political science, economics, and sociology departments, each with its own angle on it. And this was just the tip of the iceberg.

The subsidies and student frills, while cushy, weren't enough to live on, even in West Berlin, where renting a one-room, coal-heated flat with a shared toilet in the stairwell and no shower could cost you as little as seventy dollars. Part-time work, though, was plentiful and easy to come by. Wages were high enough that after a solid three-week work stint you could coast frugally for a couple of months in Berlin—or take off to the Greek islands or the Algarve, where sleeping under the stars you could while away much of a summer. Even though industry had been seeping out of West Berlin since the Wall's construction, there wasn't enough labor in the city to fill vacancies. This remained the case despite the influx of several hundred thousand foreign—mostly Turkish but also Greek, Italian, and Yugoslav—*Gastarbeiters*, who came as "guest workers" and stayed, gifting the über-Prussian city with a pronounced multicultural flair, much to the gratitude of the West German exiles. West Berlin was probably the only city in Germany where you could find graffiti proclaiming, "Rhinelanders out, Foreigners in!" Kreuzberg's diversity was a source of pride to its inhabitants, even if they didn't have much to do with one another beyond polite nods in the stairwells.

In finding work, students had it particularly easy. At the Free University's job agency Heinzelmännchen, or Elfin Helpers, you were sure to find plenty of registered geology students in their umpteenth semester. The service's smoky waiting room opened its doors at the ungodly hour of 7:00 in the morning. You'd get a number determined by lottery, buy a vending-machine instant coffee, and wait and wait. You never knew where you'd be working that day, or for the rest of the week, until your number was called. I was sent to deliver mail for the post office, stock drugstore shelves, tend the greens of West Berlin's only golf course, build bleachers, push a wheelbarrow on a construction site, and dig ditches. These jobs took me from one obscure corner of the city to another and, a gift, put me in touch with the other West Berlin, the city of people whose lives didn't revolve around the university, the clubs, or the squats.

At one of the construction sites I landed on—which just happened to be the building that is now the U.S. Embassy Office in Berlin Zehlendorf—I worked with a crew of native-born Berliners whose thick Berlin dialect, called Berlinerisch, spoken through mouths of rotted teeth and wurst breath, flummoxed me at first. It was the German that Alfred Döblin's protagonist Franz Bieberkopf speaks in the great interwar Berlin novel *Berlin Alexanderplatz*: full of *vats* and *dats*, *yuts* and *ickes*. I was the lowest man on the totem pole, but for the most part the workers tolerated me, taught me card games, and we chatted *Fussball*. But they couldn't see obliging me a cigarette break if I didn't smoke. So, as was construction-site etiquette in Berlin, I'd slide a ten-pfennig coin across the table, help myself to a cigarette, light up, and take a break.

Added up, all of the perks meant that free time, or *Freizeit* in German, was something West Berlin offered in oversupply.

Liberated from material circumstance, we *Wahlberliner* had time on our hands that today seems unimaginable: time to make art and music, or to take long walks along the Wall, sip *Milchkaffee* in the cafés, march in demonstrations, enjoy long brunches in the collective flats, search for the ruins of the Third Reich, or peruse used-book stores and flea markets. "West Berlin was like someone had made time stand still. The tempo was so much slower than anywhere else," noted the New York City designer Danielle de Picciotto. If doing nothing was your thing, West Berlin was your paradise. But this *Freizeit* was a critical prerequisite for the most impressive projects of the day. "Art needs time," Wolfgang Müller told me. "Berlin gave you that, if you were willing to live in its conditions."

As for the Berlin Wall itself, the cement monstrosity had lost some of its evil nearly twenty years down the road, at least for younger West Berliners. "You had your peace and quiet here," Motte told me, echoing sentiment in the scene. "You could do your own thing," he says. "We were okay with it the way it was. It became something very normal." None of the 1980s crew, even the native Berliners such as Motte, could remember the city without the Wall. The airlift was ancient history. Most of them didn't know a soul living on the other side. They had no reason to visit, and didn't. To twenty- and even thirty-somethings, the Wall and the booby-trapped borders looked like permanent fixtures in Europe's landscape. And, anyway, the Wall was the price that Germans had to pay for World War II and the Holocaust. They believed they deserved it. Objecting to the Wall didn't seem to make much sense. "We just smiled when figures like Reagan came here and declared that the Wall should be torn down," Käthe Kruse, a member of Die Tödliche Doris, told me. "We were so certain it couldn't happen."

One of the many moral blind spots of this unnatural metropole was that in their complacency the West Berlin hipsters showed little compassion for the Wall's victims. While they sunbathed in its lee, East Germany's shoot-to-kill order remained in effect. Sixteen people were shot and killed trying to escape in the 1980s alone, and around fifteen thousand others jailed for attempting to defect from the GDR. But, if you wanted to, you could shut this out and live in the deluxe ghetto of West Berlin as if the world beyond the Wall didn't matter.

3

Wall City Rock

Day-in, day-out, the apocalypse was right before us and
that's why every moment was lived to its fullest.

—GUDRUN GUT

Creativity is only possible in extreme life situations. I don't
think that anything valuable can emerge otherwise.

—BLIXA BARGELD

ANDERE UFER CAFÉ AND THE ADVENT OF PROTO-
queer kicked open the door of a new era in West Berlin. On its
heels, punk rock and new wave burst onto the scene, driving
the final nails into the coffin of the '70s. The exponents of the
new—Wolfgang Müller, Gudrun Gut, Claudia Skoda, Martin
Kippenberger, Blixa Bargeld, Dimitri Hegemann, and others—
were either native Berliners or had been trickling into the city
for several years; and many more would follow once word got
out about this exhilarating, new West Berlin, no longer just a
place to escape to. The smorgasbord of artists who named them-
selves the Brilliant Dilettantes* cultivated an eccentric sociotope

* In German, the group's name was Geniale Dilletanten, the word "dilettantes"
spelled incorrectly to emphasize their amateurism.

the likes of which Berlin hadn't experienced since the Weimar Republic. In fact, the Brilliant Dilettantes borrowed their name from the German Dadaist Kurt Schwitters, who had referred to himself as such. They consciously trod in the footsteps of Germany's interwar nihilists.

You don't have to look very far in Berlin today to find traces of the gifted dilettantes and their creations; they're everywhere in the old stomping grounds, and beyond Berlin too. The protagonists of the post-Wall techno scene, for example, were embedded among them, experimenting with electronic music more than a decade before its global boom. And there's not an industrial offshoot worth its salt, from Marilyn Manson to Rammstein and Nine Inch Nails, that doesn't pay homage to Einstürzende Neubauten, the most renowned Berlin brand of the '80s. The Brilliant Dilettantes even managed to alter Germanness a shade too.

Today's Berlin came into focus as the '70s gave way to the '80s. The dreary city of Bowie's *Low* was slowly washed away by a tide of funky bars and cafés, self-styled shops and experimental galleries, arty cinemas and record stores. Playful Wall art transformed the grimmest symbol of the Cold War into the world's biggest art gallery. In West Berlin, conditions existed to allow imagination to run riot, and by the late '70s a coterie had formed that exploited the opportunity.

One of the plethora of new venues was Eisengrau (Iron Gray), a shop that Gudrun Gut and her friend Bettina Köster opened in a Schöneberg side street. The ground-floor rooms with large, shop-front windows became a pivot of the punk-inspired avant-garde, and incubator of some of its keenest early projects. To its walls and floors, Gut and Bartel applied buckets of gray paint found in the shopfront, a former grocery. It was the unforgiving tone of Berlin's leaden winter skies, but the women filled the location with exuberant color.

The locale was actually more of a do-it-yourself gallery than a profit-minded enterprise, displaying self-made clothing, artisan jewelry, and fanzines. The floor they decorated with Kandinsky-like figures and the windows with disassembled puppets. "We didn't really sell much, we'd mostly hang out," remembers Gut. In point of fact, others hung out. Gut and Köster spent the days there knitting weird skirts and tops. West Berlin had no shortage of flea markets and second-hand stores, which the women combed for recyclable odds and ends. They painted old shoes in screaming bright colors and made wallets out of color film culled from the garbage bin of a pornography publisher.

Also on display was the couture of other offbeat designers, such as that of Kreuzberg resident Claudia Skoda, a Berlin native, whose exotic designs would one day make her world famous. Yet at the time, commercial success was neither anticipated nor desired. In one conversation after another I had with the protagonists of the day, every one of them stressed that the scene saw money as antithetical to innovation and originality. Commercialism, they believed, corrupted art. And why waste time pursuing money when you didn't need it in West Berlin anyway? Nor did the Berliners imagine that their creations would ever interest anyone but those in their own concentric circles.

Gut was an eighteen-year-old high school student when she made her way to West Berlin as Gudrun Bredemann in the mid-1970s, having fled her forlorn hometown in northern Germany's low-lying heathland. For her, the wafting smells of the Turkish kebab stands in Kreuzberg were the scent of urban freedom. Here, she could do whatever she wanted, even if she hadn't figured out what that was. She plowed through tomes of Marx while finishing up high school, then enrolled in visual communications at West Berlin's art college.

A strikingly handsome six-foot-tall woman with penetrating

saucer eyes, Gut drifted from one collective flat to another, sampling the flavors of counterculture and collective living, hoping to find one right for her. There were free-love communes, lesbian endeavors such as the Witch's Cauldron, student-shared flats, artists' collectives, and dozens of anarchist houses. None of them was her ticket. She was fed up with the talk and the theory, the beards and the bell-bottoms. Gut cut her hair short and kinky, wore bright yellow pants. "I wanted to do something, not read and talk about it," she told me. "This drove me crazy."

Punk was Gut's coming out. In 1977, she hitchhiked to London, hoping to see a Siouxsie and the Banshees show, which didn't happen. Instead, she heard Billy Idol's Generation X at the Vortex, where so many of the United Kingdom's punk bands were playing. Another prodigy, X-Ray Spex, performed there too, which featured female band members Poly Styrene as singer and Lora Logic on saxophone. From Islington she pilgrimaged to Ladbroke Grove, where Rough Trade Records had its original premises—home to all of the new independent music that West Berlin wasn't onto yet.

"It was so cool, exciting, so totally new," Gut told me around the corner from her Berlin recording studio, Monika Enterprise. Since her debut in the late 1970s (see photo, page 70), Gut has remained one of Berlin's most inventive personalities—member in half a dozen bands, electronic music pioneer, DJ, producer, radio host, and always on the front edge of style. And she still operates as if money isn't what counts, even though you need it to live in the new Berlin.

The overtly political bent of The Clash spoke straight to her. Fast and hard, hyper-urban, loaded with attitude; punk was the antithesis of the hairy peaceniks who seemed to be everywhere in Germany. The way she saw it, the heirs of the 1968 revolt and Kommune I had lost the plot. The long march

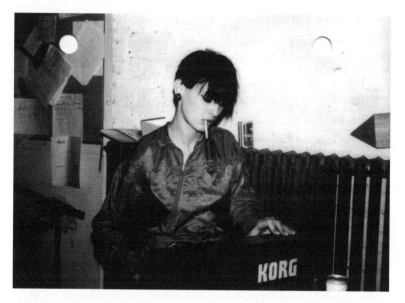

Gudrun Gut on a Korg MS20 synthesizer in 1979.

through the institutions had turned the onetime antiauthoritarian rebels into the new pillars of the system, in culture as well as politics. In London, Gut spent every last penny on clothes so that when she returned to West Berlin, it was as the city's first female punk. "It was incredibly liberating," she says of her first encounter with punk culture. "It meant living in the moment. The ethic of 'just do it' meant that everything starts at zero now. All-women bands were possible because everything was possible."

Punk stripped rock down to the basics—three chords and a simple melody—turning up the volume and speeding up the rhythm. Bands required just a guitar, a bass, and drums. The gist of The Stranglers' single "No More Heroes" resonated in West Berlin and across West Germany, too: finally an alternative to the macho rock-and-roll superstars, their money-blinded

promoters, and the traveling circuses they called tours. After all, West Germany's Krautrock pantheon was no less stocked with alpha males than The Who and Led Zeppelin.

Punk filtered into West Berlin two years after its angry outburst in the United States and the United Kingdom. By that time, the Sex Pistols had already crashed and burned. But that didn't matter. Punk's brash sound and in-your-face style was just what the doctor ordered to shake West Berlin out of its post-German-Autumn stupor. It did that and more; by sweeping away so much that had come before it, punk distanced the city another decisive step from its Nazi past. Its ethic challenged and subsumed the past, creating a new German synthesis that would accompany West Berlin until the Wall fell.

The do-it-yourself ethos of the punk revolution meant that everyone and anyone could make music or clothing—or, for that matter, art or film or media. Since the doing mattered most, dilettantism was a badge of honor, not shame. It's hard to emphasize how un-German this notion is. In the land of Humboldt and Hegel, titles, degrees, vocational training with apprenticeships, and accredited schooling were then, and largely still are, necessary for pursuing almost any profession. In essence, the same went for radical politics, says Martina Siebert, a student at the time. "Before punk we'd wait around, say, for Foucault's next book, to see what he said before doing something," she told me. "Punk said, 'Do it yourself, anyone can. It doesn't have to be perfect.'"

Apocalypse Now

Punk's cry of "no future" fit West Berlin even better than it did Great Britain. If ever there was a city that appeared to have

no future, it was superpower-contested, end-of-the-world, and corrupt West Berlin. The specter of nuclear Armageddon and West Berlin's geopolitical vulnerability informed much of the art and aesthetic of West Berlin's '80s underground, from the music of the Neubauten to *Mauerkunst* (Wall art), and its ultra party culture, too. In the bars and the squats, the late-night crowd lived out the reckless thrill of existing on civilization's frontier.

By the 1980s, Germans were acutely aware of the nuclear missiles on their soil and cognizant that, in the event of a nuclear exchange, the Germanies on both sides of the border would become battlefields. Analysts had sketched graphic scenarios of the fallout should worse come to worst: Germany would be laid to waste, again. As for West Berlin, NATO strategy abandoned the city the moment East bloc forces penetrated the Federal Republic proper. Nevertheless, the city had enough food and other supplies in warehouses and underground vaults to feed the populace for forty days. I knew one woman who kept three hundred deutsche marks in her top drawer at all times, ready to flee at a moment's notice.

At the time, the East-West conflict showed no sign of subsiding, even if its hottest theaters by then were in Afghanistan, Latin America, and Africa. In 1980, the hard-nosed anticommunist Ronald Reagan was elected the fortieth president of the United States. Reagan and the Republican right railed against the Soviet Union as the "evil empire" and spent furiously to expand America's military arsenal—daring the Soviet Union to match it. The arms race was on at full tilt, the distance from Moscow to Washington measured in the flight time of a cruise missile.

The relations between the two Berlins, and on the larger stage the two Germanies, had "normalized" over the two decades since the Wall's construction: travel restrictions were relaxed, family visitations made easier, and German-German

diplomacy ironed out other wrinkles too. But the possibility of renewed strife was always there. The 1956 barb of Soviet leader Nikita Khrushchev was valid a quarter century later: "Berlin is the testicles of the West," he said. "Every time I want the West to scream, I squeeze on Berlin." The Neubauten's Blixa Bargeld put it another way, underscoring the fact that, ultimately, the East had the upper hand: "We're all hostages here," he said. Even if it sometimes felt forgotten, the city remained an immensely valuable pawn and symbol in the geostrategy of the U.S.-led Western alliance.

By daring to edge so close to it, and plotting a daily existence in the Wall's lee, Berlin exiles felt they were plumbing the depths of the human condition. West Berlin's dark mindset reflected the extraordinary conditions of the superpower confrontation and West Berlin's precarious perch. Living so close to the edge meant acknowledging the danger in a way that few in our nuclear-warhead-stocked world were willing to do. In West Berlin, you couldn't look away, and this justified the extremes, be it in fashion or parties, punk rock or promiscuity. If today might be your last, then why not push the envelope? The names of the new scene's best haunts reflected the psychology: Risk, Jungle, Ruins, The Other Shore, Chaos, Excess, Café Black, Front Cinema, Café Seizure, and KZ 36,* among others.

West Berlin signaled its claim on punk and its derivatives with groups such as PVC, Dirty Needs, Die Stuka Pilots, Tempo, and Beton Combo, the latter working-class guys from Gropius City. In contrast to other European cities, the punk

* The names of the bars in German were Risiko, Dschungel, Ruine, Andere Ufer, Chaos, Exzess, Café Schwarz, Frontkino, and Café Anfall. The meaning of "KZ" in KZ 36 is purposely ambiguous. The club was a *Kulturzentrum*, or cultural center, but "KZ" is also the German abbreviation of *Konzentrationslage*, or "concentration camp."

and the queer crowds intermingled and cross-pollinated, which made West Berlin punk artier and more open-minded than its peers in, say, Hamburg. West Berlin's early punk bands were conscious that punk had special meaning in the divided city. In Tempo's song "You Are Leaving the American Sector," the vocalist wails the sentence familiar from the city's postwar signage (see photo, page 116) over and over in English, German, French, and Russian. Almost every band had a photo shoot at the Wall with the musicians staring straight into the camera in a tougher-than-thou pose. Even the Sex Pistols, who visited West Berlin in 1977 for several weeks, felt an affinity to the city, immortalized in their single "Holidays in the Sun." The band's John Lydon later said: "Being in London at the time made us feel like we were trapped in a prison camp environment. There was hatred and constant threat of violence. The best thing we could do was to go set up in a prison camp somewhere else. Berlin and its decadence was a good idea. . . . I loved the Wall and the insanity of the place. The communists looked in on the circus atmosphere of West Berlin, which never went to sleep, and that would be their impression of the West."

PVC, one of West Berlin's earliest punk groups, produced an anthem of sorts for the city with "Wall City Rock." Its basic English-language lyrics reflect the zeitgeist of the 1980s subculture: thanks to the Wall, West Berlin is a bizarre place to hang out and have colossal fun, if you can hack it:

I've been living near the wall
out of my window I can see it all
I can't ignore it 'cause it's not far
on the horizon it's the GDR
wall city rock, let it rock
wall city rock

Bodygards [*sic*] on patrol
passport is ready for control
got no visa can't get in
that's the life in Berlin
wall city rock
wall city rock
It's so unnatural but it still has atmosphere
you just have to watch the people living here
only if you're tough you might survive
wall city rock
wall city rock
Berlin city is the one
the only city to have some fun
you can do anything
get on your feet and start to sing
wall city rock
wall city rock.

As for Gudrun Gut, West Berlin's first female punk, she didn't start a punk band: "For me punk was just an initial thing. I wanted to do something more." Nor was Gut ready to throw post-1968 politics overboard. "We owed the student movement and the alternative scene a lot in terms of opening up discussion about everything and of course for feminism," she says. But she wanted to do feminism better too, the first step of which meant breaking with its dour aesthetic.

Gut's genres were postpunk and new wave, which she and the West Berliners quickly put their signature to without, as happened elsewhere, severing the punk-rock roots. Postpunk retained punk's anarchic ethos while opening it to computers and melodies. Its hybrids across the 1980s welcomed synthesizers, dubbing, arty improvisation, sampling, free jazz, repetition, reggae

beats, and homemade sounds. The onstage theatrics of the new bands could turn the gritty punk concert into an eye-popping performance. Technological experimentation with computers, synthesizers, and drum machines embellished the sounds of space and atmosphere, as did cheap and simple recording technology. In terms of electronic music, Gut and many other German musicians already had a leg up with Krautrock.

New wave, by embracing the synthesizer, took off from the punk-transformed landscape. Lighter and less abrasive than punk, and thus more commercially viable, the tag applied to Anglo-American bands as diverse as Talking Heads, Television, The Cars, The Smiths, Elvis Costello, Devo, and Joy Division. New German Wave would be right behind them with groups such as German-American Friendship (D.A.F.), Nena, Ideal, Malaria!, and others.

In these circles, fashion was every bit as much the dilettantes' art as music. The postpunk look of Gut and her peers was quirkier, more dramatic, gender-blurring, and futuristic than that of punk. New wave spruced up punk with mod's dandy aesthetic and a measure of glam rock's flamboyance, enabling a vast medley of crossover mingling. Like the David Bowie adored by postpunkers, its musicians and its fans were works of art in their own right with the garb, elaborate jewelry, body piercing, and tattoos.

Danielle de Picciotto, an American fashion designer who came to Berlin in the mid-1980s, told me that she and almost everybody in her crowd sewed their own clothes. Nobody from the in-scene would be caught dead in a designer label, she says, unless of course it was one of Berlin's underground designers. "A label meant selling out to the fashion industry. The thing was to wear something that no one else did," says de Picciotto, which meant piecing together outfits from colorful scraps, bits of lace, thrift store purchases, plastic tablecloths, and faded tapestry.

"Everybody was challenging gender and sexuality clichés with what they wore," she says. "All the men and women were mixing clothing and playing with notions of sexuality."

In terms of the cast of characters, there was constant flux among the bands, many of which were short-lived. Gudrun Gut and the electroclash pioneer Mark Eins formed DIN A Testbild, an improvisational electro group in which Gut played the bass and a Stylofone, an inexpensive mini electronic keyboard that Bowie had used in "Space Oddity" in 1969. An advertisement claimed that "anyone can play it," even children. She followed the how-to instructions and became a keyboardist the same day. Although DIN A Testbild went on to make music for years— it was a link in the evolution of later electronic music such as techno—Gut opted out after their first single, "Abfall/Garbage."*

West Berlin quickly became a mandatory stop for the premier British and American punk, postpunk, new wave, hardcore, and No Wave bands, some traveling all the way from New York to do a one-night show in a city that hadn't been anywhere on the radar just a few years before. In fact, New York was one of the first cities to tap into the new West Berlin, as portrayed in Christoph Dreher's documentary *No Wave–Underground '80: Berlin–New York*. Bands such as Teenage Jesus & the Jerks, DNA, Sonic Youth, and The Contortions saw kindred spirits in Berlin and linked up to play together. Gut's band Malaria! picked up its second drummer, the Ohio-born Christine Hahn, from New York, to round out the five-woman band.

The nightclub revolution that Romy Haag had touched off swept across the city. New wave infused the aesthetic of locales such as Dschungel and Café Mitropa, which had tossed out the

* *Abfall* means "garbage" in English.

beat-up upholstered furniture and clutter of the '70s hangouts, replacing it with sharply defined lines, hard surfaces, cold metal, mirrors, naked neon, and famously, in the discothèque Dschungel, giant plastic ferns. Now there were cocktails instead of just beer, costumes instead of jeans, speed instead of grass, neon instead of candlelight. A gift of the queer world, kitsch items and décor such as costume jewelry, Madonna figurines with blinking lights, and fake cut-glass chandeliers, were camped up and chuckled over. It was a welcome blast of lighthearted fun. This kind of irony, ultimately a form of critique too, was anathema to the ultra-serious left-wing politicos, on whom irony fell flat.

The bar Risiko on Yorckstrasse, just beyond the overhead S-Bahn tracks between Kreuzberg and Schöneberg, had a reputation that extended to in-the-know circles far beyond the Wall, and attracted luminaries from Bowie and Foucault to Lou Reed and Wim Wenders, despite the fact that it had just a single cassette deck as sound system. Nevertheless, this was where West Berlin's new music premiered. Drugs of many kinds were plentiful and provided gratis to bohème's beautiful and talented. The yellow-painted, no-frills club was highly exclusive in its own way: outfits and coifs determined who was welcome and who wasn't. If, wearing sneakers and a V-neck sweater, you managed to get past the door, you certainly weren't going to get a drink. The subcultural niches in West Berlin were deep and narrow, largely off limits to voyeurs and wannabes. A former lesbian hangout, Risiko was address number one for the proto-queer postpunk set, and it hosted concerts, amateur films, performance art, and fashion shows, too. "In Risiko the whole queer crowd was on display," Wolfgang Müller told me, emphasizing how completely unprecedented this was. "Risiko was a good name for it because you put your sexual identity at risk by entering. It was the one place for all the people who didn't fit anywhere else."

"It's simply where all the most exciting people went," says Käthe Kruse, Die Tödliche Doris's drummer, who confirms that in the pre-HIV/AIDS era a quickie in the bathroom was de rigueur. "Risiko was our common home," she says. "Lots of gin and tonics, lots of speed, lots of fun, great music, loud screaming conversations, and sex." You could pen your most recent thought on the yellow walls or pass out in a corner. Risiko was known for its huge drinks—and casual attitude about charging for them. "We made out-of-towners pay for the drinks," a former barkeep confided to me.

The bars and the cafés functioned as nodal points that bound the scene together. "In the 1980s," explains Alexander Hacke, Einstürzende Neubauten's teenage guitarist, "a routine day went something like this: At some point, you'd get up and leave your apartment, and then go from one place to the next. You'd probably hang out in someone else's apartment for six hours or so. Then you'd head out to a club that just opened or was still open. And then you'd move on to another club. Usually by that point you've slept some again—at your place or maybe at someone else's who you'd just gotten to know. And it just keeps on going like this."

Punk understood itself as intensely critical of mass consumption, the culture industry, and the market economy—common touchstones with anarchists of the past. Control over the production of music, so went the thinking, had to find its way back into the hands of the musicians, which the advent of cheap synthesizers and other low-tech instruments made possible. And, initially, much of punk's commerce in West Berlin functioned independently of the retail market.

West Berlin was an ideal location for a do-it-yourself music production because you could count the record labels and promoters in West Berlin on one hand. Thus musicians seized the means of economic and cultural control, empowering themselves

and the independence of their art as they did so. The Neubauten, for example, produced their first album by themselves, learning in the studio. Almost every band booked their own gigs. LPs, singles, and underground tapes were flogged by pop-up backroom record stores that were also touchpoints for the scene, such as the storied shop Zensor. Its owner, an old Kommune I cohort, drove a van back and forth to London to pick up the latest singles, which he sold at flea markets from a vendor's tray until opening Zensor. Bands such as Malaria! did impromptu soirees there, taped them, and then sold the recordings themselves. Eventually, Zensor became a label of its own, which lives on today, cutting independent, self-produced records that, initially, the major West German labels wouldn't touch.

The phenomenon of the cassette was radically egalitarian, and had an impact much like that of digital technology today, enabling artists to circumvent the record labels. The tools of punk were all relatively cheap, easy to use, and readily available: typewriters and scissors, copy machines, cassettes, tape recorders, Super 8 cameras, film projectors, sewing machines, and Moog synthesizers. These were the new means of subversion, put to use in the cellars, empty warehouses, bars, and clubs of West Berlin.

Notably, West Berlin's new self-proclaimed anarchists of Generation Punk Rock did not receive a particularly warm reception from the city's resident anarchos. The Spontis and other post-1968 factions initially wrote the punks off as unread, beer-swilling rowdies, and the Brilliant Dilettantes as artiste poseurs. There was no fatherly impulse to take them under the wing, which wouldn't have been welcome anyway. The punks looked down their noses at the over-the-hill Spontis. "Muesli munchers," they called them, has-beens, hippies.

And yet, both generations proffered something unique and

enduring to a vigorous anarchist culture in Berlin. The Spontis had the politics: thought-through strategy, theoretical depth, and street credibility from laborious community organizing. An alternative infrastructure—from shared flats to food co-ops—was in place for the 1980s newlings, which they could build on and make their own. The punks deserve kudos for infusing a jeering, raucous attitude of defiance into West Berlin. Despite the generational clash, both elements extolled autonomous communities, direct democracy, and a penetrating distrust of political parties. Not until the Wall fell did they realize how much linked them.

Listen with Pain

On the night of August 12, 1978, the music club SO36, Berlin's counterpart to Manhattan's legendary CBGB's, opened to the public. SO36 (see page 82) became home to the postpunk galaxy of bands that would emerge in West Berlin, and from the beginning it sought out indigenous talent, some of it extremely raw—just as it does today, having outlived CBGB's, at its original location on Oranienstrasse, just off Heinrichplatz.

The club, named after its zip code, was punk itself: a rectangle-shaped room with a low, self-made stage at one end and no windows. SO36 proclaimed itself in glowing blue neon characters above the street-front entrance in the heart of Kreuzberg. The walls and ceiling were painted volcano black with naked, white-neon lighting glaring down from above. Behind the bar stood a phalanx of old mini-fridges retrieved from junk piles, and oil drums that functioned as rubbish bins. The lavatory was filthy even by Berlin standards: bare toilet bowls with the seats ripped off, no soap or paper of any kind ever, walls plastered with

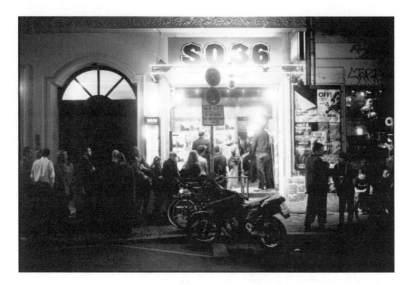

The punk club SO36 on Oranienstrasse near Heinrichplatz .

ripped-up concert handbills. That said, it functioned well enough as a location to sell and do drugs, which most times seemed its primary purpose. Getting a beer could be a bruising ordeal, best to expect scowls or even an elbow in the process. Extreme rudeness was in vogue—another punk signature that fit Berlin like a glove—which would remain a Kreuzberg emblem long after punk faded.

As early as August 1978, it's likely that many of the concertgoers at SO36's Wall City Rock festival may not even have heard of punk. Nevertheless, its opening night (the chosen date, the seventeenth anniversary of the Wall's construction, ripe with sarcasm) was the talk of the underground, and no less than Bowie and Iggy showed up toward the end—Bowie wearing an entirely inappropriate snow-white suit. Bowie remembers the concertgoers smearing masses of cake on the walls, which he interpreted as a symbolic act of defiance against the Wall.

(Another eyewitness says there was just one cake and they ate it.) Iggy, later proclaimed the Godfather of Punk, didn't hang around for long once he'd scored in the men's room.

In England, at concerts punks spit on their bands. In SO36 they threw beer cans. Schultheiss or Kindl, West Berlin's own mediocre brews, in tall cans was the punk scene's libation of choice. One of the Super 8 films made in the early 1980s, *So war das S.O.36*, shows the bands getting pelted with cans. Some musicians ducked the projectiles or tried to bat them away with the neck of their guitar. Others simply let them bounce off their bodies and litter the stage. One choice bit of footage shows a guitarist getting smacked in the ear with a half-full can. Furious, he throws down his guitar, finds the very can and flings it back down on the culprit with disgust. Then he retrieves his guitar and resumes playing.

The club's ownership changed hands as often as that of the kebab shops and liquor stores around it, and occasionally shut its doors altogether. For a while, Turkish émigrés took it over, supplementing income with big Turkish weddings. At one point it fell into the lap of the Dortmund-born artist Martin Kippenberger, an unknown at the time, though posthumously considered one of the most influential experimental German artists of the postwar era. Having moved to West Berlin in 1978, he quickly was a familiar presence in West Berlin, especially in the clubs and bars that put up with his drinking binges. Soon after his arrival, Kippenberger proclaimed that "Berlin has to be repainted," though painting the Wall didn't occur to him. Kippenberger's Office was a collaborative space similar in spirit to Andy Warhol's Factory in New York, which gave a platform to the Young Wild Ones, the name of his West Berlin art troupe— some of whom would make names for themselves, like Jörg Immendorff, and others who wouldn't.

One of SO36's early patrons was the nineteen-year-old Blixa Bargeld. A Berlin native, he had left the confines of West Berlin only a handful of times in his life. Blixa knew Gudrun Gut from The Other Side and stepped into Eisengrau, where he peddled bootleg tapes and speed. The latter sold exceptionally well, as the burgeoning new scene was ingesting amphetamines—Benzedrine, to be specific—in large quantities. This was one source of its prodigious output, hyper-long nights, and choleric demeanor. Next to an old bed in one of Eisengrau's backrooms someone scrawled: "You sleep, you miss out."

The high-strung, spindly character Blixa Bargeld, with colt-like legs and bulging eyes, was known around the scene as the projectionist at the Tali Cinema on Kottbusser Damm where *The Rocky Horror Picture Show* showed every night. The proceeds went straight to a cocaine dealer until the Tali went bust. Signature Blixa Bargeld, he darkened his left eye with liner and treated his long eyelashes like the sociopath Alex DeLarge in Stanley Kubrick's *A Clockwork Orange*. His hair was a knotty rat's nest atop the crown of his head. Blixa's gaunt, ashen face with protruding cheekbones made him look like a plague victim with just hours to live (see photo on facing page).

Australian rocker Nick Cave, then with his band The Birthday Party, remembers the first time he saw a clip of Bargeld onstage with the Neubauten:

> He was the most beautiful man in the world. He stood there in a black leotard and black rubber pants, black rubber boots. Around his neck hung a thoroughly fucked guitar. His skin cleared to his bones, his skull was an utter disaster, scabbed and hacked. . . . I'd never seen anybody look so destroyed, so ill. Then he opened his mouth and let out this cry from his throat which was something I'd never heard come from an

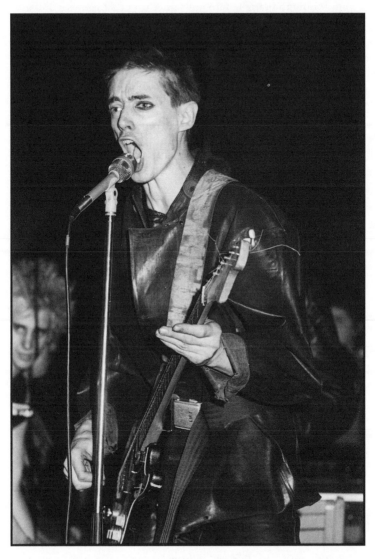

Blixa Bargeld of Einstürzende Neubauten at the Brilliant Dilettantes festival in September 1981 in West Berlin's Tempodrom.

adult human being before but something that comes out of a strangled cat or dying children.

Cave described the encounter as a "defining moment" for him. A year later he'd move to West Berlin—to make music with Bargeld, who would play guitar in Cave's new band, the Bad Seeds.

The name "Blixa" he borrowed from a felt-tipped pen label and "Bargeld" from the Dadaist painter and poet Johannes Theodor Baargeld. *Bargeld*, which means "cash" in German, was also a nod to an anarchic distrust of the world of finance. Surviving on welfare and odd jobs, Bargeld surfed couches after being booted out of high school at the age of seventeen. Christian Emmerich, as his teachers called him, wasn't expelled for deficient grades, although they were poor enough. Rather, the class spokesperson was sent packing for arson. A statement against the school's pseudo-democracy, he set fire to the assembly hall. Aloof and arrogant even then, Bargeld had musical ambitions, though his first try in a punk band fizzled after the group's second gig.

The cassette business at Eisengrau became the shop's purpose, a testament to the budding interest in the new underground music. So great was demand that Bargeld turned Eisengrau into an independent cassette label. (It was the drug sales, though, that paid the rent.) He spent his days in the shop with a tape deck, recording rehearsals, mini-gigs, and conversations. He had a helper in another West Berliner, a fourteen-year-old runaway named Alexander Hacke, who had latched on to Bargeld and the Eisengrau.

One day in late March 1980, the manager of an obscure discothèque called Moon poked his head into the shop in search of a weekend band. Bargeld volunteered in a flash. The group's name, he said off the cuff, was Einstürzende Neubauten. Bargeld had been pottering around with unusual percussion sounds together with his high school friend Andrew Chudy (stage name:

N.U. Unruh), who played drums. The two of them, plus Gudrun Gut on synthesizer and Beate Bartel playing bass, took the stage at Moon that weekend, loops of Super 8 footage running behind them. Among the improvised numbers was "Atomic Waltz" and "Dance, Dance the Downfall," to which Bargeld intermittently screeched. The band managed to stretch the set to forty-five minutes. The sparse audience responded with boos, and the Moon discothèque went under shortly thereafter.

The composition of West Berlin's signature band jelled in time. Gut and Bartel quit, turning their full energies to the all-girl bands Mania D. and then Malaria!. Although Gut says there were no hard feelings, from the onset Bargeld signaled his authority to run the Neubauten as he, and he alone, saw fit. This wouldn't change as the band consolidated its repertoire and shot into the rock stratosphere.

Einstürzende Neubauten would, like no other project, capture the angst and insanity of divided Berlin at the apex of the nuclear age. The Neubauten were inconceivable outside claustrophobic West Berlin, even if the band has enjoyed a commercial afterlife in the wake of unification. Bargeld and Unruh set about sculpting a band that would eviscerate convention more radically and thoroughly than did punk. The idea, as it evolved in Blixa Bargeld's imagination, was to concoct something so alien, so discordant, so deconstructive that it would obliterate the truisms of the music industry, of postwar Germany, of the twentieth century's dominant ideologies, and open the way for a novel postmodern synthesis. "Possible is only that which doesn't yet exist," is one of the band's lyrics. Just a handful of years down the road, in autumn 1989, what was unthinkable—namely the end of the Cold War and then the unification of Germany—became possible.

Bargeld and Unruh carted the objects of West Berlin's ruins and building sites, its junkyards and autobahns, back to

Eisengrau. The sounds were those of the intensely urban environs of the walled city: breaking glass, dripping water, creaking Styrofoam, buzz saws slicing metal, the echo of oil barrels, the mixing of cement, razor blades on mirrors. Short on cash, Unruh sold his Pearl drum set and fabricated his own out of construction site debris: tom-toms made of plastic canisters; the casing of an old electricity meter propped up on broken pieces of solid insulation; a bass drum fabricated from zinc sheeting. They lugged industrial piping and slabs of cement into rehearsal rooms and then onto stage alongside chains and power tools, sledgehammers and industrial waste.

The Neubauten recorded one of their first songs, "Steel Version," in the metal-plated interior of a highway overpass, Unruh drumming out rhythms on the steel floor with concrete blocks, Bargeld hunched over his guitar in the confined space spewing out distortion and feedback. Although never explicit in their work, in hindsight, it's hard to overlook the fact that the Berlin Wall itself was made of the very materials they were pulverizing in every possible way. The Neubauten were all about crashing boundaries, and the Berlin Wall was the nearest—even if they'd grown rather fond of it.

Bargeld and Unruh were joined by Hacke on guitar and sound board, the percussionist FM Einheit, and the Leeds-born bassist Mark Chung. FM Einheit and Chung, the backbone of the punk band Abwärts (Downward), had been dabbling with industrial noise, but within the framework of classic punk. At a punk festival near the Bavarian town of Dachau, the freshly formed five-man band visited the former concentration camp there, by then a memorial, where the Nazis had put thousands of Jews, homosexuals, and other targets of Adolf Hitler to death. As they left the memorial they filched a garbage can lid, which they'd add to their percussion section.

"At first, it's not music but if we play it long enough it will become music," Bargeld told a West Berlin weekly in 1982. "We want to expand musical norms until there's nothing left anymore that's not music." Einstürzende Neubauten, explained Bargeld, waxing more Hegelian than he was probably aware, "is a positive sound, possibly the most positive sound of all. Old objects, meanings, buildings, and also music will be destroyed, all traces of the past are abandoned: only out of destruction can something really new be created."

So tepid was their initial reception in mainland Germany that the Neubauten began performing in out-of-the-way venues abroad, first in London and then Paris, Amsterdam, and Rome. John Peel caught wind of the band and invited them to London for a session at the BBC studios. Onstage, the towering Bargeld looked like an evil wizard. His untuned guitar sounded nothing like a guitar, which was the point: any man-made construct can be its antithesis, too. Much of the stage was cluttered with the percussionists' cumbersome paraphernalia. Unruh's pyrotechnics ensured that the early shows were treacherous extravaganzas, a foretaste of Rammstein's fiery productions. FM Einheit's tribalistic rhythms evoked a primordial past, mankind stripped to its barest. FM Einheit was a spectacle in himself, a sweat-drenched, muscle-bound hulk who sent bursts of sparks and chunks of cement flying across the stage and into the audience. By the end of a gig, the stage was littered with refuse, a junkyard of twisted metal and dented instruments.

With its reputation for wild, maximum-volume concerts, the band's name spread. Its proclivity for unconventional concert venues attracted attention too, like at the former Nazi parade grounds in Nuremberg. The Nuremberg gig was a spooky, theatrical exorcism of Nazism, a ritualistic chasing away of the ghosts of Germany's past. In 1984, the *New York Times*'s Robert Palmer

paid the Neubauten a guarded compliment in a short piece on the "industrial music movement." "None of these bands has gone quite as far as Einstürzende Neubauten. The group's new album 'Strategies Against Architecture' shows a remarkably broad expressive range and the ability to combine industrial sounds the way most rock groups combine melody lines and rhythms. And the listener who plays the record, rather than going to see the show, gets to control the volume."

One factor integral to the wildness, whether partying through the night in Risiko or performing onstage, was the band's drug intake, excessive even by the day's standards. Cocaine and speed fueled much of the Neubauten's journey through the 1980s. "It was speed, not heroin, never," Blixa Bargeld told me, responding to critics who say otherwise. I interviewed Bargeld several times, once around the corner from his aquarium-like all-glass apartment building in central Berlin. German music journalists warned me that he's notoriously sulky, the mere possibility of a serious interview hinging on his unpredictable moods. At fifty-seven years of age, he's filled out his long frame, and now instead of S&M gear Blixa Bargeld never appears in public without a funeral dark, vintage three-piece suit and double-knotted tie, his neck-length hair parted in the middle. He was most obliging when I met him on a sweltering August day in the five-star Marriott hotel on Potsdamer Platz. I was in shorts and a T-shirt, he in a thickly layered suit buttoned to his chin. The glass apartment in Mitte, he told me, turned into a greenhouse on hot days, making it unlivable. So on such scorchers he moves his whole family—American wife and eight-year-old daughter—to an air-conditioned hotel, his "natural habitat anyway," he says. The Neubauten still produce fresh work and tour, as does Bargeld as a solo artist, an actor, and the author of a book on gourmet cooking. Though still on good terms with his close friend Nick Cave, he quit the Bad Seeds in 2003.

"The effect of the drug is one thing," Bargeld says about amphetamines, referring to past excesses. "But sleep deprivation is another. It causes the collapse of reason, the collapse of logical thought, and undermines established categories. Taking speed and doing one all-nighter is, well, not such a big deal. But two nights in a row, that's when things begin to get interesting, when logic and above all spoken logic begins to dissolve, when you're at the point of no reason. That's what always interested me about cocaine and speed."

The Neubauten's songs explore the far recesses of the human psyche and its earthly creations, and are replete with references to apocalypse, the end of time, and anomie. Bargeld's lyrics were a largely accurate reflection of some of the contemporaneous theories of the French postmodernists like Jean Baudrillard, Gilles Deleuze, and Paul Virilio, which were just then coming out in German translation. Ideology and contemporary truths had been eviscerated of their value—but they were still there holding everything up. Take, for example, one of the most ideological constructs of all, the Berlin Wall, infused with all of the competing claims and symbolism of the East-West conflict. By the 1980s it was a gross anachronism, but it was still there, chopping the city in two. In the Neubauten's songs cities are in flames, hyenas roam the streets, corpses dance, and souls rot. Not unlike the Dadaists' powerful critique of World War I Europe, the Neubauten articulated a savage assessment of a world whose logic had steered it into a trap from which it could not escape.

The "collapsing new buildings" of the band's name were the calamities of West Germany's postwar modernist architecture, such as Gropius City, which were both literally and figuratively collapsing on the generation of Christiane F. This was the postwar urban geography that Germans had labored so arduously to erect in order to erase the scarred landscapes of the war. But

they couldn't plaster over the Nazi era quite so easily. Its lies and crimes, hidden from view yet just beneath the surface, were cracking apart the liberal facade of the "new Germany." The Neubauten's purpose was to grind it to rubble again—using the same tools that had built it up—so that Germany and Europe would have to start over again. The Neubauten's oeuvre tapped the torment of the Holocaust, the Cold War, the Berlin Wall, the besieged squats, and the child prostitution at Bahnhof Zoo, too— in the one city in which it all came to a head.

The band rocketed to cult stardom in the early 1980s, becoming one of the few German bands of the decade to find an audience outside of Germany, despite the fact that it never had a hit like Kraftwerk's "Autobahn" (1974) or Nena's "99 Red Ballons" (1984). (Gudrun Gut's band Malaria! had the stuff to make it abroad, but sadly it fell apart in 1984.) The Neubauten had completed three U.S. tours by 1985, and were scoring ecstatic reviews everywhere. They had toned down the unruliness, for the most part, and found a more structured, accessible industrial sound. "It wasn't a conscious decision to become mainstream," their manager from 1980 to 1986, Klaus Maeck, told me. "In the first years they were proud to make their music almost unlistenable. But there's a limit to how far you can take that. The Neubauten were always more than just a punk band and wanted to expand their horizons in terms of music and their instruments." That's one way to put it. Others deemed it selling out.

The End

Subcultures rise and fall. By the late 1980s, much of the buzz in West Berlin around the Brilliant Dilettantes and their quirky experiments had fizzled. The troupe's originality and the radical

power of punk sputtered and ground to a crawl. The postpunk and new wave scenes attracted admirers from across the world, but there were few meaningful breakthroughs in either form or substance. The live music scene began to feel stale, just as rock and roll had in the '70s. Nevertheless, in terms of quantity, West Berlin's late-night partisans were greater in number than ever before, as were exhibitions and performances, nightclubs, and bands and artists. West Berlin was on the map for politically minded creative types and as a place where trends were born.

By then there was abundant spillover into the mainstream—a notoriously double-edged sword. Increasingly, the underground's best ideas were being plucked by West German companies and turned into money. Commercial fashion designers, who had once laughed at dowdy West Berlin, now regularly swooped down on the city to snatch up the independents' finest products and spirit them away to fashion capitals elsewhere. Claudia Skoda's designs took her to New York City and the fashion big leagues.

While preaching decline and damnation, the Neubauten's trajectory only went upward. Their third album, *Halber Mensch* (Half Human), was the pop-iest yet, and the group assumed the airs of rock bands it had mocked not so long ago. So respectable became the Neubauten that the Goethe Institute, a state-financed cultural institution known for usually preferring *Hochkultur,* chose them to represent Germany at the 1986 Expo in Vancouver. "Ten years ago we would have been lynched for accepting money from a state institution," Bargeld said in a television interview. He explained that he had lived for years without money—and now he wanted some too.

West Berlin in the late 1980s struck me as very gloomy. A sign of the times, many people were rediscovering George Orwell's dystopian classic *1984,* and likening the 1980s to the world of Winston Smith and Big Brother. The paranoia untethered

during the German Autumn in 1977—the conviction that the "surveillance state" was monitoring nonconformists' every move—was still very much in the air, despite everything. The mood is captured in the club scenes in the 1987 Wim Wenders film *Wings of Desire* when Nick Cave and the Bad Seeds (a long-haired Blixa on guitar) play "The Carny" and "From Here to Eternity." The logic of the Cold War set an end-of-the-world thinking in motion, which in West Berlin assumed a life of its own, propelled not insignificantly by the Neubauten and Cave. "I was convinced I'd never reach thirty," says Michael Sontheimer, who chose to take a time-out for a few years in Hamburg. He wasn't alone. I had the impression that much of the scene had become consumed by its own nihilism, which had at one time contained a homeopathic dose of irony.

Wolfgang Müller claims that Nick Cave's presence accelerated the downturn. Cave was the star in a scene supposedly without stars. He was the wildest of them all, and his persona even affected the in-crowd's mannerisms and style, says Müller. "Things became more macho and druggier," says Müller. The queer and the artsy suffered, he says. Heroin, Cave's addiction, dragged everything down. Symbolic of the day's setbacks, Christiane F. relapsed after eight clean years, though now with so much money from the book and film that she didn't have to resort to Bahnhof Zoo's underpasses.

Cynicism was omnipresent even though there were plentiful grounds for hope: for example, the new thinking of Mikhail Gorbachev in the Soviet Union. Yet this didn't disperse the doom or even engender much discussion. Sunk in melancholy, everything seemed pointless—even talking about it. Gudrun Gut sensed the dejection. She, too, was preparing to cut ties, and move to Barcelona.

4

Free Republic of Kreuzberg

You are entering the occupied sector of Berlin.

—BANNER AT THE RAINBOW FACTORY SQUAT, 1982

The years of social discord over the direction of urban planning eventually led to the abandonment of modernist methods. This decisive turning point in urban planning was the only major shift in Berlin's urban history that was not a consequence of war.

—HARALD BODENSCHATZ, URBAN PLANNER AND AUTHOR OF *BERLIN URBAN DESIGN*

WITH FEW EXCEPTIONS, DOWNTOWN WEST BERLIN was an eyesore. But Kreuzberg, an old working-class quarter that hugged the Wall, held a category of its own. The district lay in the middle of predivision Berlin, a bit to the southeast along the Spree, and before the war had been among the city's most densely peopled centers. One after another in thickset city blocks, neatly proportioned five- and six-story brick tenement buildings rose up from the streets. These were the storied *Mietskasernen*, or rental barracks, designed to house Berlin's burgeoning new working class as the city industrialized by leaps and bounds after

Germany's unification in 1871. Many of the buildings housed whole factories in the back courtyards, or *Hinterhöfe*, with the proletariat living above their workplaces. This was the logic of the *Mietskasernen*: Manchester capitalism in Berlin.

For most of its life before industrialization, the Prussian capital beyond Hohenzollern Palace, the box-shaped Baroque residence of the monarchy, had been a sleepy, oversized military garrison. (The royal family's magnificent summer palaces Neues Palais and Sanssouci lay twenty miles to the southwest in the city of Potsdam.) There was nothing Berlin could boast to match the great cities of Europe, such as London or Paris, or even Ghent or Glasgow. But Berlin rapidly morphed into an urban metropolis: in just fifty years, from 1840 to 1910, the population shot up from 329,990 to 3.7 million, half of the newcomers blue-collar workers and their families, the inhabitants of the rental barracks.*

Originally, before Allied bombs poked gaping holes in Berlin's cityscape, standing in the street one could only see the soot-streaked facades of the Kreuzberg tenements' outer ring, the brick-and-mortar fronts covered with stucco plaster, usually decorated with art nouveau ornamentation. The ground floors accommodated little shops, corner bars, newspaper stands, and artisan workshops. The more commodious front apartments had high ceilings, plenty of light, varnished wood floors, and balconies with flower boxes. These street-view residences were for better-off Berliners.

Behind the facades, though, lurked another world. The interiors of the city blocks in Kreuzberg, as well as other inner-city districts, had side wings extending back from the street-front buildings and

*On the cusp of the world war in 1939, Nazi Berlin boasted a populace of 4.3 million. In 1980, Berlin's total population—East and West together—was just three million.

more rows of multistory buildings behind them, sometimes three or four rows deep. These structures were connected by labyrinths of lightless courtyards and underpasses. In the interior honeycombs lived and labored the worker bees. The damp courtyards, teeming with children, full of laundry and garbage, smelled to high heaven. Tuberculosis was rampant. Noise ricocheted off the walls like in an echo chamber. The apartments housed as many as eight persons to a room who shared a stairwell toilet with neighbors. For bathing, the neighborhoods had pay-per-use public bathhouses.

The years of bombing and then the fierce house-to-house fighting of the Battle of Berlin decimated much of central Berlin, including parts of Kreuzberg. But compared to the vistas of rubble in Mitte, where *Berlin Year Zero* was filmed, much of Kreuzberg got off lightly. Yet, rather than repair the damage, social reformers felt that everyone would be better off without the nineteenth-century rental barracks. West German architects envisioned modern, humane housing, and automobile-friendly sectors taking the place of the discredited and now broken-down districts with their cobbled roads and smelly coal heating. In the name of modernity, postwar Berlin's officialdom began tearing down the historical city and replacing it with block-like public housing and autobahns.

The Wall doomed Kreuzberg as it shifted the district from Berlin's historical center to the periphery of West Berlin. In fact, the Wall, which zigged and zagged through amputated streets and parks in Kreuzberg, surrounded one quarter on three sides, forming a cul-de-sac. Its truncated neighborhoods were thus of little economic interest to anyone. Many abandoned the sequestered area for West Germany or new housing projects such as Gropius City. Most of Kreuzberg's private enterprises, including the small production facilities still operative in the tenements, bolted their doors too, and headed for safer ground.

The city left these unloved structures to deteriorate, turn-
ing Kreuzberg into West Berlin's premier slum (see photo, page
99). Parts of Kreuzberg were so depopulated that the U.S. Army
leased them for house-to-house urban combat exercises. Helicop-
ters buzzed overhead as GIs scampered from building to building
as if seeking cover from Soviet sharpshooters. In close collusion
with the city's politicos, real estate speculators snatched up the
buildings one after another. They emptied the apartment houses
of residents, walled up the ground floors with cinder blocks, and
grinned as they decayed; wrecking balls took care of the rest. They
planned to cash in big when the new construction commenced,
deals prearranged with their friends in office. The city referred to
the strategy as "redevelopment through demolition."

In forlorn nooks and abandoned lots, little shantytowns peri-
odically popped up; sometimes painted hippie caravans dropped
their anchors there. Mostly, though, garbage and stripped auto-
mobiles littered the deserted, cheerless lots along the Wall.
"Kreuzberg was a dead end," remembers artist Thierry Noir, a
native of Lyon, France. "It was very quiet when there weren't
demonstrations because there were almost no cars there. No
ordinary family would have lived there if they didn't have to."

Yet the very low rents attracted a mixture of bohemians, stu-
dents, urban activists, and a new working class, too, namely the
southern European guest workers, mostly immigrant families
from Turkey. One friend told me he paid just thirty-seven dollars
a month in rent in the late 1970s for a two-room apartment that,
when he moved into it, looked as if a family had packed their
valuables in haste and disappeared the day before, leaving the
sink full of dirty plates and utensils.

The first to grasp the proportions of the uninhabited hous-
ing stock were social workers and community organizers, many
of them Sponti-style anarchists who ventured into the troubled

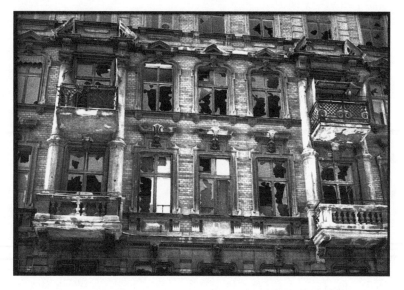

A condemned apartment building in Kreuzberg, January 1981.

neighborhoods. The district lacked basic social infrastructure for the new migrant communities, such as playgrounds or daycare and youth centers. Moreover, they found themselves confronted with the grotesque paradox that West Berlin faced an acute housing crisis—there wasn't nearly enough of it to go around— and yet whole streets of vacant dwellings had been left to rot or, worse, demolished. To their astonishment, the activists discovered soul mates in dissident urban planners and architects, as well as preservation-interested burghers, who were committed to the historic neighborhoods. They believed that modernization and renewal were possible within the context of Berlin's traditional urban geography.

However, the mix of engaged parties required one more key collaborator—namely the squatters—to force the city to rescue historic Berlin from bulldozers and carpetbaggers. More than that, they eventually beat back the architectural orthodoxy of the day.

Community organizers behind a citizen's initiative called
SO36* got the ball rolling, though they had no idea they'd trig-
ger a tidal wave of occupations that crested in the early 1980s
with more than 275 squatted buildings. Very unsquatter-like,
SO36 announced in a press release that it would begin mov-
ing into empty apartments in Kreuzberg. It estimated the total
number in West Berlin at ten thousand. The aim of the vet-
eran organizers—I imagine them as assiduous types in thick
blue jeans, with ponytails and shirtsleeves rolled up to the
elbows—was to turn the wrecks back into housing, and then
eventually offer the owners a fair rent. The objective was not to
do battle with capitalism or to make a home for their favorite
political utopia. Indeed, the people behind SO36 didn't remotely
resemble the clichéd image of West Berlin squatters as militant,
black-clad hell-raisers.

In point of fact, at no time was there a prototypical West Ber-
lin squatter, whose numbers may have exceeded 3,500 a few years
after the SO36 initiative. People broke into and squatted one
building after another in Kreuzberg, Wedding, and Schöneberg
—punks and homeless people, runaway boys and queers, artists
and radical anarchists. And that included newcomers fresh from
Swabian towns and Bavarian farm villages in search of free-
dom and adventure. Their common intention was to reconfig-
ure West Berlin's unattended spaces by turning the old workers'
tenements into attractive housing, administered by the people
who lived there. By 1981, most of the buildings on and around
Heinrichplatz and Mariannenplatz, the neighborhood of the club
SO36, had been squatted, their facades decked out with banners
and graffiti announcing their purpose.

* The organization of neighborhood locals and community organizers had
nothing to do with the punk club SO36, with the exception that both had an
anarchist bent and shared the same Kreuzberg postal code: SO 36.

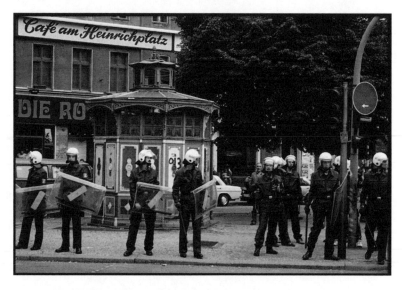

West Berlin police on Heinrichplatz during the raid of a squat in June 1984. In the background is the café Rote Harfe.

The city's response was bafflingly uneven: at times vicious, at others nonchalant. In part, it depended on who owned the building and whether the owners gave a damn in the first place. Some didn't, only too happy to sell. When the police did intervene, though, the evictions were executed with steely determination—as if they were countering the urban guerillas of the Red Army Faction. One shouldn't have been as shocked as I was by the disproportionate brute force exercised against the squats. Since the '70s, Germany's police had been trained to battle the Red Army Faction, not squatters. Moreover, some of West Berlin's squatters did in fact harbor sympathies toward and even had links to the armed underground, which justifies nothing but helps explain the overreaction.

The city declared that any building occupied after summer 1981 would be raided and cleared out, which is exactly what

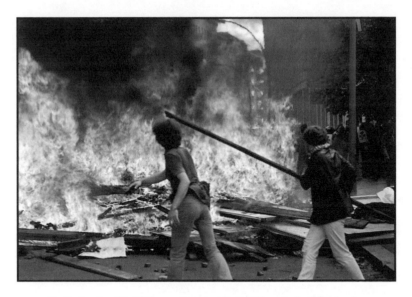

On September 27, 1981, squatters and their allies erected barricades
in the streets to impede police raids on eight squats in Schöneberg.

happened (see photo, page 101). In full riot gear, police smashed
their way into the buildings with giant cast-iron ramrods,
shields in one arm and long nightsticks in the other; paddy wag-
ons, water cannons, tank-like reinforced bulldozers, and other
armored vehicles were close behind. When the fighting spilled
out onto the street—or started at pro-squatter demonstrations—
police launched canister after canister of tear gas at the protes-
tors. The cops received volleys of paving stones in return (see
photo above). The sirens of ambulances signaled to all of Kreuz-
berg that there were casualties.

As much as I respected the squatters' cause, I admit that in
the 1980s I experienced many of them as extremely paranoid
and smug, prickly ideologues who'd bark rather than discuss. Try
to snap a Polaroid of one of the militant houses and you'd get
your head bitten off. But in talking with the very same types

years later, they explained to me that their confrontations with the police and the city were so bitter that it had turned them suspicious of everyone. One squatter was killed in the clashes, an innocent victim of the police state, as they saw it, just as Benno Ohnesorg had been in 1967. They came to see everyone who wasn't with them as being against them. Many had begun as pacifists yet turned to violence, which, they concluded, was the only answer to the violence of "the state."

One of the squats known throughout the community was 40/41 Manteuffelstrasse, a turn-of-the-century building in shouting distance of Görlitzer Strasse's elevated subway stop. (The project is distinguished today, too, even far afield of Kreuzberg as a prizewinning best practice in sustainable, multigeneration housing. A small stack of architectural journals have written it up, so that others can duplicate its example.) In the early 1980s, though, the "Manko," as the house was nicknamed, was known for its courtyard Bauhof, a not-for-profit depot for extraneous building materials of all kinds: window frames, water pipes, roofing tiles, floorboards, power cables, electrical circuiting, plumbing, and anything else that could be recycled. Open two days a week, any one of the West Berlin squats could borrow tools or help themselves to the materials that were either left over from ongoing renovations or pried off structures too damaged to save. One former squatter told me that a fair bit of it was lifted from the construction sites of private developers. Animosity between the squatters and the construction firms—the developers' foot soldiers, as the squatters saw them—had a ferocity all its own. The squatters' friends outside the scene contributed money to the cause through Bauhof's bank account, which functioned as a piggy bank for the squatter community.

The twenty-nine-year-old Markus Ghazi, one of the Manko's original squatters, had scoped out the buildings that adjoined

40/41 Manteuffelstrasse while he was living in a communal apartment on the other side of Kreuzberg. In February 1981, Ghazi and a dozen co-conspirators scaled a wall behind the courtyard to explore the property that encompassed two courtyards, two side wings, and an abandoned five-story curtain factory. When it was in operation, the factory's workers lived in the front and side buildings, just yards from the machines that they toiled over by day. The squatters had very different ideas about combining *Leben und Arbeit* (life and work) at the same location.

"The building was a ruin," says Ghazi, even though people had inhabited some of it as late as 1979. As with most of Kreuzberg's condemned housing, the owners had sent in crews to remove the windows and frames, smash the toilets and sinks, rip out the coal ovens, pull up the stairs, and punch holes in the roofing. Unfazed, under the cover of night the group pulled up behind the buildings in a VW bus stuffed with mattresses, bedding, food, and all the tools they could scrape together. They moved into the curtain factory's third floor, the only inhabitable space. "It was ice cold," remembers Ghazi, who for the next fourteen months slept on the floor in a sleeping bag.

The 40/41 Manteuffelstrasse squatters were a thoroughly mixed bunch: students (including two architecture majors), a few craftsmen, some artistic types, a couple of punks, and a musician. "We didn't have all that much in common," explains Käthe Kruse, who visited the squat in summer 1981 after she returned from half a year on the Hippie Trail, the overland journey taken by many young people in the 1960s and '70s from Europe to India and Nepal. The next week she returned home to West Germany, packed her stuff, and moved into the Manko, where she'd live for the next thirty-three years. "Our ideas about living together and the principles of the house emerged bit by bit from our work renovating it together and being part of the

[squatter] movement," she told me. "There was nothing ideological about it, though we agreed on a lot from the beginning."

Few of the squatters started out with any more of a vision. The Manko's squatters first fixed up one room—in which they all lived together—and then another, which split the group in two, and so on until they were no longer living on top of one another. The days of the common bedroom à la Kommune I were long past. There was a dose of Kommune I in all of the endeavors of the 1980s squatters, but the latter sidestepped some of the follies that had tripped up the '68 generation. In the course of a decade of alternative living and mass movements, they'd learned a thing or two. One lesson was that even in communes one needs his or her own four walls from time to time.

Bygone too was the era of the macho male revolutionary. Gender politics wasn't just discussed, it was lived out. Women worked construction, men cooked—as well as the other way around. In all-women squats such as the Chocolate Factory, an artists' collective in 6 Mariannenstrasse, women did all of the renovations. This might not sound hell-bent radical today, but at the time it was off the charts. Children attended do-it-yourself, antiauthoritarian kindergartens that post-student-movement parents had been setting up in empty shop spaces since the early 1970s. They were called *Kinderläden*, literally "kid shops."

Consciously or not, the squatters, operating illegally as trespassers who were "destroying" stolen property, embarked on a groundbreaking project in contemporary architecture and design. They reinvented the infamous rental barracks for late twentieth-century living by turning the bourgeoisie's original concept on its head. Doors were ripped off their hinges. Walls fell in the courtyards, and between rooms and apartments, too, so that at long last the sun illuminated their dark recesses. (The Allies' bombing raids had already gone some distance in

exposing the blocks' innards to the heavens, a perk that years later new construction would erase.) The innovative, low-budget designs enabled the inhabitants to interact in ways unthinkable in the originals. All of the buildings' dwellers were connected in the new design, not sealed off from one another. The second floor was transformed into an open dining room and kitchen with two long wooden tables where the group—it grew from fifteen to forty in a year—prepared meals together. Their food came from co-ops that squatters and the alternative movement had brought to life. The roof was decked out with chairs and tables; vegetable, flower, and marijuana patches ringed its perimeter. And everything was thrashed out at twice-weekly plenums, which could last hours and hours.

At a later point, the Manko was among the first of the buildings in Berlin to mount solar panels on its roof. Eventually, once grants and loans were secured, the coal ovens were replaced with gas-fired combined heat-and-power units in the cellar that generated enough heat for most of the block, as they do today. (Then an anomaly, today renewable energy production is commonplace across Germany.) The toilets' plumbing was run with the house's graywater* that was treated naturally by dripping it through huge canisters of earth affixed to the former factory's western wall.

The Manko's occupants felt that negotiating with the city administration was in their interest, and they concluded a deal in 1983 that allowed them to live in the house, administer it, and keep rent low. The buildings were put in the hands of a nonprofit holding company that included eight other legalized squats on the same Kreuzberg block.

*Graywater is waste water that comes from sinks and showers but not from toilets.

The squatting of West Berlin's derelict housing rescued neighborhoods that today—more than thirty years later—are among the gems of the new Berlin. Kreuzberg, in particular, still bears the signature of the squats and their partisans, a surprising number of whom still live in the long since legalized houses or have passed on their collective living projects to younger generations. Not only was Kreuzberg saved; the urban design movement was international in scope and halted the advance of modernist development projects in other cities, ushering in a new orthodoxy in European architecture. Little could they know, their efforts also served as the first step toward gentrification.

But pragmatic types, such as those in the Manko, weren't the only squatters in town. Other houses had been taken over by militants, one current of which called itself Autonome, whose partisans took the pragmatists to task for "colluding with the state." There could be no truly free space, they claimed, that had been negotiated with the state and property owners. With roots in Italian anarchism, the Autonome picked and chose from the tradition of the German left. Many Autonome had cut their teeth in the anti-nuclear-energy movement in West Germany, which had taken a nasty, violent turn in the late 1970s thanks to their ilk. Among the lessons that the black-hooded radicals gleaned from the clashes at the nuclear energy sites was that the state, the enemy, had to be battled by any means necessary. Their faces covered by scarves, Autonome and their allies marched together arm in arm in demonstrations in "black blocs." When push came to shove with the police—as it did, and who pushed first was never clear—out came the paving stones and, on special occasions, Molotov cocktails. Autonome, like or despise them, profoundly influenced 1980s West Berlin by setting a tone of confrontation and more-radical-than-thou criteria

that, in the end, stubbed out many good ideas, pushed away many good people, and largely prevented the community from reaching ordinary Berliners.

The new Kreuzbergers dubbed their stomping grounds the Free Republic of Kreuzberg when in 1988 the city cordoned off much of the already isolated district and shut down public transportation in order to keep protesters from disrupting the annual congress of the International Monetary Fund (IMF), as they had Ronald Reagan's visit the year before. As long as they were fenced off by the Wall on three sides and the West Berlin police on the other, the Kreuzberg habitués celebrated their now complete seclusion by declaring their own mock republic complete with papier-mâché border posts, phony visas, and, of course, a big party in the empty streets. Wild demonstrations took place anyway, foiling the city's objective to show off a tame West Berlin to the world, one safe enough to be a capital of international finance.

By the mid-1980s, West Berlin was less of an insider's tip. In addition to Nick Cave, Depeche Mode's Martin Gore and Lou Reed hung their hats in West Berlin for a while. (Contrary to myth, Lou Reed's 1973 album *Berlin*, which tells the story of a doomed pair struggling with drug addiction in West Berlin, was written before he ever stepped foot in the city.) By then, hipster and artiste circles had swelled to populate hundreds of venues across the city. When I arrived in West Berlin in 1985, the landscape was largely complete and at the disposal of newcomers like myself. Although the squats had been legalized, or the squatters evicted, you wouldn't have known it by their facades, painted with bright, colorful blotches and covered in graffiti as if the buildings had been taken just days ago. Whole sections of Kreuzberg and Schöneberg belonged to (former) squatters who marked out their turf with banners and graffiti: "These Houses

Belong to Us," "We Want to Live," "No Refuge for Criminal [Real Estate] Speculators," "No Power to Nobody!," "Better to Squat and Restore Than Own and Destroy," and "The Cops Are Against All of Us!"

The hub of Oranienstrasse's neighborhood was Heinrichplatz, a triangle of weedy grass and stripped bicycle frames where punks would sit on the curb, beer cans in hand. On its perimeter were some of the best bars and cafés: Zum Elefanten (For Elephants), Café Jenseits (Café Otherworld), Rote Harfe (Red Harp), and of course SO36. In the anarchist bookstores and impromptu exhibitions you could while away hours without spending a mark. Posters advertising demonstrations, concerts, festivals, and readings were plastered like wallpaper on buildings. Down the street in either direction were the legendary watering holes O-Bar, Das Trash, Bierhimmel (Beer Heaven), Max & Moritz, Roses Bar, Schnabelbar, and Franken Bar.

Roses Bar was classic gay-queer: an intimate spot drenched in soft red light and thick with shiny, rose-colored camp. We went there a lot, everyone comfortable regardless of sexual preference, though perhaps less certain of it by the time they left. The gay and lesbian scenes flourished through the 1980s, turning West Berlin into Europe's capital of queer, as it had been in the century's early decades. The nonqueer crowd benefited tremendously from the scene's creations, which applied a fun, campy aesthetic and offered a welcome alternative to hetero pick-up joints.

Rote Harfe (see in background, photo page 101) was the place to score. The café was (and still is) elevated about a meter from the street, tables and chairs scattered across an unfinished hardwood floor. Back in the day, a guy who could have been scripted for a film part as a drug dealer sat alone at one of the tables, a lit candle, pouch of tobacco, and cup of coffee in front of him. He had stringy shoulder-length hair and a beard, and wore a dark

green overcoat and fingerless gloves, the heating in any of these places being hit or miss. While he probably marketed more than hashish, I wasn't aware of it. Nevertheless, I can attest to the wordless protocol for buying cannabis derivatives, which was as follows: you approach his table and get the nod, which means you sit down across from him. He looks at you, you say a number that is the quantity of deutsche marks you're looking to spend. He nods, pulls a stick of brownish contraband and a hunting knife out of a leather pouch, and makes a mark in the substance with the knife. If this looks right, you nod. He heats the blade over the candle, slices off a chunk, and pushes it across the table with the blade. You push the money his way, pocket the goods, and that's that. In any one of the Kreuzberg locales you could light up a joint, technically illegal, without getting flak.

The Writing on the Wall

Spatially, the Wall demarked the enclave of Kreuzberg. In terms of spirit, the Wall's artworks, *Mauerkunst* in German, accurately reflected the ethos of the counterculture, even if its primary target was usually the regime on the other side. For me, Wall art was a mirror in which Kreuzberg could see itself, warts and all.

Thierry Noir was a twenty-three-year-old college dropout who couldn't hold a job in France. He had seen the West Berlin squatters clash with police on the French news, which looked leagues more tantalizing than anything in his hometown of Lyon. So Noir bought a one-way, cut-rate train ticket to West Berlin. In the dead of night at the German-German border, East German guards with sniffer dogs and automatic weapons shouted at him in a language he didn't understand. The coaches were searched from top to bottom under a giant spotlight that

lit up the night. This was Noir's harrowing welcome to the GDR. He says he would have turned around right there and returned to France, had he had the funds. Twenty-one hours after leaving Lyon, he arrived bleary-eyed at Bahnhof Zoo. The stench of urine is what he remembers from Zoo Station at six in the morning.

Noir trudged through the frozen streets down to the Wall with a suitcase in each hand and took a right, in the direction of Kreuzberg. He didn't pay much notice of random graffiti spray-painted on the Wall or the stenciled images and sporadic paintings. Noir landed on the steps of the former Bethany hospital in the heart of squatted Kreuzberg. He knocked on the door unaware that the three-story building, called the Georg von Rauch House, had the distinction of being West Berlin's first-ever squatted domicile, a former nurses' quarters occupied in 1971 by homeless youths and local activists. The kids' gritty defense of the building earned them immortality in the rock group Ton Steine Scherben's (Sound Stones Shards) anthem "Rauch House Song." Since then, with city funding, it had served as a halfway house for wayward kids and down-and-out artists.

O-Bar on Oranienstrasse was Noir's daytime hangout, as it was for many squatters, a second home of sorts—with heating. "Everyone in Berlin said they were an artist, a musician, or a designer," he says. So, when asked what he did in Berlin, the soft-spoken Frenchman responded, "I'm an artist," even though he hadn't produced a piece of art in his life. From the bathroom window of the Rauch House one could see the Wall and the border strip when taking a leak. The GDR border guards stared right back through binoculars. By the 1980s, the Wall was in its fourth incarnation: nearly fifteen feet in height, it was made of prefabricated concrete segments with flat, smooth, gray surfaces (see photo, page 113).

The propinquity to the Wall, the ubiquitous gray, and the bleak Berlin winter weighed on Noir. On foggy nights, he could see the spotlights searching the house fronts in East Berlin for runners. "You had to be creative to keep your sanity," he says. One night he took spray cans and drew two oversized heads on the Wall. He showed them to his friend Christophe Bouchet, a graphic artist and sculptor who had graduated from the Paris College of Art. Bouchet's studio was in the Rauch House cellar, which also had practice rooms for bands. That night the two Frenchmen, joined by musicans Alex Hacke and Kiddy Citny, began to paint colorful, man-sized figures on the Wall, images that covered the concrete slabs from top to bottom. Noir's first creations were comic-style animals and fantastic creatures, warped fairy tales, and playful riddles.

The foursome weren't by any means the first to paint the Wall. U.S. sculptor Jonathan Borofsky painted one of his "Running Men"—a naked self-portrait of a fleeing person—on the Wall in 1982, more than a year before it occurred to Noir, Bouchet, and Citny. Their impromptu plan to paint whole swathes of the Wall, however, threw open the floodgates, prompting a deluge of others to do the same. Some of those artists' quirky and complex works far outshone those of Noir and company. Moreover, the Wall painters weren't alone in tapping the Wall for art's sake. Fashion designers (using the Wall as a stage to model new designs), photographers, performance artists, and sculptors took it upon themselves to capture and recast the essence of the Berlin Wall. With its ever-changing mien, the Wall became West Berlin's biggest tourism draw: the world's longest art gallery, free of charge.

The ethics of treating a moral monstrosity such as the Berlin Wall as a canvas were contentious from the start. When painting on the Wall, Noir and Bouchet were regularly accosted by

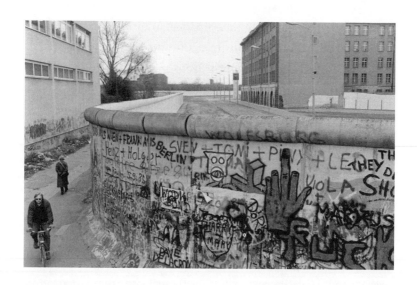

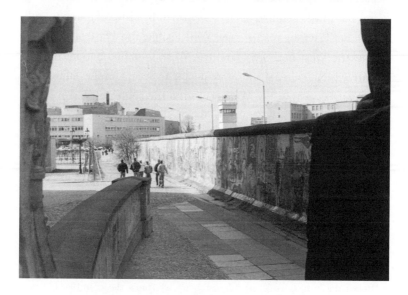

TOP Berlin Wall as seen from West Berlin, and behind it the
death strip, property of East Berlin.

BOTTOM Berlin Wall, 1987.

onlookers who objected to their mission, arguing that decoration depoliticized it, turning the Iron Curtain into something fun and frivolous. It was no coincidence that the first to paint the Wall were foreign nationals, not Germans. "For Germans the Wall was the greatest taboo ever," says Noir. "It was a national disgrace that they called the 'wall of shame.' No German would consider turning it into a work of art."*

Noir, Bouchet, and Citny argued that they sought to "demystify" the Berlin Wall by exposing its vulnerability. The oppressive, immutable, aggressive aura of the Cold War's most symbolic bulwark *could* be breached—by painting it with bright comic figures. Turning the Wall into a work of art violated borders and shifted meaning. It reconfigured the Wall, the way the squatters recast the *Mietskasernen*, yanking them loose from the meaning that until then had been determined by elites of another era. And, not least, by making the Wall visible, the Wall's art jarred loose the West Berliners' (and the West's) ossified notions of the Wall, which had enabled many people to accept, and even to like it. *Mauerkunst* put the Wall back into the center of Berlin with a bang, opening a furious discussion about the Wall, some of it taking place on the Wall itself.

Noir's cartoonish eggheads in bright red, yellow, and blue with bubble lips or bucked teeth and a single googly eye, which became his signature, called out and mocked the dictatorship, and the absurdity of the militarized barrier upon which its existence depended (see photo, page 297). Wall art brought color to West Berlin, too. The artwork—if understood as a provocation

*In fact, it was the German artist Joseph Beuys who broke the ice in 1964 by proposing that the Wall be raised five centimeters (two inches) in order to maximize its aesthetic proportions. The gag generated an outcry from those who failed to pick up the irony, and laughs from those who did. His aim was to neutralize the Wall by turning it into readymade art à la Marcel Duchamp.

designed to out embedded truisms—stood soundly in the tradition of the pranksters of the Situationist International and Kommune I. One artist, for example, painted ladders from the ground up to the Wall's lip. He thus turned the East-West equation 180 degrees, as if to say: West Berlin was walled off too, just go ahead and try to leave it. Or perhaps the anonymous artist intended to admonish westerners: "Climb over the Wall and see what's going on in the other half of the city. We're not alone here." Another work, *Tear in the Optic*, consisted of mirror shards glued to the Wall. It, too, forced the viewer on the western side to reflect on him or herself, not just on the dictatorship across the death strip. Wall art wasn't an ideological, one-sided diatribe against the East, as it's sometimes portrayed. Its subject was all of Berlin.

Since defacing the Wall, which was GDR property, was a criminal act, Wall art no matter who made it was a means of occupying and reinterpreting space. Just as Kreuzberg's condemned buildings didn't belong to the squatters, the Wall didn't belong to its artists. Anywhere from three to six yards of territory to the Wall's west belonged to the GDR, too. There were low door-like hatches in the Wall that East German border guards could pop out of at any moment. At first, the Rauch House crew only painted by night, at all times ready to sprint back to West Berlin territory should the situation get dicey. They tried not to unduly annoy the East German border guards by, for example, throwing paint buckets and other trash over the Wall.

For the most part, the East German authorities left the artists in peace. But their patience had limits. Noir and Bouchet planned to fasten a door to the Wall and paint sphinxes on either side of it, as if the door led to treasures like those in the tombs of Egyptian pyramids. At five in the morning, Noir and Bouchet, followed by a West Berlin television team, drilled screw anchors into the concrete and attached a metallic basement door.

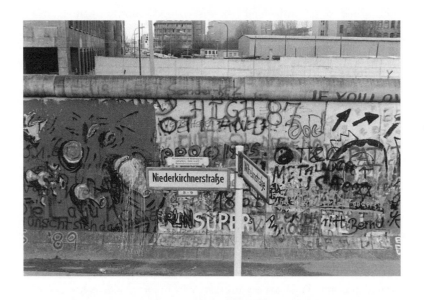

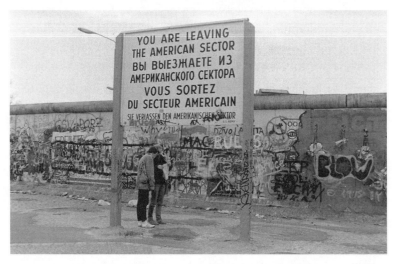

TOP Berlin Wall, West Berlin, late 1980s.

BOTTOM Berlin Wall, West Berlin, 1987.

Suddenly, one of the cameramen yelled: "Hello, back, everybody back, fast!" Noir looked up to find himself face to face with a GDR border guard peering over the lip, who then disappeared again. This was enough for the television crew, who headed home. Noir and Bouchet resumed work until the soldier poked his head over again. Backed up onto West Berlin soil, the artists watched as four guards, two with automatic weapons, climbed over the Wall, unscrewed the door, and unceremoniously tipped it into the border strip. Another time, Bouchet affixed a urinal, a sink, and a pair of shoes to the Wall as a homage to the French Dadaist Marcel Duchamp. The next day it was gone. From then on, Bouchet and Noir relied exclusively on paint to make their points.

All manner of artists flocked to the Wall: professional artists, tourists, school kids, graffiti writers from across the globe, nutcases. Noir was initially chagrined to see his work defaced by someone's tag or another image. But in time this became part of Wall art: it was pirate, temporary, and unprotected; turf that no one artist or state owned; antihierarchical and anonymous. Messy mélanges of the work of five or six or more artists and graffiti writers on top of one another was Wall art too (see photos on facing page). Among the big-name artists who helped decorate and deface the Berlin Wall in the course of the 1980s was Keith Haring, the American who made a name for himself painting vacant spaces in the New York subway system. Near Checkpoint Charlie, he painted an interlocking chain of red and black human forms against a bright yellow background (the colors of the East and West German flags).

Whatever the multitude of Wall artists intended—their motives and meanings ran the gamut—they drew attention to the Wall and reinvigorated its potent symbolism of a Europe divided: one side bright, defiant, and freewheeling; the other gray, oppressed, imprisoned. *Mauerkunst* was art from below, a

kind of punk art, or postmodern Dada. Whereas Dada crit-iqued the senselessness and moral perversion of World War I Europe, the kilometers of Wall art—kooky, insolent, playful—did the same for Cold War Europe as it entered its fourth decade.

The Other Side

I wasn't the only non-German baffled by many West Berlin-ers' disinterest in East Berlin. The scene dwellers were guilty of viewing the entire GDR as one lump pack of badly dressed, authority-abiding clones. The West Berlin DJ Motte told me there was no reason to care about it, other than the fact that East Berlin's existence made West Berlin's possible. Käthe Kruse says that she considered a day trip to the East as a waste of time and money. "You could walk around all day and not find one thought-provoking thing," she says. Blixa Bargeld, a native West Berliner, had visited the East once on a school trip to the Per-gamon Museum, to see its world-famous reconstructions of the brilliantly colored Ishtar Gate of Babylon. He didn't go again until 1989.

I didn't share their indifference. On the contrary, the GDR was terra incognita that I was impatient to explore. What intrigued me most was that while grossly deficient in so many ways, East Germany was a living, breathing, functioning system that did things—from recycling to macroeconomics—differently than in the West. This told me that society didn't have to be ordered the way it was in the West—or, for that matter, in the East, either. Alternatives *were* possible. I was also curious how a state that called itself "socialist" could have so little to do with Marx. Was the GDR a rigid dictatorship and nothing more? Could anything positive be taken away from it? And, just as intriguing, I wanted

to know how ordinary people there lived. What did they have to say about the system of "real, existing socialism," as the East German authorities called it?

Since there was a minimum of deutsch marks (about twelve dollars' worth) that you were required to convert into East marks, a trip to East Berlin was a pricey treat for the average student. Yet, when we did go, the twenty-five East marks were more than most tourists could spend in a day in East Berlin. Thus one mandatory stop for me and my small clique of international student friends was the Karl Marx Book Shop on Karl Marx Allee, where all of the seminal texts of Marxism were available and at subsidized prices. We'd return through Checkpoint Charlie loaded down with handsome, hardcover volumes of Marx and Engels. (A shock and disappointment: neither the Karl Marx nor other bookshops in the city stocked Hegel—nothing, nada—a stinging indictment of the regime's intellectual dearth. Likewise, Hegel Square in East Berlin behind the university was a puny afterthought of a space, the Hegel bust on it equally small and mediocre.)

A trip to the East was always a gas. Anything could happen. In addition to books, there was more than enough East cash for a meal and plenty of alcohol. The GDR's traditional German fare beat anything like it in West Berlin, not a city known for its culinary specialties. The department stores were notoriously spartan, but you could find wonderfully kitschy items such as black-red-and-gold wall clocks with hands in the form of an engineer's compass and hammer, the East German coat of arms. This kind of gimmick was good for laughs long after the purchase.

For months we'd been looking forward to a particular Saturday in June 1986 when we'd planned to visit the East again. The occasion was a concert of the Cockney troubadour Billy Bragg,

who was performing at the outdoor amphitheater in East Berlin's Volkspark Friedrichshain. A Billy Bragg concert in West Berlin or anywhere else would have been cause for excitement, but a gig in East Berlin was too cool to be true—and, indeed, it almost wasn't.

We set out to the Friedrichstrasse border crossing, me wearing cut-off Bundeswehr fatigues and a "Nicaragua libre" T-shirt with a red-and-black stencil of revolutionary hero Sandino on its front. My friend Astrid was punked out, face painted with eyeliner and lipstick, and the others similarly spiffed up. At the Friedrichstrasse crossing, the GDR border guards took one look at our contingent and ushered us into a windowless compartment filled with other rejects: drunks, a few minors, a skinhead, a couple attired in gothic black. After two hours of sitting and wondering nervously about our fate, we were tersely informed that our applications for day visas had been denied—and that there'd be no explanation for this decision. The guard on duty then wordlessly showed us the exit.

Five longer faces would have been hard to find. Astrid's tears streaked makeup down her cheeks. In the end, though, ingenuity trumped bureaucracy. We returned to Astrid's seven-woman collective apartment in Kreuzberg where the composition and genders of overnight guests on weekends was anyone's guess—as was the ownership of unclaimed clothing lying around. (The women made all their own clothes, so one corner had a sewing machine and a heap of odds and ends.) We shed the offensive garments, wiped off the makeup, donned button-down shirts and long pants, and slung cameras around our necks. We U-Bahned to Checkpoint Charlie, a different crossing point, where we smiled, spoke broken German on purpose, and waltzed through the border without a hitch. It was a gorgeous summer's day in East Berlin.

The Billy Bragg concert lived up to all our expectations, punctuated by a flash storm during which concertgoers, including a group of buff young cadets, stripped off their shirts and danced in the shower. We fell into intense conversation with two sincere, good-natured young men with long hair who took us vodka-drinking at Café Moscow. Finally, we had met people of roughly our peer group! We made plans to rendezvous a week later, and promised to bring the latest Billy Bragg album with us. Just minutes before the midnight curfew (and thus expiration of the day visas), we bolted out of Café Moscow, running to make it to the crossing point, out of breath but just in time.

As promised, we returned a week later to reconnect with our new friends. But the guys didn't show. We stood there in the drizzle with the album in hand wondering if we'd been duped. Had they been secret police agents? Or had informers spotted them with us and given them away? Or did they assume we wouldn't show? We couldn't know and never did, but it scratched some of the luster off the memory of an otherwise perfect day.

Part II

EAST BERLIN

5

Flowers in
the Red Zone[*]

Don't perish in the waiting room of the future.

—**PUNK GRAFFITI IN EAST BERLIN, 1982**

We always said: New York is where we are.

—**UNDERGROUND DESIGNER SABINE VON OETTINGEN**

ONE OF MY COLLEAGUES ON THE WEST BERLIN CON-
struction site had a résumé unlike the rest of the crew's worka-
day Berliners. Chris, who sported a red beard and leather cuffs,
told me stories about his driving a semi-trailer in Scotland in the
late 1970s. When the other workers cracked the first beer of the
day around one o'clock, he'd roll a joint. With an oversized drill
bit, he drew a map of Berlin for me in the cement dust. "Pren-
zlauer Berg," he said, tapping the bit on a spot to the east of the
Wall. "Things are happening there, too." The zone's not dead, he
told me with a grin, making a slangy reference to the east side,
the Soviet zone of occupation.

* "We Are the Flowers in the Red Zone" was the title of a mixed cassette of
underground GDR bands.

I found Prenzlauer Berg on one of the maps that showed East Berlin's streets and public transportation lines. A testament to the completeness of the city's division, some West Berlin maps included only the western side of the city. Almost all of the GDR's maps showed just the east side, with West Berlin as a blank space labeled "Special Political Entity West Berlin." (This posed problems when the Wall fell. Lost easterners could be found wandering the streets in the West with East Berlin maps that showed nothing in West Berlin save green spots for unnamed parks and blue spots for lakes and rivers.)

In early 1986, I ventured to East Berlin with a handful of my coterie intent on checking out Prenzlauer Berg. If Berlin were the face of a clock with the west on the left and the east on the right side, Prenzlauer Berg would be located toward the center, roughly between numerals one and three. The district's urban neighborhoods, covering about seventy city blocks, were three short tram stops from the government's seat in the capital city of the GDR, where the Communist Party headquarters, its rubber-stamp parliament called the Volkskammer, and the offices of the politburo, the party's executive committee, were located.

We hoofed it from Bahnhof Friedrichstrasse, where we entered East Berlin, through the district of Mitte over to the landmark TV tower and the cubic postwar high-rises of Alexanderplatz, the East's own showcase of modernism. From there we hiked north into the neighborhoods of Prenzlauer Berg. *Berg* in German means "mountain," which is misleading in the case of Prenzlauer Berg, since it has no mountains save two *Bunkerberge* in one of its parks, pint-sized hills fashioned out of massive, above-ground Nazi bunkers dynamited by the Soviets in 1945 and covered with tons of rubble and then topsoil. Still, it's one of the few districts in Berlin that's not as flat as a pancake.

The dramatic contrast between it and the GDR's refurbished city center left us sputtering for words. Prenzlauer Berg's old breweries and *Mietskasernen* stood in states of ruin—a hinterland that tourists weren't supposed to see, and indeed few ever did. The pockmarked tenement buildings rose up from the narrow streets like the walls of a giant urban canyon. They exhibited few signs of life: here and there a flower box on a sagging balcony, an open window, a corner beer bar. Most of the first-floor shop fronts were shuttered up and, by the looks of it, had been for years. Not a snippet of advertising or graffiti livened up the gray-brown cityscape. In the spooky silence of the pitted cobblestone streets we gaped at block after block of forlorn structures, their disrepair more extreme than those in all but Kreuzberg's roughest corners.

We walked and walked, on the lookout for any sign of something happening, as Chris had promised me there was—or someone who looked like they might know about it. But nobody, nothing. We poked our heads into a red brick and mustard yellow terracotta Protestant church on an out-of-the-way square called Zionskirchplatz, which lay at the top of an intersection of three sloping neighbor streets. Its doors were unlocked so we ventured in, finding carbon-copied hymns on coarse sheets of paper scattered among the thickly hewed pews. On a whim, we scaled the rickety wooden ladders that one after another zigzagged up to the belfry, where we peered across the city from up on high. The austere Gothic church exuded the strong vibe of a place verboten to outsiders. Since we'd already had run-ins with East German officialdom, we crept out of the silent building, quickly turned a corner, and jumped the next tram, wondering if we'd been in the right place at all.

Something *was* afoot in East Berlin, but you weren't going to stumble upon it by chance. One needed a personal contact from

someone in the know—and although those people existed in West Berlin, I didn't know them. The GDR's underground scene was well camouflaged, out of sight not just to tourists but to most East Berliners, too. Oddly enough, we'd been roaming exactly those neighborhoods where much of East Berlin's bohème made its home and had its haunts. In autumn 1989, Prenzlauer Berg and its Protestant churches, including the Church of Zion, would be the locus of the "peaceful revolution" that overthrew communism and ended the Cold War.

The Antifascist State

East Berlin wasn't barren. On the contrary, the city's artists and democratic agitators dug deep into their collective imaginations to find novel ways to fuse politics, the everyday, and culture. Indeed, they had no choice but to do so in a country where political expression through media and public assemblies wasn't an option. During the 1980s, East Berlin's underground strove mightily to utilize what they had to live self-determined lives in the recesses they'd created—and to defend them against an immensely powerful, resolute state. The scene received a helping hand from peers in West Berlin, a little-known phenomenon. But credit for the parallel world that they forged between the cracks in East Berlin, and the political spark that they ignited, lies with them alone.

The German Democratic Republic was a dictatorship both in principle and by necessity. Though the GDR's fathers labeled their top-down rule as "democratic centralism," a term coined by Lenin, in practice it was rule by the elite leadership of the Communist Party, in the GDR called the Socialist Unity Party. The state functioned as a paternalistic regent that defined the

parameters for its charges in the public sphere as well as in private. In return for compliance, the state guided and cared for the individual from cradle to grave: in state-run nurseries and schools, in universities and professional training centers, in the job market, and into old age. Every GDR citizen was promised education, health care, and a job in the country of workers and farmers.

At the same time, East Germany was itself a charge—of the Soviet Union. The GDR was among Moscow's most loyal satellites, which held the Cold War front line against the West and functioned as a reliable cog in the East bloc's command economy. East Germany's top cadre took orders from Moscow and, though they sometimes chafed under the yoke, they never said no.

The GDR, like other Soviet-allied nations across Eastern Europe, was also a dictatorship by necessity: never having had the majority support of its people. Since its formation in 1949, the GDR resisted free elections, though the East Germans were regularly called upon to queue up for fake votes in which the Communist Party and its proxies stood alone on the ballot. The party wouldn't have won a fair election at any time in the postwar decades.

The party was all-powerful only because it could rely on the services of the Stasi, officially the Ministry for State Security, or MfS, which was a vast intelligence agency and no-nonsense secret police rolled into one. Every Soviet bloc state had such a service but, with the exception of Romania's Securitate, only the exceptionally hard-line GDR had one as intrusive as the Stasi, the tentacles of which reached into every crevice of daily life. Through blackmail, intimidation, and payoffs, it permeated the little country of seventeen million people with informers in elementary schools and soccer teams, village administrations and industry, from the Baltic Sea to Saxony. Even punk bands were infiltrated. The Stasi was feared and thus largely obeyed by a population

resigned to the quid pro quo of relative comfort and lifelong security in exchange for keeping head down and working hard.

The GDR communists of the 1960s and '70s had initially been more ambitious than that, hoping to sculpt a "new socialist person" out of the German *Volk*: enthusiastic, motivated socialists, not simply subjects who obeyed out of fear. The new socialist man or "socialist personality" would be optimistic and forward-looking, disciplined at work, and a caring parent to a new generation of little socialists, preferably two per family. The second of "The Ten Commandments of the New Socialist People" stated: "You should love your fatherland and be prepared to employ your whole strength and abilities to defend the state of workers and farmers." The defeat of capitalism in East Germany, they concluded, created the conditions for such a person to emerge and live as an equal, class-conscious member of the proletariat. But until this new man actually took shape in the here and now, the state's remit was to assist in its formation, which required yet more intervention in the private sphere: prescriptions on how to live, raise children, listen to music and appreciate art, exercise, as well as other lifestyle matters. Culture played an essential role in this grand experiment, the purpose of which was to inculcate the emerging socialist person with the values of the Soviet-style system, which he or she would live by.

In the late 1960s, when the student movement was roiling West Germany, young people were on the march in neighboring Poland and Czechoslovakia, too. In East Berlin and elsewhere in the GDR, nonconformists also struck out on their own, though they were far fewer in number. East Germany still languished under Stalinist rule, despite the Soviet leader's death more than a decade before. The GDR's number one was Walter Ulbricht, a steely hard-liner who had applied Soviet logic to the letter since the GDR's founding. Proudly old-school, Ulbricht had been the

German Communist Party's Berlin chairman in the Weimar Republic's turbulent final years, who after underground stints as a Comitern agent in Paris and Prague took refuge in Moscow in 1938. His experiences from the day, as well as in the wartime Soviet Union, were seared into his political memory and reflected in every aspect of the GDR's governance.

Yet the ideas in the air in late 1960s West Berlin wafted over the borders, and East German young people picked up on them. Of course, it was out of the question that students in the GDR call to life an organization like the Socialist German Student Union, or SDS, the West German students' umbrella association with its revolutionary political aims and a personality like Rudi Dutschke at the fore. It would have been quashed at once, which is exactly what happened in August 1968 to the Czechoslovak student campaign, under the weight of Soviet tanks.

Frank and Florian Havemann, the college-age sons of scientist and dissident Robert Havemann, understood themselves as constructive critics of GDR socialism, much like their famous father. In this vein, they were keenly interested in West Berlin's lifestyle experiment par excellence, Kommune I. The Havemanns set up Kommune I East in Samariterstrasse in Friedrichshain, which they envisaged as a testing grounds for a progressive socialist lifestyle. Like Kommune I West, the communards ventured onto the terra incognita of psychoanalysis and antiauthoritarian child-rearing.* In study groups they cracked open Marx, Engels, and Lenin, reading the great theorists of socialism in the context of the late 1960s rather than Walter Ulbricht's 1930s. At one point, three of West Berlin's

* The promiscuity as politics hyped by Kommune I West wasn't an issue in the East as the atheist regime had no moral qualms about sex. Since the GDR's list of verboten fun things was long, on sex East Germans got a free pass.

Kommune I members, Rainer Langhans, Fritz Teufel, and Dieter Kunzelmann, crossed over to meet with their protégés; but, ominously, the parley ended on an awkward note, the two parties disagreeing fundamentally on the meaning of socialism. The confusion was evidence of the wholly different contexts of the respective communes and the widening gap in perception between East and West Germans.

It wasn't long before the Ulbricht regime got wise to the experiment and crushed the commune, jailing two of its members for fliers expressing solidarity with the defeated Czech and Slovak students. In the end, long hair, jeans, and rock music were what this generation of East Germans took away from the 1960s. There was no long march, no mass social movements, and no culture revolution following in its wake.

Ulbricht's fall in 1971, a consequence of friction with Moscow, and Erich Honecker's succession briefly shifted the winds against the GDR. Honecker was no stranger to East Germans, as he had held one high post after another in the GDR, including as secretary for security matters during the Wall's construction, which made him anything but an innocent bystander. Nevertheless, in an effort to sugar the pill of state socialism, Honecker proclaimed a new, post-Stalinist era of cultural diversity in the GDR—which ended up lasting nearly five years. Both within official spaces and outside of them, too, artistic fantasia flourished as never before in the GDR. Galleries opened themselves to experimental painting and other arts. *Die Legende von Paul und Paula* (The Legend of Paul and Paula), one of the GDR's finest films, was a glimpse of what East German creatives had in them when given the chance to show it. On the stage, in particular the Volksbühne in downtown Mitte, the Swiss director Benno Besson, a committed communist, pushed the GDR's flexibility to its limits, ushering in a short golden age of theater.

But this burst of measured freedom screeched to a halt with singer-songwriter Wolf Biermann's de facto expulsion in 1976. The musician's cutting lyrics were more than the thin-skinned political elite could take. Thus the state took advantage of Biermann's concert tour in West Germany to simply slam the door behind, forbidding him to return. The country's artists and critical intellectuals swung behind Biermann, prompting more arrests and expulsions in the East. But the troubadour wouldn't return, nor would the easygoing days of the early 1970s.

With the dictatorship's about-face, a process of disillusionment began in which many of the GDR's critically minded creatives gradually gave up on the state and its iron-cast version of socialism. Ever fewer showed themselves willing to bend over backward to devise clever arguments or make veiled jabs intended to coax the state out of its comfort zone. Many artists and intellectuals turned in their party cards and withdrew into their own worlds. If they couldn't affect politics even indirectly or share the public stages with regime-loyal artists, then they'd focus on their own projects and persons. But for this they required *Freiraum*, or free space, something treacherously hard to come by in the GDR.

Prenzlauer Berg's Bohème

By the late 1970s, all of the GDR's major cities had concentric circles of opposition groups and underground subcultures. East Berlin's, though, were the most cultivated—and their bastion was Prenzlauer Berg, the center of and synonym for East Berlin's bohème. Despite the fact that the GDR capital was crackling with Cold War tensions, the inner-city geography of Prenzlauer Berg and its adjacent neighborhoods of Friedrichshain and Mitte lent to

them the purposes of opposition and art. The essential infrastructure of the underground was the dilapidated rental barracks, the same type as those squatted across the Wall in Kreuzberg.

Living space was among the scarcest of the many scarce commodities in the GDR. Even people with party credentials had to wait on lists, for years, to obtain their own tiny apartment. GDR burghers joined the party and married young just to jump ahead on the waiting lists—and move out of home with Mom and Dad before they turned thirty. The exceptionally early marriages were one prominent factor in the GDR's sky-high divorce rate.

But the GDR's city planners, just like West Berlin's, saw the old tenement buildings as dinosaurs. Across the GDR, war-pummeled neighborhoods were dynamited and modernist blights, in the GDR called *Plattenbauten* (literally "concrete-slab buildings"), replaced them. It wasn't greedy developers and corrupt politicos who drove the building frenzy, but rather the logic of GDR socialism. The functionalist, egalitarian block projects were considered the housing appropriate for the cog-in-the-machine socialist. Not coincidentally, its design enabled the authorities to oversee and control its inhabitants with precision. Even though West Berlin's somber estates such as Gropius City had become synonymous with social ills and anomie, the East Germans marched blindly into the same morass. Some of the by-products of these alienated spaces were the neo-Nazis and violent soccer hooligans who in disproportionate numbers called the high-rises home. Nevertheless, most of the tenements' ordinary residents considered the swap a no-brainer. The brand-new apartments featured bathtubs and showers, washing machines, winter-proof windows, all-your-own toilets, central heating, and even telephones.

The urban flight, in addition to politically motivated expulsions and stepped-up legal migration, left thousands of

abandoned apartments more or less for the taking. Whole floors and wings of buildings were empty; courtyards once filled with children were piled high with junk and carpeted in moss. This was *Freiraum* in quantity, if you were prepared to break a few laws and apply elbow grease to claim it. In doing so, you could circumvent the state and pick your own housing—regardless of party affiliation or job status.

Squatting in the East followed a different playbook than in West Berlin. The first step entailed scoping out a vacant apartment: one without curtains or lights on at night. An empty mailbox, a broken window, or untended balcony were telltale signs that had to be monitored over weeks. Then one had to enter the residence, which in the best of cases simply meant picking the lock. If that didn't work, the lock had to be kicked in. Ideally, the neighbors should be out. After breaking in and then repairing the door, the scam then was to obtain the building's bank account number and begin paying rent. After three months, if you could prove that you'd kept up payments, the housing authorities slapped you with a fine for breaking in, and then issued you, a recently confessed criminal, a proper lease. This was squatting East Berlin style: tactical, nonconfrontational, full of contradictions.

The 1954-born Harald Hauswald belonged to a generation of Prenzlauer Berg dropouts before the punks and new wavers. Called hippies, tramps, or long-hairs, in the 1970s they populated their own milieu in the neighborhoods north of Alexanderplatz. After dropping out of a photography apprenticeship, Hauswald, beanpole thin with a ponytail and unkempt beard, left his small hometown north of Dresden, helping himself to his first walkup in a Prenzlauer Berg courtyard on Choriner Strasse. He landed a part-time job as a telegram deliverer, a plum gig for Hauswald, who while on the job strolled through

the city with a camera around his neck shooting street scenes and workaday Berliners.

Hauswald's eye was drawn to scenes that didn't fit into socialism's mold (see photos, pages 137–38). In the old buildings and narrow side streets, Hauswald uncovered a rich menagerie of Berliners: the elderly and obese, drunks, maimed war veterans, garbage pickers, lonely widows and widowers, and other souls left behind like beached seaweed at low tide in the condemned topography. We're uniquely indebted to Hauswald for this work, as it furnishes us today with a glimpse into a now long-lost world. Few others cared enough to risk the penalties of capturing it on film. Hauswald, though, obviously perceived great beauty amid the melancholy in Prenzlauer Berg and he chronicled the simple, down-to-earth joys of common folk dancing, drinking, and sharing company with one another in the anodyne watering holes they called their own. Their lives were woven into the urban fabric of these neighborhoods in a way unthinkable in the impersonal expanses of the new housing projects.

Indeed, the cracks and crevices of the *Mietskasernen* offered the system's malcontents some degree of cover for their artistic projects and nonconformist lifestyles. Speiche,* one of the GDR's seminal punks (see photo, page 141), claims that at one time he held keys to seven apartments, only two of which he ever slept in, depending on where the partying had deposited him the evening before. The others he lent to a silkscreener, painters, and visiting anarchos from Poland and Hungary. Some of the East German squatters had "open flats," namely apartments that anyone in the know could access, the key hidden behind a loose brick in the wall or under the doormat.

* Speiche earned this nickname as he was a thin as a bicycle spoke, *Speiche* meaning "spoke" in German.

TOP In 1987, seniors in East Berlin under a Communist Party banner that reads, "Peace isn't just being—it's doing!"

BOTTOM In the East Berlin subway, the U-Bahn, mid-1980s.

TOP At a café off Alexanderplatz in East Berlin, 1980.

BOTTOM Child playing on Kastanienallee in Prenzlauer Berg, 1985.

Just by organizing space independently of the state, this community was disputing the state's claim of total control and exercising democracy, too. Every informal reading group, shared flat, or punk band had to devise a way to organize itself, make decisions, run discussions or projects. In all of the official organizations, this was the party's prerogative. The East Berlin bohème started from scratch and made up democracy as it went along.

Tiny shoots of civil society poked up in the left-behind spaces of East Berlin's working-class tenements. Students, newcomers from across the GDR, and other restless types trickled into the old neighborhoods. The scene wasn't held together by anything more than its diverse partisans' desire to do their own thing, to the extent one could in a dictatorship. A plethora of subsets and cliques, artist groups and bands, came to call Prenzlauer Berg home. Practice rooms for musicians and artist studios were there for the taking. Unofficial projects established themselves in back rooms and cellars, such as the Zinnober puppet theater on Kollwitzplatz, which wove alternative values into classic German fairy tales. Private galleries dotted the neighborhoods, apartments, or other spaces that held small, short-lived exhibitions, news of which was passed by word of mouth. The apartment of Gerd and Ulrike Poppe in Rykestrasse and the workshop of ceramicist Wilfriede Maass hosted regular (and irregular) readings, followed by wild, red-wine-fueled parties. The circles were small, and eventually everybody had slept with most everybody else, I was told. An array of bars and cafés, such as Café Mosaik, Fenglers, Café Nord, and Wiener Café, became known as places where the scene met and drank until morning. After a while, the establishments' managers, either fed up with the debauchery or pressured by the police, closed down or simply made the black sheep unwelcome. The partying then gravitated to other establishments or back into private homes and ateliers for a while.

Hauswald was everywhere in the underground's circles, fascinated by their breadth across mediums and generations. He gave a face to the GDR that the authorities wanted no one to see. Indeed, Hauswald was one of the few photographers who had the full trust of the opposition groups and subcultures, which was critical, as cameras threw up red flags. After all, the Stasi could have no more valuable a spy than one snapping pictures at illegal happenings. Hauswald was particularly at home among the alternative designers, fashion photographers, and models who helped fuel the creative chaos of Prenzlauer Berg with flamboyant alternative fashion shows held in courtyards and private apartments. These designers, like the women of the independent group Allerleirauh, clothed the bohème, providing its denizens with funky alternatives to department-store frump. So high was the demand for their products, Sabine von Oettingen, one of the group's leading lights, told me, they could never make enough of it.

Time was a commodity that the East Berlin bohème had in great supply. Getting by on little was easy, as rent, public transportation, and food were all subsidized in the name of the working class, the low prices fixed by the state. Time was so abundant that fending off boredom could be onerous, a phenomenon astutely pictured in Jürgen Böttcher's classic 1966 film *Jahrgang '45* (Born in '45). A measure of the slowness of time was the way the Prenzlauer Bergers communicated with one another. Since almost no one had a phone, if you wanted to liaise with a friend, you'd wander over to his or her place. If the friend wasn't in, you'd use the pencil and roll of note paper hanging from a nail on the doorframe to say you'd stopped by. The next day, the friend might drop by your apartment. If you were out, you'd receive a note. Eventually, you'd meet up, maybe a few days later in Mosaik or on Kollwitzplatz, at a party or another friend's

East German punk rocker Speiche and his girlfriend, Tupfer, in 1988.

place. There was no hurry in Prenzlauer Berg; the quarter's artistes had endless hours to dabble and tinker, think and reflect.

Prenzlauer Berg's bohème came together like a jigsaw puzzle, piece by piece. There was nothing premeditated about it, but at some point in the 1980s, it was there, a lively and original community of loosely networked individualists. The youthful anarcho-punk circles constituted one piece of it. The scene's core constituents, though, were a generation older than the punks, figures like the artist Bärbel Bohley and poet Sascha Anderson. Anderson was the scene's linchpin, known to everybody and with his finger in every pot: bands, ceramics, samizdat publishing,* connections with West Berlin intellectuals. What the bohème didn't know was that Anderson was working for the Stasi as an informer, playing a double game all along. And he wasn't alone.

The Berlin Wall was ever-present in the lives of the East Berliners and is one prominent subject of Hauswald's work, even though an image of the Wall itself never appears in his GDR-era work. Because photographing the antifascist bulwark was prohibited, as well as the fact that it was nothing but an unadorned, blank cement wall, there are, in stark contrast to the West Berlin side, few photographic images of it today. But Hauswald found other ways to convey its reality. One such photo, a posed shot, sums up the dilemma of the GDR's disaffected young people. In it, a man and woman stand in a brick-strewn lot where a building once stood. The couple—the woman fully naked, the man wearing only a leather jacket— are standing beneath a brick wall about the height of the Berlin Wall itself with a tall wooden ladder leaned against it. The couple stares into the camera as if to say: this is our choice, remain

* Samizdat was the term applied to the East bloc oppositions' self-made, self-distributed, and thus illegal fliers, newssheets, and other literature.

among the ruins, stripped bare of dignity, or climb the ladder out of the GDR.

Too Much Future

The East German Protestant church was one of the few non-communist institutions in East Germany with a modicum of independence. From day one of the postwar occupation, the church fought fiercely to keep the communists from proscribing its activities in the East, where the vast majority of Germans are Protestant. Though the churches were virtually empty on Sundays, they were critical to the anticommunist underground. Dissidents and free thinkers enjoyed a degree of protection under the wing of those parishes with courageous pastors. And the Protestant church was more than just a toehold for the political opposition; it would contribute decisively to the overthrow of the communist regime and the country's democratic rebirth.

The Church of Zion regularly lent its premises to independent-minded groups whose activities the state refused to sanction. Nothing happened in the GDR without Big Brother's say-so, and the state zealously guarded every square meter of space, delimiting the *Freiraum* that troublemakers could exploit. In one sense, East Berlin was awash in free space as abandoned apartment buildings and disused factories dappled Prenzlauer Berg and neighboring districts; but the GDR dictatorship policed it vigilantly, on guard for anything that looked "conspiratorial." In the church sanctuaries, the punks held ear-splitting concerts, alternative clothes makers staged far-out fashion shows, and an array of democratic oppositionists printed samizdat. The activists of the Umweltbibliothek, or Environmental Library, even had an open-to-the-public café and gallery in parish rooms on

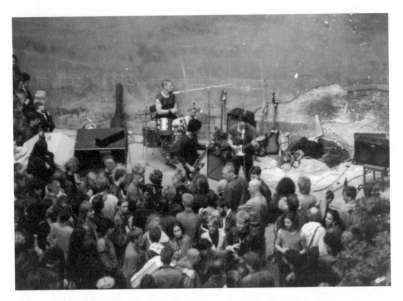

Punk band Antitrott in an East Berlin courtyard, June 1987.

the second floor, the only one of its kind in the GDR. All of the opposition, and the church too, wielded culture and lifestyle as political weapons.

It was a year and a half after my first foray into Prenzlauer Berg, on an October night in 1987, that events at the Church of Zion on Zionskirchplatz catapulted the shrillest protagonists of East Berlin's underground into the public spotlight. The state authorities knew much about the scene—thanks to the long arm of the Stasi—but had until then strained to shield it from the eyes of law-abiding citizens, as well as the wider world. The party line dictated that the workers' and farmers' state required only one culture: that of socialism. The existence of punks, goths, heavy-metal heads, graffiti sprayers, skinheads, skaters, rappers, poppers, and others—all subcultures born in the West—was mortifying confirmation that the state had lost control of one

segment of its populace. And, damningly, it was the youngest, kids born and raised in the GDR: in other words, the future of socialism.

The underground's partisans in and around Prenzlauer Berg had eagerly anticipated the evening of October 17. Their own bands, persona non grata on the stages of the GDR's youth clubs, played sporadically in the churches, private residences, and discreet corners of public parks outside of the city (see photo on facing page). The names of the groups alone—Wutanfall (Fit of Rage), Rosa Extra (brand name of a GDR tampon), Unerwünscht (Undesirable), Schleim-Keim (Slime Germ), Planlos (Planless)—reflected the gist of their politics. Their lyrics, though, left nothing to the imagination. Punk in the GDR was the rudest, most direct, unswerving critique of the regime.

But that evening in the Zion church one of West Germany's most promising rock bands, Element of Crime, was playing alongside the dark wave Prenzlauer Berg cult band Die Firma (The Firm). The clandestine East-West gig had, as usual, been advertised by word of mouth. But so singular was the prospect of hearing such a popular West Berlin group, news of the concert had leaked out beyond insiders.

"We were excited because pulling off such a big concert would have been a victory for us," remembers Dirk Moldt, a leading figure in the opposition group Kirche von Unten (Church from Below). "Had it gone as planned, it would have shown that we, the subcultural and opposition scenes, had managed to carve out this *Freiraum* for ourselves, and of course it would show up the official state youth culture for the bore that it was," he says.

The chances of such an event falling through always loomed large—and the risk factor was particularly high in light of the unusual gig. Anything could go wrong: communication between East Berlin and West Berlin was laborious; the borders

themselves were unpredictable; and the scene was riddled with secret police informers. One word from above and the police could bust the gig in minutes and throw the ringleaders behind bars, as had happened before. But the logistics were in the capable hands of a twenty-two-year-old anarcho-agitator named Silvio Meier, also of Church from Below, who had superb connections to the West Berlin scene—not least through his exiled older brother, living in Kreuzberg—and had before acted as the point man between West Berlin bands, the church, and the underground.

By late afternoon, everything was falling into place. Element of Crime's five members had crossed the border on tourist visas and rendezvoused with Silvio Meier in a café near Zionskirchplatz. So as not to arouse suspicion, they brought neither instruments nor hardware with them. "We didn't know the ropes," Jacob Ilja, Element of Crime's guitarist, admitted to me, referring to the ways of the GDR underground. Ilja and I had met for coffee at Kapelle, a café on the square with a wide-angle view of the tall, nineteenth-century church. "Silvio was very aware of who was around us, on which side of the street we were walking, when we should talk and not. He was very cautious and we just went along with it," Ilja remembers. Element of Crime's willingness to play in the East—and to take the risks involved—illustrates that not all West Berliners were uninterested in the other half of the city. "We were curious what it would be like to play in a forbidden venue, in a church, in East Berlin," says Ilja. He added: "We had played in prisons and did other benefit gigs because we thought it was the right thing to do. This was in the same vein."

Although for the easterners the Wall was an insurmountable and cruel barrier that circumscribed their lives, there was regular truck of various sorts between East and West Berlin.

Western journalists, international diplomats, day tourists, and some privileged East Germans, such as older people and state-accredited artists, came and went pretty much at will. Some of them reached out to the hounded subcultures and opposition in East Berlin, and in doing so linked the divided city, however tenuously. As Meier and Moldt saw it, every such cross-border endeavor like the gig was more evidence that the regime didn't exert total control. By having unsanctioned West Berlin bands play in East Berlin churches, the oppositionists breached the Wall without crossing it themselves. Such a concert defied the state and opened up space—both intellectual and physical—in which independent thinking and activities could flourish. The Berlin Wall was only the most visible of the many walls that existed for the GDR's discontents, yet even it was porous when the will existed to circumvent it. Such East-West happenings were also testimony that the Wall-era generations of young Germans on both sides shared more than just a common tongue, despite the decades of separation.

Grainy black-and-white film footage from the concert shows a full house in the cavernous Church of Zion, probably a thousand people packed into the nave, some sitting on the backs of pews, others crowded around the altar, which was the stage. One frame catches a grinning Silvio Meier with a plastic cup of beer, a long earring dangling from his left lobe. The mood is obviously upbeat, but the temperature chilly as punks, hippies, and the church's staff dance in bulky clothing. If the underground revered one of its own bands above all others, it was indisputably Die Firma, whose dark, funereal sound and searing political lyrics hit home. An iconic photograph survives from one of the Zion church concerts, taken by Harald Hauswald (see photo, page 149). In the photo, Die Firma's guitarist André Greiner-Pol plays from the elevated pulpit, his left foot on its lip, electric

guitar resting on his thigh as he hunches over his instrument. His long shadow falls on the wall behind him alongside the oversized shadow of a crucifix that stands on the other side of the altar. The crowd gazes up at Greiner-Pol as if he were a messiah, the giant shadows of the guitarist and the cross highlighting the unlikely bond between the subculture and the church.

After Die Firma finished, Element of Crime played a long set using their counterparts' instruments. When the band finished its encore, Meier, Moldt, and the wary church staff sighed with relief. They'd pulled it off, they thought. But their relief was premature. "We had just finished our last song," remembers Element of Crime vocalist and songwriter Sven Regener. "Then we heard something at the other end of the church. We strained to see what it was, heard screaming, people scattered in every direction. We, of course, thought it was a police raid."

It wasn't the police, although there were plenty of cops stationed near the church. It was East German neo-Nazis—another current of the new subcultures—who had burst through a side entrance in attack mode just as the concert crowd was exiting. The thirty or so young men armed with bottles and clubs screamed, "Sieg Heil!," "Attack!," "Jews out!," and "Skinhead power!" and swung wildly at anyone in their path, dropping bodies to the floor. The skinheads were immediately recognizable to the Prenzlauer Berg set: closely shaven heads, green bomber jackets, high black jackboots. They'd been terrorizing the scene for years but had never entered a church or struck so boldly at such a well-attended event. Members of the terrified audience rushed out to the police officers standing at the edge of the church's property and pleaded with them to intervene. But the police wouldn't budge even as shrieks pierced the night air.

Some of the sturdier concertgoers finally got it together to

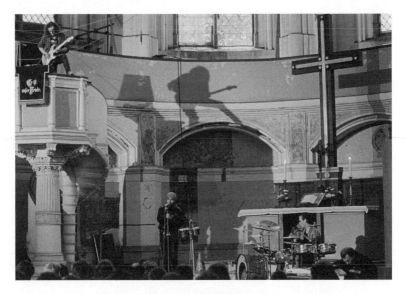

Musicians from the band Die Firma perform in
the Zion church in October 1987.

repel the intruders, which pushed the brawling out into the
churchyard before the outnumbered skinheads took to their
heels. The whole episode didn't last more than fifteen minutes or
so, but it constituted the neo-Nazis' most audacious attack yet on
their chosen rivals, the punks and the hippies.

Far-right Nazis in the GDR presented the state with an enor-
mous conundrum, since it was an article of faith in East Ger-
many that communism was immune to fascism. After all, when
Hitler took power in 1933, the Nazis persecuted social democrats
and communists remorselessly, sending them off to labor and
death camps. According to communist doctrine, fascism was a
form of capitalism: the most advanced state of bourgeois mar-
ket economics and class domination. By this logic, all capital-
ist societies were implicitly protofascist, including the United
States and West Germany. Communism, on the other hand, had

supposedly eradicated fascism "root and branch," which is what East Germany claimed to have done. World War II's leftover Nazis and their successors, so maintained the regime, were all in West Germany, where they'd reinstated themselves in the halls of power. The West's "belligerent fascism" was the GDR's ostensible justification for building the Wall, which it called "the antifascist protection bulwark."

The GDR authorities must have realized instantly that they weren't going to be able to sweep the Church of Zion episode under the carpet as they had lesser dustups in the past. The GDR's dirty laundry was now strewn across Prenzlauer Berg. There were Nazis in the antifascist GDR, so many that it couldn't just lock them all up, though it had tried to. Now the state had to explain why young East Germans, schooled from infancy to be good socialists, had turned to errant ideologies such as fascism and anarchism.

Indeed, the East German newspapers reported the delicate incident. The authorities had arrested suspects among the neo-Nazis shortly after the hullabaloo, including two West Berliners. This led the GDR media to the inevitable conclusion that Westerners had instigated the whole affair. The terse coverage in the East didn't begin to explore the episode's larger significance, which was that youth subcultures hostile to the tenets of state socialism had exploded in number since the early 1980s. The East German state had its work cut out for it: it had to stop those ideas and that spirit of defiance from infecting the population at large. After the Zion church free-for-all, this was going to be all the harder, but the GDR's officials were acutely aware that everything hinged upon it.

The episode also underscored that the East obviously wasn't as uniformly gray-toned as most outsiders assumed. The West Berliners shared the city with 1.2 million fellow Berliners.

Among them, the state's critics had fashioned a highly inventive, subaltern counterculture under ominous conditions—and at great risk. But if the westerners, or the East German government, assumed that the unconventional outfits and coiffeurs of the East German kids simply mimicked their West Berlin peers, they were grossly misled. This they'd discover later, when the GDR's democratic opposition finally threw caution to the wind and called out the dictatorship on the streets.

The explosion of the subcultures highlighted the GDR's plight in the 1980s. East German punks began appearing at the tail end of the 1970s, shortly after those in West Berlin. In the context of dictatorship, though, punk and its offshoots conveyed subversive meanings that upped the ante, for its adherents and the state. The intent of GDR punk was to challenge the state's claim to absolutism and to show up its stale, hackneyed message. And the GDR authorities, though they grasped little about subculture, understood this much. A punk concert in an East Berlin church wasn't just another concert; it was political protest with an unvarnished missive to the youth of the GDR.

The easterners didn't have anyone like Gudrun Gut in West Berlin who'd venture to London on their behalf. Just learning about new music and styles required curiosity and fortitude. The first strains of the fast-paced, three-chord melodies arrived across the borders thanks to Western radio and television, some of which were specially set up in West Berlin to broadcast eastward to "captive Europe." Listening to Western radio stations and watching TV wasn't illegal, although it was frowned upon. East Berliners received a wealth of nonsocialist media, not least the West-Berlin-based British Forces Broadcasting Service (BFBS) and thus programs such as John Peel's weekly BBC show.

As the 1970s drew to a close, Robert and Ronald Lippok, two Prenzlauer Berg teenagers who just happened to live on

Zionskirchstrasse, were taping everything they could off the BFBS, American Armed Forces Network, and West German stations: world music, Krautrock, Frank Zappa, Stevie Wonder, and more. They were bored to tears with the classic *Ostrock* bands such as Die Puhdys and Silly. New sounds fascinated them and they scoured the airwaves to find them. When the brothers first heard punk on Peel's show, it spoke to them like a prophet. "It hit us so hard because it had so much energy and such a different energy than what we knew," explains Robert Lippok. "The music in the GDR was so friendly and happy. Punk sounded like the answer to the questions that we were asking. Until then our feelings didn't have a form."

The punk aesthetic seemed to fit the Lippoks' weltanschauung, too: the all-black duds, the zippers, the clothespins, wild hair, chains, the circled-A, androgynous makeup. Just appearing in punk dress in public was a barb in the regime's direction. "With the punk look," says Robert, "you could express that you were against the system without saying or writing anything. It wasn't just to look cool. You stepped outside the system and said, 'I don't belong to you anymore.'"

For easterners, the do-it-yourself of punk was obligatory. They *had* to make everything themselves, and this meant improvising. They designed badges, fabricated their own instruments, used shoe polish to dye their hair, and started up home-made cassette labels. The Lippok brothers, for example, who founded the experimental band Ornament & Verbrechen (Ornament & Crime), discovered that, when shaken, a three-gallon plastic milk jug filled with East German Lego could sound a lot like the snare drum in free jazz. They also crafted a Dr. Seuss-esque clarinet out of a garden hose and clarinet mouthpiece, and a drum out of a drawer covered with goat skin. Electronic sounds

and recording gear were jerry-rigged out of East-bloc-issue household appliances, radios, and stereos.

For Robert Lippok, seeing Einstürzende Neubauten on West Berlin TV make music with cylinder blocks under a bridge triggered an epiphany. "It wasn't even as much as a guitar and three chords that one needed," he recalls, "just a chunk of cement." The Lippoks set Ornament & Verbrechen into motion, an open-ended music project that combined sounds from jazz, industrial, and synth pop.

For the things they couldn't stitch together themselves, they called upon their grandmothers. Seniors were often granted travel privileges to West Berlin, as their likelihood of running was lower—and if they did, it was simply one less pension the state had to pay. Thus punk shops and record stores in West Berlin (the names and whereabouts of which the GDR kids knew exactly) became accustomed to timid grannies in East garb pulling out shopping lists for record albums, Dr. Martens, and secondhand leather jackets.

In the GDR, do-it-yourself could have deep-reaching, seditious implications. One required state-authorized training and an official qualification in East Germany to do almost anything on a professional level from cutting hair to making art. You couldn't be a professional artist, for example, if you hadn't graduated from an art academy. The punk belief that "anyone can do it"—and then actually doing it—was an affront to the system. As such, it was a way for the individual to counter the state in everyday life without appearing overtly political.

"The state said that you're nothing and can do nothing without it," explains Heinz Havemeister, a musician born in East Berlin and co-author of a book on the GDR's independent music. "The do-it-yourself thing circumvented the hierarchy of the

GDR's music sector, the whole system of the youth clubs and censors and everything. It was incredibly self-empowering, which is exactly what the state feared most. Suddenly," says Havemeister, "it was as if everything was possible."

Havemeister says that punk in the GDR was also not only a way to distance oneself from the masses but also a means to "defend yourself against the majority." Its underdog, against-the-grain attitude wasn't present anywhere in the GDR. This message, delivered by peers brimming with self-confidence, told kids that they could do the same. With the advent of punk, their isolation wasn't the end of something but the beginning of everything. This fearlessness and the feeling of being in control of one's own life was crucial not just for their own self-confidence, but for the tenor of the political opposition, too.

There were other fundamental disparities between punk in the East and its peer in the West. Unlike Christiane F.'s clique and the West Berlin punks, it wasn't "no future" that the GDR kids were rebelling against, but rather "too much future." Socialism ensured that they'd be employed and looked after until they died. The future was *all too* predictable: work, obey, take holidays on the Baltic coast, die. In the GDR, one wasn't even permitted to be unemployed, there being no such category. Those who didn't have jobs were labeled "asocial" and could be arrested. The kids felt themselves prisoners of a future they wanted no part of.

On the GDR's streets, punk's provocation left no doubt about its punch. GDR citizens, the remnants of the new socialist man program, were thoroughly offended by the weirded-out kids. After three decades of social engineering in the GDR, the average citizen was in many ways strikingly more conservative than the typical West German, who at least had been exposed to the

modernizing currents of the '60s cultural revolution. In a system that prized uniformity, originality was a vice, not a virtue. The fact that punk toyed with alternative sexualities and gender types made it all the more odious. This was terra incognita for East Germans.

And the punks took it on the chin every which way they turned: from waiters and train conductors, teachers and taxi drivers, neighbors and total strangers. Speiche told me that he'd be spit at and punched just strolling through the city, once even dragged off a streetcar by cadets-in-training near a police academy and beaten to a pulp. "Your like should be gassed!" he'd hear from people who called themselves antifascists. If you showed up in high school as an outlandish punk, you'd be thrown out on your ear. In contrast to the West, punk could derail your life: forget a real job, ever. Nevertheless, and indicative of the dictatorship's waning clout, the ranks of the punks and the other subcultures expanded, even as the state beat up, imprisoned, and expelled them.

The man on the street might have been unpleasant and the skinheads frightening, but the police and the Stasi were another story. There wasn't a punk in 1980s East Germany who hadn't been subjected to interrogation, a hectoring lecture full of threats, and usually a bruising for good measure. Speiche calculates that he was detained nearly three hundred times during the course of the late '70s and '80s. One time they hauled him in, pinned him down, and shaved off his red-and-white mohawk. The reasonable conclusion of Speiche and other punks, even before the Church of Zion attack in 1987, was that they had to defend themselves.

The fact that East Berlin was the locus of the subcultures played a role in the unusually harsh treatment meted out to the first generation of punks. In the GDR capital city, nerves were

raw and stakes high. Whereas West Berlin offered nonconform-
ists anonymity, in East Berlin, the showcase of the entire East
bloc, nonconformity was in the glare of the spotlight. Accessible
to tourists via West Berlin, East Berlin was the only glimpse of
communism in practice that many westerners would ever have.
Considering the city's indigenous riches, it should have been a
piece of cake to impress the foreign visitor. East Berlin was home
to the Prussian city's historical center, which stretched from
Brandenburg Gate all the way along Unter den Linden to Alex-
anderplatz, and included all of the prewar museums, Humboldt
University, and the city's oldest churches. But its citizens had to
be presentable too: to look and behave as happy socialists should.
Malcontents, even men with longer hair, were often escorted
away from the prime attractions.

Moreover, all of the major Western media had offices in West
Berlin, which ensured that any hiccup of protest or repression in
the East would receive global coverage. Strategically, the GDR
was the Soviet empire's capital closest to the class enemy in the
West, the front line. And, as a second German state, the GDR
and the city of East Berlin symbolized Europe's division. From
Moscow's perspective, the GDR couldn't afford to go soft, as this
could conceivably open a path to reconciliation with the Federal
Republic—and pave the way to German unification. East Ber-
lin's rulers were well aware that their power, and their necks,
remained intact only as long as they preserved the status quo.

The story of Namenlos (Nameless), one of the very first GDR
punk bands, illustrates the lengths to which the state was pre-
pared to go to stomp out the perceived menace of punk. The four
teenagers—Jana Schlosser, Michael Horschig, Frank Masch,
and Mita Schamal—found one another in 1982 by chance, trav-
eling on the U-Bahn and wandering the streets on their own in
search of a café that would serve them. They bonded quickly,

not least for purposes of safety. "We did everything together. We never walked alone," remembers Mita Schamal, the drummer and youngest band member at seventeen, in the documentary film *Ostpunk!* Bit by bit, they rounded up a Russian guitar, a homemade sound board, and other essentials, all hardware that, while low quality, was precious.

The earliest punks drifted around the city, searching out hideaways where they could be alone. After practices in cellars and empty courtyards, the gang would buy a bottle and explore the empty factories and warehouses in East Berlin, where they'd come across relics of bygone eras. One of their hangouts was the ginormous *Gasometer* in Prenzlauer Berg, an abandoned gasworks that covered a full city block north of Dimitroffstrasse. Photographs from the day show them clowning around and writing anarcho graffiti on the walls of squatted apartments where they'd congregate until ousted by police or the neighbors.

Namenlos had performed its entire twelve-song repertoire in churches, artists' studios, and abandoned buildings only five or six times before the state pulled the trigger. Given their in-your-face lyrics, it was only a matter of time. One Namenlos song went: "Minefields and barbed wire, so that no one dares to go over them / Walls and electric fences that rob us of our freedom / Automatic weapons and a minefield so that we like it here." In another song entitled "MfS-SS," the band compared the Stasi (the MfS) to the Nazi SS, Hitler's elite guard that had led the occupations of Nazi-vanquished Europe and run the Holocaust's logistics. The refrain went: "Look out, you're being watched by the MfS, MM—ff—SS!" Another song, "Nazis Again in East Berlin," was no less heretical, since, according to the regime, there could be no Nazis in East Germany. Namenlos's insinuation, a scorching insult to the GDR, was that there was something fascistic about the antifascist state.

This went too far. The Stasi unit responsible for "politicals" had already been assigned to crack down on the country's nine hundred or so punks. It labeled them as "criminal elements," instructing all public institutions to shut them out. Looking back into the Stasi files, it's clear now that the order came from the very top: "The illegal punk music group Namenlos should be crushed." One circular read: "The minister [the Stasi director] has ordered the ministry to go after punks with full rigor in order to undermine escalation of this movement. In the face of resistance, take off the kid gloves. We have no reason to be gentle with these figures."

In summer 1983, the authorities unleashed a wave of repression against punks. Many males were immediately conscripted into the GDR's National People's Army (NVA), others expelled from the country. Namenlos was singled out for unusually harsh treatment. In August 1983, the band's entire cast was arrested and placed in detention. The first thing their professional interrogators did was to have them rub a small piece of cloth, called a "sniff rag," on their genitalia that was then dropped into a small jar with their name on it. This degrading, intimate violation of the private sphere was made in order to record their scent, should they at some point in the future require dogs to track them down. Schamal, not a legal adult, was assigned to a psychiatric clinic. The others waited five months behind bars for a trial, and were finally sentenced to between one year and eighteen months of prison for "publicly treating the state's organs and their activities and measures in an undignified way." The court referred to the band's guitars as "crime instruments."

Everyone in the scene knew about Namenlos's fate, remembers Speiche. Yet it didn't reverberate the way the authorities had counted on. The crackdown didn't break the movement's back; on the contrary, it fueled the growth of a new generation

of punks. The Lippok brothers started Ornament & Verbrechen shortly thereafter, in early 1983. New punk, postpunk, ska, rockabilly, and new wave cliques proliferated, not just in East Berlin but also roughly simultaneously in the cities of Halle, Weimar, Leipzig, and Erfurt. When Namenlos's members were released from jail, they reconstituted the band at once, boldly making good the pledge in their lyrics: "If we go to prison for it, you should understand well / One day we'll come out, and then we'll be terrorists." These groups, though, constituted just a miniscule sliver of the youth at large—most of whom were as quiescent as their parents.

Nevertheless, disaffected young people from around the GDR who'd heard about Prenzlauer Berg and its bands began migrating to East Berlin. One of them was Silvio Meier from Quedlinburg, a town in the Harz Mountains along the German-German border. Meier had just turned twenty-one in 1986 when he left his quiet, gabled hometown for East Berlin. With the GDR drifting, unsure how to confront the changed reality of the 1980s, Meier ached to apply his copious energy to hasten the dictatorship's demise. This was impossible in small-town Quedlinburg, which had already rid itself of his brother, Ingo, who'd been expelled from the country for lighting the GDR flag afire one night. But in East Berlin, perhaps, Silvio could avoid the same fate. When the regime did unravel, he figured, there had to be people with fresh ideas to step in. Ideas were something Meier had aplenty. The GDR, he felt, could still become a genuinely socialist, radically democratic Germany. But how? Germans already had one authoritarian capitalist state, he reasoned, in the form of the Federal Republic. They didn't need another. But a Germany that took the promises of *liberté, égalité*, and *fraternité* as seriously as Meier did—this was another story.

Meier, a small man with a substantial nose, had a magnetic personality and loose tongue that usually eclipsed his slight physique. His instructors at the Quedlinburg vocational school— Meier trained to be a toolmaker—weren't charmed by his antics. His street-cool and freaky hair was off-the-charts in Quedlinburg. He'd dress in all black and ramble on about the Enlightenment and French existentialism, his pet topics. "He was probably the brightest guy in the class," said Erhard Grimm, a friend from Quedlinburg who followed on Meier's heels to East Berlin. "But if he wasn't making wisecracks he'd put his head down on the desk and doze off. He still passed the tests but the instructors gave him hell. They even called his father in to deal with it." In one way or another, Silvio and his brother Ingo had butted heads with the system since high school. A defiant streak ran in the Meier household, despite Herr and Frau Meier's cautious discretion. While Silvio cleared all of the hurdles to practice toolmaking, his prospects weren't bright. He rejected the Socialist Unity Party, which his parents had joined decades ago out of idealism. In East Berlin, he knew he had soul mates, he just had to find them. It didn't take long.

A mishmash of punks and freaks, recently shown the door at two other East Berlin churches, had found an open niche at the Church of the Redeemer, southeast of Prenzlauer Berg, not far from the stretch of Wall that bordered Kreuzberg. The pastor there and church social workers offered the kids what it had, which while no-frills was at least a speck of *Freiraum*. On about an acre of land across from a railroad track, the austere Gothic church with soaring spires had, previous to World War II, operated a hospital. During the war, Allied bombing leveled the clinic to its foundations. The church staff, after hauling away the rubble, found the cellar, the hospital's former morgue, more or less intact. They threw rolls of heavy-duty black tar paper over

it, pinning down its corners with chunks of rubble. A short brick staircase led down into the three windowless rooms. While the Protestant youth groups powwowed in the cozy parish house next to the church, the agnostic punks and other misfits got the Corpse Cellar, as some called it; others fondly knew it as the Piss Pot. Regardless of the name or the conditions, they were plenty glad to have it.

Its rooms were practice spaces for bands such as Antitrott, Wartburgs für Walter, Der Bruch (The Breach), and Kein Talent (No Talent), and evenings once a week the teenage-punk community congregated there for bottled beer and loud music. This is where Silvio linked up with Dirk Moldt and many of the others who'd form Church from Below. The troupe at the Redemption Church organized a daylong spring festival on the property above the former morgue. Meier lent a hand to a glorious day during which one band after another played, from across the GDR as well as from Poland and Hungary, and West Berlin, too.

"These kids were punks and hippies and others who knocked on our doors because they had nowhere else to go," explains Michael Frenzel, a social worker, who at the time worked at the Church of the Redeemer, and today still works with the church's youth programs. The Pentecostal and Galilee churches in Friedrichshain had turned them out: too much stress and too many hassles, they were told. Frenzel, though, welcomed these characters from the fringes. "The Protestant Church's doors are open to the marginalized and persecuted," he told me many years later. "The punks and their crowd exercised participatory democracy, which is, in theory, not so different than the rules by which the early Christian communities lived. Everyone could have their word."

The cellar rooms weren't just for making riotous music and swilling beer. They hosted discussions about anarchism, Nazis,

the environment, capitalism, the Cold War, and draft evasion. When it came to the GDR's mandatory military service, the church and the disaffected kids saw eye to eye. Nearly every young man in East Germany had to serve in the NVA, either as a soldier or as a *Bausoldat*, an option for declared pacifists, who'd wind up digging ditches or peeling potatoes. Refusing even to go the route of construction soldier was punishable with a prison sentence. Michael Frenzel, for example, spent two years in a cell for doing so, and therefore commanded authority and respect among the youngsters contemplating draft resistance. Almost all of the male habitués of the Piss Pot went that path, though by the mid-1980s the regime seemed less prepared to prosecute than it had been in Frenzel's day.

Frenzel remembers Silvio Meier as an engaged and serious young man "aware of what he was doing and the consequences this could have," referring to jail or expulsion. In East Berlin for less than a year, Meier had become a fixture in circles that weren't simple for outsiders to penetrate. "He had such a big mouth," says Uta Ihlow, who worked with him in a makeshift printing press tucked away in cellar rooms belonging to the Church of Zion parish. "That's why everybody knew Silvio, everybody," she says, referring to the East Berlin underground.

At about this time, Silvio met Christiane Schidek, a willowy knockout with long, henna-red curls who went by the nickname Chrischi. A native of the northern port city of Rostock, she was a few years older than Meier, and by profession an accountant. But she had ditched the office job and left Rostock to join a rural cooperative in the Brandenburg countryside outside of Berlin. The two crossed paths at a party in Prenzlauer Berg, Schidek's first encounter with the romantic world of the underground. In a self-knit sweater, muddy boots, and other country apparel, she says, she felt wholly out of place and wondered what this guy

named Silvio, done up in all black with a new wave pompadour, wanted with her. But they went back to his place and sat on the rooftop overlooking nocturnal Berlin. They talked and talked: about socialism, travel, the GDR, their families, and their dreams. By dawn they were a couple and remained one until Silvio's death. I never saw Chrischi wear anything but a leather jacket and short black miniskirts with black tights and ankle-high Dr. Martens, and she was always at Silvio's side.

Nazis on the East Side

Other subcultures flourished in the course of the 1980s but, with the exception of the punks, none of them dumbfounded the East German authorities like the Hitler-glorifying skinheads. The kids with shaven skulls and flight jackets seemed to multiply like yeast bubbles in the postwar high-rise blocks across the country. But East Berlin was the stronghold. The young men mouthed the basics of Nazi ideology: racial supremacy, Jewish networks, a greater German state—comprised only of Germans. Prone to violence, they jumped and badly beat up not just rivals from the underground but foreign nationals, too, including guest workers from the GDR's sister socialist countries Vietnam, Mozambique, and Poland. In train stations and buildings, hand-painted slogans worthy of Kristallnacht appeared—and were promptly erased the next day by the authorities. At night, they'd venture into old Jewish cemeteries and knock over gravestones. The young Nazis were on full display at soccer games mixing with street-fighting hooligans, provoking fistfights with the other team's fans, the security guards, and the police. In their own minds, they constituted the most radical, principled opposition to the communist state they hated so intensely. After all, it

was in school that they learned that fascism was the opposite of communism.

Interestingly, average East Germans, those who found the punks so abhorrent, didn't mind the clean-shaven, hardworking, serious, and masculine young men with bald craniums. There was nothing on their person that announced they were Nazis, despite the rumors to this effect. When the police investigated the young men for crimes, co-workers spoke highly of them. On the night of October 17, 1987, at the Zion church, it was evident that the police, who refused to intervene, were willing to let the skinheads do some of their dirty work. The police reacted only when the melee provoked a public outcry—because they had to.

In the end, the authorities' enabling of the raid on the Church of Zion backfired badly, embarrassing the state with the awkward publicity. Some factions high in the GDR hierarchy took the issue of right-wing radicalism to heart and ordered a small, covert research group composed of Humboldt University sociologists to conduct a top-secret study for them. The sociologist who led the study, Loni Niederländer, told me that you could have heard a pin drop when she presented her findings to the Stasi a year later. These young men who called themselves Nazis, mostly between seventeen and twenty-two years of age, were overwhelmingly workers employed in blue-collar jobs (in other words, the proletariat). They hailed from secure families, a disproportionate number of whom were party loyal or military personnel. Many of the young men had served or intended to serve extended stints of military service. The right-wingers, she underscored, were products of the GDR; the phenomenon hadn't been transplanted from the West to the East, even though there was considerable traffic across the Wall. But rather, a neo-Nazi current had reproduced itself in the East by its own devices, for reasons unique to the GDR.

Shocked and still more confused, the officials put the study under wraps, threatening Niederländer if she so much as whispered about it. Their concern was justified as the study found that youth from the epicenter of the antifascist state, who concurred with many of its core values, were inclined toward fascism. Another study conducted out of Leipzig's Zentralinstitut für Jugendforschung found that one in eight young East Germans felt that the Nazi era had "good sides, too." Six percent of the youth surveyed said they sympathized with neo-Nazis. Something—though the officialdom knew not what—had gone terribly, terribly wrong.

At about the same time, some of Prenzlauer Berg's opposition intellectuals took it upon themselves to analyze the problem. After all, the skinheads had been terrorizing the bohème for years. Their thoughts were pulled together by Konrad Weiss, a dissident filmmaker, whose analysis overlapped with Niederländer's, but went further. The GDR, Weiss argued, claimed to have swept away the ideas underpinning Nazi Germany much too quickly, in order that it could declare itself the "good" Germany and pin the Nazis' crimes on West Germany. However, in the GDR, argued Weiss, opportunists simply exchanged their Nazi membership for that of the Socialist Unity Party without fundamentally altering their thinking. And, instead of embracing a new, civic democratic culture, the GDR itself adopted an authoritarian system that extolled strict party discipline and militarism, which made the transfer all the smoother. "Our everyday culture was never fully de-Nazified," wrote Weiss in one of the opposition's samizdat publications. "It's not the individual and the particular that are high on the socialist scale of values, but the collective and the general," he opined. "It's not originality and innovation that are praised, but subordination and convention. It's not contradiction and critique that are

encouraged, but conformism and moral cowardice." With the formation of a Stalinist dictatorship of the proletariat, he argued, the GDR bypassed the chance to link itself with the democratic traditions of the 1848 revolution and the Weimar Republic. It was thus hardly a surprise that there were Nazis born and raised in the GDR.

When the Berlin Wall did finally come crashing down, concern about the far right in eastern and western Germany was washed away in the flood of bonhomie. So too were the enormous disparities in the socialization of the two states' populations. But these differences would rear their heads again shortly thereafter, presenting the city of Berlin and the united Germany with dynamics that would remain potent long after the birth pangs of a reunified Germany had subsided.

6

Glasnost from Below

The Wall will remain in place for 50 or even for 100 years if the reasons for its existence are not removed.

—ERICH HONECKER, EAST GERMAN LEADER,
JANUARY 19, 1989

Life punishes those who arrive too late.

—MIKHAIL GORBACHEV, OCTOBER 7, 1989,
IN EAST BERLIN

BY THE MID-1980S, THE CONTRADICTION BETWEEN the GDR's Brezhnev-era mindset and the zeitgeist of a globalizing, ever more high-tech world had become so conspicuous that even younger party comrades, those in the secondary tiers of power, grumbled aloud that the status quo was untenable. The GDR's Erich Honecker, born in 1912, had the reputation of a stickler even among the Warsaw Pact allies: as someone wholly incapable of fathoming a socialism not girded by spy networks and Soviet tanks. Yet, with one significant exception, the East bloc's old guard remained glued to its seats.

Signs of renewal came from the most unlikely place of all, namely the Soviet Union itself. In spring 1985, a fifty-four-year-old career communist named Mikhail Gorbachev assumed leadership of the world's preeminent communist country. In the Soviet Union, Gorbachev had shot like a meteor through party ranks, becoming the first Soviet leader born after the 1917 October Revolution. Gorbachev inherited a Soviet Union staring at a bloated military budget, a yawning trade deficit, technological stagnation, and bitter popular dissatisfaction. He entered with broom in hand, intent on sweeping the cobwebs out of the gear shaft. The world watched enthralled as he introduced "glasnost" and "perestroika," the Russian terms for openness and restructuring, words that in the past had made comrades blanch. Moreover, he did so in the name of, and not opposed to, socialism; Gorbachev sought to modernize communism in order, he was convinced, to rescue it.

Yet most of the Warsaw Pact allies dug in their heels, afraid—as it turned out, for good reason—that opening the barn door just a crack would prompt a stampede. Everywhere in the East bloc, populations were restive, and opposition groups were pulling at the seams, demanding democratic changes such as liberty to travel, freedom of speech and assembly, and multi-party democracy. In East Germany, too, pro-democracy groups composed of critical intellectuals, church figures, and the denizens of the subcultures were raising their voices. In East Berlin, Prenzlauer Berg was their redoubt.

One of the key dissident groups, the Initiative for Peace and Human Rights (IFM), arose out of the small, illegal peace and environmental groups that coalesced in the slipstream of West Germany's social movements of the 1970s and early '80s. The IFM was led by figures born in the 1940s and early '50s, such as the Poppes, Wolfgang Templin, Reinhard Weisshuhn, Katja

Havemann (the widow of dissident scientist Robert Havemann), and the Prenzlauer Berg painter Bärbel Bohley, among others. The IFM maintained that lasting peace in Europe could only be achieved if democracies were established across the East bloc. Sweeping political reforms were imperative in all of the communist countries, they argued, using language similar to Gorbachev's. Although the IFM resembled the 1980s dissident groups in Poland, Hungary, and Czechoslovakia, such as the latter's Charter 77, with which it enjoyed close relations, it called for democracy but—a key difference between East Germany's critical intellectuals and those in Central Europe—the Germans stopped short of endorsing Western-style democracy and a market economy. In terms of praxis, its members authored open letters to the regime, produced a samizdat newsletter, and conducted discussions about German history, gender equality, and human rights.

Another opposition current, Church from Below, sprang to life in June 1987 in East Berlin's Galilee Church on Rigaer Strasse (see photo, page 170). The younger crowd that grabbed the reins of Church from Below, most of them early twenty-somethings, fused counterculture and politics so tightly that it was impossible to pry them apart. The group owed its existence to the fact that the German Protestant church, though integral to the opposition's work in so many ways, was itself deeply divided. Conservatives in the church insisted that the clergy remain on the terra firma of spiritual matters and tread gingerly with the communist authorities. Over the course of the postwar decades, they argued, the church had labored mightily to secure Protestants in the GDR the freedom to worship their God and live according to their faith—and jeopardizing this hard-won *modus vivendi* was foolhardy. The more cautious among the Protestant bigwigs never warmed up to rock concerts on their altars, and

In front of the Pfingstgemeinde (Protestant Pentecostal Parish)
in East Berlin, June 25, 1987. The banner proclaims
Church from Below's founding.

resented the flak they inevitably caught for it. In early 1987, the
church leadership abruptly scratched that year's annual "peace
workshops," which were a kind of alternative congress that had
taken place under church eaves since 1982. At the modest one-
day forums, independent peace activists would discuss issues
such as the arms race and nuclear energy, and network among
themselves.

Within the very same church, activist currents fed up with the
leadership's fence-sitting were pushing ever harder from below.
Parish pastors, church social workers, peace and environmen-
tal activists, and concerned laymen demanded a more frontal
approach to the ever-more out-of-touch state. The church's influ-
ence and its premises, they argued, should be leveraged to much
greater impact. The time was right. Gorbachev had been in power

for two years; in Poland and Hungary, opposition forces were on the move. Almost everywhere the communists were backpedaling, and the GDR's authorities looked completely flummoxed. The peace workshops, the critics claimed, were exactly the kind of independent, critically edged happenings that should be replicated across the country: free speech and assembly in action, pushback to the regime's bullying. And now, just as the fight was heating up, the church leadership had gone timid.

Church from Below's original raison d'être was to urge the Protestant church toward greater openness, internal democracy, and regime-critical stances. One of its founders was the long-haired pastor Walter Schilling, who had for years provided sanctuary to nonconformists and stood up to the state's abuses. A modern-day Luther, he was a thorn in the church's side, which is why it shuffled him from one far-flung parish to another. Yet exile proved unable to thwart his resolve—or that of the many churchgoers ever more prepared to call out the regime.

Among Church from Below's originators was a faction—including Silvio Meier, Dirk Moldt, Christiane Schideck, Speiche, Kathrin Kadasch, Micha Neider, Silke Ahrens, and Jo Müller—almost all of whom eschewed religion. In fact, with the exception of Kadasch, they considered themselves agnostic, and thought of churches primarily as venues to rock and print samizdat zines. This stripe would suffuse Church from Below with energy and ideas, and flavor its politics with a dose of anarchism. This didn't offend the likes of Schilling, who warned the church leaders that this new force, and eventually its entire generation, would make a stand with or without them. As far as Schilling was concerned, if atheists proved better allies than fellow Christians in taking on the regime, then so be it.

Meier was at the center of Church from Below from its inception, always talking, spinning off ideas, organizing logistics,

networking. The group's founding brought together figures from the various peace groups and fringe scenes, who threw in their lot together. Meier's tiny apartment in Bänschstrasse in Friedrichshain became a focal point, the place to meet to catch the latest buzz. "He absolutely had to have a finger in everything," said Dirk Moldt, who produced an illustrated zine with Meier. "When he was into an idea he'd put incredible time and energy into it—and convince others to do the same. But it could be really difficult to get one's own ideas across, too. It always took a lot of time."

The Stasi was an ever-present factor in the lives of Meier and Church from Below. The archives attest that the activists were followed, spied upon, photographed covertly, and harried. At the time, none of Church from Below could know for sure who was and wasn't working for the secret police. The Stasi's methods were brutal, designed to crack even the toughest nuts. Over the years, it had developed sophisticated techniques (well portrayed in Florian Henckel von Donnersmarck's Oscar-winning 2006 film *The Lives of Others*) much more effective than brute force, although violence wasn't excluded from the program. Top figures in the GDR opposition and subculture had been blackmailed and recruited, relating to their handlers details of the underground's work. The files also show that, remarkably, the innermost circle of Church from Below was clean. Incredibly, it hadn't succumbed to exceptionally fierce pressure. This speaks not only to their integrity, but also to their tightness, a quality that would distinguish them in post-Wall Berlin, too.

Perhaps because of their youth, much of Church from Below crew hadn't, before its founding, been dragged in by the Stasi and interrogated. But now they were on the radar. Silvio Meier's day came in September 1988, when he, Chrischi, Speiche, and several dozen others were cuffed after staging a protest in the

Silvio Meier and Church from Below activists (Christiane Schidek, known as Chrischi, with back turned) shortly before their surprise attack on IMF officials in East Berlin on September 29, 1987. Covert photos taken by the Stasi.

Silvio Meier, right, at the second national congress of
Church from Below in Halle, November 1988.

city center near the Pergamon Museum. Although they couldn't
know it at the time, the Stasi had been informed of their plans
and clicked blurry black-and-whites of them every step of the
way (see photos, page 173).

The backdrop was the International Monetary Fund's annual
meeting, taking place in September 1988 in West Berlin, which
was cause for left-wing activists from across West Germany to
rally in West Berlin, their aim being to impede the works of
international capitalism. For safety reasons, the city of West
Berlin took the extraordinary move of requesting that its com-
munist counterpart, East Berlin, put the fund's officials up for
the nights, fearing belligerent demonstrations outside a hotel or
even an attack. Apparently, West Berlin officials felt that only a
proper police state could provide the requisite security. Church
from Below caught wind of their government's audacious act of
hypocrisy through its contacts in West Berlin, with whom they

met several times in the East to coordinate strategy. Through the West Berliners, Church from Below and assorted allies obtained the IMF officials' program—and decided to give the fund's suits some guff from the east side. Their outrage stemmed from the fact that the socialist GDR was accommodating the IMF, overseer of Western imperialism. In other words, Church from Below's critique came from the left.

The Stasi had the group of forty in its sights from the moment it set off to Alexanderplatz. With their pockets full of East German pennies, they laid in wait at the Pergamon Museum on Museum Island, where the IMF delegates were inspecting the second-century B.C. Pergamon Altar and the Market Gate of Miletus. When the suits exited the museum, the crew sprinted toward them and sprayed the officials with handfuls of small change. Then they turned on their heels and ran like crazy.

The police picked up the bulk of them shortly afterward and transported the crew to one of the Stasi's remote locations on East Berlin's outskirts. One by one, the gang was given the full *Darkness at Noon* treatment: a night in pitch-black cells, grillings under blinding lamps, no food or drink. "They kept asking us why we'd protest against the state given that we called ourselves socialists," remembers Chrischi. "They couldn't seem to grasp we were calling them out on their socialist credentials. 'How could you let those fat cats come into the GDR?' we asked them. 'This is capitalism in its purest form!' They couldn't respond. They didn't know what to say." The prank obviously threw the Stasi for a loop, and they tossed the bunch back out onto the street the next day. The kids were shaken up, but relieved to be out.

The events of 1987 and 1988 enabled the GDR's democratic opposition to break out of its underground lair and finally achieve recognition beyond its own tiny circles. It made international headlines in 1988 when dissidents in East Berlin hoisted

an unapproved banner at the annual march in memory of the January 1919 murdered communists Rosa Luxemburg and Karl Liebknecht. The event was high profile in the GDR, indeed practically sacred, and therefore carried live on television with the communist elders lined up solemnly shoulder to shoulder. On the rainy weekend of January 17, protestors from the Prenz-lauer Berg scene raised banners with the direct quotes of the leading German communist of the interwar period, Rosa Lux-emburg: "Freedom is always the freedom of those who think differently" and "The only path to rebirth: the broadest possible democracy." The banners weren't visible for more than a few minutes before Stasi and undercover police in the wet throng ripped them down and arrested the activists. Undeterred by the negative media, the regime promptly expelled the "traitors" to West Berlin.

Radio Glasnost

As physically impermeable as the Wall was for the easterners, the multifarious forms of back and forth between the alternative scenes illustrate that more was permeating the Berlin Wall than one suspected—and much more than the GDR authorities could control. Another crossborder endeavor was *Radio Glasnost*, a radio program examining GDR topics that was produced in East Ber-lin by oppositionists but aired from West Berlin—with eastern listeners in mind. The fact that more GDR citizens than ever learned about the January 1988 events at the Rosa Luxemburg procession, among other opposition doings, was in sizable part the result of *Radio Glasnost*, which itself was largely the work of one man, a former GDR citizen living in West Berlin named Roland Jahn.

Jahn, a native of the southerly university city of Jena, was an outspoken opponent of the GDR until it expelled him and forty other peace activists in summer 1983, an outrage that sent ripples across Cold War Europe. The thirty-year-old Jahn, a short, solidly built man, had already been arrested and jailed for the crime of riding a bicycle festooned with a small, dime store-purchased red and white flag—Poland's national flag—on which he had handwritten: "Solidarność, solidarity with the people of Poland." The mass protests that shook Poland in 1980, led by the independent trade union Solidarity (Solidarność in Polish), rattled the GDR's skittish functionaries, which even broke with East-bloc etiquette by restricting travel across the border to Poland during the uprising. (The Polish mass movement, actively supported by nearly ten million Poles, is widely seen as jarring loose the first brick in the East bloc's bulwark, which eventually led to the fall of Communism a decade later.) Upon Jahn's release, the regime tormented him, insisting that he leave the country—and never return. But Jahn wouldn't go. So one day they handcuffed Jahn, locked him in the toilet compartment of a westbound train, and packed him off on a one-way journey. In hindsight, in light of his unstinting work on behalf of the GDR opposition from West Berlin, the East Germans had committed a blunder of considerable proportions.

Jahn was just one of tens of thousands of former East Germans stranded in West Berlin during the decades of division. Whether they had been kicked out, had escaped, had left legally, or, like student leader Rudi Dutschke, had come over before the Wall went up, these refugees knew the GDR intimately, and by telephone and mail kept closely in touch with family, friends, and allies in the old *Heimat*. By dint of living in West Berlin, they were smack in the middle of the GDR, even if they were forbidden to enter it. ("Say good-bye to your family," GDR border

guards sneered at musician Robert Lippok as he left the country for West Berlin in January 1989. "You're never going to see them again.")

Jahn belonged to the cliques of GDR expats that had gelled in West Berlin, circles knit tightly by common experiences in GDR jails and interrogation rooms. In fact, political exiles from across the East bloc settled in West Berlin, making use of its location and resources to agitate in their homelands. The GDR outcasts had their taverns, such as the Kuckucksei (Cuckoo's Egg)* in Kreuzberg, flush against the Wall, where they'd meet and drink and talk politics until the wee hours. Not coincidentally, the Kuckucksei collective was run by Church from Below co-founder Hans-Jürgen Buntrock, who had been expelled from the GDR for his participation in the Luxemburg protest. (In the late 1980s, I walked by the establishment many times, noting its humorous name. But like most West Berliners I had no idea that inside it GDR exiles were plotting communism's overthrow—much less that they'd help pull it off.) Jahn and others, including Silvio Meier's brother Ingo, built clandestine networks, helped fellow easterners new to West Berlin with housing, raised money, and organized the transfer of printing and other supplies. Ingo Meier, who had put down roots in Kreuzberg, served as the conduit between West Berlin anarchos and Church from Below.

The likes of the IFM, Church from Below, and photographer Harald Hauswald relied on their exiled colleagues to inform the West German media of human rights violations in the East, not least of their own mistreatment, and to press the Western media

* In German, a cuckoo's egg is an egg that belongs to different parentage than the occupants of the nest. It is a synonym for an illegitimate child.

to run reports of infractions as big as possible.* This way, when the state cracked down on the opposition, the world would know about it. This afforded them a degree of protection, as the socialist GDR had become so reliant on the monies of the capitalist Federal Republic that the last thing East Berlin needed was a high-profile brouhaha that could throw a wrench in the negotiation of further loans.

Another aspect of Jahn's PR work on behalf of the East German opposition was to broadcast programs on taboo GDR issues, such as human rights abuses and environmental degradation, thus providing the East Germans with objective, critical news about their own country. One feature, for example, about industrial pollution in Bitterfeld, a town hosting the GDR's chemical factories, was watched by millions of GDR viewers. (By contrast, the opposition's samizdat newssheets had print runs of a couple of hundred and very rarely reached beyond the underground.) The images of sludge spewing into the Elbe River earned Bitterfeld the title of the most polluted town in the GDR and a synonym for the state's ecological neglect. The TV report, based on clandestine footage shot by East German environmentalists, had been taken with a camera that Jahn had Western colleagues smuggle over in a car trunk.

As widely watched as these broadcasts were in the GDR, Jahn realized that he needed a regular, full-hour program devoted exclusively to the GDR opposition. If a mass movement was

* Hauswald's East-West contacts were critical to his work as most of his photos couldn't be published in GDR media. Instead, he sold them to West German media and publishers. He'd then pick up his earnings and new photography supplies from West German journalists accredited in East Berlin. The Stasi knew he did this, followed him closely, but could never catch him in the act.

ever to grow out of the menagerie of small opposition groups, the GDR burgher had to know about them. In August 1987, the West Berlin station Radio 100 began once-a-month transmission of *Radio Glasnost: Out of Control.* The planning and editorial decision-making happened in East Berlin, the remit of Jahn's contacts in the opposition. Interviews with dissident figures, reports, and songs of underground bands were then smuggled over to Jahn. The programs were produced and aired from West Berlin. The Stasi put agents on Jahn in West Berlin, as it did other exiles, but it couldn't hinder *Radio Glasnost* from broadcasting twenty-seven times, the final show running in early 1990. While its impact can't be measured quantitatively, there are few former oppositionists from East Berlin who don't cite its singular importance and Jahn's diligence.

The East Berlin underground's crossborder liaisons didn't run in just one direction, namely westward. On the contrary, they extended over its eastern frontier too. Across the East bloc, a dense web of contacts and friendships had been spun over the years—above all in Poland, Czechoslovakia, and Hungary—a world that the average West German couldn't begin to grasp. Since the GDR and the Central Europeans were allied as "socialist brother countries," travel to the East was usually, though not always, unproblematic. Indeed, parallel to official relations among the brother countries, a below-the-radar network linked East German and Hungarian punks, GDR oppositionists and their counterparts in Solidarity, anarchists in East Berlin and Prague. Music fans would think nothing of hitchhiking down to Budapest to hear the cult group Vágtázó Halottkémek, or Galloping Coroners, an ethno-speedpunk band that mixed free jazz and driving guitars with Hungarian folk rhythms. At the three-day Jarocin music festival in western Poland, East Germans, Czechs, Slovaks, Hungarians, and Poles pitched tents and heard bands

banned from stages across most of the East bloc. At Jarocin and elsewhere, friendships were forged over the years, as well as a familiarity with their opposite numbers' cultures, affinities that didn't disappear the day the Wall vanished.

The Peaceful Revolution

In January 1989, Erich Honecker kicked off the year that would change everything with the infamous gaffe that the Berlin Wall could stand for another fifty or even one hundred years. Little could Honecker surmise that before the year was out, the reasons for the Wall's existence would in fact be removed: namely, he and his cronies would be swept off history's stage. The seventy-seven-year-old's gratuitous blunder infuriated even many party-loyal East Germans, and underscored just how out of touch the gray-hairs of the politburo had become. The year 1989, the last of communist East Germany, was the bicentennial of the French Revolution, a historical touchstone for the GDR leadership who understood communism as the triumphant conclusion of the quest for *liberté*, *égalité*, and *fraternité*. Moreover, the GDR had even bigger plans to celebrate the fortieth anniversary of its own founding on October 7.

The scattered opposition groups, among them Church from Below chapters across the GDR, were stepping up protest on all fronts, basing most of their demands on Gorbachev-style reforms. Yet, in terms of anything to show for it, they were leagues behind the Polish and Hungarian democracy movements that had extracted promises of multiparty elections for later that year. In April 1989, Poland's Communist Party caved to popular will by scratching its constitutionally inscribed role as the country's ruling party. The outlawed trade union Solidarity

was recognized as an independent political party, the first in the Soviet-led camp. Oddly enough, in East Germany, the *Betonköpfe*, or "cement heads" as critics called the ruling East Berlin cabal, appeared to grasp something that Gorbachev hadn't, namely that the dictatorships in Eastern Europe couldn't be reformed without letting the genie out of the bottle.

As spring blossomed in 1989, dissatisfaction with business as usual was palpable as never before. Antigovernment splinter groups shot up across the country, announcing themselves by way of handmade fliers or unsigned public letters. The team at the printing press in the cellar of the Church of Zion's parish house burned the candle at both ends, filling orders for everything from manifestos to handbills and posters. Mornings, the authorities awoke to the unusual sight of graffiti on the GDR's walls: "DDR-KZ," "Freedom—Enough of the Party's Lies," "The Wall Must Go," "Tear Down the Wall of Shame," and the Gorbachev quote: "We need democracy like we need air to breathe."* In Leipzig, the GDR's second largest city, the St. Nikolai Church held peace vigils every Monday that were growing ever more explicitly political, to the chagrin of the church's national leadership, which was clearly losing the battle to harness its activist clergy and their unhappy flocks.

With good reason, the Church from Below section in East Berlin was brimming with confidence and new plans. After nearly two years of butting heads with the church, the group finally received rooms of its own on church premises. Until then, the group's core had convened where it could, in private apartments,

* In contrast to West Berlin, in the East graffiti was strictly outlawed, and multiple infractions could lead to a jail sentence—though not because it was an eyesore. As a means of communication, it circumvented the state's monopoly on information. Because spray cans were hard to come by in the GDR, opposition graffiti writers used paint and brushes.

parks, or at the Piss Pot. Their model was the "flying universities" organized by the Polish opposition before martial law was imposed in 1981: open seminars were held in private homes and other places, a different location every time, the details communicated by word of mouth. This was just one of the lessons the Germans culled from their East bloc peers. But loosely organized as it was, the clique around Church from Below struggled to maintain coherence, which is precisely why the state guarded *Freiraum* so vigilantly. Without Silivo Meier's organizational and people skills, say the former activists today, the whole venture would probably have veered off the tracks before 1989. So vexed was the troupe with the church's stall tactics regarding their demands, it threatened to squat church premises and launch a hunger strike. The church leadership finally gave way, but pointedly reminded them that the church's primary purpose was spiritual and not political. "The church is there for everyone," they were told, "but not for everything."

On the border of Prenzlauer Berg and Mitte, the St. Elizabeth parish house looked out onto the remains of the St. Elizabeth Church, which had gone unattended since 1945 when an incendiary bomb crashed through its roof, burning everything to cinders save its stone walls. Though it was overgrown, one could still make out its classical facade and Doric columns from Invalidenstrasse, and next to it the parish house. Church from Below's two ground-floor offices and a much larger main room may have looked humdrum with the wood paneling and peeling white walls, but the group was positively thrilled. A new chapter had begun, and they knew it.

The first move was to stamp their imprimatur on their new café, club, and headquarters, which they christened "KvU" (the initials of Kirche von Unten, or Church from Below). With sledgehammers, they knocked down a wall to expand the main

room for concerts and then crafted a long hardwood bar at its front. All of the walls were painted black, the window frames red. The St. Elizabeth's pastor, a timorous fellow, hadn't been keen on the idea from the beginning. Indeed, the church higher-ups had saddled him with the escapade against his will. Apparently, the usually soft-spoken man blew his top when he walked in on the construction work. But it was too advanced to reverse. In the years ahead, he'd give the KvU endless grief about the noise, the late nights, the traffic, and the mess. Alas, the good pastor had never envisioned running a clandestine punk club out of the back of his parish.

A new challenge was the conducting of discussion and decision making in a much larger group. "Before KvU we had operated according to consensus," explains Moldt. "We wanted everyone involved in every project. But the group was small then. Once we had KvU more people came in. But many of them weren't used to open, unstructured discussions where everybody gets a chance to talk. This wasn't the way anything in the GDR worked."

KvU's 1989 program kicked off with a benefit: an evening of theater, live music, an auction, and a puppet show on behalf of earthquake victims in Armenia. The fundraiser was contested within the group from the start since the GDR, as a socialist ally of the Soviet Republic of Armenia, could well have sponsored such a benefit itself. In effect, the question being posed was: what is our relationship to the GDR's "real existing socialism"? The KvU troupe wanted a superior, directly democratic social-ism, not Leninist "democratic centralism" and not Western-style democracy, either. This much was undisputed. But was anything at all salvageable from the experiment of postwar communism? And was "bourgeois democracy" *completely* useless? In the end, they went ahead with the Armenia gig. Hungry, displaced people were hungry, displaced people, regardless of the GDR's

relationship to the Soviet Union. But the hard questions weren't answered. In less than a year, Church from Below would have to pose them again in an entirely new, dramatically more urgent context.

Once they got the ball rolling, Church from Below didn't stop until the Wall fell. The café and library opened its doors, and program events followed one after another. While open discussion was integral to KvU, it was never the end in itself. Their lot weren't bookworms or armchair theorists. *Aktionismus* was their thing—direct action. They were doers with a goal: to pry wide open the fissures appearing everywhere in the GDR's cracking facade. Silvio and Moldt tended to dominate proceedings, which was also contested, as it would be in the future, especially by the women. Yet, admit the others today, the two kept discussion from straying down dead-end paths.

In KvU, they brainstormed over the arrests of dissidents in Dresden, and ways to express solidarity. The striking students in West Berlin and the hunger-strikers of the Red Army Faction in West Germany received words of support too, a gesture to the larger framework of their actions. The KvU group unrelentingly badgered the Protestant church to take a more principled, proactive stance vis-à-vis the state; in return, the church badgered the KvU crew to incorporate more Christian themes into its work. There were art and photography exhibitions, verboten film nights, and evenings devoted to topics such as "Afro-Germans" and the "Third World." Nationwide congresses of Church from Below happened at the St. Elizabeth parish, too. And, of course, there were concerts and parties, lots of them.

Although many of Church from Below were draft resisters, they weren't necessarily pacifists, and the option of employing violence against the far right was raised almost at once. On the night that filmmaker Konrad Weiss spoke at KvU about

neo-Nazis in East Germany, the crowd there concurred with Weiss that the GDR had enormous catching up to do in coming to terms with the past. But, unlike Weiss, they felt that skinhead violence had to be countered head-on, too, with bare knuckles if necessary. Speiche had boxed as a kid and coached some of them on the basics. Others began investigating the martial arts. Since the skinhead raid on the Zion church, they knew they were on their own.

"In hindsight everything we did looks so incredibly serious," Silke Ahrens, an original Church from Below member, told me in the living room of her loft apartment in Prenzlauer Berg. Above her desk are black-and-white photos of the old days: Silvio atop someone's shoulders, laughing; Moldt camouflaged under a mop of frizzy hair; Speiche shaking hands with Manfred Stolpe, a senior administrator in East Germany's Protestant church. "But there was a 'fun factor' in everything we did, which was part of our vision, how we wanted to live," she says. Pranks and Situationist-style happenings were integral to their politics. This was evident in Moldt's fanzine-style comics in *mOAning star* and many of KvU's events. Ahrens, for one, performed a comic skit using the works of the German anarchist poet Erich Mühsam, which served the dual purpose of acquainting people with Mühsam's ideas and having a laugh.

One date circled on KvU's calendar was May 7, 1989. Church from Below was among a handful of younger dissident groups that saw the nationwide local elections in the spring as a choice opportunity to out the regime. The GDR was proceeding with the single-slate pseudo-elections that it had scheduled for May despite the fact that other East bloc states, including the Soviet Union, were planning free votes. The GDR authorities' hubris turned out to be a stupendous error that, arguably, set off the peaceful revolution.

The farce that went by the name of voting in the GDR was a propaganda spectacle. Everyone was obliged to vote, yet the ballot had only listed slates of candidates from the Communist Party and its satellites. On election days, the streets were decked out in banners and flags; trade union branches, sports clubs, and other bodies ambled to voting centers, where one picked up a ballot, marked and folded it, and then dropped it into a cardboard box. Every station had Stasi personnel there, whether in uniform or undercover, which enabled the state to know exactly how people voted. One election after another, the authorities boasted in *Neues Deutschland* that the party slate had received more than 99 percent of the vote. Another victory for communism!

Dissenters had two options: one could boycott the travesty altogether, which was unlawful, or vote "no" by neatly crossing out every name on the ballot, an option that few knew about. Any variation of this—for example, not crossing out *every* name or scrawling an *X* across the ballot—invalidated the ballot, which meant that it wasn't counted at all. Most GDR burghers went along with the ritual like all the other mindless drills in their world.

GDR opposition groups such as IFM had attempted to put candidates on the May 7 ballot but, predictably, to no avail. Yet Church from Below, Weissensee Peace Circle, Environmental Library, and a few more small groupings picked up on a little-known clause in the election law that allowed the public to attend ballot counting. "This was a right we had on paper," explains Ahrens, who helped coordinate the monitoring from the KvU. "So together with some of the church's social workers we thought we'd give it a whirl, see what happens. Honestly, many of us saw it as a lark. But why not try?"

In addition to East Berlin, democrats in Dresden, Leipzig, Halle, Jena, Erfurt, and many other towns organized locally to have their people in as many polling stations as possible. Since

the GDR had thousands of polling stations, they knew they couldn't cover all of them. But several districts in East Berlin—Mitte, Friedrichshain, Weissensee, Prenzlauer Berg—had more than a hundred people in place, two or three per station.

To everyone's astonishment, the first-ever volunteer election monitoring in the GDR went off without a hitch. "We thought security guards would arrest us or lock us out once the polls closed," says Ahrens. But no, with law book in hand the self-appointed monitors watched on as volunteer election officials tallied the results. All of the East Berlin monitors met back at the St. Elizabeth parish with their station's results. The count at KvU showed that 10 to 20 percent of the electorate in the monitored districts had voted "no." This certainly wasn't a flattering statement about the civic courage of the GDR citizen, the majority of whom were obviously too apprehensive—as late as May 1989—to defy the state even in such a symbolic way. But this time around, the KvU crowd thought, the state couldn't possibly claim a 99 percent "yes" vote. It would have to backpedal.

Nonetheless, later that evening as regular as clockwork, one of Honecker's ministers, Egon Krenz, appeared on state television to announce a 98.85 percent result for the party slate. The next day *Neues Deutschland* trumpeted: "An Impressive Acknowledgment of Our Policies of Peace and Socialism!"

"At that moment, we knew we had them by the balls," says Jolly, one of the Protestant social workers in the orbit of KvU. Just from the "no" votes that the monitors had counted, the government couldn't possibly have the 98.85 percent it claimed. The regime obviously knew that they had the real totals, yet so great was its hubris that it refused even to admit that it had "only" received 90 percent of the vote.

With proof that the results were fudged, a clear violation of GDR law, Church from Below and its allies shifted into attack

mode. The underground media out of the Church of Zion, run by the anarchists of the Environmental Library, published the findings and distributed them as best they could. More important, Roland Jahn and the West German press splashed the findings across front pages and broadcast them in all directions: the vote was rigged, the results falsified, the party was lying. The GDR authorities were too stunned to respond. What could they say? They'd been caught cheating in their own phony elections.

The election fraud and the onset of the dogged campaign that followed marked a pivotal moment in the demise of communist East Germany, one usually shortchanged in history books. For one, with the aid of *Radio Glasnost*, it dramatically boosted the profile of opposition groups that many people knew about only vaguely. Second, the exercise illustrated that it was possible to go toe to toe with the state—and win. Church from Below, Weissensee Peace Circle, and Environmental Library, the three main groups behind East Berlin's monitoring, had dared to push—and, lo and behold, the walls gave way. Such an in-your-face act of defiance had never before gone unpunished. But this time arrests didn't follow. The purportedly all-powerful state was wounded and staggering, brought to its knees by do-it-yourself election monitors who'd never participated in a fair election in their lives. The vote fraud remained a headline topic for the GDR opposition for the next six months, and even after the Wall's fall.

On June 4, bloodshed the other side of the globe echoed loudly in the GDR. The communist leadership in China ordered its army to crush the student-led pro-democracy movement unfolding on Tiananmen Square. Tanks rolled across Beijing. Troops opened fire, killing an estimated 2,700 people. The brutal clampdown was treated with outrage across most of the world. But, ominously, East Germany's official media organs justified it as the "suppression of a counterrevolution."

Nevertheless, unbowed and sensing disarray, the younger activists vowed to protest the rigged May vote on the seventh of every month and demand democratic elections. Yet the "7th demos," as they were called, got off to an inauspicious start. On June 7, the protestors attempted to hand over the monitoring results to the district attorney's office and file charges against the election commission. But this time security forces didn't hesitate to pounce. They surrounded them, ripped down the signs and banners, and threw roughly half of the protesters into paddy wagons, which sped away to Stasi interrogation cells. Contrary to the hopes of Church from Below, the fraud campaign initially wilted in the scorching heat of the summer months; it didn't translate directly into empowered citizens coming out of their shells or the church discovering backbone. Of course, the grisly massacre in Beijing had everyone on edge. In fact, most East Germans thought it was just a matter of time before tanks rolled down their streets. The detentions on June 7 underscored that the regime wasn't buckling without a fight.

Meanwhile, Hungary had taken over the lead in the East bloc in breaking with communism with the spectacular opening of its western border to Austria, in effect snipping open a hole in the Iron Curtain. At first in trickles and then as a torrent, East Germans started leaving to Austria and West Germany via Hungary. By the end of summer, thousands a day were fleeing in their rinky-dink Trabants, jam-packed with possessions. The Hungarian border guards had orders not to stop them.

In East Berlin, though, the numbers at the 7th rallies dwindled to just KvU's punk rock faction and a handful of others. Rather, it was in the industrial city of Leipzig, south of Berlin, that revolution was afoot. By September, the Monday vigils at the St. Nicholas Church had begun to morph into demonstrations with ever more discontents joining the peace prayers until

the church was bursting at the seams. The cries for free elections, the lifting of travel restrictions, and civil liberties grew louder. At the Monday rallies, Leipzigers first chanted the powerful words that would brand East Germany's peaceful revolution: *Wir sind das Volk!* ("We are the people!"). The slogan was deeply subversive, speaking the truth that the legitimacy of the communist elite's paternalistic rule in the name of its subjects, the ontological bond between the party and the masses, had been declared invalid.

Back in East Berlin, despite the *Wunder* of the Leipzig uprising, the peaceful revolution sputtered until October 7, the date of the GDR's fortieth anniversary celebrations and the fifth vote-fraud demonstration. The morning began with a pompous military parade along Unter den Linden, followed by street parties across the city. The Stasi's records show that the word from the very top of the security apparatus was that all "hostile activities will be terminated by any means necessary." That afternoon, Silvio, Chrischi, and the rest of the troupe met as usual at Alexanderplatz for the demo. Compared to the twenty thousand on the streets in Leipzig, the crowd was paltry, just three hundred or so. Nevertheless, Alexanderplatz was swarming with police and Stasi, the plaza thick with tension. Stasi records show there were literally thousands of security personnel in and around the square, ready to strike. The KvU regulars figured that Alexanderplatz, the most visible public space in the republic, was ideal for the protests because, with so many people milling about and media everywhere, arrests would be conspicuous. Moreover, the crowds gave the protesters an audience, and thus the possibility of winning afternoon shoppers to their cause.

Before long a swarm of onlookers and Western TV teams hovered around the protestors. As they ambled to the nearby

Palace of the Republic, a steel-and-glass congress hall where the GDR leadership was meeting with none other than Soviet leader Gorbachev, the procession ballooned in size, remembers Chrischi. Participants chanted "Gorby, Gorby," "Democracy now or never," "No violence," and "Gorby, help us!" By the time they were within shouting distance of the Soviet premier, the procession had grown to three thousand people. Following orders, the beefed-up security forces lit into the crowd with all their might. From all sides, police, Stasi, and toughs from the Communist Party's youth sections grabbed demonstrators, beat them to the ground, and hustled them into police wagons. Mayhem broke out, says Chrischi, but the demonstrators clung to one another for all they were worth. But at some point, the security forces managed to sever the pack in two.

"They had us trapped, encircled," Chrischi recalls. "We could see the other protestors on the other side of the police line and we knew we had to get there. And then we just decided to make a break for it, to run at them all together as fast and hard as we could. It worked, I thought, at first. There were just too many of us. Gerd and I made it without having our heads bashed in, but in the crush we were all separated from one another. I lost Silvio. I couldn't see him anywhere."

They fused back into one unit, though minus Silvio among others, whom the security forces had collared in the chaos. The incensed crowd headed north toward Prenzlauer Berg, where more of their forces were camped out in the Gethsemane Church, staging a hunger strike in the name of the GDR's political prisoners. "Come, join us!" the crowd yelled to pass-ersby, who did exactly that. As they passed the state-run media agency they yelled, "Liars! Liars!" and "Free speech! A free media!" In the meantime, armored combat vehicles had lined up along Schönhauser Allee, just around the corner from the

Gethsemane Church, which was full of protesters. The police tried again to stop the march by cutting off intersections, which allowed Stasi special forces and antiriot squads with mounted water cannons to bear down on the marchers. Women were beaten up, onlookers bloodied, bones broken with nightsticks. One armored police van after another was filled with handcuffed demonstrators.

By this time Silvio was in a holding cell packed with hundreds of other battered and terrified people who were wondering whether a full-scale Tiananmen-style crackdown was under way outside the prison's walls. "We had no idea at all what was happening," says Jolly, who had been detained earlier in the day and had talked briefly with Silvio in the prison yard. "We didn't know whether the revolt spilled over or martial law was in place." In Leipzig, Dresden, Plauen, Jena, Magdeburg, Karl Marx City, and Potsdam, where protests also happened on October 7, hundreds of other protestors were bloodstained and behind bars too. Yet, in stark contrast to China, no one was killed.

"October 7 and 8 were absolutely crucial days," explains Frank Ebert, who worked the Environmental Library's printing press. "This was the point when the scales tipped, when the people turned against the regime. There was real anger about the repression and an outpouring of solidarity with those jailed or in the hospital. People from the neighborhood came over with food and blankets. They let us use their showers, whatever we needed," recalls Ebert, who was decamped in the Gethsemane Church. A sign that "the people" now also included key figures inside the state apparatus, the security forces in Leipzig refused to suppress the Monday demonstration on October 9. As for the Soviet tanks in nearby garrisons, they had obviously received orders from Moscow to stay put, not to intervene as they had in past uprisings in the East bloc.

At the Gethsemane Church, Chrischi, frantic that Silvio might be enduring torture or facing years of imprisonment, turned her anxiety to good purpose. A speed typist, she took hundreds of pages of testimony from eyewitnesses. Others tried to get any information they could about those in custody: Where were they? Were they hurt? Did they have lawyers?

Jolly and Silvio were released a week later. The Stasi records show that neither uttered a word to interrogators other than: "I refuse to make a statement." Both had physical examinations during which their bodies were extensively examined, measured, and recorded. Silvio was 5 feet 8, 137 pounds. On the sixth day of their captivity, the cell doors swung open. As it turned out, with everything on the line, the regime appeared to have undergone a crisis of conscience. It abandoned the China-style crackdown and took to negotiating with the opposition. The military vehicles on Schönhauser Alle and elsewhere in the GDR withdrew to their garrisons like snails into their shells.

If the GDR honchos thought these goodwill gestures might have a calming effect, they were gravely mistaken. The peaceful revolution, which started on a note of violence, broke wide open. Church from Below was one of many dozens of groups—many newly formed, others with droves of new members—that jumped to press their advantage. While it is the case, as KvU veterans today claim, that the older Prenzlauer Berg dissidents and opposition intellectuals were not on the streets on October 7 or hunger-striking at the Gethsemane Church, they weren't by any means inactive. Figures such as the Poppes, Bärbel Bohley, Markus Meckel, Jens Reich, Konrad Weiss, the pastor Rainer Eppelmann, and many others were in the process of forming parties and coalitions with political manifestos, not a simple task considering the diversity of the opposition from Maoists to Christian democrats. With the flood gates unlocked, artists,

theater companies, trade unions, and professional groups all joined the cacophony.

I never dreamed I'd see ordinary GDR citizens march against the regime. Until then, they struck me as every bit as materialistic and narrow-minded as their West German counterparts, if not more so. I had to see this, I told myself. Leipzig was where the people had risen first, and from week to week the numbers on the street ballooned. The afternoon train from East Berlin to Leipzig would get me there in time for the demonstration, if I could get a ticket, which wasn't a foregone conclusion. It was in violation of GDR law to leave East Berlin with the day visa bought at Friedrichstrasse. Moreover, I assumed the train would be packed to the brim with protestors. But I was completely mistaken. The ticket was easy to buy and, even though the train was full, it wasn't protestors in the cars. Every seat was occupied by a fastidious-looking klein-burgher minding his or her own business. Not a soul looked up from their newspaper or knitting.

I thus had no choice but to stand near the toilet at the back of one car, where I was soon joined by three middle-aged men. One was a portly, stony-faced type dressed in a one-piece, green-and-white floral-print cotton jumpsuit. The get-up was so ridiculous that I had to repress a stage double-take. The two others, virtual carbon copies of one another, were no more credible. Husky men, they had matching mustaches and bangs, and were clad from head to toe in identical stonewashed denim suits. Both had Gorbachev buttons in exactly the same spot on their lapels.

At the time, I didn't know much about the Stasi, but it was obvious to me that these guys weren't who they pretended to be. I kept my mouth tightly shut the entire two-hour trip, nodding now and then as they tried to lure me into incriminating discussion. "Look at those stinking factories," the man in the jumpsuit exclaimed in German as we passed the industrial town of Bitterfeld with its

pollution-belching chemical factories. "The biggest stinkers in all of Europe!" he said, turning his attention to me. I knew my accent would give me away so I just nodded *ja*, shook my head *nein*, shrugged my shoulders, and smiled a lot. It was an excruciating journey, but when we finally arrived at the Leipzig Bahnhof an acquaintance was waiting for me as promised. She whisked me off to the demonstration, which was just beginning.

I knew the faces in the Leipzig throng not from punk rock concerts and underground printing presses but from ticket counters, the S-Bahn, restaurants, and the streets. This was no longer just bohemian dissidents and Christian pacifists defying the regime—everyday folk made up the multitude. The marchers called out: "No violence!," "We're staying [in the GDR]!" and "Free elections!" The collective feeling of empowerment and hope was electrifying. As we marched past the city's Stasi headquarters, boos and hisses filled the downtown. Stasi provocateurs among the demonstrators urged storming the building, but the demonstrators singled them out, expelling them from the procession. In Leipzig, for the first time in the GDR since the workers' uprising in 1953, law-abiding "socialist man," whose quiescence over decades had ensured the regime's survival, was protesting en masse.

On October 17, Erich Honecker, GDR leader since 1971, was shoved aside by a younger party cadre willing to consider wide-ranging reforms. Yet the figure they placed on Honecker's throne was none other than Egon Krenz, the man ultimately responsible for the manipulated election results. In the days ahead, taboos fell in rapid-fire sequence; but it was too little, much too late to rescue the regime. In Leipzig, 300,000 people marched, while tens of thousands demanded change in Magdeburg, Dresden, Schwerin, Zwickau, Halle, Stralsund, and East Berlin. "Events happened so fast that we barely had time to respond,"

remembers Moldt. "We'd move quickly to put our foot in the door so that they couldn't turn around and shut it on us. But then another door flung wide open, and then another and another."

On November 4, an estimated 500,000 people massed on Alexanderplatz in the face of the regime's seats of power. Protesters squeezed in between the graying high-rises; many thousands more flowed over into side streets. Artists, intellectuals, theater directors, reformist GDR politicos, and other prominent figures spoke on a raised dais overlooking Berlin's biggest demonstration ever. Church from Below, punks from the Redemption Church, and the Environmental Library circle went as one anarchist bloc, the first ever in the GDR. Ahrens had sewn them oversized red-and-black flags to wave above the crowd. One banner read: "Anarchy is possible, mister neighbor," which rhymes in German.* The troupe was naturally elated with the full-scale revolution that they had in no small way helped to ignite. But in the multitude they were an inconspicuous fleck. The demonstration's organizers hadn't approached any of the Church from Below or Environmental Library figures to speak that afternoon from the podium. In fact, the thought had probably crossed no one's mind.

Five days later, on November 9, the Wall came crashing down. I was in Budapest, on my way to Nicolae Ceauçescu's Orwellian tyranny in Romania. The Church from Below was scattered across Berlin or nearby. "I thought I'd be living with the Wall my whole life," Moldt tells me, a startling admission for someone prepared to devote his life to bringing it down. A child of the Cold War, I felt the same way, and had written as much just weeks before.

* *Anarchie ist machbar, Herr Nachbar.*

Part III

THE NEW BERLIN

7

The Miracle Year

MUCH INK HAS BEEN SPILLED OVER THE BIZARRE AND unceremonious way the Berlin Wall tumbled on November 9, 1989. The suggestion that a botched press conference or a string of misunderstandings caused the East German border guards to stand aside that fateful evening obscures the real reasons that compelled the GDR's officials to act. In point of fact, the "velvet revolutions" across Central Europe were set in motion by the human rights and democracy groups—such as Solidarity in Poland, Charter 77 in Czechoslovakia, and the Initiative for Peace and Human Rights (IFM) and Church from Below—whose members risked prison and their families' well-being to call out the state, defy authority, and kick the door ajar, even if just a crack. Momentum, the masses, and some serendipity, too, took care of the rest.

Indeed though, there *was* a botched press conference on November 9, 1989. At the daily 6 p.m. media briefing in East Berlin, politburo member Günter Schabowski read from a statement approved by Egon Krenz, the acting head of state, that the GDR was introducing "temporary modifications" to its travel

regimen. Schabowski spoke to the journalists as if he were reiterating a bureaucratic detail, saying in a tired voice that all GDR citizens could quit the country or travel abroad as they wished, though they would still have to apply to GDR authorities do so. He appeared not to realize exactly what he was saying, nor did he notice that the news was not meant to be announced until the next day. Asked when this went into effect, Schabowski looked confused but then said, "So far as I know, that is, uh, immediately, without delay." It took some time for the bewildered media to conclude that the GDR's borders might be, as of that moment, passable to one and all. Schabowski had said it applied to all entry points and border crossings. And, if this was the case, the Berlin Wall was history.

Roland Jahn was watching a live broadcast of the press conference from the SFB studio in West Berlin. The second he heard it, Jahn grasped its implications. He sprang out of his chair and bounded into the newsroom: "The Wall's open!" he yelled. "The Wall's open!" He and his colleagues scurried like madmen to put together a special broadcast. How else would East Germans know that they were finally free?

As the West German media broke the story, East Berliners began gathering at the checkpoints insisting that they cross freely into West Berlin. The border guards balked at first, having heard nothing of it. The crowds swelled, and began to writhe and push. The border troops let a few through just to buy breathing space, but this emboldened the ever more impatient crowd. Egon Krenz, the politburo, and the Stasi were receiving panicked messages from the checkpoints. Their quandary was crystal clear: either respond with brute force or move aside. They opted for the latter.

The news set just about everyone in Berlin into motion. The images broadcast around the world, and replayed millions of

times since, show giddy easterners flooding through the crossing points at Bornholmer Strasse, Heinrich Heine Strasse, and Invalidenstrasse, embracing their western cousins, passing bottles of bubbly, and dancing on the Wall's lip. Long lines of East German-make Trabants and Wartburgs inched across the border, passengers hanging out the windows, delirious with joy (see photos, page 204). Yet, as moving as these scenes were, other emotion-packed, fall-of-the-Wall-night stories have never been told. The figures of the two cities' undergrounds—some of whom had shaken the Wall's foundations—were all nearby, but they weren't drinking warm champagne with total strangers.

Shortly after the breakthroughs, Jahn's phone started ringing with calls from old friends who'd crossed into West Berlin. They met up later that evening in Kreuzberg at Kuckucksei, Harald Hauswald among them, partying on the house until dawn. Jahn, however, ducked out early. He had to return to his native Jena that night; he caught the day's last train to visit his parents for the first time in nearly five years.

Blixa Bargeld told me that he was in a Kreuzberg studio located in one of the Wall's blind corners, recording "Crying Song" with Nick Cave and the Bad Seeds. They'd been hermetically sealed off from the world for hours and hadn't heard the latest. "We stepped outside for a cigarette," Bargeld told me. "This part of Kreuzberg was usually empty, deathly silent at night. Nobody there, usually, at most a few drunks. But it was full of people milling about. I asked someone what was going on and they told me the Wall was down." Blixa, Nick, and the band watched the merrymaking with bemusement, smoked another cigarette, and returned to the recording session.

Robert Lippok of the band Ornament & Verbrechen had been in West Berlin exile for less than a year when, sitting in Café M in Schöneberg sipping a coffee, he spied an old buddy from one

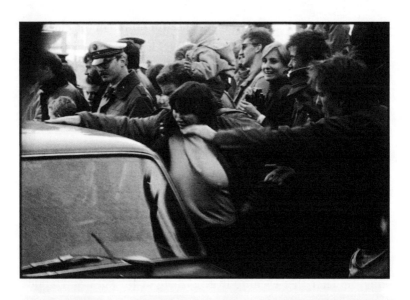

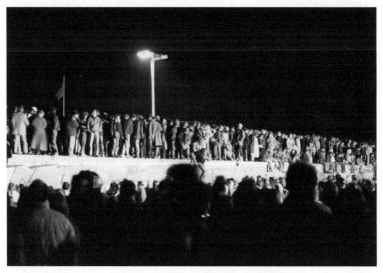

TOP November 10, 1989 at Checkpoint Charlie.
West Berliners greet their long-lost eastern cousins.

BOTTOM At Brandenburg Gate along the Wall on November 10, 1989.

of the early GDR punk bands walk by. He flagged him down, assuming he'd been expelled. Updated on the dramatic happenings, Lippok raced back to his place in Kreuzberg. To his great surprise and joy, he found his family standing there in front of his apartment building, waiting for him. They'd come independently of one another from East Berlin, meeting there unexpectedly.

At one in the morning, Lippok and his relatives returned to the Wall where the revelry was in full swing. "It was like everybody was on drugs. The vibes were super strange," he remembers. "The [GDR] border guards, the biggest bastards ever, were waving and smiling. It was like everyone was on ecstasy." Lippok asked the border guards whether he was assured safe return to West Berlin if he spent the night at his family home on Zionskirchplatz. "They said they had no idea," Lippok recalls. "So I didn't go."

Danielle de Picciotto was out of town, doing a fashion gig in Graz, Austria. Motte called her and broke the news. He was home, in their apartment overlooking the Wall and the death strip. "He was sobbing," she says, and they weren't tears of joy. Motte had grown up in West Berlin and had lived there his entire life. He couldn't imagine anything else, nor did he want anything more than West Berlin's isolated crucible of counterculture and easy living. Motte intuited at once that the West Berlin he knew and loved was now gone forever. He couldn't possibly suspect that its fallout would turn him, a bit player in West Berlin, into a rock star among global DJs.

Christiane Felscherinow was in West Berlin for a stint, after having fled several years before to the Greek islands, where she lived on a remote beach. In West Berlin, the hell of fame and the temptations of too much money and too many drugs had been too much, plunging her back into addiction after six clean years.

Neither her music career nor her acting career ever really got off the ground. In Greece, she was on and off heroin, keeping company with a handful of young Greeks in similar states of dependency. On the ninth, Felscherinow was with her Greek boyfriend in an apartment she had kept in Reuterstrasse, not far from the Wall itself. They were as high as kites, unwilling or unable to get out of bed. "I thought, if the Wall's open today, then it will be tomorrow, too," she wrote in her second book, the 2013-published *Christiane F.: Mein zweites Leben.**

As for the East Berlin bohème, they wasted not a second in making a beeline to Kreuzberg and the nightspots they'd heard so much about. Micha Neider from KvU, out of town in the nearby city of Potsdam, hitchhiked to West Berlin, negotiated public transportation until it closed for the night, and finally walked and hitchhiked again all the way to Pink Panther, a punk club from way back, where he commanded a barstool until daybreak. A few hours later, the West Berlin banks opened. In such a buoyant mood was Germany, the West German government announced it would gift every East German one hundred marks, about sixty-five dollars. On a borrowed bicycle, Micha raced from bank to bank collecting one of the crisp blue notes after another until finally the banks caught on.

The day after the Wall fell, Kathrin Kadash, another Church from Below founder, ventured to one of Kreuzberg's progressive

*This second, very confused and rambling memoir in no way compares to *Wir Kinder vom Bahnhof Zoo*. In it, Felscherinow tells stories of capricious behavior that would have laid any normal person low. At fifty-four years of age in 2016, she is alive, though not well. Living in seclusion in Berlin, stricken with hepatitis C, she is part of a methadone substitution treatment that—usually, she says— keeps her off the real thing. Her proceeds from the first book and the film, she confesses, went primarily to drugs, lawyers, and doctors. Her NGO, the F. Foundation, advocates for more effective policies to address addiction and drug use.

bookstores on Oranienstrasse, where she bought a translated copy of George Orwell's *Animal Farm*. She then visited an alternative kindergarten, and returned to Friedrichshain to read. After twenty years penned up in the East bloc, she was dying to travel—but neither West Berlin nor West Germany were destinations high on her list. A week later, she left for Sweden.

Chrischi and Silvio hooked up quickly with Ingo Meier, who had been living in Kreuzberg since 1986. During his West Berlin residence, Ingo had fallen in with the Autonomen, West Berlin's radical anarchists. He suggested to Silvio and Chrischi, as a gas, that they all go hear what Germany's chancellor, Helmut Kohl, had to say on this historic night. So the trio metroed across the city to the Schöneberg city hall where the chancellor, who had cut short a visit to Poland, was addressing a jubilant audience. Other Autonomen had joined them, dispersing in the crowd.

At some point, Ingo's comrades interrupted the event, shouting at the chancellor and pelting the podium with tomatoes. Police barreled into the crowd, smacking with their nightsticks anyone who looked like a troublemaker. Chrischi, with her hennaed locks, black jeans, and leather jacket, got mixed up in the tangle and was whacked on the shoulder and then yanked aside for questioning. She says the police were mortified when she pulled out her GDR passport. Had she really just come over from the East tonight? What did she think about it all?, they asked wide-eyed. Apologetic, they let her go.

Anarchy in the GDR

Shortly thereafter, in some of the first sober moments following the all-German lovefest, East Germany's democrats—namely the former opposition and those who had since joined them,

the latter including an unknown thirty-five-year-old physicist named Angela Merkel—got down to brass tacks. The Wall's fall had reshuffled the deck completely; now, ostensibly, everything started again from zero. The agenda for the GDR was wide open. Top on their long to-do list was creating the infrastructure of a genuine republic, which would pave the way for free elections. This was the hour of the dissidents, who rightfully basked in the glow of their unexpectedly swift and nonviolent triumph. They promoted their new civic-minded parties and spoke for the East German "citizen's movement," a coalition of their parties and other grassroots groups. At the official sessions of the Central Round Table, an interim forum composed of the citizen's movement, the Protestant church, and reform-willing communists, negotiated a way through the tumult and uncertainty. The elephant sitting on the table was the Stasi, which the democrats insisted be dismantled at once. But how? Who was going to do it? The vast, secretive security apparatus was heavily armed and not accustomed to taking orders from anyone but the GDR's top bosses. They weren't going to walk off the stage because a handful of hippies, until a week ago the object of their surveillance operations, commanded them to do so.

The KvU crowd understood themselves as part of the citizen's movement and had every intention of weighing in on the furious debate over the GDR's future. One of the older Church from Below members, Reinhard Schult, was on the round table. At the same moment, though, every one of the crew was suddenly faced with existential personal questions that demanded searching introspection, such as: who am I, and what do I want in this new, unfamiliar world? Suddenly, options they could only have dreamed about a week before were now available to them. Everything was possible! And, naturally, they were chomping at the bit to travel.

I was in Budapest when the Wall fell, preparing to leave the next day for Romania. A hair-raising week in the cruel dictatorship of Nicolae Ceauçescu erased any illusions in my mind that the entirety of the East bloc would enjoy velvety revolutions. Ceauçescu ruled Romania with an iron fist, to such a degree that there was scarcely opposition at all, to say nothing of punk rock. Ceauçescu wouldn't show the East Germans' compunction about clamping down Tiananmen-style. The capital city of Bucharest, which Ceauçescu had used bulldozers and dynamite to transform from the onetime "Paris of the East" into a ghastly nightmare of rusting towers, had all the trappings of a full-fledged police state. Paramilitary guards patrolled every public space with long nightsticks in hand. Pedestrians shuffled head down along unlit city streets, no one daring to talk to foreigners, which was punishable by law. Director Cristian Mungiu's harrowing *Four Months, Three Weeks, Two Days* (2007), arguably the finest film of the postcommunist era, captures the terror of those days with perfect pitch.

Upon my return to Budapest, I was never so pleased to see my little courtyard apartment in the city's fifth district, just off the Danube's right bank. Although Hungary's turn toward democracy had been under way for years, in autumn 1989 the city was buzzing as the final vestiges of the ancien régime crashed to the ground. The Hungarians flaunted their unspectacular overthrow of communism and beamed with pride for having opened the floodgates for the others. The situation in Cold War Hungary, called the "cheeriest barracks in the East bloc," had never been as bleak as in the GDR, to say nothing of 1980s Romania. And now the Magyars were the darlings of the West, with an enviable head start on both democracy and a market economy. Most observers saw Hungary as a shoo-in to be the region's model democracy. Yet, in the euphoria of the moment, they

failed to factor in that the new liberties had also awakened old ghosts: illiberal strains of nationalism, worryingly akin to those of the interwar period, which had led Hungary into an uneasy coalition with Adolf Hitler. Sadly, never again would I experience Hungary as lighthearted as it was in autumn 1989.

But at the time there was nothing but goodwill all around, and the crowded beer bars along the Danube were overflowing with it. One rathskeller in our street called Frigat, complete with kitschy maritime décor, was a favorite of expats and Hungarian girls who wanted to meet them. It was in Frigat, about a month or so before the Wall fell, that my apartment mate Maggie and I spotted two unusual figures leaning against the bar. Micha, sporting a lopsided punk coiffeur and earrings, and Gerd, with his brightly hennaed hair and tank top, looked oddly out of place. We immediately got to talking about Church from Below, and its plans to upend the GDR—to make it live up to its name as the German Democratic Republic. If they had wanted to flee the GDR, they told us, they'd have already done so, as so many of their acquaintances had. We immediately bonded with the two, but hardly took their talk of a new GDR seriously. A month later, though, everything was different, and we still had their address on a scrap of paper.

As electrifying as the moment in Hungary was, Berlin without its Wall, a city I didn't know, beckoned to me. My means of transport between Budapest and Berlin for the next two years was the overnight train en route from Bulgaria, which usually left Budapest's East Station around eleven o'clock at night, stopping in Bratislava, Prague, Dresden, and then East Berlin. Invariably the trip was an adventure, whether you were up for it or not. In the six-bunk couchettes your roommates for the night could be German, Romanian, Roma, Slovak, Serb, or another *Mitteleuropa* ethnicity. You'd meet businessmen and prostitutes,

black-marketeers and families. Conversation happened in a hodgepodge of languages inevitably accompanied by a bottle. Whatever the case, you didn't get much sleep.

I arrived back in Berlin in December 1989, the week Einstürzende Neubauten played East Berlin, the first big post-Wall concert in the East. It was only fitting that the Neubauten be the first, having destroyed the Wall onstage for nearly a decade. The band members were dumbstruck to find they had a clued-in fan base in East Berlin. The Prenzlauer Berg bohème was there in force, positively gleeful about finally experiencing live what they knew only from bootleg cassettes. In fact, fans descended on the VEB Elektrokohle Lichtenberg, a state-owned power plant with a good-sized auditorium, from across the GDR. Now, Einstürzende Neubauten's "dancing the apocalypse" had an entirely new context, one that every easterner grasped intuitively: a perishing world, walls crashing down, rubble and detritus everywhere. Dancing to it was a perfectly natural reaction.

Between interviews and frantic spurts of writing, I took time to wander through the desolate neighborhoods that had festered alongside the Wall for three decades. I had to keep reminding myself that I was in the middle of Europe. The city's condition was shabbier than most West Berliners had anticipated, as the GDR had dandied up those bits of East Berlin that observers could see from the observation platforms on the other side. Just behind these Potemkin facades, decades of neglect stared you in the eye.

The KvU regulars were also prowling the frozen streets of East Berlin in the final days of 1989. Their purpose was to locate a suitable building to squat, an endeavor they had discussed at length, though hypothetically, before the Wall's opening. Silvio and the contingent climbed over walls and fences, boosted one another through open windows, and marched up and down

wooden staircases with lock picks in hand, sizing up the structures' plumbing and rooftops. Many of the houses that they inspected in Friedrichshain, on either side of Frankfurter Allee, were scheduled for demolition, and thus were not only empty but stripped of interior doors and electrical wiring. Others were in better shape, though they reflected Friedrichshain's norms of shared toilets in the stairwells, cast-iron sinks with spigots, and man-sized ceramic coal ovens.

The group finally settled on 47 Schreinerstrasse, a freestanding building with rubble-strewn, weed-choked lots on either side of it—the handiwork of World War II British bombers. A document tacked up in the foyer stated that the building was condemned. The grounds: an infestation of pigeon ticks. Its cracked cement balconies sagged but weren't in danger of collapsing, at least not imminently. A central staircase opened at each floor to a pair of apartments on either side, their varnished wooden doors with art nouveau inlays among the few signs of better days.

Although there was no sign of pigeons or ticks, the building wasn't uninhabited. It had two sets of tenants, a sixty-year-old widower and a low-income, alcohol-plagued family of four, the kind of people socialism had stranded in these neighborhoods. "What are you doing here?" one of them barked in a thick Berlin dialect from behind a crack in a doorway, obviously intimidated at the sight of the troupe. "This building is now squatted," the intruders responded matter-of-factly. Later that day they painted the same message on a white bedsheet and hung it from the second-floor balcony: *Dieses Haus ist besetzt!*

Characteristically, this group wasted no time putting their objectives into a typed manifesto. It stated that they had no intention of seeing a communist dictatorship replaced by a state subservient to the interests of big business. This wasn't what

they'd fought for so bitterly during the darkest days of the GDR. They were going to create something new out of this unloved state, starting with the squat, where community would be based on the principles of "socialism, mutual understanding, and solidarity." This was a unique opportunity in history, they wrote, to define their lives and society as they wanted to, unencumbered by a paternalistic authority. They exhorted others across the GDR to do the same.

The core group of 47 Schreinerstrasse was fourteen men and six women, all from Church from Below. After they had divvied up the rooms and dragged mattresses up the stairs, the old building experienced the full force of this group's impressive agency. Indeed, their resourcefulness struck me every time I visited. In the GDR, a society plagued by material shortages, one had to make do with what one had. And it helped that all of the Schreinerstrasse men worked with their hands: Mimi was a trained roofer; Jo and Joni, electricians; Silvio, a toolmaker; Dirk, watchmaker; Micha, mechanic; Gerd, organ builder; Keule, electrical engineer; Patrick, carpenter; and Ekke, gardener. Each tackled some aspect of house repairs, putting more sweat into the structure than the state had in the entire postwar era.

Schreinerstrasse's women remember it a bit differently. "Chrischi and I did all the painting," says Kathrin, a kindergarten teacher who was one of the few with a full-time job. "The guys," she remembers, "were mostly just sitting around smoking joints, listening to music." The politics of gender was not a subject among the group in the GDR days. This would change.

They tore down walls to rearrange the geometry of the apartments; stripped, sanded, and painted floors; erected loft beds; mounted a homemade solar water heater on the roof; tacked up posters; sculpted a Jacuzzi by tearing apart and then welding together three bathtubs; and arranged no-frills but comfortable

common rooms on the fourth floor, which included the one functional kitchen where everyone ate together. Furniture and kitchen supplies were a cinch to come by. The squatters' countrymen, the newly liberated easterners, chucked their old stuff into the street by the dumpster-full to make room for new furnishings purchased from West Berlin department stores. The squatters picked out what they needed from the overflowing bins on the curbs. Their gripe with the GDR had nothing to do with the quality of kitchenware. They also found volumes of Marx and Engels's collected works in their handsome GDR-edition dark-blue hardcovers, Rosa Luxemburg's writings, and the poetry of Bertolt Brecht. People had tossed them out along with their party memberships.

Everyone at Schreinerstrasse had a passion that he or she could now openly pursue. Moldt was writing a book about his adventures in Transylvania, Romania. Gerd played violin in the world music band Micheli Baresi. Jo and Micha set up a second-hand bike shop behind the squat. Mimi was by now seriously into martial arts. Heike studied psychology at Humboldt University. Speiche and others helped start up the nightclub IM Eimer. Silvio, Chrischi, and Joni saw that the squat and its allies in the democracy movement desperately needed a printing press of its own and joined forces with Uta Ihlow, who had run the press at the Church of Zion. They came upon a serviceable, manually operated offset press in West Berlin and began Hinkelstein Press in three cramped rooms, formerly the location of an urban horse stable, in a back courtyard along Schreinerstrasse.

"At first we had no idea what we were doing," Ihlow admits. "None of us had any real experience, and our products were pretty shoddy." But veteran West Berlin activists supplied them with more secondhand equipment and valuable tips. "With some help we got the gist of it," says Ihlow.

The press's hours were erratic, as the Schreinerstrasse brigade

rarely appeared before noon. "Silvio in particular always looked totally beat," Ihlow says. "There was so much discussion every night [at the squat] that they never got enough sleep." Nevertheless, after a few months, the ever-more-professional Hinkelstein Press supplied the new scene in East Berlin with posters, fliers, concert bills, tickets, invitations, and newssheets, its machines clattering into the wee hours of the morning.

Most of the Kreuzbergers initially had no idea that a place called Friedrichshain was a stone's throw from their watering holes—or that there could be likeminded peers there. But the West Berlin left eventually found its way to Schreinerstrasse. "Oh, they visited and told us exactly how squatting is done," Moldt says with irony in his tone, describing the first bunch of visitors as "humorless." "You don't, for example, register with the local housing authorities, as we did." Moldt, Silvio, and the others informed this contingent that they'd been squatting apartments in East Berlin for years and knew something about it. The East Berliners, for example, had managed to achieve rapprochement with the communal housing authorities and had eventually legalized their status as tenants. "But for them [the West Berliners], squatting was a nonstop battle against officialdom. That's the word they used, *Häuserkampf*.* This defined everything they did," Moldt says. "But we didn't see our lives or our politics in such martial terms. We wanted to be part of the GDR's transformation, not just wage opposition."

Despite many surface similarities, more separated Friedrichshain in 1990 and Kreuzberg of the early 1980s than first

* The closest English translation is "urban warfare," but more specifically the term refers to fighting the establishment, with militancy when called for, from the squats. For these radicals, the squats were not only *Freiraum* for doing their own thing, but symbols of and bases for their struggle against capitalism and the police state.

met the eye. Take, for instance, the squatters' relationship to the police, which in West Berlin was saturated with distrust and resentment. The East Berlin punks had been battered black and blue by their police. Yet, across the GDR, the disappearance of the Communist Party and its bosses had thoroughly rattled the police force, the Volkspolizei, or VoPo for short, which had for decades functioned as a reliable arm of the party. Out of fear or bewilderment or inefficacy, or a combination of reasons, the VoPo, as if born again, gave the newcomers the run of the inner-city districts in 1990. East Berlin squatters recall how warm and fuzzy the VoPo were at first, even lending them a hand when they could.

In early 1990, the Schreinerstrasse crew made a bold move that fundamentally transformed the landscape in Friedrichshain and East Berlin. They were aware that at any time the city's administrators might snap out of their funk and try to evict them. They had no illusions about the East Berlin police once they'd receive orders to get with the program. Moreover, the Wall's breach hadn't eradicated the GDR's far right. On the contrary, the power vacuum and the nationalist euphoria of the day had emboldened the GDR's homegrown Nazis, who had already zeroed in on 47 Schreinerstrasse as a target. (The rightists had squatted their own building in Lichtenberg, the district abutting Friedrichshain to the east.) Recognizing the strength in numbers, the Schreinerstrasse bunch drew the West Berliners a map marking all of the buildings in Friedrichshain ripe for squatting.

In Kreuzberg and far beyond Germany's borders, the word was soon out that much of East Berlin was fair game, open to anyone with a crowbar in hand and project in mind. Freaks and restless souls from across Europe flocked to Berlin to take advantage of this unprecedented urban space, large swaths of an entire city up for grabs. Caravan colonies picked up from wherever they had hitched their ramshackle circus wagons and lumbered into

the abandoned lots that speckled Berlin's east side. Whole artist collectives such as the U.K.-based Mutoid Waste Company and the Amsterdam Balloon Company from the Netherlands rolled into town in noisy convoys, their paraphernalia in tow. Until 1990, East Berlin had led a secluded life, the foreigners in the GDR limited to modest numbers of students and guest workers from other socialist countries. Nor had West Berlin been a booming international attraction. For the first time since Christopher Isherwood left Berlin in 1933, the year Hitler came to power, Berlin—East as well as West—was wide open to the world.

In Mitte and neighboring Prenzlauer Berg too, apartment buildings, industrial spaces, and former Nazi bunkers were occupied one after another. A feather in the cap of anarchism, though state-prescribed law and order was effectively suspended, there wasn't a rash of looting or vandalism, as conservatives might have predicted. On the contrary, the suddenly boundless space and absence of authority set the stage for an explosion of imaginative energy. Christoph Links, whose contribution was a startup publishing cooperative, called it "the wonderful year of anarchy," a label that stuck.

On the east side, the subcultures of East and West Berlin collided with a bang. "It was like a gust of fresh, warm air into the city," says Gudrun Gut, who had been in the process of packing her bags to leave West Berlin for Barcelona—but on the spur of the moment reversed her plans.

More than forty residential buildings in the vicinity of Schreinerstrasse were occupied, including a cluster of nine on the short Mainzer Strasse and seven in a row around the corner on Rigaer Strasse. At its height in 1990, squatters across East Berlin commandeered 130 houses, every one of which boasted a distinct profile. On Mainzer Strasse, for example, house number 4 was Tuntenhaus, or House of Queers, home to a close group

of gay men and transvestites who had been shunted around West Berlin for years before finding Friedrichshain. Number 3 was the domain of a no-nonsense lesbian faction, and 5 and 6 belonged to West German Autonome. Twenty-three Mainzer Strasse ran the Edith Piaf Collective Kitchen, where locals could eat for a dollar.

It's fair to distinguish inner-city East Berlin in 1990 as a "temporary autonomous zone," or TAZ, a term coined by the popular anarchist thinker Hakim Bey. In his anarcho standard *The Temporary Autonomous Zone*, Bey describes a transient pirate utopia of uncontrolled social or geographic space. A TAZ could be as contained as a double bed or as vast as a city. This, argues Bey (born as U.S. citizen Peter Lamborn Wilson in 1945), is what contemporary anarchists should strive for: flesh-and-blood autonomous zones where decentralized experiments in living are possible, for a few hours, days, or months. Communes and bohemian enclaves can last even longer, argues Bey, whose debt to the Situationists he readily acknowledges. For Bey, the TAZ is "a microcosm of that anarchist dream of a free culture" in the here and now; a "guerilla operation" liberates an area and then, before the state crushes it, the project dissolves itself to re-form again elsewhere. A key element is the "TAZ as festival" when "all structure of authority dissolves in conviviality and celebration." Parties or other forms of bacchanalia liberate spaces as well as persons from the prevailing truth and established order. Festivities mark the suspension of rank, norms, dogma, and prohibitions. According to this definition, pockets of Kreuzberg in the 1980s were TAZs too, as was, arguably, West Berlin's Kommune I. Berlin's free techno scenes late into the 1990s and beyond boasted characteristics of a TAZ. (Since then, ravers have enthusiastically appropriated the concept, apparently to Bey's disapproval.)

Definitions aside, the greater squatter and alternative scene in East Berlin took full advantage of the plentiful space, fusing subculture with new forms of subversive politics and experimentation in everyday life. The community gave birth to an impressive array of self-organized institutions, including radio stations, newspapers and magazines, publishing houses, an anarchist political party, do-it-yourself open libraries, unlicensed taxis, and even for a while its own currency. The new weekly, *Die Andere* (The Other) reported on the TAZs across the GDR and kept a close eye on the Central Europeans' velvet revolutions. Since none of the East Germans now had time to travel around Central Europe reporting, the editors asked me to pitch in. I'd write in English, fax them the copy, and they'd translate into German. The neighborhoods even devised a minuteman security network that alerted the community to skinhead attacks.

The squats were the backbone of the TAZ. On Prenzlauer Berg's Schliemannstrasse, a group of rock climbers from the East German university town of Jena squatted one building, the edifice of which was turned into a climbing wall. The house became the headquarters of East Germany's first independent climbing club. Nearby, 14 and 15 Dunckerstrasse were taken over by a group from the Free University's Institute of Eastern European Studies, who beckoned friends, and friends of friends, from Yugoslavia, Poland, and Russia to join. The adjacent squats had a cellar techno club, bar, and barebones recording studio. At the base of Schönhauser Allee, number 5 was the residence and practice rooms of the cult East German punk bands Freygang and Feeling B, which harbored the nucleus of the future supergroup Rammstein. An East-West film cooperative coalesced at 5 Tucholskystrasse, where it produced a regular news show for the squatter scene on videocassettes that were passed from house to house, to cafés, and to makeshift mini-cinemas such as Lichtblick Kino on Kastanienallee.

"Every squat was organized differently," my friend Rüdiger Rossig, who lived at 14 Dunckerstrasse, told me. The form of organization that eventually prevailed was a matter of trial and error, the composition of its members—and a lot of patience. "At our house there was a pretty low level of organization," says Rossig. "We'd start a meeting and then twenty minutes later someone would walk in late because he was too stoned to get out of bed. So we'd start the meeting all over for his sake. Eventually we just cancelled the group meetings. We noticed that if you wanted to achieve anything, you had to go to your neighbors' kitchens, sit there with them, smoke a few joints, drink a few teas, and talk things over. This took more time than any plenum." Rossig notes that at the 77 Kastanienallee squat, in contrast, meals, shopping, and cleaning duties were perfectly planned and carried out in shifts, to the benefit of the entire house. The difference between the two setups was that Kastanienallee included more than a handful of residents who'd participated in large, decentralized projects before, and knew the ropes.

Money wasn't a concern, at first. Rent was unpaid or very cheap. Many of the West Berliners had access to student loans or part-time work in West Berlin, which provided them with West German deutsche marks. When exchanged into eastern marks, this went a long way toward subsidized eastern goods and services. (A pack of filterless Karos was less than a dollar. The overnight train from East Berlin to Budapest cost just twenty-five dollars.) There were also thousands of new, temporary jobs funded by the West Berlin city council. One simply had to propose a halfway-credible project, such as organizing puppet shows for neighborhood children or minding a recycling center, and deposits would arrive twice monthly into your bank account. My good friend Heike jumped from one such job to another during the early 1990s, at one point serving as an aide in a Catholic-run

urban orphanage in Prenzlauer Berg. Many of the 47 Schreiner-strasse residents continued to work for Volkssolidarität, the East German equivalent of Meals on Wheels. The state-run agency provided senior citizens with warm midday meals six days a week. The delivery crew would tool around the old neighborhoods on bicycles, the insulated pots of stew, potatoes, and boiled vegetables secured to their racks. It was part-time work, and leftovers were consumed at the squat. Never again would it be so easy to live on so little in Berlin. (Nor, once senior care was privatized, would seniors receive warm lunches for pennies.)

House squats were just a fraction of the occupations. The former Schultheiss brewery in the middle of Prenzlauer Berg was a sprawling fortress-like structure complete with brick towers and turrets that dominated a good-sized city block. In the GDR years, it was employed mostly as a warehouse and fell into disrepair. But in late 1989, it landed in the hands of a group of young architects and design aficionados whose progressive visions for East Germany had been shelved by the GDR authorities, a phenomenon portrayed in Peter Kahane's 1990 film *Die Architekten* (The Architects), one of the best—and last—films made by DEFA, the GDR's film studio. These squatters turned the brewery's twenty buildings and six courtyards into a freewheeling forum for the creative and performing arts, earning it the name Kulturbrauerei, or Culture Brewery.

A once-grand 1910s department store destroyed in the war became Art House Tacheles, a behemoth of a structure in which as many as thirty artists at a time worked and lived. Its high, muraled walls became an emblem for Mitte, where street art and graffiti now decorated the facades. Beneath Café Zapata on the ground floor, Tacheles's dark catacomb of a cellar was one of the first techno spots in the city and a launching pad for others. You could hear Spanish, French, Italian, and Dutch spoken in

Tacheles's corridors—and above all pidgin English, the new vernacular. One could roam the premises of Tacheles for hours with a plastic cup of draft beer and a joint. Hashish was sold beneath the stairwell.

Thanks to two of East Berlin's overnight impresarios, a seventeen-year-old punk rocker named Swan Maass, and the thirty-odd-year-old light-installation artist Peter Rampazzo, the expansive sandy lot behind Tacheles became the grounds of a sci-fi sculpture garden like none other in the world (see photo, page 223). Maass, daughter of prominent GDR dissidents, and Rampazzo, a GDR exile living in West Berlin in the 1980s, teamed up immediately after the Wall crashed—and shortly after that fell in love.

Rampazzo had fled the East bloc by swimming across the Drava River from Hungary to Yugoslavia. In West Berlin, he collaborated with Dead Chickens, a performance art group that incorporated his otherworldly light sculptures and projection affects into their traveling monster-mash shows. Rampazzo learned that the Wall had been breached only after he opened his latest exhibition at midnight on November 9 in Kreuzberg's Arcanoa Club. He was at the door, selling tickets for five deutsche marks (three dollars) apiece. "Five marks, that was nothing," he says, "but people kept asking if they could come in for free. I said, 'just five marks, come on.' Then they told me they were from the East." That very evening Rampazzo struck up a friendship with a group of East Berlin musicians from the Prenzlauer Berg community whom he would come to know quite well in the years ahead.

"Our idea was to make an art squat, not for living in but for pursuing all kinds of art and music," Rampazzo told me at a small Italian restaurant near the Jannowitzbrücke. On its curb was Rampazzo's ramshackle camper van, his only domicile for

A sculpture in the yard of Art House Tacheles, 1990.
About two dozen artist-squatters spent the winter in
the bombed-out former department store.

the past decade. "In West Berlin, the squatting was long over. The police tossed you out in a day. But in the East, the space had no limit," he remembers. Rampazzo, Maass, the Prenzlauer Berg rockers, Speiche from Schreinerstrasse, and a handful of others opened the four-story club they named IM Eimer (Down the Drain) on Rosenthalerstrasse in early 1990. Eimer served as the location set for the *Good-bye, Lenin!* scene in which the protagonist, played by German actor Daniel Brühl, and his girlfriend go out on the town for a night.

Before opening, they had had to dig out the cellar, which lay under several tons of rubble. Much of the ground floor had caved in years before, leaving a gaping hole that confronted visitors upon opening the front door. The first floor, despite the yawning void in its middle, was stable enough around the edges to support

The interior of the club IM Eimer. Its proprietors found most
of the ground floor caved in and the cellar full of rubble.
One entered through a cellar door.

a band, a makeshift bar and fridge with bottled Czech beer, and a dozen or so intrepid concertgoers (see photo, page 224). The more cautious could enter through the cellar and peer up through the hole to see the bands or DJs above. Rampazzo adorned the interior with psychedelic neon tubing and glow-in-the-dark installations, turning the club into a wild 3-D trip à la *Blade Runner.* Rampazzo's installations, as it turned out, were ideal for techno, and Eimer eventually became known for its electronic dance music parties. For those who paid anything at the door, the cover was a couple of deutsche marks, just enough to meet costs.

Every so often, the unlikely couple of Maass and Rampazzo fled the noise and chaos of Eimer for the tranquil countryside outside of Berlin. They'd throw a mattress on the top of a Trabant square-back and take off. Once, having turned down a dead-end country road in error, they stumbled upon a couple of disused Soviet tanks, fenced off with wire. The Soviet army was in the process of withdrawing from eastern Germany and had left refuse in its wake, such as these tanks, which were, it appeared, slated for the junkyard. Local kids had already crawled under the fence and were playing atop of the Red Army weaponry. Maass and Rampazzo climbed into the tanks and began dismantling them, seeing at once potential for Eimer's cyberpunk décor.

Maass and Rampazzo soon learned that the disappearing GDR was a gigantic flea market stretching from the Baltic Sea in the north to the Czech border in the south, where unnamed middlemen were eager to sell off whatever they could. Even the Stasi had venues where everything from carpets to cafeteria supplies, Lenin's collected works to wallpaper, were for sale. For just seven hundred dollars, the duo bought an off-road Soviet-make military truck with heavy-duty, chest-high wheels that they'd use to move Rampazzo's installations and bands' sound systems around the city.

One afternoon, out mushroom picking in rural Brandenburg, they came upon a prize even more sensational than the panzer: two abandoned Soviet MiG 21s, fighter aircraft, stripped of their weaponry and engines but otherwise intact. Rampazzo filmed the jets and then ran the footage all that night on Eimer's walls. As it happened, some of the guys from the Mutoid Waste Company stopped by that evening. The English performance group, with its *Mad Max* aesthetic and passion for XXL scrap machinery, had been part of London's free rave scene before police raids on their warehouses inclined them to move on. East Berlin was a godsend, a playground of their wildest fantasies. Their thing was welding scrap automobiles and other machines into super-large, postapocalyptic sculptures. They'd already begun to decorate Tacheles's back lot with sliced-up Trabants and other reconfigured GDR debris.

In terms of size alone, the MiGs (see photo on facing page), weighing several tons apiece, were of an entirely different order than the group's usual fare. Yet they were too tempting to just leave there without trying. The "mutoids," as they were called, leased a mobile crane and two semi-trailer trucks from an East German construction company. Under the cover of night, they liberated the jets and towed them into Berlin, straight down the city's main drags, to Tacheles. The mutoids then stuck the MiGs nose down into the sand, as they did pink-painted tanks (called the Pink Panzer) along with other tossed-away military hardware they would procure in the future. In doing so, they'd bury the Cold War, creating a landscape where the ripped-out innards of the GDR and the flotsam of the Cold War were transformed into a colorful garden of antimilitaristic artwork.

The off-the-cuff atmosphere made for exceptional nightlife, the mise-en-scène morphing from week to week (see photo, page 228). Galleries and tiny bars and brick-and-board cafés popped up and then disappeared without a word. Sometimes parties were

Soviet leftovers: a MiG 21 in a Brandenburg field.

advertised with a handwritten flier taped to a street lamp: "Party at 21 Auguststrasse tonight in back courtyard. Bring wine."

I lived on Friedrichstrasse, across from the Tacheles sculpture garden. One could cut through it, emerging at the mouth of Auguststrasse, a quiet side street that featured several of my favorite locales. Café Ici was a no-frills, candlelit bistro where you could strike up a conversation or find a chess partner without trying. The matron was an aging, garishly made-up diva who lined the café's high walls with dozens of painted portraits of herself. Every rickety chair in the place was one-of-a-kind, by the look of them plucked from refuse bins or bought in secondhand shops. A down-and-out former opera singer made the rounds most nights singing requests for a deutsche mark.

On the way to Ici, you'd pass three squats in a row, which were the creations of art and drama students who performed experimental theater pieces on their own stage in the rear house. They named their project "KuLe," combining the first letters

**The local bohème at the bar Obst & Gemüse
across from Art House Tacheles, 1992.**

of *Kultur* (culture) and *Leben* (life). Gigantic papier-mâché crea-
tures loomed in their courtyard and hung from high window-
sills as if monsters were scaling the building. Farther along
was the Mulackritze, a bar that on warm nights spilled into the
street. The original Mulackritze was a 1920s tavern that under-
world figures, prostitutes, and the theater crowd (among others,
Marlene Dietrich) had frequented in the day. It survived the war
but was shut down in 1951 and then demolished by GDR bull-
dozers in 1963. There was something magical about evenings at
its post-Wall incarnation, even though physically it was noth-
ing special: two nondescript, low-ceilinged rooms with a keg of
draft beer and roughhewn wooden tables lit by dripping candles.
Eimer, which usually started up later, was around the corner.

While the likes of Tacheles and Kulturbrauerei immediately
caught the eye, there were many other, less visible projects, too.

The Ch. Links Verlag, for example, the GDR's first independent publishing house, took up Soviet communism as its theme. Links himself did not hail from the underground but, like many others, had been part of the system, as an editor at the state-run Aufbau Press. The Wall's fall presented him with the opportunity to break away and, finally, tackle the questions he had long wanted to: How has GDR propaganda and falsified scholarship affected our society and our minds? What was true about what we'd been taught—say, about the 1953 workers' uprising in East Berlin—and what wasn't? The earliest publications of Ch. Links Verlag examined the distortion of history and philosophy in the GDR. The first studies on the Stasi, the magnitude of which easterners were only just beginning to comprehend, were products of this serious little press, and the topic of the Stasi would figure prominently in its catalogues for years to come—in fact, to today.

Purely by chance one afternoon, I stumbled upon an unadvertised, do-it-yourself exhibition in a local community center titled "Mythos Antifaschismus." Its subject, in a vein similar to the investigations of Ch. Links Verlag, was the GDR's official doctrine of antifascism, which had functioned as one of the state's sturdiest cornerstones. Even in the early 1990s (in fact, even in some circles today), there were Germans who insisted that one redeemable aspect of the GDR was, in contrast to the other Germany, its hard line on Nazism.

The impromptu exhibition, surely the first of its kind, threw a harshly critical light on GDR antifascism by deconstructing its content. The meta-exhibit displayed artifacts that were part of a GDR antifascism exhibition including statues, artwork, books, speeches, and photographs. Beneath each item was an explanation on poster board in neat handwriting of how its messages served to legitimize and glamorize the regime, as well as to buttress the GDR's militaristic, authoritarian, black-and-white

political culture. Latent anti-Semitism, too, could be read into the subtext of official antifascism.

I took in the exhibition slowly, gradually comprehending how it was that young East Germans could become neo-Nazis in the self-proclaimed antifascist state. While outwardly demonizing the Nazi regime, the GDR had internalized many of its values. I sought out the exhibition's curator, a woman named Annette Leo, a former GDR journalist and independent historian. When I complimented her first-ever exhibition, she rolled her eyes and sighed. "That's nice to hear because it's not what most visitors say," she told me, referring to the neighborhood's native East Germans. "They claim I'm besmirching one of the best things about the GDR. They tell me this is how the West Germans bad-mouth everything about the GDR," she said.

Ch. Links Verlag and "Mythos Antifaschismus" were two of the earliest baby steps that eastern Germans would take in a complex and unflattering coming to terms with the dictatorship of the GDR. At the same time, Annette Leo underscored, the eastern Germans had to reassess their understanding of the Nazi past, which had been instrumentalized by the regime. Only in this way, she told me twenty-five years ago, could they hope to expunge the remnants of the Third Reich in their culture. As a professional historian for the next two decades, this is what Leo would try to do at some of Germany's most prestigious universities.

Walls in the Mind

The temporary autonomous zone of East Berlin was arguably the very first location in all of Germany where "Ossis" and "Wessis" not only met but worked and lived together. In the squats,

the techno clubs, and common projects, the eastern and western Germans got to know their counterparts quite well—for better and for worse—after the decades of separation. Living cheek by jowl and organizing projects, these protagonists probed much deeper into the private spheres of their peers than one did just chitchatting in a bar. Thus it's not an exaggeration to say that Germany's long, vexed reunion began in the occupied venues of East Berlin. And, just as happened later on a larger scale across Germany, tensions flared once the feel-good vibes of the Wall's fall and communism's collapse wore off. Four decades of profoundly dissimilar socializations had left their mark, and the lopsided processes of unification would only aggravate this.

Of course, the novelty of the unknown other was one source of the miracle year's thrill. The easterners had experienced everything—from kindergarten and Kafka to punk rock and nude sunbathing—through the prism of "real existing socialism" and its termination. This is what we talked about into the late hours on Auguststrasse and in Hungary in Budapest's indie club Tilos Az Á. There was no small talk. Could you read Kafka and Dostoyevsky in your country, we'd ask. How? What did it say to you? Why? They were just as fascinated that I'd read Kafka and Dostoyevsky in the United States, and in what it said to me, as well as why Americans were so uptight about nude sunbathing. Is it true, I was asked in Romania, that the United States really lost the war in Vietnam? Yes, I answered, it's true, despite the fact that Romanian communists had said it. If *everything* the communists told them wasn't a lie, the young woman asked me, how was she to separate the true from the false? And then, of course, there were the big-ticket questions on the world stage: the future of the two Germanies, of the Soviet Union, of NATO, and of a Europe no longer divided.

Yet, the better they got to know them, the more the easterners

tended to find the West Germans condescending and arrogant, as if nothing the easterners knew or had experienced mattered now that "their" system was crushed and discredited. Many western Germans—though by no means all—tended to look at the eastern Germans as hopelessly uncool, poorly dressed, and provincial. Spoken or not, there was the insinuation that most "Ossis" had timidly tolerated a brutish dictatorship for decades, which in fact had a grain of truth to it. My friend Uli, a doctoral candidate in philosophy at the Free University, told me that the "Ossis" were the "better Germans," which was not a compliment. He meant that they had preserved the worst characteristics of the German prototype. After all, the easterners hadn't experienced the liberating storm of the 1960s, he argued, which is why eastern Germany in 1990 resembled West Germany in the 1950s. Unfortunately, I never had the chance to introduce him to the Schreinerstrasse bunch.

The apartment building of Tom Sello and a handful of others from the Environmental Library on 7 Fehrbelliner Strasse in Mitte, not far from the Church of Zion, was one of the first to test the all-German waters. The group, oppositionists all of them, had moved into the wreck in the course of 1989. The building was so bomb-damaged that GDR housing officials approved the move only on the condition that they not request repairs or amenities. In early 1990, Sello recruited a handful of westerners to join them, as a number of the building's apartments were empty. He knew the West Berliners, who belonged to a network of acquaintances who had smuggled over ink, paper, and spare parts for the underground printing press.

For Sello, the experience was both enriching and frustrating. The West Germans considered themselves leftists, says Sello, and were deeply skeptical of the Federal Republic, which they had fought on many political fronts over the years. Yet they

knew little about the GDR. According to Sello, the westerners "firmly believed that the old GDR was essentially a good thing, since it was something other than ruthless capitalism. I tried again and again to make the point that this was not the case, that this kind of socialism, if that's what you want to call it, was fundamentally deformed. But it didn't sink in, and then the next day it was as if I hadn't said anything at all. The picture they had in their heads was intact."

East-West tensions tore apart the flagship project of Tacheles. A West Berlin contingent came to the project after easterners had squatted the property. The westerners, it turned out, wielded important know-how. West German activists had been working in collectively managed, self-administered projects for years and knew the ins and outs of job creation programs, welfare benefits, and lease contracts, too. Leo Kondeyne, an easterner and one of Tacheles's original squatters, was on Tacheles's board. The westerners were so savvy that he and fellow easterners lost every battle, he says. "They had ten or twenty years of experience in nonprofit associations and managed to maneuver us into corners," claims Kondeyne, whose interest was "just to make art." "Before we knew it, big-name professional bands were playing at Tacheles. No one knew what was happening with the money," he says.

The westerners had gripes too. A good friend of mine, a West German woman, moved into an apartment collective in Prenzlauer Berg that had been advertised explicitly as a *Wohngemeinschaft*, the kind of living arrangement dominant among young people in West Berlin since the student movement. The two other women in the four-room apartment were easterners and simpatico, both graduate students thrilled to be in the middle of it all in Prenzlauer Berg. My friend hit it off with them, but she quickly noticed that they had no experience living in an

apartment collective. How could they have in the GDR? Thus they weren't familiar with the generally accepted rules of this West German institution. The young woman in whose name the apartment was leased, my friend discovered much later, had charged her well over a third of the rent, which is all she should have had to pay. Moreover, the woman's mother would show up occasionally with a key, leaving snarky notes to the "subletters" to wash the dishes. In West Berlin, this would have been positively scandalous, even unthinkable. But in the east, the nature of the *Wohngemeinschaft*, the great-grandchild of Kommune I, was up for grabs.

Manuel Zimmer was a West Berlin native who found himself caught up in an uncomfortable East-West tiff in a squat in Mitte's historic Jewish quarter. Three of the group's members, the only easterners, wanted to open a club in the building's first floor and cellar, which had housed a bakery in the 1950s. With its thick brick walls, the space was ideal for parties and raucous gigs, which the squat had been hosting from time to time. The easterners wanted to make a small business out of it, put it on firm financial footing, advertise events, and bring in better-known bands. But the westerners insisted on keeping it off the grid and informal, with variable opening hours.

"It was really hard for us," Zimmer says, "to tell easterners that we didn't want them to start up their own business because we considered it capitalism. I mean, this is why they couldn't start their own club in the GDR! But we didn't want a commercial club that was just like every other club in West Germany and everywhere else. It was a really awkward situation."

The easterners eventually won out and opened the club Zosch, which survives today as a rare instance of a squatter-era club that paid its own way over twenty-five years in pricey, tourist-infested Mitte. In fact, Zosch isn't like "every other"

glitzy, antiseptic club in Germany. With its ivy-clad, graffiti-sprayed walls, banged-up wooden tables, and reasonable prices, it still has a vintage feel to it. Zimmer's vision of an improvised club with no cover charge and whenever-they-felt-like-it hours had zero chance of surviving beyond the wildest days of the interregnum.

"Sure, some Wessis were overbearing and arrogant, but we didn't divide the world into Ossis and Wessis," Moldt says of 47 Schreinerstrasse, which was the only all-easterner squat that I knew of in East Berlin. In fact, Schreinerstrasse was probably more open to West Germans than were most of their country-men since, as GDR outcasts who dressed the part, they were treated with disdain by law-abiding GDR citizens. In the squat, there was no love lost for fellow Ossis. On the contrary, the crew hoped they'd find kindred spirits out there in the wider world, for example in Kreuzberg. They did, and by mid-1990 there were four western Germans and a Dane among them. The Schreiner-strasse crew did pick up useful ideas from the West Germans, not least of which was a rethinking of gender roles. Kathrin immersed herself in the topic of gender, eventually joining a West Berlin women's collective that had come together during the women's rights movement. She even helped it set up an office in Friedrichshain, around the corner from Schreinerstrasse.

The specific expertise of both the easterners and the west-erners would become relevant when the authorities finally took notice of East Berlin's metamorphosis—and undertook measures to proscribe it. The squatters could only hold on to their houses and the TAZ by sticking together. In the end, this was too much to ask of the scene's radicals.

8

One Nation, One State, One City

In the West, they're smarter. Money is the Wall.

—BANNER IN MAINZER STRASSE, 1990

IN THE WEEKS AFTER THE WALL'S FALL, ORDINARY eastern Germans pounced on the opportunity to become active citizens. Without instruction from above, the newly formed demos of the postcommunist GDR set in motion a sweeping, self-styled democratization, from nurseries to the highest echelons of state. Every municipality fashioned its own self-government. The GDR's former subjects ousted the old guard from workplaces and sports clubs, forming committees and elected councils in factories, farms, and schools. Direct democracy was the order of the day across the land.

In the GDR media, you could see and hear how its staffs were overhauling the old structures—with humor and brio, and the intention to create something of their own, not simply replicas of the West German standard. In East Berlin, everyone I knew was tuned in to the radio station DT64 (its English jingle: "Power from the east side!"), which had been the youth program in East

Germany. The music,* off-the-cuff humor, and acerbic newscasts were my soundtrack to the miracle years.

Communism's implosion happened so suddenly and definitively that East Germans were caught without a plan. Church from Below was exceptional, with its notion of democratic socialism. Some eastern Germans envisaged that after free elections an independent GDR would set its own course, probably adopting some of West Germany's better facets, such as a strong multiparty parliament, but perhaps also elements akin to democratic socialism or participatory democracy. Still others looked further down the road, open to the idea of unification when a healthy, democratic GDR was on its feet, in a position to negotiate with the Federal Republic—and then as an equal—about a merger of some sort, with both states bringing something to a united Germany.

But these hazy visions of a new Germany were expunged on March 18, 1990, the day of the GDR's first (and last) free parliamentary election. The vote, the crowning achievement of the former dissidents, delivered them a bracing slap, jolting the first-hour democrats back to reality.

The Federal Republic's chancellor Helmut Kohl had begun pushing hard for unification soon after the Wall's breach, and many eastern Germans piled on the bandwagon, jubilant about the promises that "Helmut," as they endearingly called him, was making about "blossoming landscapes" in the east and quick prosperity for all (see photo, page 238). The Christian Democrats poured millions into their campaign in the GDR. In Leipzig, the

* This included the Western spectrum of rock from the Rolling Stones to U2, critical GDR bands such as Silly, Die Art, Sandow, and Feeling B, and bands that sprang up once the Wall fell, such as Bobo in White Wooden Houses and Inchtabokatables.

German chancellor Helmut Kohl at a campaign rally in the
eastern city of Erfurt, March 1990.

Monday demonstrations continued in the aftermath of November 9. But the chanting shifted ominously from the republican "We are *the* people!" to the nationalistic "We are *one* people!," raising the specter of unification from the streets. A Leipzig banner in February 1990 summed it up adroitly: "If the deutsche mark comes to us, we'll stay. If not, we'll go to it."

Kohl's conservatives rode the new nationalism and wave of chummy post-Wall euphoria to a landslide victory on election day, crushing the GDR's citizen's party like an insect. Running together on one slate called Alliance 90, which included the Initiative for Peace and Human Rights (IFM), the former oppositionists* captured just 2.9 percent of the vote—a pathetic, humbling result for the standard-bearers of the peaceful revolution. Arguably, the March vote was the culmination of the May 7, 1989, election-monitoring initiative and the campaign that followed it. Yet, less than a year later, the episode had been consigned to a forgotten footnote.

Most observers, myself included, had predicted decent turnouts for the GDR's new parties, such as Alliance 90 and the East Greens, enough at least to make them a force to be reckoned with. We also assumed that the left-of-center Social Democrats, less gung-ho about unification than Kohl, would fare well in the postsocialist east. But they too were steamrolled by the nationalist juggernaut. In Kohl and his Christian Democrat Union, the easterners chose a strong-willed authority figure who assured them that everything would be rosy—all they had to do was fall in line. Kohl campaigned with the slogan "no experiments," assuring GDR citizens that there'd be no unproven capers. Rather than reinvent the GDR, the majority opted for the tested

* The Greens East and the United Left, also part of the larger citizen's movement, ran separately from Alliance 90, garnering 2 percent and 0.2 percent, respectively.

and certain. With the vote, Germany set itself on the road to unification, even if in spring 1990 virtually no one thought it would happen that year.

The lurch to the right blindsided 47 Schreinerstrasse. Covering the elections for the *New Statesman*, I dropped by the next day anticipating the worst. The gloomy silence in the kitchen said it all. At first, many of the artists and squatters, not just those of Schreinerstrasse, refused to recognize that unification of some sort was now a foregone conclusion. Moreover, they remained steadfast in their view of the Federal Republic as an archconservative power that could quickly revert to darker pasts. To them, a united Germany conjured up visions of Nazism and Prussian militarism. (Though wrong, they weren't alone. The thought of a unified Germany also frightened Britain's Margaret Thatcher and much of France's establishment, too, which was initially opposed to it.) I didn't see eye to eye with them. But I felt that the Federal Republic had done an admirable job of coming to terms with its past, though it still had edges to smooth out. Nevertheless, I too had had high hopes that a new Germany could capture, at the very least, a flicker of the grassroots enthusiasm visible across the country.

Despite the body blow, the KvU crew and other civic forces remained intensely engaged, for instance on the Stasi's fate. The Schreinerstrasse squat was convinced—as was the entire former GDR opposition—that central to sculpting a democracy out of the wreck of communism was the dissolution of the despised spy service and the prosecution of its crimes. Moreover, eastern Germans had to process all of the new information about the secret police, and come to grips with its legacy. This meant opening its archives to the public. The GDR's skeletons had to be dragged out of the closet, thrust into the light of day.

The topic had become all the more burning as evidence trickled to the surface that former dissidents, even top figures

initially beyond suspicion, had collaborated hand in glove with the Stasi, and the revelations confounded their circles. One of the bombshells was that two members of the cult band Die Firma had worked for the Stasi for years. Like no other group, Die Firma's funeral dark wave sound and caustic political lyrics resonated with the opposition's youngest. The revelations bowled me over too, as it was my *Liebling* among the postpunk bands, whose existence I first learned about in the aftermath of the Church of Zion raid. Soon after the borders opened, I was first in line to see Die Firma in Knaack club and IM Eimer. The band's scathing lyrics, growled by the bassist and singer, Tanja Besson, a legendary figure in the East Berlin underground, sent chills up one's spine. Songs like the mesmerizing "Kinder der Maschinenrepublik" (Children of the Machine Republic), about the hypocritical mores that had warped their youths, ensured that Die Firma never received authorization to play in the state-run venues.

The revelations raised all kinds of uncomfortable questions. How authentic was the underground in the first place, if figures like Besson and others such as the bon vivant of Prenzlauer Berg Sascha Anderson were Stasi informants? Had the Stasi in effect "created" the opposition and the underground for its own purposes, to channel dissent into manageable compartments and then stymie it? After all, it had held the East Berliners in check until late 1989. Maybe the subcultures had been a controlled ploy to divert anger and frustration. And, of course, there was the question of what to do with the outed informants among them, those who had betrayed their friends and the cause.

Many years later, in hindsight, it's fair to conclude that neither the underground nor the democratic opposition were simply marionettes of the Stasi. They were larger than the Stasi's network, as Church from Below illustrates, and possessed volition of their own. At most, I think, the moles managed to slow

and distract the opposition; but they didn't own it. As for the fate of the informants, there was more understanding for the individual circumstances of betrayal than I had expected. "We had to look at everything before we started kicking asses," Speiche told me. "Some people had cooperated because they were blackmailed, like [Frank] Trötsch [Die Firma's keyboardist], in his case because he was a diabetic and required special medicine."

In mid-November 1989, the GDR's interim governors officially disbanded the secret service without agreeing what would happen next with its mammoth apparatus, personnel, and assets. This included its files on four million East and one million West Germans, an estimated twenty billion sheets of paper. If arranged on a single shelf, the upright files would have extended for sixty-seven miles. Some of the communist reformers—who soon after their fall from absolute power renamed themselves "democratic socialists"—wanted to spin off from the Stasi an Office for National Security, a "new" intelligence service for the postcommunist GDR. This limbo served the interests of the Stasi personnel, who into January 1990 were at work stealing, burning, and shredding documents. They were heavily armed and possessed immensely valuable and damaging information. Observers could see them come and go from their fortress complex on Normannenstrasse at will, for example, to buy new paper shredders in West Berlin.

This incensed many ordinary GDR citizens, now galvanized by a taste of people power. Dozens pitched tents outside the gates of the Lichtenberg headquarters to impede former agents' access to it. But secret entrances enabled the spooks to dodge the protesters. Finally, fed up with the dithering of the GDR's new officials, one evening in mid-January the demonstrators scaled the fence and stormed the building, barricading the archives with

bricks and mortar. With the occupation, the people snatched away the ancien régime's last remnant of power. In response, the government created citizens' committees to start the gargantuan task of dismantling the Stasi.

Yet the citizens' committees, too, soon ran into brick walls, their mandates and staff curtailed by the new—as of April 1990—elected GDR government. It dictated that the Stasi archives be closed for thirty years to everyone except the Federal Republic's intelligence service. This too was entirely unacceptable to most East Germans. Forty-seven Schreinerstrasse wasn't alone in demanding full access to their files, which they required to piece together their pasts. But even a hunger strike couldn't sway the new interior minister, who insisted that opening the files would only open the door to blackmail and retribution.

In response, the Schreinerstrasse troupe and Hinkelstein Press devised a prank that surely would have made the Situationist Internationale and its heirs beam. They printed thousands of fake application forms that explained how all GDR citizens could gain access to their records. All they had to do was to fill in the form and personally bring it to the former Stasi headquarters at nine o'clock Monday morning. Throughout the night, the protagonists from across temporary autonomous zone East Berlin delivered the forms—two per mailbox—across Friedrichshain, Mitte, and Prenzlauer Berg.

The stunt was a tremendous coup. The next day hundreds of people lined up outside the Normannenstrasse building, forms in hand. The media was on the scene to document the ruse, which the hopeful applicants also finally grasped as such, to their disappointment. Yet the point was driven home: East Germans wanted their files. And, thanks to gritty pressure from below, that is what eventually happened. Unlike in Poland, Hungary, and elsewhere in Central Europe, Germany set up a special

commission that enabled all GDR citizens with Stasi records to inspect their files. This cleared the air in Germany, removing figures from political life who—when it could be proved—had cooperated with the Stasi, but also, just as critically, sparing Germany (most of) the accusations and counteraccusations of secret police involvement that dogged the Central Europeans for decades to come.

Meanwhile, two key dynamics were playing out in Berlin and eastern Germany at large. First, the police force on the east side, which was merging into its West Berlin counterpart, had recovered its self-confidence and was beginning to enforce the new laws of the land. This included property rights, which meant that prewar owners could have real estate appropriated by the communists returned to them. This augured ill for the squatters, who found themselves tied up in complicated legal battles and increasingly at odds with the constabulary.

Second, the far right was on the march as never before, exploiting the power vacuum to organize and, among other endeavors, terrorize the autonomous zone with impunity. The Schreinerstrasse squat was especially vulnerable because of Friedrichshain's proximity to the district of Lichtenberg, where the tower blocks began and far-right gangs commanded broad allegiance. Schreinerstrasse and nearby Mainzer Strasse were the scene's bulwarks, the front line of what increasingly looked like a war between the subcultures. At night, neo-Nazis raided Friedrichshain, pelting the squats and the scene's cafés with stones, meting out beatings to anyone who crossed their path. I remember that even in the neighborhoods of Mitte and Prenzlauer Berg groups of twenty or more assorted skinheads and hooligans could be seen roaming the streets, beer bottles in hand.

Most of the Friedrichshain squatters had boarded up all of the windows on their first two floors and double-bolted their front

doors. Schreinerstrasse constructed a trap door through which in-the-know friends could come and go. Squatters armed themselves with pepper spray. No one went out on the streets alone. Some of the squatters relished mixing it up with the skinheads. There were tough customers among them who could dole out as good as they got. Unwilling to be passive victims, the squatters launched counter-raids on the right wing's headquarters, a short bike ride away. The Schreinerstrasse guys gladly pitched in. But they weren't intimidating as fighters. Silvio may have been one of the slightest, but none of them were burly.

All the more alarming, the far right's violence was by no means confined to Berlin. Across eastern Germany, right-wing extremists were wreaking havoc, which, in contrast to their harrying of the squats, grabbed national attention and international headlines. West German far-rightists, more sophisticated than their counterparts in the east but less reckless, sprang to aid their brethren and secure a foothold there. This was exactly what West German neo-Nazis had been waiting for decades to happen: the ousting of the Soviet occupiers and with it national unification, which meant a unified Germany's expansion to the Polish border. The GDR's dissolution was just the first step, the far right argued, in forging a "foreigner-free greater Germany" that would eventually encompass parts of today's Poland and the Baltics. This was the Germany of Adolf Hitler's Third Reich at its prewar pinnacle in 1937.

It was around this time that I met Bernd Wagner, a former GDR police chief working then in the interior ministry. Wagner was considered "clean" of Stasi ties, a man of integrity and thus, in the aftermath of November 9, put in charge of combating political extremism. Getting to him wasn't easy, as his new office was in the former Stasi prison complex in Hohenschönhausen, one of East Berlin's high-rise districts, which was terra

incognita to me. I located the address and the sprawling complex with its twenty-foot walls, but I couldn't find an entrance anywhere as I circled around it. The monstrosity looked impenetrable, and I eventually gave up after an hour of searching. "Yes, that's the point," Wagner told me, when I finally met him the next day outside the fortified compound. "They knew how to protect themselves." As an everyday police offer, he'd never been in the building before the Wall fell, he told me as he unlocked what I then recognized as a door embedded in the wall's exterior.

Wagner was deeply concerned about the far right's ascendance in the post-Wall GDR. "The far right sees it as a revolutionary situation," he told me. "They think they might even come to power," he said, dismissing the possibility but underlining the intent. The problem was that his West German colleagues took neither him nor the far right in the GDR seriously. "They tell me that the GDR was an antifascist state so it can't be all that bad!" he said, incredulous that even some westerners swallowed the GDR's bogus antifascism. They told him the problem wasn't more than a few hundred rowdies and soccer hooligans, and that everything was under control. Don't make waves, they intimated.

The West Germans were keenly aware that the British and other allies feared a resurgent, nationalist Germany, and that hyperbole about Nazis in Germany sullied the country's image, and perhaps its chances to unify. Yet, undeterred, Wagner spoke out to anyone who'd listen. The VoPo were dramatically underarmed, incapable of taking on the marauding packs of neo-Nazis, whose armories and logistics their western buddies had augmented since the Wall's breach. Moreover, Wagner said, an element in the East German police actually condoned the rightists. Wagner's office coordinated with the squatters, providing them with a hotline number to call should they

come under attack. If the authorities' attitude doesn't change quickly, Wagner told me then, something very nasty could happen very soon.

As disturbing as the neo-Nazis were, just as unnerving were the many ordinary Germans who appeared to sympathize with them. Neighbors and bystanders cheered on as the shock troops heaved rocks and Molotov cocktails into the housing of foreign asylum seekers. The same liberty that exhilarated the Schreinerstrasse troupe frightened others socialized in the sclerotic GDR, those who had never in the first place complained about "too much future" or a society too uniform. Rather than seize the moment to explore new vistas, the uncertainty caused them to lash out against the symbols of disorder and change, a phenomenon described by the journalist Sabine Rennefanz in her book *Eisenkinder* (Iron Children). The narrow-minded prejudices that the GDR had nurtured now had free rein. A snippet of graffiti I saw on one housing project read: "Just do it." No further explanation was required.

Half a dozen people were killed in 1990—stabbed or beaten to death, one thrown out of a window—and countless injured in public, with witnesses standing by. In East Berlin's running street battles between left and right, the police appeared overwhelmed.

In Hungary, Romania, and Yugoslavia, I had also run across far-right cultures and upstart parties preaching hatred. It troubled me that the media wasn't taking them more seriously, caught up as it was trumpeting "the end of history," as political scientist Francis Fukuyama called liberalism's victory in the wake of communism's collapse. Just as strains of old-school nationalism were stirring in Central Europe and the Balkans, Fukuyama argued that liberalism was now the only political ideology with relevance. The moment belonged to feel-good stories: the free elections across Central Europe, the playwright

Vaclav Havel assuming the presidency of Czechoslovakia in the Prague Castle, the West's historic triumph in the Cold War.

I spent considerable time tramping through public housing estates in eastern Germany and glum towns in Central Europe where national rightists had their bases. I wanted to ascertain what motivated them and how malignant they really were. How much support did they have? Who were their proponents in the halls of power? Could they come to power? With their racist visions and xenophobia, they sounded just like West German and other extremists across Western Europe, yet they had completely different socializations. Was it the same phenomenon or a different one?

The foot soldiers of this movement were frightening and nauseating to behold. One evening in 1990, I was stranded in Ostbahnhof, an East Berlin train station, on my way to Poland when, without warning, about 150 skinheads and assorted soccer hooligans burst into the station like a tidal wave inundating a coastal town. Shrieking, "Foreigners out!" and "Heil Hitler!," they scared every sensible person out of the main hall and proceeded to ransack the station. They broke anything made of glass, pulled down signs, and pulled apart kiosks, jumping up and down in their jackboots on top of fast-food counters until they burst into splinters. At one point several of the thugs made their way to the upstairs restaurant, where I was seated with others watching the spectacle aghast. Two waiters, and a barrel-chested dishwasher who'd obviously had martial-arts training, bravely rushed out to meet them, making a good show of it and preserving the sanctity of the restaurant, which had filled up with petrified travelers. By the time the police arrived, the rowdies had fled, the trashed train station eerily quiet.

The Battle of Mainzer Strasse

Strolling through Friedrichshain's Mainzer Strasse neighborhood in summer 1990 was a taste of what the afterworld would look like were God an anarchist. In a matter of weeks, squatters had transformed the tranquil environs around the two-block-long street north of Boxhagener Platz into a teeming boho paradise (see photo of nearby Kinzigstrasse, page 251). Bedsheets with painted aphorisms and black-and-red flags dangled from windows and rooftops. "Against a Europe run by suits and patriarchs," read one hung from the feminist house. The Kurds' flag fluttered from another. Graffiti, the new lingua franca, was everywhere, indicating more than one stripe of anarchist present: "Nazis out," "Fight the System!" "Muesli for everybody!" "Beware, this is a slogan." Giant, colorful murals—much like Berlin Wall art—decorated some facades, soaring all the way to the roofs' eaves. With the Wall disappearing into tourists' pockets, the squats became the city's new urban canvas.

Mainzer Strasse's occupants were delightfully conspicuous with their dress-down apparel, technicolor and dreadlocked hair, pierced faces, tattoos, bare chests, and cowboy hats in a neighborhood that had been largely monochrome a month before. All black was the no-nonsense look of the hardcore anarchos, often in combination with a hooded sweatshirt and checkered Palestinian keffiyeh. Others dressed up in kooky costumes or strolled down the street in nothing at all. The squatters set up ratty sofas and upturned plastic beer crates on the sidewalks where they brunched and smoked grass into the late afternoon. Music, like the squatter anthem "Rauch-Haus-Song," blared from open windows, and the new residents transformed rock-strewn lots into playgrounds for their ragamuffin children.

On sunny days, the buildings' flat rooftops were covered with bath towels, plastic chairs, and naked bodies sprawled out across the black asphalt surfaces. With breathtaking views of the city, one could clamber across the roofs to visit other buildings on the block. Nearly every squat had its own makeshift café, bar, or "info-stand" where fliers announced demonstrations or denounced enemy number one, Helmut Kohl. A slow-moving, big man from the deeply Catholic Rhineland with unflagging loyalty to the United States and German big business, Kohl was a favorite target for ridicule. At night, candles and campfires lit the cool, damp courtyards.

As impressive as the Mainzer Strasse area was in size, with its cluster of squats over several blocks, the potent influence of West Berlin militants set it apart from the artier scenes in Prenzlauer Berg and Mitte. "You could feel the dominance of the West Berlin radicals," says Manuel Zimmer, one of the film-makers behind AK Kraak, a collective that produced a weekly news and feature show for the community. "We wanted to do a segment on Mainzer Strasse, but first they required that we ask permission," he says. Zimmer knew enough about the West Berlin left's paranoia to know that they shunned visual media that showed faces, a precaution to remain under the "police state's" radar. Nevertheless, Zimmer didn't expect they'd only allow him to film on one day, and then just between eight and ten o'clock in the morning, well before a soul had stirred. "This was really stupid," he says. "It was typical of the old West Berlin left—closed, conspirative, suspicious of everyone. It was so out of sync with the spirit of the day."

About 120 squats had convened a council where they shared information, coordinated projects, and made decisions. Silvio Meier was Schreinerstrasse's designate, and a respected figure. "Silvio was a clear and strong voice, someone who spoke often,"

Outside a freshly squatted apartment building on Kinzigstrasse in Friedrichshain, two blocks from Mainzer Strasse, 1990.

remembers Annette Klumb, the spokesperson for 22 Mainzer Strasse. It was obvious to everybody, she says, that the Schreinerstrasse house was tight-knit, and understood the squats as a long-term political project, not a one-off adventure. In the squatter community, says Klumb, Silvio, Moldt, and Chrischi were outspoken moderates in a scene that was radicalizing as the date of unification, set for October 3, 1990, drew nearer and Berlin's two police forces cooperated ever more closely across the city. In the council, the West Berlin radicals were gradually gaining the upper hand.

By late summer, the dominant issue facing the squats was how to respond to the city's pressure to strike deals. The status of just about every squatted house was in some way unique. Some had owners interested in reclaiming the property, while other former owners or their descendants didn't care. Some had perished in the Holocaust; their relatives in Israel, the United States, and elsewhere were being tracked down. But by and large, where possible, the city was trying to accommodate the squatters. After all, the West Berlin city government was a leftist coalition of Social Democrats and Greens, which included figures who'd been active in West Berlin's squats. But unlike the Schreinerstrasse bunch and many other squatters, the militants remained stubbornly opposed to any accommodation with the city. "For them, the project could only be revolutionary if it was illegal," explains Zimmer. "If you paid rent, then you were part of the system. They wouldn't compromise. They said 'we want everything,' 'we want to change power relations in society.' Direct confrontation was the only way to do it."

The tension mounted as the standoff devolved into threats and wild accusations. Temperate voices such as Silvio's were pushed to the margins. The louder, more aggressive currents in the squatter community now set the tone, an ugly showdown

all but certain. "There were some things the Ossis knew better than we did," one Mainzer Strasse figure, a West German, told me years later. "But when it came to fighting the German police and security forces, we were the ones who knew what had to be done," he said. "We told them [the moderates] to get out of our way and let us do it." A disaster was in the making.

The standoff prevailed into October as the city celebrated German unification on the third of the month, forever after a national holiday. Instead of October 3, Germans could have chosen November 9, the day of the Wall's opening, as their national holiday. The ninth would have emphasized the moment of liberation, the gaining of freedom, and the civic courage of those who made it happen. Moreover, the ninth is also the anniversary day of Hitler's ignominious Kristallnacht, when in 1938 Nazis across Germany vandalized and plundered Jewish shops. Were November 9 the holiday, Germans would have both one of their finest and one of their blackest moments to ponder and from which to seek orientation. But instead the nationalist feat of unification was granted the distinction.

For the big day, the city was decked out in triumphant splendor as world leaders including U.S. president George H.W. Bush and Soviet leader Gorbachev basked in the glow of Germany's reunification and the eventuality of Europe's mending too. Berlin could be a bridge between Eastern and Western Europe, a constructive force in facilitating an undivided continent from the Atlantic to the Urals.

Kohl had driven unification forward with all of his might and consummate skill, pulling off in months what many had assumed would take years. In doing so, he had transformed his reputation from one of a provincial politico in charge of a rump state under Washington's wing into a statesman of international renown, and chancellor of a country of 80 million in the center

of Europe. The unification treaty snapped the Cold War shack-
les off Germany, making it fully independent for the first time
since Nazi rule. Two months later, in December 1990, the Ger-
man people rewarded Kohl, reelecting the Christian Democrats
and "the unification chancellor" to a third term in office. On the
eve of unification, I took a walk along the jam-packed avenue
of Unter den Linden where thousands had gathered to celebrate
the historic day. I remember thinking that I had better start get-
ting used to German patriots waving black, red, and gold flags.
This was the new Germany.

The confrontation between the squatters and the city of Ber-
lin came to a head in mid-November at Mainzer Strasse. Offi-
cials insisted that the squatters leave at once or face eviction. The
militants refused to budge unless all of the East Berlin squats
were legalized on their terms. There was no middle ground.

At daybreak on November 14, hundreds of police and heavily
armed antiriot troops burst through the squatters' barricades at
either end of Mainzer Strasse with armored bulldozers. Columns
of mounted water cannons, heavily armored personnel carri-
ers, and green-and-white paddy wagons followed, as helicop-
ters buzzed noisily overhead. A sorrowful analogy, the raid was
the biggest military operation in Berlin since the GDR had put
down the workers' uprising in 1953. The street was boarded up
like a ghost town, balaclava-masked militants camped atop roofs
with arsenals of paving stones, cinder blocks, ripped-out toilets
and bathtubs, and crates of Molotov cocktails. They were intent
on ending it all in a proverbial blaze of glory.

When the storm troopers began prying off the boards and
knocking down the houses' doors, the squatters mercilessly
rained down ammunition on their heads. The bloodlust on both
sides was sickening. The police shot tear gas grenades through
the windows and blasted the upper stories with water cannons.

The battle turned definitively in favor of the police when special forces units took the rooftops, which enabled them to enter the houses' upper floors.

The battle of Mainzer Strasse didn't last a full day, but when it was over the street looked like it had been hit by a typhoon. Debris lay everywhere and tear gas hung in the air. Seventy police officers were hospitalized, and 417 squatters and their allies behind bars. A week later the Berlin city government resigned in the face of vicious criticism. For weeks afterward, 47 Schreinerstrasse overflowed with Mainzer refugees who crashed in the kitchens and hallways, any corner that could fit a sleeping bag. The magnitude of the violence that day inflicted such trauma that even today, twenty-five years later, it's difficult to find eyewitnesses willing to talk about it.

For many of the squatters and others, too, the wonderful year of anarchy ended with unification or, at the latest, with the battle of Mainzer Strasse. Indeed, it became much harder to occupy apartment buildings on the east side. But there was still plenty of space open to impresarios, some of it free, some at a pittance. Neither unification in October 1990 nor the gradual emptying of the squats extinguished the vitality of eastern Berlin's subculture, which adapted to it and reinvented itself, just as Hakim Bey argued that a TAZ must. The techno scene, one of the hallmarks of 1990s Berlin, was just beginning to blossom. The legendary techno club Tresor, for example, only opened its doors in 1991, kicking off the era of the giant electronic music clubs.

The squatter community, however, began to unravel after the defeat of Mainzer Strasse, political fragmentation taking a toll on the big-picture projects. This differentiation was also happening in the circles of the former dissidents, where the post-Wall civic groups were imploding as their members scattered across the Federal Republic's party spectrum. In Schreinerstrasse, too, unity

began to fray. Kathrin, fed up with the alpha males, directed her energies toward her women's group. Others drifted toward far-left antifascist cabals. Several returned to the project of the KvU Café, which had kept its doors open through 1990, converting to a punk and hardcore club, open weekends for brunch as of noon.

Everyone traveled, of course, taking advantage of the far-flung squatter network across Europe to visit Amsterdam, Basque Country, Copenhagen, and Rome. Others took off for months at a time to knock around Africa or the Middle East. In terms of seeing the world, they had catching up to do. Silvio and Chrischi gave birth to the squat's first baby, Felix, who was followed by other progeny.

For me, the magic terminated on the night of November 21, 1992. I was in my apartment in Mitte on the twenty-second working on my book about the far right when I heard on the radio that there'd been an altercation around the Samariter-strasse metro stop, a few blocks from Schreinerstrasse. The vague report mentioned something about "rival youth gangs," which could have meant anything.

I ventured over to Friedrichshain on the U-Bahn, as I hadn't seen the crew for a while anyway. Climbing the stairs to the street, I came upon a group of young punks sitting around lit candles and scattered flowers. On the wall above them hung a hand-painted placard reading: "Silvio wurde hier ermordet." I stopped in my tracks and asked the kids in disbelief, "Silvio Meier? From 47 Schreiner? It can't be. Dead? Murdered?" They nodded silently. One of them, not fifteen years old, came over and gave me a hug.

At the house, I ran into Micha and Thomas leaving through the front door, their faces streaked with tears. Silvio, Joni, Ekke, and Christine, they told me, had been in the metro stop late the previous evening when a shouting match started among eight or

so young guys and three women from the right-wing scene. The squatters descended the stairs to the platform, only to learn that the metro wasn't running any longer. When they went to exit the station, the gang cut them off. They pulled knives. Silvio and Ekke went down, blood seeping through their clothes. Joni was wounded too, and then kicked in the head until he passed out. Police and ambulances arrived with lights flashing and sirens screeching. But by the time they reached Silvio, he was dead.

Silvio was the glue that held Schreinerstrasse together. In some way, everyone could relate to him. The next day an angry demonstration formed in front of the squat, and marched straight to the perpetrators' neighborhood in Lichtenberg. The contingent—and I was part of it—ransacked one of the Nazi kids' youth centers. But it didn't soothe the pain. A few weeks later, 47's inhabitants traveled to the Baltic coast north of Berlin to scatter Silvio's ashes in the sea. The trials of the teenage rightists slapped them with sentences of eight months to four and a half years. The judge called them "hooligans" with no expressly political motivation. Soon afterward, Chrischi and one-year-old Felix left for Kreuzberg, and others followed or relocated farther afield, some as far away from Germany as they could get.

9

Peace, Joy,
Pancakes

There was no east. There was no west.
There was just music.

—JOHNNY STIELER, TECHNO CLUB PIONEER

THE 1990S WEREN'T THE END OF ANYTHING FOR THE
ravers of the techno generation in unified Berlin. The new era
with its new spaces had a new sound: techno, and in ecstasy a
new drug, too. In the early 1990s, on the dance floors of the all-
night-and-all-the-next-day techno parties in eastern Berlin's
mind-blowing spaces, Germans came together and bonded—as
long as the music played and the pills lasted. Like punk had a
decade before, techno unceremoniously dethroned its prede-
cessors and struck out onto new terrain. Across the decade and
through the aughts, the electronic dance music scene mutated
and morphed, switched locations, and beguiled new fan bases.
Its wild global popularity baffled its creators as much as anyone.
And, say some, techno died in Berlin, too.

Post-Wall Berlin branded itself as techno capital of the
world—and the imprint stuck. What began as cozy in-crowd
parties of hundreds became Berlin's expansive electronic

clubscape, which lured thousands of single-minded, fun-seeking nightclubbers to the city every weekend. The rapid, thumping bass lines were the soundtrack to the first decade of the new Berlin, and twenty-five years later its clubs—Tresor, Watergate, Golden Gate, Berghain, Club der Visionäre, About Blank, Ritter Butzke, among many others—attract ravers from across Europe. With the masses came the record labels, clothing lines, promoters, and merchandising agents that descended on the party like locusts. There's no better emblem of techno's loss of innocence than the Love Parade, which swelled like a tidal wave from year to year before it crashed in agony.

Opinions range wildly on ostensibly straightforward questions such as "What is techno?" and "Where was it born, and when did it die?" It definitely doesn't hail from Berlin. Detroit, Chicago, London, and Frankfurt can all with some legitimacy claim partial parentage. Today the term *techno*, at least in Berlin, covers many types of electronic dance music that rely on mixes of computer-programmed sounds, repetitive synthesizer rhythms, thudding computer drums, and recorded samples. Its foundation is the drum beat and synth bass line upon which other sounds, vocals, or melodies are played, sped up, or distorted. Inexpensive hardware, including drum machines and mini-keyboards such as the Roland TB-303 that emit the squelchy bass lines that were initially techno's signature, made it all possible.

The West Germans touted electronic pioneers from the pantheon of 1970s Krautrock greats including Kraftwerk, Deutsch-Amerikanische Freundschaft, Tangerine Dream, and Can. From early on, West Berlin bands integrated synthesizers and drum machines into their repertoires. But it was, arguably, in 1988 in the little club Turbine Rosenheim in West Berlin that early techno first lit up on Berlin's radar. The West Berlin DJ known as Motte had been dabbling with e-sounds and dance

music when something called "acid house" burst onto the scene, a kind of proto-techno from Chicago's club culture. Acid house was up-tempo, soul-based dance music with a heavy electronic bass line and drums. Other electronically generated effects could lend it a psychedelic quality, one reason that the United Kingdom's fling with acid house in 1988 and '89 was dubbed the Summer of Love.

Once a week at Turbine Rosenheim, Motte, an unassuming, stick-thin character with thick black plastic glasses, hosted an acid house night. Motte had been around the late-night crowd for years, playing in bands and spinning discs on all-night shifts for sixty dollars a shot in cash. "I was always looking for something new, something that went beyond what was," Motte, known as Dr. Motte now for two decades, told me. In West Berlin, he says, the electronic scene had grown from an insider's tip in gay circles to a decent-sized crowd bored with West Berlin's usual fare.

"People wanted to dance and not stand around in the corner with a mixed drink," recalls Michael van den Nieuwendijk, a music journalist who would later become DJ Mijk van Dijk. "The place was so small that hardly ten people fit on the dance floor," says van den Nieuwendijk about Turbine Rosenheim, "but as soon as the room filled with smoke [from a fog machine] and the garish flashing strobe lights you felt like you were in a huge white room with all of the others on the dance floor and no one else. When the beat stopped for a moment people would blow whistles, wave their arms in the air. The more you danced, the more it seemed like the fog machine was blowing strawberry-scented clouds onto the dance floor."

You were more likely to experience white rooms and strawberry-scented clouds if you had swallowed a tab of ecstasy, the new drug in town that fit electronic dance music like a glove. Ecstasy, or simply "X" or "E," or MDMA, is a psychoactive,

consciousness-altering amphetamine that had been developed in the United States in the 1980s and used initially in experimental therapy situations. Some therapists described it as a wonder drug that helped patients jettison inhibition and come outside of themselves.

One afternoon, Danielle de Picciotto, who'd been in West Berlin for all of two weeks, stuck her head into Turbine Rosenheim. De Picciotto, originally from Tacoma, Washington, had transplanted herself from New York City to West Berlin in the mid-1980s. She knew about the Brilliant Dilettantes, whom she'd first caught wind of when Einstürzende Neubauten played at the Palladium in New York City—and nearly burned down the stage.

The Fashion Institute of Technology graduate found New York's money-centric fashion world soul-destroying. So she left it for West Berlin, where she could design original, off-the-wall fashion without worrying about profit margin. She sewed clothes for herself and friends, for rock stars and actresses, and for the artisan boutiques that now punctuated Kreuzberg. Her designs were appreciated even if they were impractical. She had more orders than she could fill for bead-encrusted, stretchable costumes covered with feathers, studded leather jackets with band logos stitched into the back, elaborate silk evening gowns covered with flowers, and skin-tight, brightly colored jumpsuits with golden appliqués. Some of her biggest hits were towering hats that she fabricated out of plastic blow-up animals—the perfect accessory for a night at Kumpelnest 3000.

When de Picciotto popped into Turbine Rosenheim, Motte was there, cleaning up from the night before. They began to chat. "Want to see something?" he asked. Motte proceeded to pull out his front tooth, hold it up in the air, and stick it back in his gums again. Danielle cracked up laughing. Before long,

the two were a couple, and an electrical storm of artistic energy (see image on facing page). De Picciotto says that she and Motte first encountered ecstasy at a rave in London. "It struck us how differently people acted on X," she says. "The atmosphere was so playful, lighthearted, friendly. People interacted with one another in a way we didn't know in Berlin."

While ecstasy had appeared in West Berlin by that time, De Picciotto says that the DJs and creative types weren't doing it regularly yet. "The new quality of the nightclub," explains de Picciotto, "with fog enveloping the whole dance floor, the lights in your face, the repetitive music in such small spaces, this was all so otherworldly, so extreme, that it felt like an enhanced state of mind." You didn't need drugs to feel like you were on them, she says.

On the other side of West Berlin on Köpenicker Strasse, a dead-end street amputated by the Wall, one of West Berlin's all-around impresarios, Dimitri Hegemann, had just opened Fisch-büro, or Fish Office, a hangout for musically attuned people and free thinkers who, with time to kill, bounced kooky ideas off one another and performed Dadaist gags. Characters came and went, not least Timothy Leary, the U.S. psychologist known for advocating LSD. The Fischbüro housed an alternative dating service, waltz classes, a relationship therapy practice, and West Berlin's first techno club in its basement, a former bomb shelter.

Hegemann, who is today one of Berlin's mightiest club owners, gravitated to West Berlin as did so many others in the late 1970s, landing at the Free University a step ahead of conscription officers. He played bass in the new wave band Leningrad Sandwich and, as did Motte, moved in the circles of the Brilliant Dilettantes. In 1982 at SO36, Hegemann masterminded the first Berlin Atonal Festival, a forum for new electronic music that at the time included Einstürzende Neubauten, Malaria!, and Die

Invitation to a 1989 house party in the West Berlin club Fischlabor:
Motte as DJ, Danielle de Picciotto showing her latest designs.*

Tödliche Doris. But Hegemann, a rare mélange of aficionado and entrepreneur, probed further, attracting ever weirder electronic and *elektro* sounds to the festival. Industrial bands such as Psychic TV and Test Dept. played, as did Final Cut, the group co-founded by Detroit's Jeff Mills, one of techno's fathers. In the Fischbüro's cellar, Hegemann opened UFO, the first West Berlin club dedicated solely to acid house and other hard-edged electronic dance music, the likes of which would one day wear the badge of techno. UFO never had a sign on its door, and UFO parties could take place at other venues in West Berlin, too. The locations were announced on a weekly dance-music radio show.

One entered the building through a side doorway in the back courtyard, then walked through an uninhabited apartment into its kitchen, which had a trap door in the floor. Wooden stairs

* Fischlabor and Fischbüro were separate clubs in West Berlin.

led into a low, cobwebbed cellar. The only lighting was a single strobe. The place would have been a death trap had fire broken out, thus there was no chance of obtaining a license for it. Hegemann didn't even try. The DJs who played there, nobodies at the time, would become the superstars of world techno: Motte, Westbam, Jonzon, Tanith, Kid Paul.

During a cigarette break at Turbine Rosenheim one night, Motte noted to his colleague Westbam that the revelry at acid house parties in disused warehouses outside of London didn't stop when police busted a gig. With ghetto blasters at their feet, the party carried on outside in the early-morning daylight. West Berlin was known for its street demonstrations, mused Motte, but they'd become as rote as the music scene. Back home, he woke Danielle to tell her about his idea to have a techno parade in West Berlin.

"Hey, I have a totally cool idea," he bubbled the next afternoon at the Fischbüro. "Let's throw a party on the Kudamm [West Berlin's pricey shopping mile]. We'll say it's a demonstration and call it the Love Parade." The only way the group could occupy such a prominent street in the middle of the day was as a political demonstration. So they registered the party as a protest against the Berlin Wall. An exquisite irony, the parade had nothing to do with the Wall. Just months before the Berlin Wall would tumble, the acid house crowd used it as a goofy pretext for a shindig. The site, the Kudamm, was a joke too; none of West Berlin's cool and trendy went anywhere near the posh shopping avenue, which was as politically incorrect as wearing lederhosen.

Motte says the Love Parade had always been envisioned as more than just another party. Peace and love can be fostered through dancing and music, he argued—and still does. "I thought if we can do this again and again, it will grow," he recalls. "Other cities will hold them, too. And at some point,

everybody will be dancing with one another. Then there won't be any more wars. The lefties [in West Berlin] were always against something. If you don't have a vision that you want to share with others, nothing will ever happen."

This, roughly, was the philosophy of the techno movement that the rave guru Dr. Motte would personify and espouse for the next twenty-five years: music and dance for world peace. "It's no less valid today than then," he told me in 2016. "If people are dancing, they're not throwing bombs." Had he floated the idea in 1989 in SO36, he might have been lucky just to have been laughed out the door. Most of the UFO crowd was only luke-warm about it. But de Picciotto was up for anything and went to work making fliers and stitching together costumes.

Only a dozen persons, Motte and de Picciotto included, orga-nized the first Love Parade in July 1989. The UFO DJs prere-corded cassettes for the big day. The posters read: "The World Wide Party People Day—This Year and Forever." The slogan of the protest parade was no more precise: *Frieden, Freude, Eierkuchen* (Peace, Joy, Pancakes).

So meager was the crowd convened at Wittenbergplatz in downtown West Berlin that afternoon that de Picciotto worried that the whole thing would flop. She distributed everything she had on hand: rococo skirts with roses, sportswear in screaming bright colors, and platform shoes (borrowed from a local sec-ondhand shop). Others showed up with oversized sunglasses, long Woodstock-style necklaces, smiley T-shirts, and baseball hats adorned with plastic flowers. No wonder the turnout was paltry, de Picciotto thought to herself, the idea was *so* un-West Berlin, where everything had to be deadly serious, ultra-intellectual, and druggy. But the caravan took off anyway with three privately owned cars (one of which sold bottled beer out of the window), a VW minibus, a float platform mounted with a

stereo setup, big speakers, and a DJ booth. Motte and Danielle footed the bill for everything: $460.

At first, there were more police than dancers. "And we weren't very loud either. But the police cars' lights gave it a disco effect," Motte says. The streets were full of Saturday shoppers with bags and groceries. The pedestrians gawked. They'd never seen a demonstration like this in West Berlin. They were by now used to the May 1 Labor Day marches in Kreuzberg, which had devolved into ugly skirmishes between the police and assorted ultra-leftists; automobiles turned upside down and burned, shops looted, hundreds of arrests. But this weird bunch was all smiles.

"Then people started to join us," remembers DJ Tanith, "with their shopping bags in hand. What we saw was that this music can move people. It has a positive allure." The dancers waved onlookers into the procession regardless of their appearance. This gesture itself was sacrilege in cooler-than-thou Kreuzberg. These burghers were the squares they'd fled West Germany to lose. The crowd grew to 150 people or so bouncing along the Kudamm, blowing whistles and sounding fog horns, dancing straight past KaDeWe, the swankiest department store east of the Iron Curtain.

At first glance, the Love Parade appeared to me and many others as a silly farce. Dancing to repetitive, lyric-less, electronic music for world peace? I thought this can't be for real—and, at first, I dismissed it. Yet there were voices, in addition to Motte's and Danielle's, who credited electronic dance music, as well as its parades and parties, with important, dissonant meaning. The DJ Westbam, for example, saw the Love Parade as firmly in the tradition of Berlin's squatter movement, an anarchic taking of the streets. Certainly it captured the hedonism of West Berlin in the '70s and '80s. The spontaneity of the UFO parties and the Love Parade was straight from the Spontis' playbook. Moreover,

the music was completely do-it-yourself; making it was easy and anyone could dance to it. At the time, there was nothing commercial about it. The colors and the plastic and the silliness were so novel that they shocked just as Kommune I once had, a provocation that might make the West Berlin scene dwellers reflect on how twisted their own misanthropic weltanschauung had become.

Just months after the first Love Parade, a peaceful, inclusive demo against the Berlin Wall, the demonstrations of East Germany's peaceful revolution broke out in Leipzig. They, too, were proudly nonviolent, impromptu, and directed against East Germany's walls; they also drew onto the streets burghers from all walks of life. Unawares, Motte and Danielle had tapped into the zeitgeist of autumn 1989, which would charge across the East bloc and shake the Cold War world to its foundations.

Sound of Flat Hierarchies

The first tuned-in easterners found UFO soon after the Wall dissolved. Music junkies in the East had been glued to the late-night electronic dance music shows on West Berlin radio stations. When they first appeared out of nowhere at UFO's door, the West Berliners grimaced at the nerdy look. But given the exceptional circumstances, all codes were waived, which was ultimately in techno's spirit. Inside everyone stripped down anyway, erasing the most visible outward sign of origin. (Outside the dance clubs, clothing and hairstyles would brand "Ossis" and "Wessis" for years to come.)

It didn't take long for the ravers to discover East Berlin's menagerie of locations: World War II bunkers, abandoned soap factories, long-shuttered bank vaults, old power stations. At first,

there were "free parties" across Mitte and Prenzlauer Berg, the dates and locations of which were conveyed by word of mouth. Gabi, a West Berlin designer friend of mine, and her friends tooled all over the east side to find them. Their outdated maps and unfamiliarity with the terrain didn't help. "We'd get totally lost," says Gabi. "Then you had to get into these places, which could mean stacking up three beer crates and climbing up to squeeze through a window or a hole of some sort. The parties lasted until they threw us out, sometimes for days."

"It was all so completely new to all of us," says Motte. "Everybody was living the moment, just dancing together, communicating with their bodies and music. Everyone was welcome who liked the music. We were all brothers and sisters, one family." In contrast to the squats, the dance floors of the techno parties were overflowing with good vibes—and only good vibes. "Techno was the opposite of everything that came before it," explains de Picciotto. "So it fit the Wall's coming down perfectly. Techno was like an explosion, a celebration of life. All of Germany was celebrating. We'd dance for hours and hours in a trance."

Techno, says de Picciotto, fit the zeitgeist because it was instinctive, all about the senses and nonverbal bonding. "There was a lot of hugging and cuddling," she says, above all in the after-hours lounges, which were cozy rooms in the clubs with cushions, sofas, and pillows where, after a night or more of nonstop movement, the ravers would chill out. They'd lie about for hours, limbs and torsos interwoven in a heap of bodies, quietly caressing one another, heads buzzing from the music and the pills.

One of the east's first electronic dance clubs was Ständige Vertretung, or Permanent Representation, deep down in the cellar rooms under Art House Tacheles. A group of Australians had opened it, naming the underground labyrinth after a sign they had unscrewed from West Germany's diplomatic embassy

in East Berlin and attached to the dungeon's entrance. Through Danielle, the Aussies asked Motte to play there once a week. The hype around electronic dance music sent the east kids into orgiastic convulsions. Motte's first packed gigs at Ständige Vertretung gave him a taste of what life outside of West Berlin's high walls had to offer.

The east's opening coincided with the arrival of industrial techno in Berlin, a sound harder, more electronic, and starker than acid house with its groovy soul rhythms. The new techno DJs quickly included easterners who put Berlin's stamp on the subgenre *Tekkno* or *Tekknozid* that played at the first big parties in East Berlin. The fliers for the first-ever *Tekknozid* party announced its debut in an ominous tone:

> Warning: *Tekknozid* is not a new synonym for disco. The hardest techno beats from house, industrial, hip-hop, electronic body music, new beat and acid operate on the subconscious in interaction with psychedelic light installations and effects. The boundaries of time and space disappear in total ecstasy. Visions from the subconscious provide a view into cyberspace, that undefined data space behind monitors, synthesizers, and satellite antennas.

The German music critics Felix Denk and Sven von Thülen say three factors explain post-Wall Berlin's love affair with techno, and techno's with Berlin: the tremendous power of the new sound, the magic of the clubs' locations, and the open-ended freedom inherent in techno culture. Much like the leveling impact and invent-it-yourself ethic of punk, they argue that with techno, "Suddenly, everybody could program their own world: spin discs, mix tracks, start up zines, make T-shirts. Techno was music that required participation; it was a sound of flat

hierarchies.'" Techno didn't have stars or personalities, at least not at first. "The individual disappeared in the tracks. The star was the party itself," they argue in their seminal book on techno in Berlin, *Der Klang der Familie*, named after Motte's hit track translated as "The Sound of Family."

Since "everyone who liked the music was welcome," as Motte claims, the clubs attracted rightists, too. Anyone and everyone could rave from neo-Nazis to students, soccer fans to office workers. All you had to do was move to the music, any way you wanted. (The ostensibly apolitical nature of electronic dance music and its attraction to right-wingers made many on the left, including the Schreinestrasse crew, deeply skeptical about techno. "Sure they got along so well," Moldt quipped to me, "the music was so loud they couldn't hear one another.")

In search of the perfect dance club venue on the east side, UFO and Fischbüro owner Hegemann had had his keen eye peeled for months when at the tail end of 1990 he peered into the darkness of the clammy subterranean dungeon that lay beneath the former Wertheim department store. The original store, the biggest in Europe until the Nazis seized it from Jewish owners, had occupied a full city block in downtown prewar Berlin. But World War II bombing had razed most of it, stranding a last fragment on the edge of postwar Potsdamer Platz's no-man's land—appropriately, between East and West. Below the surface, the former vault with corroded safe deposit vaults and barred windows was covered in rust and grime but otherwise largely intact. "We were speechless. It was sensational," says Hegemann about first stepping into the hall. "It was magic. It was like the walls were talking to us," he says in the documentary film *The Story of Tresor*. Hegemann knew at once that he had finally found what he was looking for.

The fabled techno club Tresor opened its doors in early 1991. By the time it moved to Köpenicker Strasse along the Spree

in 2005, a step ahead of the wrecking ball, its name would be known across the world and, for many in the know, synonymous with Berlin's shamelessly hedonistic club culture. And it's still in operation today, Berlin's longest running electronic dance club, housed now in a former power plant.

It hadn't taken long for Hegemann and company to hook up electricity, a sound system, and minimalist lighting in the basement rooms. The décor was the bare concrete walls and broken safes, all readymade, just as he'd found them. Word about Tresor's opening leaked out, and on its debut night there was already a queue. Hegemann is uniquely responsible for moving techno from Detroit to Berlin, incurring a debt to the American city that he would later repay. One of his first moves was to sign up the pioneers of Detroit techno—Jeff Mills, Juan Atkins, Blake Baxter, Robert Hood, and others—for extended "residences" at Tresor. So blown away were the techno icons by the Tresor experience they found it hard to begrudge Berlin its purloined title of capital of their sound. They even recorded for Hegemann's new Tresor label, helping him to spread "Berlin techno" around the world. Tresor's cold, hard, unforgiving sound—with no concession to melody— became the stripe identified most closely with Berlin.

On Tresor's heels followed Bunker, WMF, Elektro, KitKat-Club, Planet, Ostgut, and E-Werk, among others across the rollercoaster 1990s, some of which came and went in a matter of months, their living in the now, fuck tomorrow, part of the concept. No one thought they'd last forever. No one gave the day after tomorrow any thought at all.

Daniel Bier, a twenty-year-old West German who'd already knocked around the world some by 1991, found his way to techno, like so many others, through Berlin's gay scene. Before long, he was a disc jockey known as Disko in the new club Planet, located in a deserted factory on the willow-lined north bank of the Spree

River. Never far from the action, Motte and Danielle called Planet home too. Danielle worked the door together with three bodybuilders who'd fled from a land she'd never heard of before, Bosnia and Herzegovina. In the countless hours they spent together, they told her about the wars in the former Yugoslavia as well as the ethnic politics of Berlin's violent underworld.

From the console at Planet and then its ginormous successor E-Werk, Bier witnessed techno's dizzying ascent—and its sorry plunge. Bier says that at the beginning, techno was a vision of an international Germany that rejected the categories of the Cold War and the post-Wall world order, too. "It was zero hour and we started with nothing," he says. "There was no sexism, no homophobia, no east-west, no racism. The scene was a social utopia, one night at a time." In this early phase, the techno clubs and their communities were, arguably, temporary autonomous zones, too, no less than the squats. In fact, when it came to raw hedonism—sex, drugs, multi-daylong parties—the clubs outdid the squats by legions. "From one moment to the next we were the hottest thing in all of Europe," remembers Bier, who initially found the attention intoxicating. It followed that if techno was a world revolution, as Motte claimed, then the more revolutionaries, the better.

It took half a dozen glorious years, says Bier, before Berlin's techno impresarios were yanked back down to earth, or at least until he was. The media, including MTV, which would soon have its European headquarters on the Spree, couldn't get enough of it. Middlemen showed up on every front, eager to cash in; cigarette companies and energy drinks poured untold millions into gimmicky advertising; generic techno pop caught the ear of the casual clubber. And the drugs took their toll on the unwitting.

Shortly thereafter, the low-cost airlines leaving from London, Madrid, Stockholm, and Oslo dumped entourages of decked-out

partiers on the tarmac for long weekends of revelry. The culture journalist Tobias Rapp dubbed them the "Easyjetset," in his book *Lost and Sound: Berlin, Techno, und der Easyjetset.* Berlin, thrilled with every morsel of revenue it could scrape together, was pulling in tourists by the hostel-full. Unlike the backpack travelers of the past, these visitors weren't in the slightest interested in exploring the objects of Berlin's disturbing history: the Reichstag, the Wall's remains, the Topography of Terror exhibit, the Holocaust Memorial. Berlin, it turned out, had more to offer than World War II history and construction sites. Similar niches cropped up around the gay, the art, and the alternative fashion scenes, which set Berlin's tourist numbers on a steep upward trajectory.

Though a plus for the city's notoriously unbalanced books, we —the residents of Berlin—clenched our teeth at the rat-a-tat-tat of tourists' roller luggage along the cobbled streets. Worse yet, building owners rented out apartments to tourists by the week, turning valuable housing into ersatz hostels for party hoppers. Packs of tourists pubcrawled down Oranienburger Strasse and Simon-Dach-Strasse like spring breakers in Fort Lauderdale. They chased the Berliners away from Art House Tacheles, which took on the features of a tourist trap, and bars like my regular Obst & Gemüse, where ordering a beer became an ordeal.

"Suddenly it was big, big business," says Bier. "It wasn't about music anymore but money, just money. The scene became corporate and very conservative, everybody protecting what they had and wanting only to get bigger." Unlike most of his colleagues, Bier threw in the towel around the millennium.

If you know where to look, you'll still find many of the illustrious '00s clubs dotting either side of the Spree all the way to Treptow Park, territory once bisected by the Wall. The gritty favorite Golden Gate is tucked away beneath the Jannow-itz Bridge train stop. A little farther on is the entrance to the

KitKatClub, a graffiti-covered door embedded in a metro stop, its entrance visible only to insiders. The three-story mainstay of Tresor, stout and imposing, is set back from Köpenicker Strasse. YAAM's urban beach, complete with bar shack and volleyball court, is a Sunday-afternoon delight. Well into its second decade, the Watergate boasts two floors in a Spree-front office building. On a flooding canal just off the Spree, you could mistake the teensy-tiny Club of Visionaries and its neighbors for houseboats, the way they jut out over the waterfront.

The transformation of Berlin's electronic music scene from underground to establishment poses the questions eventually asked about all subcultures that attract the masses: When do commodification and mainstream appeal strip away everything that was subcultural about them? To what degree is turning a profit anathema to outside-the-box creativity and cool? Is Tresor, twenty-five years down the road, anything more than a well-run, medium-sized business?

Subcultures by definition are not for everybody. They lie beyond mainstream taste and morality—and as such expose the status quo's narrowness. It is the eccentricity of the margins that makes their products original and subversive. When their environs become so safe that the next-door neighbor and the postman feel comfortable there too, it's not fringe anymore. Counterculture rebels against the *Normalbürger* precisely because they lack the imagination to undertake anything qualitatively new. Once accepted by society, the scenes become unable to reinvent themselves, to explore new terrain that might offend patrons. Or, as Daniel Bier remarks about techno, they turn conservative, bent on holding their place and just getting bigger.

Of course, clubs, communes, and art houses have bills to pay too. If they fancy themselves above the schmutz of lucre or are badly managed, they'll go down the tubes like so many extraordinary

venues have over the years. There's nothing hypocritical about properly bankrolling an off-the-wall, hypercritical project— providing that the funder doesn't tamper with it. On the other hand, advocates of the temporary autonomous zone claim that the nature of truly radical, idiosyncratic projects is transient. They come and go. The death knell is not when the doors shut, but when their avant-garde spirit is snuffed out. This happens when money becomes the raison d'être, a stop on *Lonely Planet*'s Ten Must-See Places in the city. Once it's in the travel books, it's dead.

Pondering these questions, I stopped by Culture Brewery in Prenzlauer Berg to talk with one of its founders, the architect Stefan Weiss, and Sören Birke, the current manager of the multimedia enterprise, which includes the popular dance club Soda Club. Weiss says he stepped back from Culture Brewery when he saw that the 1990s squat would no longer be a rollicking experiment in alternative art forms—the original idea. In the course of the decade, the behemoth structure housed many dozens of unusual projects. And it rang up a staggering debt, so much that its artists and anarchists at one point lost hope that it would survive. But Sören Birke and a few well-heeled investors paid off the debt and installed a big multiscreen cinema that shows the latest German, foreign, and Hollywood films. The former horse stables were prettied up and turned into boutiques. New York University has its office and classrooms in its northern wall. Yet there's still plenty that's hip about the Culture Brewery, such as a theater group run by mentally challenged people; Literaturwerkstatt, a forum for literature and poetry; the mammoth Kesselhaus concert hall, where the latest in world music performs; among other worthwhile undertakings. "The bottom line," Birke told me, "it's still here, one of the survivors. We compromised, but the essence of Culture Brewery is basically still there. It's the only way."

There's another way to look at it too, in favor of mainstreaming. When underground ideas, sounds, or images seep into conventional culture, the status quo itself is altered. Surely, one aim of politically subversive art is to do exactly that: change the world. When commonly held assumptions are challenged and subverted, a new synthesis is born, whether that be in the art world or politics or everyday life. The subculture's loss is the mainstream's gain. It becomes broader, richer, more hybrid. Berlin's past is replete with examples—from Kommune I to techno—of counterculture changing dyed-in-the-wool Germany.

As for the clubs, journalist Tobias Rapp argues that their door staff—controversial characters in Berlin nightlife—play a critical role in preventing the club cosmos from going the route of the Hard Rock Cafes. The bouncers separate the wheat from the chaff for the very reason that were there no threshold criteria, they'd be overrun, and nothing special left about them. It's only this way, he argues, that the club universe in Berlin doesn't devolve into a money-minting Disneyland. This is why people are willing to queue at Berghain's entrance for hours: to gain access to something exclusive and mysterious, a place that's explicitly *not* for everybody, where they can do things you *can't* do elsewhere. Subcultures aren't simply to watch; they demand participation. I once saw the costumed door person at Bar 25 turn away a long line on its side-walk entrance, saying to the crowd: "You have to *bring* something to the bar! Not just come and *take*!" No voyeurs allowed.

The Death of Love

What happens when there's no exclusivity, and money becomes the object, is graphically illustrated by the Love Parade's descent into mediocrity and disaster. From year to year the procession

lurched from one smashed attendance record to another: from 150 in 1989 to 2,000 in 1990 (see photo, page 278). By 1994, its organizers counted 120,000. There were 750,000 in 1997, and then the astronomical 1.4 million people on the weekend of July 10, 1999. (A disturbing comparison, that's three times as many as rallied on Alexanderplatz in November 1989 to demand that the Wall go.)

By 1999, the extravaganza had long outgrown the Kudamm, and instead plowed through Tiergarten Park, winding up on the Strasse des 17. Juni around the Victory Column, a phallic Prussian monument to militarism. There Dr. Motte, perched like a god on scaffolding high above the crowd, spoke of music's role in peace, brotherly love, and communion among peoples, the same themes behind the great-grandmother of all Love Parades in 1989. When I interviewed him in 2016, he trundled out the same platitudes. At fifty-six years of age, Motte is a kind but sad character, a man who refuses to recognize that his day is past. The parade was world famous by the mid-1990s, attracting hundreds of thousands from outside Berlin. It had become signature Berlin—and, money-wise, a bonanza for the city. In the late 1990s on just one weekend in July, the ravers and fellow travelers would drop a gobstopping $110 million in the city. At its apex in 1999, the German broadcaster SFB paid $370,000 for the rights to carry the event live on three TV channels. Hawkers sold official T-shirts, CDs, lighters, and other trinkets emblazoned with the year's motto, "Music Is the Key."

In eighty-degree weather, the masses danced to nineteen DJs who rode on fifty-one floats, sponsored by Fanta, Telekom, Camel, Ford, and Clairol. Even Germany's conservative political parties had (paid) places in the extravaganza. This, they figured, was how you reach the eighteen- to twenty-seven-year-olds. The spectacle deposited three hundred tons of garbage in the city,

DJ Sven Väth at the fourth Love Parade in Berlin. Number of ravers
in attendance: 15,000. Five years later it would be one million.

according to the NGO Save the Tiergarten, which also docu-
mented how the urine of a million-plus people killed off the flora
and fauna. On top of it all, the Love Parade left the $250,000
cleanup bill with the city—as it was still registered as a political
demonstration. By this point, many of the founders, including de
Picciotto, no longer together with Motte, had fled the debacle,
launching a dissident Fuck Parade as antidote to the Franken-
stein they'd brought to life.

The city finally revoked the parade's political status. In 2004
and 2005, the sponsors failed to come up with adequate funds
for the cleanup—and the Love Parade didn't happen. In 2006
though, Rainer Schaller, owner of the no-frills McFit gym chain,
bought into the enterprise and became its operational director.
Schaller saw the Love Parade as a vehicle to promote McFit,

which he pursued by hiring professional strippers and adding other novelties such as "New Talent Stages," "Chill Out Areas," and "Love Guards." Finally sick of it all, Motte opted out, in hindsight blaming himself for not putting the beast out of its misery when he had the chance.

Had Motte done this, fond memories of the best of the Love Parades might have lingered forever after rather than the grisly images of July 24, 2010. As of the mid-2000s, the music festival moved on from Berlin to the rust-belt cities of the Ruhr Valley such as Essen and Dortmund, and in 2010 the former factory town Duisburg was in line. The festival was still attracting well over a million faithful, which is exactly what concerned Duisburg's police chief. He aired grave reservations about safety. After all, down-at-the-heels Duisburg itself numbered only 480,000 people. But local politicos greedy for the tourism overruled him.

On the afternoon of the July 24, the city's security personnel realized too late that far too many people at once were entering the 250-yard-long tunnel that led to the festival grounds, a former railroad yard. The police tried to halt the flow into the underpass, the only entrance. But panic broke out and the pushing triggered a deadly stampede. As people fell to the ground, they were trampled, others crushed against the concrete walls. So great was the confusion and unwieldy the crowd, it took hours before ambulances and paramedics could get to the injured. In the end, the last Love Parade left nineteen dead and 340 injured. Many of the victims died of suffocation. I never imagined that the Love Parade's end could be more horrific than what it had become over the years. But I was wrong.

Conclusion: Berlin Now

BERLIN TODAY IS THE RESPECTED CAPITAL NOT ONLY of the unified Germany but, arguably, of Europe itself. Germany's muscular economy stands second to none on the continent, and it is to Berlin, not Brussels or Paris, that U.S. presidents and other world leaders look when crises strike between the Atlantic and the Urals. The mighty, including the International Monetary Fund, come and go from Germany's seats of power along the Spree every day. Even the Free University, once a furnace of radicalism, now churns out graduates who could, and probably do, work at the IMF. Moreover, Berlin's manic growth has smoothed over many of its rough edges, spackling its once ubiquitous feral lots, and erasing the former death strip too.

The quandary facing Berlin is whether a world-class metropolis so buff with gravitas can remain idiosyncratic, sharply critical, and experimental—inviting to nonconformists as well as bankers and statesmen. So far, Berlin has pulled it off, though just barely, and not without casualties. Many of the new Berlin's defining projects—Art House Tacheles, Planet and Bar 25, the indie clubs IM Eimer and Knaack, to name just a handful—have

fallen to gentrification and are now gone forever. The electronic dance music clubs are overrun with party tourists. The list of subcultural landmarks—from Mauerpark to RAW Tempel—currently fighting for their lives is long and heart-wrenching. Rents have skyrocketed in Prenzlauer Berg, Kreuzberg, and Friedrichshain, so much so that many artists can't dream of living there. The district of Mitte, one of the miracle years' hubs, is now the playground of Berlin's well-off professional class; flashy cocktail bars and boutiques having long since replaced the hole-in-the-wall cafés in Auguststrasse.

Yet Berlin has clung to its quirky demeanor, and its flair today owes a huge debt to the unpredictable, contrarian currents that course through it. There's still *Freiraum*, or free space, though it's harder to come by; today's brilliant dilettantes have to juggle and skimp to eke out *Freizeit*, or free time, for their projects. But it's possible. The *Kreativen*, or "creative class" as they're called today, are integral to the new Berlin.

1990s Funk

Berlin's journey since the early 1990s can be read as a cautionary tale. The freshly unified city embarked on a colossal transformation—without consulting its inhabitants. Immediately after the Wall's fall, investors and their friends in office were determined to make Berlin over into a postindustrial urban center of global stature, complete with skyscrapers and an upscale inner city dominated by a sprawling government sector, an entertainment industry, and corporate office buildings. This Berlin, they pronounced, would be outfitted to host the summer Olympics in 2000. A mega airport like Frankfurt's would come. In case there was any doubt that it was all about business,

the luxury car manufacturer Daimler-Benz, best known for its Mercedes series, had bought most of Potsdamer Platz on the cheap and was transforming downtown Berlin into one mammoth, deafening, dusty construction site, its horizon marked by the awkward angles of tower cranes and scaffolding. A decade of nonstop building commenced with the new government quarter around the Reichstag, the competely reconfigured Potsdamer Platz, and a central train station. These projects and many others, as well as massive investments in infrastructure, were meant to stitch the city back together and turn it into an urban center worthy of its new status. (A magnificent irony, in 2010 Daimler-Benz moved all of its Berlin-based offices and twelve hundred employees back to Stuttgart because the rents on Potsdamer Platz, the highest in the city, were above the company's means.)

But Berlin's planners drastically overestimated the speed at which the city would rejuvenate—and ignored the nature of its cachet. Contrary to expectations, through the 1990s the population shrank, the anticipated private sector investment never came, and the towers of newly built, nondescript office blocks sat empty for years. Germany's western cities and states had to dig deeply into their pockets to bankroll fraught Berlin, the republic's costly basket case once again, just as it had been in the Cold War years. The Olympics bid flopped spectacularly, not least a consequence of a passionate, grassroots anti-Olympics campaign, an unmistakable message to Berlin's political class that its citizens intend to keep their city livable.

Berlin tried on and threw off branding images, one after another. Just before the century's turn, though, the city's administrators were struck as if by a thunderbolt: in its off-grid culture and temporary spaces Berlin possessed something highly unique, even sexy. Moreover, it functioned as a drawing card, luring not only tourists en masse but also overwhelmingly young

inhabitants and entrepreneurs, the kind who thrived on Berlin's edgy vibe and consciously *didn't* want to live in a glass-and-metal clone. The city had done *absolut nichts* to plan or promote it, but there they were, the so-called creative industries,* the by-product of decades of counterculture that had pried open physical and intellectual space. Big-time corporate investors weren't pumping in the millions, but publishing houses, film companies, record labels, fashion firms, design festivals, art galleries, and digital media were migrating to the capital—or starting up in Berlin. Germany's storied publishing house, Suhrkamp, for example, left Frankfurt for Berlin expressly to tap into the city's panache. One recording company after another fled the Rhineland for the Spree metropolis.

The city leapt onto the wagon with the zeal of the converted proclaiming Berlin as a "creative city" full of unused crannies for all manner of self-styled projects and small businesses. "The 'creative city' mantra was integrated into Berlin city marketing," claims sociologist Claire Colomb, "with various campaigns selling the constant change, experimentation, and trend-setting taking place in the city as significant attractiveness factors. Some of the 'off-beat,' alternative or underground cultural and artistic scenes were officially integrated into place, marketing strategies, for example the techno and clubbing scene."

Something the planners couldn't guess, the torrent of cultural enterprises and visitors streaming into Berlin had only just

* In Germany, the creative industries are broadly defined to include broadcasting, music, film, design, publishing, media, advertising, art, the performing arts, architecture, and software development. I do not consider advertising, broadcasting, and software development among the valuable cultural pursuits that I'm writing about, and architecture and media only in certain cases. But I wasn't consulted on the categories, and there are no figures for my more narrow concept of critically minded urban culture and its penumbra.

begun. By 2002, the creative sector had breathed life into eighteen thousand businesses that supported ninety thousand jobs, 8 percent of the city's workforce. By 2012, there were nearly twice as many such enterprises and jobs, and an astounding gross of $21.5 billion, 10 percent of Berlin's total. Two years later, the branch had grown by twenty thousand more jobs. Something about Berlin was prompting startups in diverse sectors, by the 2010s vaulting Berlin to startup champion of all of Europe. Meanwhile, Berlin had overtaken Rome as tourists' third most desired destination in Europe, behind only Paris and London. These visitors weren't coming for the *hoch cuisine* or the opera but to hear Ruppert's Kitchen Orchestra on a Sunday morning in Mauerpark or to explore the art galleries on Brunnenstrasse or just wander through the streets of Kreuzberg and Prenzlauer Berg. Gay tourism in Berlin constitutes a world and industry unto itself.

Yet, while the city lauded the creative industries, it neglected to aid the creative class in the way that mattered most, namely by maintaining the conditions conducive to enabling free time and free space. While tapping its cool, the city undermined its creatives with a growth strategy that offered up to investors and developers the very ground beneath their feet—and the roofs over their heads.

As Berlin climbed out of its slump, rents inched upward. Although higher rents were probably inevitable, the city possessed the means to curtail excesses and augment social housing. Instead, it sold off most of the social housing on the east side, the revenue from which it loaned back to the new owners to renovate the housing stock. Block upon block of the historic buildings benefited tremendously from the full-scale renovations that they'd been denied since the war. The reconstructed facades and fresh paint did the neighborhoods wonders. But privatization

meant leaving the housing of the poorly paid, and the creative minds among them, to the fate of the housing market.

I experienced Berlin's gentrification from the front lines as it rippled outward from the city center. Downtown Mitte was hit first, which is where I lived in the early 1990s on Friedrichstrasse, the grand shopping mile of the 1920s. I sublet a ground-floor apartment with the luxurious features of central heating and telephone. The spot was a plum, set back from busy Friedrichstrasse in an enclave that had been built by the Huguenots, French Protestants who'd fled seventeenth-century France. Outside my balcony was a wild thicket through which I could hear elephants, horses, and other animals at the Charité's veterinary clinic next door. The Huguenot Quarter was so desirable in the GDR decades that the party reserved it for prominent East Germans, among them the Dadaist artist John Heartfield and philosopher Ernst Bloch (both long deceased by the time I arrived).

My cushy setup there was typical of the times. My "landlord" was a GDR-born engineer whose name was on the lease. Having left for a job in Bavaria, he let his subsidized apartment to me, padding the rent (against the law) by a hundred dollars or so. But at $235 a month, I couldn't complain. I left two years later, though, the storm of construction creeping up Friedrichstrasse in my direction.

My next abode was in one of the old five-story tenements on Immanuelkirchstrasse in Prenzlauer Berg, about a ten-minute cycle from Friedrichstrasse. The cobbled street, lined with pear trees, sloped gently upward from the base of Friedrichshain Park to the Immanuel Church on Prenzlauer Allee. When I moved into a three-person apartment collective in 1994, the street only had a couple of businesses on it, one of which was the peaceful café Briefe an Felice (Letters to Felice) at the address to which the Czech-German writer Franz Kafka sent his famous letters to

his fiancée, Felice Bauer. Across the street from my flat, a small coal yard operated out of a gap in the cityscape left by an Allied bomber. At my desk, I'd watch this scene straight out of the 1930s as the coal schleppers, black as ravens from the stuff, stacked their back boards with briquettes and lugged them to the delivery truck. The gap let sunlight shine in all day long and afforded me a clear view of the bulbous TV tower on Alexanderplatz. The neighborhood was still largely populated by its 1980s inhabitants: low-paid workers, destitute types without formal employment, seniors, students, the local bohemia. Since the Wall fell, outsiders like me had moved in too. My building had a unique history in that a group of East German medical students had found it through a newspaper blurb advertising an empty, partially renovated building in need of tenants.

Throughout the 1990s, the street evolved slowly, imperceptibly so at first. Small businesses came and went quickly, such as shoe repair shops, cafés, bars, massage parlors, tiny artist studios-cum-galleries, liquor stores. Some of the poorer families migrated to the high-rise estates or other areas, while many better-off families headed for Berlin's green suburbs. As young singles gravitated to the neighborhood to replace them, local kindergartens and schools shut their doors. Quality nightclubs such as Knaack and Magnet dotted the map, as did the late-night Kommandantur at the base of the old water tower, a dive that the neighborhood piled into around midnight. On Walpurgis Night, the night of April 30 when, according to pagan myth, witches dance in celebration of spring, we hauled drums and other instruments to Kollwitzplatz where we made music and roasted sausages over a bonfire until dawn.

Barely two years later, gentrification was in full swing. Briefe an Felice and the coal yard had closed, the latter eventually replaced by a modern apartment building that obstructed,

forever, my cherished sunlight. The construction hullabaloo had crossed from Mitte into Prenzlauer Berg, commencing a ten-year process of refurbishment that prompted a relentless, top-to-bottom demographic turnover, which would change the *Kieze*, or neighborhoods, beyond recognition. I turned one of the bright, high-ceilinged front rooms of my spacious walkup into an office. But I couldn't enjoy it. The jackhammers started at 6:30 a.m. and didn't taper off until dark. At no point during the aughts was there not a renovation site in earshot.

In the meantime, my building was sold to eight parties living in the house: the former medical students, now doctors, and a few others. Although they weren't collectivist-minded types, they wanted to run the house for the benefit of everyone in it. Their monthly meetings lasted for hours, but not as long as those of our next-door neighbors, who had turned their building into a cooperative, the structure itself owned by a nonprofit building association, every member of the co-op with one vote. This ownership model, with case-by-case variations, was the form that most of the legalized squats eventually took, which didn't cancel out direct democracy but rather institutionalized it.

My friend and next-door neighbor on our second floor, an art teacher at the nearby Kurt Schwitters high school, had fixed up the ground-floor shop front, a fish store in the GDR days, transforming the rooms into an informal club called Privatwirtschaft, or Private Sector. The club, a nook of *Freiraum* for everyone in the house, was open whenever we felt like opening it, and available for happenings and hanging out, concerts, art exhibitions, parties, and screenings of soccer games. Idle passersby could stop in for a drink at the bar.

The demographic shift in Prenzlauer Berg was unmistakable as young professionals and small upper-middle-class families moved into the handsomely refurbished buildings, some of the

most coveted real estate in all of Berlin. The newcomers' new cars clogged up both sides of the narrow streets. And the singles of the '90s hooked up with one another to become the families of the aughts. Kindergartens reopened and playgrounds sprouted like dandelions as Prenzlauer Berg acquired the reputation as the family-minded fertility capital of the entire Federal Republic. Nowhere in Germany—where for years deaths outnumbered births—were Germans having more children.

Almost all of my acquaintances were employed in the creative sector—as journalists, translators, musicians, designers—and most of them chose to sacrifice the security of nine-to-five for the freedom of flexible contract work. In addition to Berlin's general affordability, this is possible thanks to a venerable institution called the Künstlersozialkasse, the Artists Social Insurance Fund, which offers a broad category of artists, including writers and translators, health and disability insurance, as well as matching social security payments, for a monthly rate gauged to income. The streets of Prenzlauer Berg came to be lined with bookstores, yoga studios, the co-working spaces of design firms and IT startups, translation collectives, artist studios, and new media outfits. I currently share a collective office with a computer programmer, a professor of cultural anthropology, and a freelance film critic.

I, too, was a Prenzlauer Berg single who found a life partner and settled down. Our child attends one of the area's kindergartens between the Culture Brewery and super-trendy Kollwitzplatz. Typical Prenzlauer Berg, all of the kindergarten's kids and their parents are white, educated, and gainfully employed, a striking contrast to Kreuzberg, for example, where ethnic diversity has survived even though the rents there have shot through the roof, too. The parents of my son's pals come from eastern and western Germany, and across the European Union. But not

from Turkey or Eastern Europe. And, of course, there are the North Americans. We're a sizeable minority here. Some make no effort whatsoever to learn German. Why bother? Nowadays, in stark contrast to the past, nearly everyone speaks English.

As comfortable as patrician Prenzlauer Berg is for families, there's no denying that it's lost its edge. If you want to go out on the town, you usually have to leave its streets for Kreuzberg, Friedrichshain, or Neukölln. Knaack club, which had survived a dictatorship and jarring post-Wall transition, had to close shop because its neighbors in a newly constructed building, one that "forgot" to install soundproof walls, couldn't deal with the weekend noise. Magnet club packed up for Kreuzberg; Kommandantur couldn't pay the exorbitant rent and closed. The lights around here go out at 1 or 2 a.m. Every empty lot is being filled, some of them by gated communities, like the blindingly white Swiss Gardens on the edge of Friedrichshain Park, built on a plot where a caravan community had dropped anchor in the 1990s. One can only assume that these newcomers behind their locked gates want to keep Berlin out.

So pricey is the neighborhood now that it has come full circle: the artists and the artisans face displacement. Indeed, the owners of my building now have an immensely valuable asset in their hands. Like many of our acquaintances with older leases, I'm fighting tooth and nail to stay.

Beyond Mitte

Yet Berlin has much more to offer than Mitte and Prenzlauer Berg. With the choicest downtown addresses out of reach, many of the hipsters, including many of the U.S. college grads doing the Berlin thing for a year or two, head toward Wedding and Neukölln, two

districts of former West Berlin that back in the day had been populated by proles, migrants, and students like myself. Today those are the neighborhoods we go to for craft beer and live music.

Indeed, the unconventional in Berlin hasn't been eradicated—but rather displaced. The dance clubs, for example, that once lay on the fringes of Potsdamer Platz, the very center of Berlin, journeyed east several miles in the aughts to the banks of the Spree between Kreuzberg and Friedrichshain. And the likes of Tresor (see photo on facing page), Watergate, Golden Gate, and Berghain are still there today, the latter setting the benchmark for decadence, the way Chez Romy Haag did in its day. Newer dance clubs such as Magdalena, Else, About Blank, and Salon zur Wilden Renate have popped up yet farther along the river's banks near the Elsen Bridge, where Kreuzberg meets the former eastern district of Treptow. Die Wilden Renate is just one of the many clubs and locales that riffs off the early 1990s with its living room décor and peeling wallpaper. While the techno clubs aren't the otherworldly sensation they were in the 1990s, they remain on the cutting edge of electronic music worldwide, aided by the many producers in Berlin, and have expanded their repertoire to include concert gigs, performances, and art exhibitions. The Atonal Festival, for example, one of the incubators of contemporary electronic music, happens between Dimitri Hegemann's Tresor and Kraftwerk, the latter an abandoned GDR power plant that Hegemann makes available for spectacles such as the four-day festival.

The rooftop venue Klunkerkranich, an open-air club perched high atop a shopping center in the heart of Neukölln, demonstrates that the only limit to space is limited imagination. Another group of Berlin artistes—you could call them gentrification refugees—took this thought to heart and hammered together a ramshackle flotilla of house boats and party rafts. Either on the Spree or in

**At Tresor, DJ Tanith at the club's twenty-fifth
anniversary celebrations, 2016.**

a Friedrichshain inlet, these pirates, as they refer to themselves,
created the conditions for their collective living projects and
artistic endeavors that they find so elusive now on land.

Many artists have migrated yet farther east, beyond the his-
torical city, where artists still have their pick of vast *Freiraum.*
A twelve-minute S-Bahn trip from Alexanderplatz, the old
working-class district of Schöneweide has disused industrial
warehouses and long-shuttered red-brick factories that now
house four hundred artists—and with room to spare.

There was a stretch during the 1990s when no one of right
mind chose to enter the GDR's prefabricated cement high-rises,
once the modernist pride of the communist state. Yet today, a
sunny three-room apartment in Marzahn, Hellersdorf, or Hohen-
schönhausen goes for about $500 a month—roughly a quarter

of the going price in Mitte. There's not an exodus underway but rather a trickle that could well tick up if inner-city rents continue to do so. In 1998, Alice Salomon University, a progressive college for social work, was a pioneer, moving from its confining quarters in David Bowie's Schöneberg to much larger ones in Erich Honecker's Hellersdorf, a no-man's land chock-full of social problems. Yet, fourteen years later, when the city shut down Art House Tacheles after investors bought the property, a handful of its exiles, such as the French sculptor Kerta von Kubin and her Italian partner Claudio Greco, transplanted their studio to the high-rise suburb of Marzahn (which is closer to downtown Berlin than Greenpoint, Brooklyn, is to Penn Station), where they joined others escaping gentrification. Now intrepid tourists even make their way out to Marzahn to check out their Kunstwerkstadt and marvel at the living remnants of real existing socialism.

The mainstreaming of Berlin may have elbowed its politics to the center, but Berlin remains a politically charged city, and home to a sweeping array of activist cabals that segue between maverick politics and urban culture. The Computer Chaos Club (CCC), for example, is Europe's premier hacker assembly with five thousand internet activists—the city's latest anarchists—who program and hack in the name of web neutrality and data privacy. As the focal point of the antisurveillance movement, Berlin and its CCC branch were turbocharged by Edward Snowden's disclosures about the National Security Agency, which drove Snowden, among other digital fugitives, into exile. U.S. filmmaker Laura Poitras, who helped bring Snowden's sensational revelations to light, and Wikileaks hacktivist Jacob Appelbaum, also American, chose Berlin over Russia for self-imposed exile. Poitras returned to the United States in 2015 after producing the film *Citizen Four* about Snowden, for which she won an Oscar. Appelbaum, though, an icon among the CCC activists, has

remained in Berlin, at the front of a fast-growing underground of anonymous hackers whose targeted disclosures of government and corporate secrets are changing politics as we know it.

Street art collectives, with names like Pappsatt, Plakatief, and Mentalgassi, represent just a sliver of an urban art movement that has painted and papered over Kreuzberg, Friedrichshain, and Neukölln with some of the most vivid political street and poster art anywhere in the world. So dense is the mass collage across whole neighborhoods that one requires a guide like street art blogger Caro Eickhoff, a Berlin native, to make sense of it. She leads tours under the raised U-Bahn tracks near Kottbusser Tor and through the streets of the now long legalized former squats such as the Manko in Manteuffelstrasse. From the murals, paintings, stencils, sculptures, and silkscreen prints, Eickhoff tells these barrios' narrative of resistance and self-determination, pointing out faded images from as far back as the 1970s women's movement, as well as political slogans from the days of the squatters wars, one relic at the corner of Manteuffelstrasse and Paul Linke Ufer that even takes a shot at West Berlin's 1980s interior minister. The hieroglyphics of the present can be even trickier to decipher as hip-hoppers vie with skateboard gangs and migrant kids for a speck of visibility on Kreuzberg's walls.

Reclaim Your City (RYC) is a loosely organized outfit that grew out of Berlin's street art movement—and treads in the footsteps of the great Situationist Henri Lefebvre, author of the classic *The Right to the City*. RYC understands itself as a network for diverse Berlin campaigns that agitate for affordable living, direct democracy, and the openness of public space to art. The young men and women engage very much in the spirit of Berlin's squatters and the 1980s Wall artists, but with a contemporary twist. RYC has led protests—including the squatting of public spaces—against the city's selling off of open-space

One half of the legendary wall mural by the street artist Blu,
who later painted over it in black to protest the crackdown on the
squatters in the Cuvry lot. Tents can be seen in the foreground.

downtown property in a desperate move to replenish its coffers. Among its allies are groups such as Kotti&Co, a tenacious tenants' rights group, in which old and young, German and Turkish, have bonded together to contest the eviction of locals and their shops from the old Kreuzberg neighborhood around Kottbusser Tor, which Berliners refer to as "Kotti."

One high-profile campaign involving both groups revolved around the Cuvry-Brache, a three-acre plot of wasteland along the Spree in Kreuzberg where homeless people, refugees, and assorted nomads had set up a tent-and-hut settlement in the mid-2010s. The lot bordered on two brick tenements whose high windowless firewalls proffered a perfect canvas for two of Berlin's most iconic murals: the gigantic white creatures of the Italian artist Blu (see photo on facing page). The first evinced the early struggles of eastern and western Germans in the years after reunification by depicting two floating, vaguely human figures in the act of unmasking each other, one showing the "east side" gang sign, the other the "west side" sign. The second image, a businessman, his hands cuffed by golden watches, had adorned as many postcards as the floating creatures.

Yet the empty lot and the muraled buildings were central to Mediaspree, a highly controversial city initiative to turn the banks of the Spree between Jannowitzbrücke and Elsenbrücke into a high-end hub for the media and communications sector. RYC was just one of dozens of civic groups that protested Mediaspree with all of their energy. Nevertheless, the city cleared out the Cuvry lot's tent city in December 2014, fencing off the property. The next day, in solidarity with the ousted squatters, Blu painted over the giant murals with black chalkboard paint, scandalizing the city and drawing livid op-eds. One of his helpers, street-art aficionado Lutz Henze, explained the surprise move in the *Guardian*:

Gentrification in Berlin lately doesn't content itself with destroying creative spaces. Because it needs its artistic brand to remain attractive, it tends to artificially reanimate the creativity it has displaced, thus producing an "undead city." This zombification is threatening to turn Berlin into a museal city of veneers, the "art scene" preserved as an amusement park for those who can afford the rising rents.

If squatters and artists couldn't occupy the Cuvry-Brache, then Blu wasn't going to lend the city or the lot's owners his artwork—and contribute to the zombification.

Today, Berlin businesses and even local officials hire graffiti artists to decorate their walls for the purpose of stimulating business. Some artists gladly accede, which Blu and his allies argue gives fake, commodified art a prominent place, while open public spaces, where real art can happen, are developed by the very same business interests. The French Wall painter Thierry Noir, for example, paints his androgynous bubble-head figures from the days of the Wall on the surfaces of hostels and banks, or for any trinket company or retailer (see photo on facing page) that pays him to do so. Noir bubble-head key chains, T-shirts, and coffee cups are on sale near almost every major Berlin tourist attraction. In fact, this is all Noir does now—bubble-heads for money—or has done for the last twenty-five years.

The squatting of whole buildings tailed off by the mid-1990s. Yet the Berlin tradition and the spirit of direct action survived beyond the circles of Kreuzberg anarchos. In 2012, the seniors of the Stille Strasse community center, deep in former East Berlin, got the bad news that their center, which also served other local clubs and clientele, was going to be shut down. The city claimed that it simply couldn't afford the extensive renovations on the 1930s villa (which, by coincidence, had been the home of

The French street artist Thierry Noir advertising
German-brand refrigerators.

the former Stasi chief, Erich Mielke, in the GDR era). But the fifty seniors, predominantly retired eastern German women, weren't going without a fight. They dragged mattresses and sleeping bags into the building and painted neatly on a bed cloth in bright blue and red letters: *Dieses Haus ist besetzt!* The gambit lasted 111 days, during which the obscure street was besieged by media reporting on it daily. Finally, the social charity Volkssolidarität (by coincidence, the organization for which Silvio Meier and the KvU crowd had worked in the GDR) offered to take it over and pay for the repair work. Like other former squats, the community center today is self-administered, a model of real existing do-it-yourself democracy.

Probably the greatest victory of people power following the torpedoing of the Olympics bid was the preservation of Tempelhof Field. The sprawling 877-acre property—the size of Central Park—in the middle of old West Berlin had been an inner-city airport, the cavernous, polished-marble main hall built by the Nazis. It won international fame as Berlin's lifeline during the 1948–49 airlift, when over nearly a year some 200,000 flights landed on its runways with supplies for the sealed-off West Berliners.

When in operation, it was always a treat to fly from Tempelhof because it was so easily accessible on the U-Bahn and, because of its diminutive size, quick and easy to navigate. The Nazi architecture, all symmetry and Roman kitsch, lent it a Leni Riefenstahl feel, much like the 1930s-built Olympia Stadium does today. It made one's skin tingle to imagine Nazi flags hanging from the high ceiling. The noise and its size doomed it, though at first Berlin's politicos had no concrete plans for the prime real estate and historic building. But while the city mulled over it, Berliners turned it into Germany's biggest public park, employing the abandoned runways to bike and rollerblade,

the grassy field to picnic and fly kites. Neighbors would haul an old sofa and beach umbrella into the park for a day of reading. Baseball diamonds materialized, as well as urban gardening tracts, a self-made mini-golf course, and sculpture gardens.

Unsurprisingly, the choice real estate came into developers' sights, and the city proposed turning about a third of it into housing and commercial buildings. Since the plans envisioned hundreds of acres for recreational space open to the public, the city was incredulous at the fuss over its blueprint. Nevertheless, so incensed were the plan's opponents that a civic initiative called 100% Tempelhof Field kickstarted a referendum on the fate of the land, which culminated in over 60 percent of Berliners voting to keep the property intact. The hangars have since been used for concerts, exhibitions, and even the national press ball. For over a year now, the building temporarily houses refugees from Syria and elsewhere. The tens of thousands of migrants— from the Middle East, Africa, and Asia—settling in Berlin will transform the city over the next decades more than anything else. If their presence seasons Berlin's jambalaya as vigorously as the Turkish migrants did West Berlin in the 1970s and '80s, the city will be much the richer for it.

Among newcomers now indelibly woven into Berlin's fabric are the central and eastern Europeans who followed past generations of westward migration to Berlin. In the 1990s, they didn't advertise their cultural differences, as most migrants don't, but if you kept your eyes peeled, you'd see the Russian specialty shops, Polish cafés, and grocery store sections stocked with frozen pierogies and canned carp. The bars in Mitte served the Czech beer Staropramen and Polish Żywiec, while kiosks sold newspapers in several Slavic languages. Stories of ruthless "eastern European" mafia and their carjacking rings were plastered across the German tabloids.

Berlin's urban culture profited quickly from the strains of *Mitteleuropa.* A steady flow of bands and theater troupes from east of the Oder-Neisse Rivers came and went from IM Eimer, Tacheles, and the Volksbühne. A group of college-age Polish expats, fed up with the lumping of "eastern Europeans" into one unruly pile, opened Club of the Polish Losers, a bar with worn oriental carpets and a small stage in the back. The club's name drew attention to precisely the stereotype that dogged them: the Poles either as criminals or deadbeats, clad in cheap stone-washed denim, the kind hawking plastic wares at the Poland market on Potsdamer Platz. The club was everything that the market wasn't: urbane, self-conscious, brainy. Next to it, the Pigasus Polish Poster Gallery specialized in poster art and films.

Wladimir Kaminer, a 1967-born Russian writer with Jewish roots, emigrated to Berlin in 1990, in the middle of the year of anarchy. One night he improvised a marathon dance party at Kaffee Burger on Torstrasse, featuring sounds unfamiliar to Berlin's night life, such as Russian pop, polka punk, and klezmer ska. The wild, sweat-drenched saturnalia made history as the first ever "Russian Disco" (also the title of his first book, an international bestseller, and feature film). Since then, every second Saturday Russian Disco night at little Kaffee Burger packs in the revelers.

Russian Disco was the spark that ignited an explosion of East-bloc-origin bands, radio programs, and dance nights in Berlin. The Bosnian-born taxi driver and part-time construction worker Robert Soko, for example, felt that he, too, had something to share. The urban postpunk sounds of 1980s Yugoslavia were an insider's tip, one I had already stumbled upon during stints in Belgrade and Zagreb. At the Arcanoa in Kreuzberg, Soko's Balkan-folk-to-Yugo-punk shindigs brought together the young Bosnian war refugees, who had flooded the city, and Berlin regulars—until the petite club couldn't hold them any longer. So

Soko took his BalkanBeats show on to bigger venues, and then on the road to London, Paris, and Geneva. Much the same way, Kaffee Burger launched the nine-member "emigrantski raggamuffin" band RotFront, which performs an up-tempo blend of klezmer, ska, and punk at music halls across Europe.

A handful of West Berlin's old haunts have survived, more than you'd imagine, evident from a stroll down Kreuzberg's Oranienstrasse, although the ownerships have changed hands since the 1980s and the tourist hordes in the street now resemble those in Venice. The punk club SO36 on Heinrichplatz, for example, which has more than once come perilously close to disappearing, is alive and duly insolent. But it has recast itself over the years too, turning necessity into invention by branching out into hip-hop, crossover, techno, balkan ska, and drum 'n' bass. Once a month, SO36 hosts a special dance night for the LGBTIQ Muslim community, minorities within a minority. It's not, for good reason, highly publicized, but those who want to know about it, do. There's belly dancing and tea, as well as booze.

More than a few of the dramatis personae from the Berlin of the Wall era are as inventive as ever. Gudrun Gut, for example, the diva behind Malaria!, runs the recording outfits Moabit Musik and Monika Enterprise, the latter a label that records, above all, female musicians, not least Danielle de Picciotto (see image, page 302), but also the experimental savant of the GDR bohème, Robert Lippok. As for Einstürzende Neubauten, it still tours the world's stages from time to time. In 2014, the Neubauten took up the offer of the town of Diksmuide in the Flanders region of Belgium to put its tragic World War I experience to music and bring it to the stage on the centennial anniversary of the war's outbreak. In Berlin at the sold-out Tempodrom, Bargeld's legendary shrieks and Unruh's percussion aptly evoked the carnage and suffering of Europe a century ago.

Invitation to a DJ evening featuring Danielle de Picciotto (left)
and Gudrun Gut (right) at Der goldene Hahn, early 1990s.

The Neubauten's performance implicitly linked the nation-
alist madness of World War I with trends in today's Europe.
Never in its history has the European Union faced such crisis, a
perfect storm of mass migration flows, the lingering eurocrisis,
Brexit, and the steady rise of the far right. Indeed, right-wing
extremists have come a long way since the early 1990s. They've
still got bully boys who burn down refugee centers, but now in
the form of "New Right" parties they sit in parliaments across
Europe, too. Germany's Bundestag is, as of 2016, still one of the
few exceptions to this rule, but it won't be for long should its own
New Rightists, the Alternative for Germany (AfD), live up to
opinion polls. The AfD is particularly menacing in eastern Ger-
many, where broken promises and decades of stagnation stirred

deep resentment against the new overlord. Germany paid a high price for Kohl's one-sided imposition of the Federal Republic on the east, which radicalized the racist sentiment and illiberal currents already there, the heritage of Soviet communism. The West's takeover nipped democratization from below in the bud—and today we're battling its by-products.

The photographer Harald Hauswald lives in Prenzlauer Berg, just as he had, his ponytail now long gray. He's still active as a professional photographer, one of the guiding lights behind the 1990-founded photo agency Ostkreuz, known worldwide for its socially engaged documentary style. I saw him recently at the Stille Strasse community center (the squatted seniors' center) where he was showing photos from 1980s East Berlin. We spoke about a renaissance of interest in the GDR's subcultures. Kids who weren't alive when the Wall fell are listening to the underground GDR bands again, perhaps discovering a raw, subversive streak that's absent in their own pop culture.

Can Detroit Be Berlin?

Long before 2011, when Detroit inquired about simulating Berlin's resurgence from postindustrial trainwreck to cool-but-safe-for-capital capital city, other cities had picked up on Berlin's do-it-yourself ethic and upcycling of urban detritus. Yet Detroit looked like a particularly good match: a once proud industrial city reduced to economic disaster zone with sprawling graveyards of vacant factories. In its ruins, artistic energy still flowed, such as in its electronic music scene, a flash of genius back in the 1990s that Berlin borrowed to its own advantage, forever after. Thousands of buildings stood empty in the depressed Motor City when Tresor owner Hegemann initiated Detroit-

Berlin Connection, a project that aims to inject some of Berlin into its American soul mate. Hegemann zeroed in on two features that Detroit lacked, namely around-the-clock drinking hours and temporary use provisos for derelict properties. The lessons from Berlin: embrace the night and reconfigure space.

But there's more that other cities can cull from the Spree metropolis. Berlin illustrates that cities err to their own misfortune when business interests smother the taproot of urban culture. The creations of artists and outsiders reverberate far beyond their little studios and clubs. Their circles have a value that can't always, in the short term, be calculated in dollars and cents. City governments may create funds for culture or even farm out studios to artists, as Berlin now does, but more to the point are the conditions necessary to do it yourself. The eccentric and the truly original require space and time, something Berlin has offered in the past. Cities can do most for creatives by preserving low rents with laws that bolster tenants' rights and cap rent hikes. They must keep neighborhoods livable, and maintain affordable social and health insurance for artists and writers.

As for the creative class itself, it has to roll up its sleeves, too. Berlin's creatives have to take up the fight against gentrification, instilling anticampaigns like RYC and Kotti&Co with the kind of zest that distinguished from-below movements of the past. The iconoclasts of street art, like Blu, are out in front, battling the commercialization of Berlin—and its art—from the trenches. The movements of bygone eras that mixed subversive politics with subculture and living experiments weren't one-off flukes. They challenged the status quo—and changed it, inspiring others along the way. With such a wealth of creative talent in the city, in terms of quantity greater than ever, today's international Berliners can make this happen if they take up the

challenge. If not, they'll have only themselves to blame when Berlin looks like every other clone city in Europe.

At the end of the aughts, two of Berlin's most prodigious bon vivants, Danielle de Picciotto and her husband, Alexander Hacke, the original guitarist and now bassist of Einstürzende Neubauten, decided they'd had it with Berlin. The city they'd loved and that had inspired so much of their work over three decades had lost its pop. So the couple packed their belongings into crates, terminated their lease, and hit the road. They took off to travel the world in search of another place that fired their imaginations the way Berlin once had. The duo crisscrossed Europe, and then Asia, driving through the United States and Mexico, staying some places for days, others for months. They slept on couches and in artists' residencies, watering the flowers of out-of-town friends, dog sitting. In character, they churned out music, artwork, fashion, biographies, and more as they roamed the planet. They'd return to Berlin every now and again for a Neubauten tour or other gigs.

De Picciotto and Hacke had initially planned to live the gypsy life for a year. But it stretched to three and then five. Yet they never located a city that did it for them like Berlin had. Now they're back in Berlin—temporarily, they stress—working out of studio space in Wedding. Remaining unsettled keeps them on their toes, de Picciotto told me, open and alert to the new.

As for Berlin, she hasn't given up on it. After all, Berlin's urban culture has persevered through far worse than gentrification and mass tourism. Berlin, drawing on its past, still has the power to reinvent itself, she says.

Epilogue

I'M DEEPLY GRATEFUL TO THIS PROJECT FOR MANY reasons, but above all for giving me cause to reconnect with old friends, in particular the 47 Schreinerstrasse crew, some of whom I'd kept in loose contact with over the years as they bore children and tacked through the world. Others I'd lost touch with completely. Church from Below partisans Micha Neider and Gerd Fahlberg intrigued me from the moment I encountered them in Budapest, and the fortunes of the larger troupe, now scattered, still do today. I visited Micha recently on his tumbledown farm on the Danish island of Bornholm in the Baltic Sea. Gerd, who runs a scuba diving school on the Colombian coast, north of Panama, rarely returns to Germany. Dirk Moldt trained as a historian to chronicle the GDR's protest culture, while Kathrin Kadash, after a life of unsatisfactory heterosexual relationships, married a woman with whom she and her daughter live just outside of Berlin, where she works with children with special needs. Hinkelstein Press, founded by Church from Below activists, is a small print collective, now located in a Kreuzberg courtyard, which remains conscious of its seditious past.

Since Silvio Meier's death, 47 Schreinerstrasse and its neigh-
borhood have evolved as Berlin has. Yet the streets around the
Samariterkirche still bear the signage of the miracle years
of anarchy. The facades of Rigaer Strasse's former squats bear
splashy murals and bedsheet banners. A bright green dragon
snakes its way up the side wall of 47 Schreinerstrasse, overlook-
ing a playground. Handbills and concert posters are plastered
on the front door; inside, the rusty, banged-up mailboxes look
vintage 1990. The Schreinerstrasse house, like those in Rigaer
Strasse and many other former squats, are now zero-equity
cooperatives, owned by nonprofit associations and run by their
residents. All of the co-op members pay modest rents and meet
monthly in the ground-floor café to hash out issues the way they
see fit.

The building houses thirty-five people, including a hand-
ful of originals such as Speiche, Deni, Ekke, and Moldt. There
are now two kitchens per floor, each shared by a suite of three
flats. Micha's son lives with his American mother on the fourth
floor. Chrischi and Felix moved back a couple of years ago, after
twenty years in Kreuzberg. Felix, now twenty-five years old,
studies psychology in Berlin. Chrischi, who works two part-time
office jobs, never remarried or found a life partner after Silvio.
But she's at peace with herself, pleased to be back in 47 and,
when I could pin her down, eager to revive the old days and sort
through the memories.

Once a year she and Felix march in the annual Silvio Meier
demonstration, an event organized by "antifascist" groups, left-
ist anarchos mostly from Friedrichshain and Kreuzberg who,
from the youthful looks, I assume were born after the Wall
fell. The rally starts in Silvio Meier Strasse perpendicular to
Schreinerstrasse, the renamed street a gesture on behalf of the
district to recognize Silvio's engagement and memorialize his

tragic death. The demo last year took much the same route as the angry march in 1992, into the Lichtenberg high-rise blocks where rightists still rule the roost. Paving stones inevitably fly and police sirens breach the night. In neither Berlin nor the rest of Germany has the phenomenon of racist extremism dissipated, though its countenance has changed. The far right has gone mainstream, and today it's part of Germany's political landscape, as it is across Europe.

A tiny but enduring redoubt against reactionary thinking—and, in general, all things establishment—is the punk and hardcore club KvU. After being shunted from the St. Elizabeth parish to other venues around Berlin, and then nearly shut down for good, KvU found a new home in a former GDR industrial zone off Storkower Strasse. The Protestant church social workers responsible for its shepherding are Michael Frenzel and Jolly, the very same figures who liaised with the GDR punks in the 1980s. They're still there for young outcasts, regardless of their views on the Almighty. Behind the bar, high on a cluttered shelf, there are copies of the single book on Church from Below, compiled by its first-hour members. Its cover displays a faded black-and-white photo from the first Church from Below congress in 1987. Five activists hold up a banner (see photo) that reads "Miracles can happen, Church from Below."

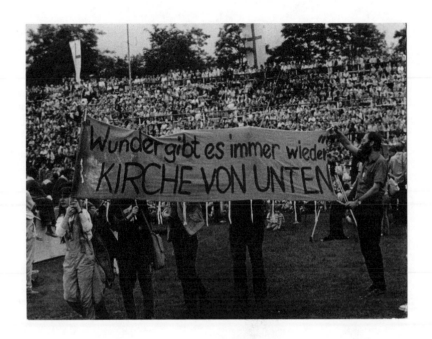

Select Bibliography[*]

Berlin Super 80 (CD/DVD). *Die Tödliche Doris* a.o., 2011.

Boehlke, Michael, and Henryk Gericke. *Too Much Future: Punk in der DDR*. Berlin: Verbrecher Verlag, 2007.

Brown, Timothy Scott. *West Germany and the Global Sixties: The Anti-Authoritarian Revolt, 1962–1978* (New Studies in European History). Cambridge: Cambridge University Press, 2013.

Brown, Timothy, and Lorena Anton (eds.). *Between the Avant-Garde and the Everyday: Subversive Politics in Europe from 1957 to the Present.* New York and Oxford: Berghahn Books, 2011.

de Picciotto, Danielle. *The Beauty of Transgression: A Berlin Memoir.* Berlin: Gestalten, 2011.

de Picciotto, Danielle. *We Are Gypsies Now: A Graphic Diary.* Berlin: Metrolit, 2015.

[*] This bibliography includes only select sources used for research purposes. It does not include sources mentioned in the text or footnoted as sources.

Diederichsen, Diedrich, and Leonard Emmerling. *Geniale Dilletanten: Subkultur der 1980er-Jahre in Deutschland.* Berlin: Hatje Cantz, 2015.

Enzensberger, Ulrich. *Die Jahre der Kommune I: Berlin 1967–1969.* Cologne: Kiepenheuer & Witsch, 2006.

Farkas, Wolfgang, and Stefanie Seidl. *Nachtleben Berlin: 1974 bis heute.* Berlin: Metrolit, 2013.

Felsmann, Barbara, and Anett Gröschner (eds.). *Durchgangszimmer Prenzlauer Berg: Eine Berliner Künstlersozialgeschichte der 1970er und 1980er Jahre in Selbstauskünften.* Berlin: Lukas Verlag, 2012.

Fesel, Anke, and Chris Keller, et al. *Berlin Wonderland: Wild Years Revisited, 1990–1996.* Berlin: Gestalten, 2014.

Galenza, Ronald, and Heinz Havemeister. *Wir wollen immer artig sein: Punk, New Wave, HipHop, und Independent-Szene in der DDR 1980–1990.* Berlin: Schwarzkopf & Schwarzkopf, 2013.

Gründer, Ralf. *Verboten: Berliner Mauerkunst: Eine Dokumentation.* Vienna: Böhlau Verlag, 2007.

Gutmair, Ulrich. *Die ersten Tage von Berlin: Der Sound der Wende.* Berlin: Tropen, 2014.

Harriman, Andi, and Marloes Bontje. *Some Wear Leather, Some Wear Lace: The Worldwide Compendium of Postpunk and Goth in the 1980s.* Bristol: Intellect, 2014.

Ingram, Susan, and Katarina Sark. *Berliner Chic: A Locational History of Berlin Fashion.* Bristol: Intellect, 2011.

Kaiser, Paul, and Claudia Petzold. *Boheme und Diktatur in der DDR: Gruppen, Konflikte, Quartiere, 1970–1989.* Berlin: Verlag Fannei & Walz, 1997.

Kowalczuk, Ilko-Sascha. *Endspiel: Die Revolution von 1989 in der DDR*, München: C.H.Beck, 2009.

Lothar, Schmid. *Häuserkampf im Berlin der 1980er Jahre: Squatting in Berlin in the 1980s*, Berlin: Berlin Story Verlag, 2013.

Marshall, Peter. *Demanding the Impossible: A History of Anarchism.* Oakland, CA: PM Press, 2010.

Moldt, Dirk, u.a. *Wunder Gibt es Immer Wieder: Fragmente zur Geschichte der Offenen Arbeit Berlin und der Kirche von Unten.* Berlin: Hinkelstein Druck, 1997.

Moldt, Dirk, and Wolfgang Rüddenklau (eds.). *mOAning star: Eine Ostberliner Untergrundpublikation.* Berlin: Robert-Havemann-Archiv, 2005.

Müller, Wolfgang. *Subkultur Westberlin 1979–1989: Freizeit.* Hamburg: Philo Fine Arts, 2014.

Ring, Kristien. *Selfmade City Berlin: Stadtgestaltung und Wohnprojekte in eigeninitiative.* Berlin: Jovic Verlag, 2013.

Roehler, Oskar. *Mein Leben als Affenarsch.* Berlin: Ullstein, 2015.

Sadler, Simon. *The Situationist City.* Cambridge, MA: MIT Press, 1998.

Seabrook, Thomas Jerome. *Bowie in Berlin: A New Career in a New Town*. London: Jawbone Press, 2008.

Wolle, Stefan. *Die heile Welt der Diktatur: Alltag und Herrschaft in der DDR 1971–1989*. Berlin: Ch. Links Verlag, 2013.

Notes

Introduction

ix *"The Berlin experience is how"* Dimitri Hegemann, *Deutschland-radio Kultur,* April 8, 2014.

1. Learning to Love the Wall

12 *"We blended them out"* Jürgen Teipel, *Verschwende deine Jugend: Ein Doku-Roman über den deutschen Punk und New Wave* (Frankfurt: Suhrkamp Verlag, 2001), p. 110.

15 *"the ruins of German history"* Philipp Felsch, *Der lange Sommer der Theorie: Geschichte einer Revolte, 1960–1990* (Munich: C.H. Beck, 2015), p. 187.

20 *only twenty out of the city's four hundred cinemas* "Zerstörung in Zahlen," 70 Jahre Kriegsende, Radio Berlin Brandenburg, http://www.rbb-online.de/politik/thema/2015/70-jahre-kriegs ende/beitraege/kriegsschaeden-berlin-2--weltkrieg.html.

34 *"The only thing missing from the commune was a toilet seat"* Peter Schneider, *Rebellion und Wahn: Mein '68.* (Cologne: Kiepenheuer & Witsch, 2008), p. 132.

2. Bowie's Berlin

42 *against the backdrop of the German Autumn* Agata Pyzik, *Poor but Sexy: Culture Clashes in Europe East and West* (London: Zero Books, 2014).

44 *"and Berlin had been their spiritual home"* Tobias Rüther, *Helden: David Bowie und Berlin* (Berlin: Rogner & Bernhard Verlag, 2008), p. 84.

46 *they called him "Mr. Boffie"* Rüther, *Helden: David Bowie und Berlin*, p. 125.

49 *"There wasn't anything else I could do"* Romy Haag, *Romy Haag: Eine Frau und mehr* (Cologne: Quadriga Verlag, 1999), p. 67. All Haag quotes are from her German biography, translated by Paul Hockenos.

52 *appear at his scheduled next gig in Hamburg three hours late* Ibid., p. 193.

64 *"The tempo was so much slower than anywhere else"* *Party auf dem Todesstreifen—Soundtrack der Wende* (documentary film, dir. Rolf Lambert, 2014).

3. Wall City Rock

66 *every moment was lived to its fullest* "Die Stille war eine Offenbarung," *taz*, Oct. 1, 2012.

66 *I don't think that anything valuable can emerge otherwise* *TIP*, vol. 19 (1982).

79 *"And it just keeps on going like this"* Max Dax and Robert
 Defcon, *Nur was nicht ist ist möglich: Die Geschichte der
 Einstürzenden Neubauten* (London: Bosworth Music, 2006), p. 49.

86 **something that comes out of a strangled cat or dying children**
 Seele Brennt, documentary film (dir. Christian Beetz, 2005); Kirsten
 Borchardt, *The Music Makers: Einstürzende Neubauten* (Höfen,
 Austria: Hannibal Verlag, 2003), p. 25.

89 *"until there's nothing left anymore that's not music"* *TIP*, vol.
 19 (1982).

91 *"That's what always interested me about cocaine and speed"*
 Dax and Defcon, *Nur was nicht*, pp. 51–52.

4. Free Republic of Kreuzberg

95 *the only major shift in Berlin's urban history that was not a con-
 sequence of war* Harald Bodenschatz, *Berlin Urban Design: A Brief
 History of a European City* (Berlin: DOM Publishers, 2013), p. 92.

5. Flowers in the Red Zone

125 *New York is where we are* Paul Kaiser and Claudia Petzold,
 *Boheme und Diktatur in der DDR: Gruppen, Konflikte, Quartiere,
 1970 bis 1989* (Berlin: Fannei & Walz Verlag, 1997), p. 370.

148 *"We, of course, thought it was a police raid"* "Rechts Gegen
 Rock," *Tagesspiegel*, Oct. 16, 2007.

158 *"We have no reason to be gentle with these figures"* Ronald
 Galenza and Heinz Havemeister, *Wir wollen immer artig sein . . .*

Punk, New Wave, HipHop und Independent-Szene in der DDR von 1980 bis 1990 (Berlin: Schwarzkopf & Schwarzkopf Verlag, 2013), p. 76.

158 **"*publicly treating the state's organs and their activities and measures in an undignified way*"** "Pogo hinter Stacheldraht," *Berliner Zeitung*, Nov. 1, 1997.

9. Peace, Joy, Pancakes

258 **There was just music** *Party auf dem Todesstreifen: Soundtrack der Wende*, documentary film (dir. Rolf Lambert, 2014).

260 **"*People wanted to dance and not stand around in the corner with a mixed drink*"** "Ein Geheimzirkel erobert die Welt," *Spiegel*, July 31, 2008.

264 **"*We'll say it's a demonstration and call it the Love Parade*"** Felix Denk and Sven von Thülen, *Klang der Familie: Berlin, Techno, und die Wende* (Berlin: Suhrkamp Verlag Berlin, 2012), p. 54.

265 **"*If you don't have a vision that you want to share with others, nothing will ever happen*"** Ibid., p. 57.

266 **"*It has a positive allure*"** Ibid., p. 61.

271 **the stripe identified most closely with Berlin** Theo Lessour, *Berlin Sampler: From Cabaret to Techno, 1904–2012: A Century of Berlin Music* (Berlin: Ollendorff Verlag, 2012).

Conclusion: Berlin Now

283 **"*for example the techno and clubbing scene*"** Claire Colomb,

"'DIY Urbanism' in Berlin: Dilemmas and Conflicts in the Mobilization of 'Temporary Uses' of Urban Space in Local Economic Development," unpublished paper, January 2015, http://www.sheffield.ac.uk/polopoly_fs/1.452222!/file/Colomb.pdf.

284 *8 percent of the city's workforce* Claire Colomb, *Staging the New Berlin: Place Marketing and the Politics of Urban Reinvention Post-1989* (London: Routledge, 2012), p. 232.

284 *10 percent of Berlin's total* "Kreativwirtschaftsbericht," Senatsverwaltung für Wirtschaft, Technologie, und Forschung, Berlin, 2013.

284 *startup champion of all of Europe* "Berlin etabliert sich als die Start-up-Hauptstadt Europas," *Berliner Morgenpost*, Jan. 21, 2016.

Photo Credits

Page 21 (top) *Germany Year Zero:* Stiftung Deutsche Kinemathek

21 (bottom) *Germany Year Zero:* Stiftung Deutsche Kinemathek

25 First phase of the Wall: Michael-Reiner Ernst/Stiftung Berliner Mauer

26 (top) The Wall, 1962: Michael-Reiner Ernst/Stiftung Berliner Mauer

26 (bottom) The Wall from West Berlin: Michael-Reiner Ernst/Stiftung Berliner Mauer

30 Demonstration: Klaus Lehnartz/Bundesarchiv

40 *Christiane F.*: Stiftung Deutsche Kinemathek

49 Romy Haag: Romy Haag website

70 Gudrun Gut: Photographer unknown/Private Collection Gudrun Gut

82 SO36: © Lothar Schmid | worldwidefotos.de

85 Blixa Bargeld: Anno Dittmer/Fotostudio Faceland

99 Kreuzberg apartment building: © Lothar Schmid | worldwidefotos.de

101 Police line: © Lothar Schmid | worldwidefotos.de

102 Squatters: © Lothar Schmid | worldwidefotos.de

113 (top) Death strip: FORTEPAN

113 (bottom) Bubbleheads: FORTEPAN

116 (top) The Wall, late 1980s: FORTEPAN

116 (bottom) The Wall, 1987: FORTEPAN

137 (top) East Berlin seniors: Harald Hauswald, OSTKREUZ

137 (bottom) East Berlin subway: Harald Hauswald, OSTKREUZ

138 (top) Café: Harald Hauswald, OSTKREUZ

138 (bottom) Child in car: Harald Hauswald, OSTKREUZ

141 Speiche and Tupfer: Harald Hauswald, OSTKREUZ

144 Antitrott: Robert Havemann Gesellschaft/Siegbert Schefke

149 Die Firma: Harald Hauswald, OSTKREUZ

170 Pfingstgemeinde: Harald Hauswald, OSTKREUZ

173 (both) Silvio Meier and activists: GDR Ministry for State Security/ Robert Havemann Gesellschaft

174 Meier in window: Gabriele Trier/Robert Havemann Gesellschaft

204 (top) Checkpoint Charlie: © Lothar Schmid | worldwidefotos.de

204 (bottom) Brandenburg Gate: Sebastian Fritsche

223 Sculpture: Ben de Biel

224 Club IM Eimer: Ben de Biel

227 MiG: Ben de Biel

228 Bar Obst & Gemüse: Ben de Biel

238 Helmut Kohl: Bundesarchiv

251 Kinzigstrasse apartment building: Ben de Biel

263 House party invitation: Danielle de Picciotto

278 DJ Sven Väth: Ben de Biel

291 Tresor: Ben de Biel

294 Mural: © Lothar Schmid | worldwidefotos.de

297 Thierry Noir: Christoph Neumann/VATERBLUT

302 DJ invitation: Danielle de Picciotto

309 Banner: Robert Havemann Gesellschaft/Siegbert Schefke

Index of Names

Abwärts (Downward), 88

Adenauer, Konrad, 28

Ahrens, Silke, 171, 186–88, 197

Anderson, Sascha, 141, 241

Antitrott, 144, 161

Appelbaum, Jacob, 292–93

Ash, Timothy Garton, 17

Atkins, Juan, 271

Baargeld, Johannes Theodor, 86

Bad Seeds, 86, 90, 94, 203

Bargeld, Blixa, 54, 66, 73, 84–91, 93, 118, 203, 301–2

Bartel, Beate, 67, 87

Bassey, Shirley, 50

Baudrillard, Jean, 91

Baxter, Blake, 271

Beachy, Robert, 47–48

Besson, Benno, 132

Besson, Tanja, 241

Beuys, Joseph, 38, 114

Bey, Hakim, 218, 255

Bier, Daniel, 271–73, 274

Biermann, Wolf, 133

Birke, Sören, 275

The Birthday Party, 84

Blu (street artist), 294, 295–96, 305

Blumenschein, Tabea, 54

Bobo in White Wooden Houses, 237

Bodenschatz, Harald, 95

Bohley, Bärbel, 142, 169, 194

Böll, Heinrich, 38

Borofsky, Jonathan, 112

Böttcher, Jürgen, 140

Bouchet, Christophe, 112, 114–15, 117

Bowie, David, 1, 4, 19, 42, 46, 51–56, 67, 76–78, 82, 292

Bragg, Billy, 119–21

Brandt, Willy, 25

Brezhnev, Leonid, 167

Brühl, Daniel, 223

Brunckhorst, Natja, 40

Buntrock, Hans-Jürgen, 178

Bush, George H.W., 253

Can, 259

Cars, The, 76

Cave, Nick, 84, 86, 90, 94, 203

Ceauçescu, Nicolae, 197, 209

Chrischi (wife of Silvio Meier),
 162–63, 171–72, 173, 175,
 191–93, 207, 252, 256–57, 307

Christiane F. *See* Felscherinow,
 Christiane

Chung, Mark, 88

Citny, Kiddy, 11, 114

Colomb, Claire, 283

Contortions, The, 77

de Picciotto, Danielle, xiii, 16,
 64, 76, 205, 261–68, 278,
 301–2, 305

Deleuze, Gilles, 91

Denk, Felix, xiv, 269–70

Depeche Mode, 108

Der Bruch, 161

Deutsch-Amerikanische Freund-
 schaft (D.A.F.), 76, 259

Devo, 76

Die Art, 237

Die Firma, 145, 147–49, 241

Die Puhdys, 152

Die Tödliche Doris (Deadly
 Doris), 46, 64, 79, 263

Diedenhoven, Claudia, xiii, 16

Dietrich, Marlene, 19, 228

DIN A Testbild, 77

Disko. *See* Bier, Daniel

DNA, 77

Döblin, Alfred, 63

Dr. Motte. *See* Motte

Dreher, Christoph, 77

Dutschke, Rudi, 29–32, 38, 60,
 131, 177

Ebert, Frank, 193

Eickhoff, Caro, 293

Einheit, FM, 88–89

Eins, Mark, 77

Einstürzende Neubauten, 1, 14,
 41, 54, 67, 72, 79–80, 84–85,
 89, 153, 211, 261–62, 301, 305

Ekke (one of the Schreiner-
 strasse crew), 213, 259–57, 307

Element of Crime, 145–46, 148

Elvis Costello, 76

Eno, Brian, 45

Eppelmann, Rainer, 194

Ernst, Max, 18

Fahlberg, Gerd, 192, 210, 213,
 214, 306

Fassbinder, Rainer Werner, 47,
 53

Feeling B, 219, 237

Felscherinow, Christiane, 39–43,
 50, 51, 54, 57, 91, 94, 154,
 205–6

Fetisch (a DJ), 12

Final Cut, 263

Fosse, Bob, 19

Foucault, Michel, 51, 71, 78

Frenzel, Michael, 161–62, 308

Freygang, 219

Fukuyama, Francis, 247

Gente, Peter, 54

Ghazi, Markus, 103–4

Goldin, Nan, 54

Gorbachev, Mikhail, 15, 94, 167–68, 170, 181, 191, 195, 253

Gore, Martin, 108

Greco, Claudio, 292

Greiner-Pol, André, 147–48

Grimm, Erhard, 160

Gropius, Walter (Gropius City), 40–42, 56, 73, 91, 97, 134

Gut, Gudrun, 54, 66–70, 75–77, 84, 92, 94, 151, 217, 301–2

Haag, Romy, 48–52, 55, 77

Hacke, Alexander, 79, 86, 88, 112, 305

Hagen, Nina, 54

Hahn, Christine, 77

Haring, Keith, 117

Hauswald, Harald, xiii, 135–36, 140, 142, 147, 178–79, 203, 303

Havel, Vaclav, 248

Havemann, Florian, 131

Havemann, Frank, 131

Havemann, Katja, 169–70

Havemann, Robert, 131, 169

Havemeister, Heinz, xiv, 153–54

Heartfield, John, 18, 44, 285

Hegemann, Dimitri, 66, 262–64, 270–71, 290, 304

Henckel von Donnersmarck, Florian, 172

Henze, Lutz, 295

Honecker, Erich, 132, 167, 181, 188, 196, 292

Hood, Robert, 271

Horschig, Michael, 156

Howley, Frank, 59

Ideal, 76

Iggy Pop, 1, 45, 53–54, 82–83

Ihlow, Uta, 162, 214–15

Ilja, Jacob, 146

Immendorff, Jörg, 83

Inchtabokatables, 237

Isherwood, Christopher, 19, 44, 217

Jahn, Roland, 176–80, 189, 202–3

Jolly (Protestant social worker), 188, 193–4, 308

Jones, Grace, 53

Joni (one of the Schreinerstrasse crew), 213–14, 256–57

Jonzon (a DJ), 264

Joy Division, 76

Kadasch, Kathrin, 171, 206–7, 213, 235, 256, 306

Kahane, Peter, 221

Kaminer, Wladimir, 300

Kein Talent, 161

Kennedy, John F., 24, 25, 60

Keule (one of the Schreinerstrasse crew), 213

Khrushchev, Nikita, 73

Kid Paul (a DJ), 264

Kiesinger, Kurt Georg, 28

Kippenberger, Martin, 66, 83

Klumb, Annette, 252

Kohl, Helmut, 207, 237–38, 250, 253–54, 303

Kondeyne, Leo, 233

Köster, Bettina, 67–68

Kraftwerk, 92, 259

Krenz, Egon, 188, 197, 201–2

Kruse, Käthe, 64, 79, 104–5, 118

Kubrick, Stanley, 84

Kunzelmann, Dieter, 33, 35, 132

Lamberty, Tom, 57

Langhans, Rainer, 35, 60, 132

Leary, Timothy, 262

Lefebvre, Henri, 293

Leningrad Sandwich, 262

Leo, Annette, 230

Liebknecht, Karl, 176

Links, Christoph, 217, 228–29

Lippok, Robert, 151–53, 159, 178,
 203, 205, 301

Lippok, Ronald, 151–53, 159

Luxemburg, Rosa, 176, 178, 214

Lydon, John, 74

Maass, Swanhild, xiii, 222–23

Maass, Wilfriede, 139

Maeck, Klaus, 92

Malaria!, 76, 77, 80, 87, 92, 30

Mania D, 87

Marcus, Greil, xiii

Masch, Frank, 156

Meckel, Markus, 194

Meier, Ingo, 159–60, 178, 207

Meier, Silvio, 146–48, 159–63,
 171–74, 178, 183, 185–86,
 191–94, 207, 211–15, 245, 250,
 252, 256–57, 298, 307

Meinhof, Ulrike, 42

Mercury, Freddy, 53

Merkel, Angela, 208

Michele Baresi, 214

Mielke, Erich, 298

Mills, Jeff, 263, 271

Mimi (one of the Schreiner-
 strasse crew), 213–14

Moldt, Dirk, xiv, 145, 147–48,
 161, 171–72, 184–86, 196–97,
 214–15, 235, 252, 270, 306–7

Motte (a DJ also known as Moth
 and Dr. Motte), 16, 64, 118,
 205, 259–70, 272, 277–79,

Mühsam, Erich, 186

Müller, Jo, 171

Müller, Wolfgang, xiii, 46–48,
 54, 64, 66, 78, 94

Mungiu, Cristian, 209

Mutoid Waste Company, 226

Namenlos (Nameless), 156–58

Neide, Micha, 171, 206, 210,
 213–14, 256, 306–7

Nena, 76, 92

Niederländer, Loni, 164–65

Noir, Thierry, 98, 110–15, 117,
 296–97

Obermaier, Uschi, 35

Ohnesorg, Benno, 29, 31, 60, 103

Ornament & Verbrechen,
 152–53, 159, 203

Palmer, Robert, 89

Paris, Heidi, 54

Patrick (one of the Schreiner-
 strasse crew), 213

Peel, John, 89, 151–52

Planlos (Planless), 145

Poitras, Laura, 292

Pop, Iggy. *See* Iggy Pop

Poppe, Gerd, 139, 168, 194

Poppe, Ulrike, 139, 168, 194

Psychic TV, 263

PVC, 74

Rammstein, 219

Rampazzo, Peter, 222–23

Rapp, Tobias, 273, 276

Reagan, Ronald, 64, 72, 108

Reed, Lou, 78, 108

Regener, Sven, 148

Reich, Jens, 194

Rennefanz, Sabine, 247

Roeingh, Matthias. *See* Motte.

Rosa Extra, 145

Rossellini, Roberto, 20–21

Rossig, Rüdiger, 219–20

Sander, Helke, 45–46

Sandow, 237

Schabowski, Günter, 201–2

Schaller, Rainer, 278–79

Schamal, Mita, 156–58

Schidek, Christiane. *See* Chrischi

Schilling, Walter, 171

Schleim-Keim (Slime Germ), 145

Schlosser, Jana, 156

Schneider, Peter, 34

Schult, Reinhard, 208

Schwitters, Kurt, 67

Sello, Tom, 232

Semler, Christian, xiv, 28–29, 32, 36, 38

Siebert, Martina, 60, 71

Silly, 152, 237

Skoda, Claudia, 66, 68, 93

Smiths, The, 76

Snowden, Edward, 292

Soko, Robert, 300–301

Sontheimer, Michael, 12, 48, 94

Speiche (East German punk rocker), 136, 141, 155, 158, 171–72, 186, 214, 223, 242, 307

Stalin, Josef, 22

Stolpe, Manfred, 186

Talking Heads, 76

Tangerine Dream, 259

Tanith (a DJ), 264, 266, 291

Teenage Jesus & the Jerks, 77

Television, 76

Templin, Wolfgang, 168

Test Dept., 263

Teufel, Fritz, 35, 132

Thatcher, Margaret, 240

Ton Steine Scherben (Sound Stones Shards), 111

Trötsch, Frank, 242

Tupfer (girlfriend of Speiche), 141

Turner, Tina, 53

Ulbricht, Walter, 130–1, 132

Unerwünscht (Undesirable), 145

Unruh, N. U., 87–88, 302

van den Nieuwendijk, Michael, 260

van Dijk, Mijk, 260

Väth, Sven, 278

Verba, Eva Marie. *See* Haag, Romy

Verbaarsschott, Edouard Frans. *See* Haag, Romy

Virilio, Paul, 91

von Kubin, Kerta, 292

von Oettingen, Sabine, 125, 140

von Thülen, Sven, 269–70

Wagner, Bernd, 245–47

Wagner, Richard, xiii, 17

Warhol, Andy, 50, 83

Wartburgs für Walter, 161

Weiss, Konrad, 165, 185, 194

Weiss, Stefan, 275

Weisshuhn, Reinhard, 168

Wenders, Wim, 78, 94

Westbam (a DJ), 264

Wilson, Peter Lamborn. See Bey, Hakim

Wowereit, Klaus, 2

Wutanfall (Fit of Rage), 145

Zellermayer, Heinz, 59

Zimmer, Manuel, 234–35, 250, 252

About the Author

PAUL HOCKENOS is an American journalist and author who writes for *The Nation*, the *Chronicle of Higher Education*, *Foreign Policy*, the *New York Times*, and many other media outlets. He has held prize fellowships with the American Academy in Berlin, the European Journalism College, the German Marshall Fund of the United States, and the Carnegie Endowment for International Peace. He is the author of three books, including *Joschka Fischer and the Making of the Berlin Republic*, and lives in Berlin.

Celebrating 25 Years of Independent Publishing

Thank you for reading this book published by The New Press. The New Press is a nonprofit, public interest publisher celebrating its twenty-fifth anniversary in 2017. New Press books and authors play a crucial role in sparking conversations about the key political and social issues of our day.

We hope you enjoyed this book and that you will stay in touch with The New Press. Here are a few ways to stay up to date with our books, events, and the issues we cover:

- Sign up at www.thenewpress.com/subscribe to receive updates on New Press authors and issues and to be notified about local events
- Like us on Facebook: www.facebook.com/newpressbooks
- Follow us on Twitter: www.twitter.com/thenewpress

Please consider buying New Press books for yourself; for friends and family; or to donate to schools, libraries, community centers, prison libraries, and other organizations involved with the issues our authors write about.

The New Press is a 501(c)(3) nonprofit organization. You can also support our work with a tax-deductible gift by visiting www.thenewpress.com/donate.